An Ethology of Religion and Art

Drawing from the ethology of art and the cognitive science of religion this book proposes an improved understanding of both art and religion as behaviors developed in the process of human evolution. Looking at both art and religion as closely related, but not identical, a more coherent definition of religion can be formed that avoids pitfalls such as the Eurocentric characterization of religion as belief or the dismissal of the category as nothing more than false belief or the product of scholarly invention.

The book integrates highly relevant insights from the ethology and anthropology of art, particularly the identification of "the special" by Ellen Dissanayake and art as agency by Alfred Gell, with insights from Ann Taves, among others, who similarly identified "specialness" as characteristic of religion. It integrates these insights into a useful and accurate understanding and explanation of the relationship of art and religion and of religion as a human behavior. This in turn is used to suggest how art can contribute to the development and maintenance of religions.

The innovative combination of art, science and religion in this book makes it a vital resource for scholars of Religion and the Arts, Aesthetics, Religious Studies, Religion and Science and Religious Anthropology.

Bryan Rennie is a Professor of Religion and Philosophy in the Religion Faculty at Westminster College, USA.

Routledge Studies in Religion

Religion, Modernity, Globalisation
Nation-State to Market
François Gauthier

Gender and Orthodox Christianity
Edited by Helena Kupari and Elena Vuola

Music, Branding, and Consumer Culture in Church
Hillsong in Focus
Tom Wagner

Transformational Embodiment in Asian Religions
Subtle Bodies, Spatial Bodies
Edited by George Pati and Katherine Zubko

Media and the Science-Religion Conflict
Thomas Aechtner

Freethought and Atheism in Central and Eastern Europe
The Development of Secularity and Non-Religion
Edited by Tomáš Bubík, Atko Remmel and David Václavík

Holocaust Memory and Britain's Religious-Secular Landscape
Politics, Sacrality, and Diversity
David Tollerton

An Ethology of Religion and Art
Belief as Behavior
Bryan Rennie

For more information about this series, please visit: https://www.routledge.com/religion/series/SE0669

An Ethology of Religion and Art

Belief as Behavior

Bryan Rennie

Routledge
Taylor & Francis Group

LONDON AND NEW YORK

First published 2020
by Routledge
2 Park Square, Milton Park, Abingdon, Oxon OX14 4RN

and by Routledge
52 Vanderbilt Avenue, New York, NY 10017

Routledge is an imprint of the Taylor & Francis Group, an informa business

British Library Cataloguing-in-Publication Data
A catalogue record for this book is available from the British Library

Library of Congress Cataloging-in-Publication Data
A catalog record has been requested for this book

ISBN: 978-0-367-35467-1 (hbk)
ISBN: 978-0-429-33161-9 (ebk)

Typeset in Bembo
by codeMantra

Contents

Figures

Acknowledgements

All quotations from Alfred Gell's *Art and Agency: An Anthropological Theory* (Oxford: Oxford University Press, © Alfred Gell 1998) are reproduced with permission of the Licensor through PLSclear.

Extensive material from Ellen Dissanayake, *What Is Art For?* © 1988 is reprinted with the generous permission of the University of Washington Press.

All quotations from *On the Origin of Stories: Evolution, Cognition, and Fiction* by Brian Boyd, Cambridge, Mass.: The Belknap Press of Harvard University Press, Copyright © 2009 by Brian Boyd are given with the generous permission of Harvard University Press.

The image of René Magritte, "The Treachery of Images (This is Not a Pipe) (La trahison des images [Ceci n'est pas une pipe])" is © 2019 C. Herscovici and used with the permission of the Artists Rights Society (ARS), New York. Digital Image © [2019] Museum Associates/LACMA. Licensed by Art Resource, NY. © ARS, NY, Los Angeles County Museum of Art, Los Angeles, California, USA.

The image of Marcel Duchamp's *Fountain* is © Photo © Tate Gallery, London and is used by permission of Tate Images.

Octavio Ocampo's *The General's Family* is reproduced with permission from Visions Fine Art: Publisher/Agent/Representative for Octavio Ocampo USA.

The drawing and photograph of the Bison from the Salon Noir in Niaux, France, are used with the generous permission of Jean Clottes.

The artist's impression of the building of Göbekli Tepe © *National Geographic* is used with the permission of National Geographic images.

The image of the anthropomorphic pillar from Göbekli Tepe is used with the generous permission of the Göbekli Tepe research staff of the German Archaeological Institute.

The cover of *If Jesus Lived Inside My Heart* by Jill Roman Lord, illustrated by Amy Wummer, is reproduced by generous permission of the Hachette Book Group.

The image of *I am a Stranger from Another World* by Howard Finster is used with the kind permission of the John F. Turner Collection © Photograph by M. Lee Fatherree.

I would like to acknowledge the invaluable support and encouragement that I received from Jeff Kripal, Norman Girardot, and Ann Taves. I hope that the inevitable errors in this book, which are entirely my own responsibility, are not a disappointment to them. My colleague and neighbor, Russ Martin, kept me going when my own faith in this project threatened to fail me.

Last, my wife and my partner in all that I do, Rachela Permenter, deserves more than I can ever acknowledge in writing. I hope that I behave accordingly.

1 General introduction[1]

> Good sense is the most evenly shared thing in the world, for each of us thinks
> he is so well endowed with it that even those who are the hardest to please in
> other respects are not in the habit of wanting more than they have.
>
> (Descartes, *Discourse on Method*, 27)

Religion as a content area rivals good sense as a faculty. Even those who are
the hardest to please in other respects are not in the habit of wanting to know
more than we already know about it, but readily come to firm conclusions
and set behaviors concerning religion ... and thereby hangs a tale. The ini-
tial thesis of this work is simple enough. It is that the history and philosophy
of religion and the history and philosophy of art are critically in need of
integration and mutual consideration. This is not to state that religion and
art are "the same thing" (or "things" at all). Clearly, they are not. They are
two discrete abstract nouns, and there are sustainable distinctions to be made
between them. There can be art objects and events that are unconnected
with institutional religion, and there may be religious activities that lack all
artistry. On the other hand, the objects and activities of the material culture
to which these two abstract nouns refer, both past and present, are so inextri-
cably interconnected that it is imperative to our understanding of each that
we cease the futile and damaging attempt to tell their stories as if they were
entirely distinct. Since the Renaissance, and particularly since the Protestant
Reformation, the insistence in the modern, Western, European, Christian, or
post-Christian world on conceiving religion and art as fundamentally dissim-
ilar has been carried forward with remarkable tenacity. However, with the
recent and increasing emphasis on the material culture of religion and with
cognitive and evolutionary insights into both religion and art (and with the
introduction of some long-overdue humility and self-awareness in the West),
it is increasingly apparent that this distinction and the conceptions of art and
religion associated with it are fatally flawed. *An Ethology of Religion and Art:
Beauty, Belief, and Behavior* clarifies and justifies these claims and draws out
some of their implications and entailments, resulting in an understanding of
art and religion and their relationship that is detailed, accurate, and, I hope,
extremely useful.

What's the problem?

I first started thinking seriously about the problematic relationship of religion and art when I began teaching an undergraduate course of that name in 2005. Not that I hadn't thought about it before—I had thought about it enough to know that it worried me. Religion alone is a deeply problematic concept and the many attempts to define it have never proven satisfactory. Combined with the equally ill-defined concept of art it constitutes a "two-body" problem in which the behavior of one imprecise variable is unpredictably influenced by the dynamics of another that is equally elusive. It is common knowledge that religion and art are inextricably bound up with one another so as to be almost inseparable prior to the Renaissance and across the world. A huge proportion of everything that is identified as "art," culturally from Angkor Wat to the Ziggurats, and chronologically from Göbekli Tepe to the Crystal Cathedral, has overtly religious themes. As Barbara DeConcini, one-time president of the American Academy of Religion, put it:

> there are important connections between religion and art: both are oriented toward meaning, and both deal in universal human values—both are fundamental to being human. What is more, religion and art share remarkably similar discourses. Each works primarily through story, image, symbol and performance.
>
> (1991, 2)

The German theologian, philosopher, and biblical scholar Friedrich Schleiermacher (1768–1834) insisted in 1799 that "religion and art stand beside one another like to friendly souls whose inner affinity, whether or not they equally surmise it, is nevertheless still unknown to them" (1958, 158). In the 19th century, the Danish philosopher and author Søren Kierkegaard (1813–1855) felt that art had only recently achieved integrity and autonomy from religion. He also believed that art had gone too far and was beginning to become a substitute for religion. Sacred and profane inspiration were for him fundamentally incomparable, and he thought that if the Christian tradition were seen as an aesthetic phenomenon, then it was in danger of being explained away (1940). In *The Sacred Shrine: A Study of the Poetry and Art of the Catholic Church* (1912) the Finnish philosopher Yrjö Hirn (1870–1952) argued that the early equivalents of religion and art existed seamlessly blended together in the earliest stages of their development. In *Sacred and Profane Beauty (Vom Heiligen in der Kunst*, 1957), the Dutch phenomenologist of religion Gerardus Van der Leeuw (1890–1950) argued that the arts and religion began in a state of original unity, each art, and religion itself, only later achieving its own integrity and autonomy (2006). More recently, Marcia Brennan, in a fascinating work, *Curating Consciousness: Mysticism and the Modern Museum* (2010), has indicated the continuing, if concealed, consanguinity of art and religion by arguing that art museums remain places of mystical experience, suggesting that even

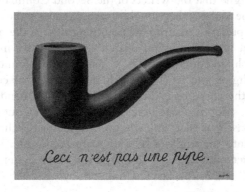

Figure 1.1 La Trahison des Images by René Magritte (1928–1929). Los Angeles County Museum of Art. © C. Herscovici/Artists Rights Society (ARS), New York. Digital Image © [2019] Museum Associates/LACMA. Licensed by Art Resource, NY. © ARS, NY, Los Angeles County Museum of Art, Los Angeles, California, USA.

modern art never really separated itself from the complex mystical traditions that preceded it.

The Biblical Second Commandment orders that

> you shall not make for yourself a graven image, whether in the form of anything that is in heaven above, or that is on the earth beneath, or that is in the water under the earth. You shall not bow down to them or worship them.
>
> (Exodus 20.1–17)

This has often been taken as driving a wedge between art and religion, making them undeniably distinct. Yet, as David and Linda Altshuler convincingly point out (1984), early Jewish synagogues were by no means bereft of art. Their conclusion is that the Commandment is an organic unity composed of two halves. It is not a prohibition of art *per se*, but a prohibition of "bowing down and worshipping" our own representations—a warning, I would argue, against "the treachery of images"—that is, against mistaking the representation for the thing represented.

It would be a mistake to assume that such a caveat would be too sophisticated for early Hebrew authors. They were equally, if differently, sophisticated as any anatomically modern humans. David Lewis-Williams, a scholar of both the contemporary San art of South Africa and Paleolithic cave painting, warns us that even the artists of Paleolithic images may have had no intention to represent physical, empirical items but specifically to represent "spirit beings" (2002, 194). While the visions were real *as visions*, they were not real in the sense of representing "a real bison," that is, a physical, flesh and blood being. If Paleolithic artists could exercise such sophistication, it is no stretch of the

imagination to argue that the writers of the Second Commandment did, too. The essence of the idolatry they sought to avoid is taking the representation to be the thing it represents, treating the pointing finger as the moon.

How, then, *are* art and religion related? As one walks into the bizarrely folded and convoluted edifice that has grown up on the foundation that is the confluence of religion and art (I can't help but think of the edifice as a Frank Gehry marvel), the entrance is littered with crumpled handbills. Pick them up, unfold them, smooth out the creases, and they turn out to be warnings: John Dixon counsels us that "[n]early every attempt that has been made to incorporate art into the study of religion or to account for art theologically has to some degree done violence to one or the other, either by distortion or impoverishment" (1983, 78). David Chidester says that

> as soon as we say, "Religion and Aesthetics" we are caught in a problem. It would seem that we are bringing together two relatively separate and independent entities: two separate areas of human activity, two separate subject fields ... into some arbitrary juxtaposition.
>
> (1983, 55)

James Elkins has said, "I can't think of a subject that is harder to get right, more challenging to speak about in a way that will be acceptable to the many viewpoints people bring to bear" (2004, ix), and Elkins observes that, for some people, the word "religion" can no longer be associated with the ideas of art. "Talk about art and talk about religion have become alienated one from the other, and it would be artificial and misguided to bring them together" (x). Yet there is, arguably, a "field" of the study of religion and art. In 1991 DeConcini told us that "Religion and art has been a 'field' in the sense that one can study it in graduate school and find positions teaching it in colleges only since the 1950s" (1991, 323), but 13 years later, David Morgan was still asking, "is there, in fact, a history of art and religion *as a field of study*? ... has 'art and religion' been a discreet and circumspect topic of enquiry?" He concludes that it is "presumptuous" to see the study of art and religion as a distinct field (2004, 17).

Trying to teach the subject(s) seemed a nightmare of haunting, ill-defined behemoths lurking just out of sight, eternally vanishing into the mists of ignorance. When I first taught the course, I took Lewis Carroll's *The Hunting of the Snark*, in which the Bellman, who captained the hunt, had a map that was "a perfect and absolute blank," as the *leitmotiv*. In Carroll's immortal words:

> ... beware of the day,
> If your Snark be a Boojum! For then
> You will softly and suddenly vanish away,
> And never be met with again!

... and each Snark threatened to be a Boojum. The whole complex threatened to be so far from anything that could be dealt with reliably and rationally, especially by a single individual, that it seemed inevitably to lead to such

pretentious nonsense that one's every opinion could evaporate (or sublime) before the righteous scorn of one's colleagues. I soldiered on, buoyed up by the indefatigable enthusiasm of my students and their apparently unshakeable conviction that I knew what I was talking about. The best single book I could find on the subject, Diane Apostolos-Cappadona's anthology, *Art, Creativity and the Sacred: An Anthology in Religion and Art*, was first published in 1984 and contains articles that, albeit extremely valuable, date from the 1930s and 1940s and are thus ignorant of developments that are more recent. It is also a graduate-level text. I supported my students as best I could and helped them through the readings and provided as many more as I could find that might enlighten them (and me) concerning the relationship of religion and art. Apostolos-Cappadona's book is immensely helpful as an introduction to the problem, but it raises more questions than it answers, being full of suggestive, somewhat breathless, indications that art in religion enables "the expression of the inexpressible" and "vision of the invisible." It is almost universally agreed that art permits the artist to express and the audience to apprehend that which is otherwise inexpressible and beyond apprehension. There are also obvious implications as to the nature of the invisible that is thus revealed. It is not simply that invisible agents such as gods and spirits become available to experience through the media of sculpture or painting or as elements of narrative (although this is far from unimportant). It is the universal, the infinite, "the undifferentiated continuum," the transcendent, the *structure* of reality, ultimate reality, or the truly real, that is somehow made available to the bodily senses. Thomas Franklin O'Meara claims that "art suggests a mode of subjectivity that not only rejects the technocracy of words but which unleashes, bestows, and discloses the more of Presence" (206). O'Meara quotes the German Idealist philosopher Friedrich Wilhelm Joseph Schelling (1775–1854) as saying that "Beauty is the infinite presented in the finite" (1978, 208). Similar statements occur throughout the volume: according to the sculptor, Stephen De Staebler, "[i]f you strip away all the doctrines and dogmas, religion becomes a very precarious relationship between a frail and finite reality and a sense of all-present infinite reality" (26). F. S. C. Northrop calls this

> apprehending the undifferentiated continuum in and through the immediately apprehended differentiated continuum ... this mode of knowing not only apprehends the immediately sensed world of "differentiated" objects and feelings, but—in and with that—the underlying "undifferentiated," sacred unity that empowers and is the ground for everything.
> (1946, 315–358, 394–404, as quoted by Richard Pilgrim 1984, 138)

O'Meara also says that

> the aesthetic illustrates human theological interpretation of divine revelation. The aesthetic modality is a basic fact of experience. Aesthetics can describe religion, revelation, faith, and thinking about faith with

the strength and clarity equal to the categorical style…[Aesthetics] does not presume that theology or life is mainly word, syllogism, myth, or symbol.

(205)

In the same volume, Paul Tillich talks of "the deceptive character of the surface of everything we encounter which drives one to discover what is below the surface. … The truly real which cannot deceive us… Ultimate reality is expressed in artistic forms" (220). Effective art reveals "the breathing of the universal in the particular," according to the catalog of the exhibition "Bernard Leach: 50 years a Potter" (Leach 1961, 88 quoted by Cecilia Davis Cunningham, 9). "The transcendent appears through art," according to Langdon Gilkey (1984, 189). O'Meara says that for Schelling art is "a realization of absolute consciousness. It is an access to the structure of reality—past, present, and future. Art, like philosophy, is revelation" (1978, 209–210).

But what on earth does all this *mean*? Isn't it just sublime nonsense? Does it express anything other than the writers' love of art? How can one *explain* it? Is the Snark a Boojum or not? Clearly, art is being assumed to perform what is usually thought of as the central function of religion—to reveal the otherwise unknown nature of the "really real," the sacred, the invisible world or cosmic order, which determines the ultimate value of our behavior. The present volume proposes to explain how it does so.

I initially picked up an Ariadne's thread provided by phrases such as Paul Ricoeur's "disclosure of new modes of being, of new forms of life, gives to the subject a new capacity for knowing himself" (quoted in DeConcini 1991, 325) and John Dixon's "the worshipper returns to his own circumstances not so much better informed about the nature of the common life as prepared to see the ordinariness of things radiant with the faith" (1984, 288). Apostolos-Cappadona has also edited an anthology of articles by historian of religion, Mircea Eliade, on the subject of religion and art (Eliade, 1986), and such phrases are reminiscent of Eliade who, in his discussion of religious symbols, had said that symbols allow people to "become conscious" of alternative modalities of the real. They "disclose to us a perspective from whence things appear different." They "make the immediate reality 'shine'" (1986, 6). Eliade is often accused (among other things) of being a "closet theologian," and an obfuscatory mystic who simplistically accepts the reality of transcendental agencies and whose understanding of religion is, therefore, incoherent (McCutcheon 2001). I do not believe this to be the case, as I will explain in detail in Chapter 6, but the problem remains: how can one make coherent sense of such claims? How *are* religion and art related?

Elkins points out that "there is almost no modern religious art in museums or in books and art history" (ix) and it is, perhaps, from the apparent disappearance of religion from modern art that we should take some clues. While I agree that talk about art and talk about religion have become alienated from one another, I disagree strongly that "it would be artificial and misguided

to bring them together" (Elkins, x). It is telling that, while Elkins recognizes that he accepts a very particular definition of art for a very particular reason—"in order to avoid having to say what art should be about, or even what it has been about." He defines art as "whatever is exhibited in galleries in major cities, bought by museums of contemporary art, shown in biennales and the Documenta, and written about in periodicals such as *Artforum*, *October*, *Flash Art*, *Parkett* or *Tema Celeste*" (1). This is what is often termed "the institutional definition of art." Ellen Dissanayake and the ethologists of art who are principal contributors to my argument fundamentally reject it. While such a definition sufficed for Elkins' particular purpose in that volume, it has very particular consequences. This institutional definition of art has its own virtues and can be, and often is, invoked as an ostensive definition of the class (I will say more about the nature and types of definition in a following chapter), it simply *assumes* the fundamental discontinuity of art and religion and thus provides no possible response to the questions raised by most of the aforementioned authors concerning the indisputable *connections* between the two. Religion and art may have *become* alienated, but they had some earlier relation, even in the modern West, and they still do in much of the world as they did throughout history. It is necessary and extremely instructive to consider that relationship.

Tracing the relation of religion and art throughout human history may be like trying to trace the trajectory of two sparks through an ongoing explosion. I was much encouraged while struggling to understand the art of divination in the *Yijing* when I came across Richard Smith's assertion that "an impossible task is nonetheless worth undertaking if the topic is interesting enough" (2008, xii). Art and religion are certainly interesting enough, and their relation may not, in the end, be impossible to disentangle. No-one can be fully expert in all aspects of such an inquiry and a certain dilettantism is unavoidable. It is necessary to take risks to construct novel and creative hypotheses that can be further inspected, tested, and, if not falsified, gradually improved upon. A sensible limitation to a specific genre, geographical area, or historical period, with a concomitant narrowing of the relevant material, is an advantage that this study cannot have. My analyses in the following chapters stray into various fields in which I am not entirely expert and so will be vulnerable to the readings of specialists in each area. I am not an evolutionary biologist or geneticist—my appeals to those fields are made to support the coherence and viability of the understanding of art and of religion that I elucidate here rather than claiming to have unlocked the genetic code of religion.

I am attempting to write for readers of different backgrounds and I hope that my peers in the history and philosophy of religion will find something of use and value in the following speculations about religion in general. I also hope that students will be able to use the book to improve their understanding of the nature and interrelation of religion and art. Finally, I hope that the general reader with an interest in either religion or art will benefit from the book. With these things in mind, I can only call for an initially charitable

reading,[2] tolerant of failure to refer to all of the relevant literature, which allows the larger understanding to emerge. This study emerges from the aesthetics of religion, a subset of the philosophy of religion. It is, however, a philosophy of religion broadened along the three axes suggested by Kevin Schilbrack (2014), who proposed that a philosophy of religion that is adequate to its task (and not artificially restricted to problems of philosophical theology appropriate only within the Western monotheistic traditions) must be expanded along the axis of alternate religious traditions, the axis of lived as opposed to merely literate or intellectual religion, and the axis of other disciplines that study of religion. I entirely agree, and the following chapters seek to achieve a perspective that draws on the whole panoply of religious behavior, on a wide variety of disciplines, and on lived religion as a matter of human behavior and physical activity rather than abstract doctrine and disembodied thought.[3]

Given these caveats, an initially "artistic" approach that is necessarily creative is more appropriate than an attempt to be entirely prosaic, categorical, or pseudo-scientific. The braiding of an argument, no matter how prosaic and categorical the language employed, is a creative process, the art of which should not be underestimated.[4] It is also necessarily historical to some extent. The study of religion properly constitutes a history and philosophy of religion,[5] and I cheerfully count myself among those who insist on the creative nature of historiography. Nineteenth-century conceptions of science still haunt the contemporary understanding of history, but to quote Hayden White,

> as a discourse about things no longer perceivable, historiography must construct, by which I mean imagine and conceptualize, its objects of interest before it can proceed to bring to bear upon them the kinds of procedures it wishes to use to "explain" or "understand" them.[6]

The discourse before you fully intends to be creative and I hope that it proves imaginative.

What's the solution?

While this study is not itself science, it does use some of the findings of science. My intention is to investigate and elucidate the relationship between art and religion *as behaviors* and to do so I will apply techniques and concepts proper to "ethology." This will, therefore, be an ethology rather than an aesthetic of religion. Ina Wunn's entry in the second edition of the Macmillan *Encyclopedia of Religion* describes the ethology of religion (Wunn 2005). Wunn is a distinguished German scholar of religion with doctorates in both natural history and the history of religion who has written extensively on the ethology of religion. According to her *Habilitationsschrift* of 2002, she practices Religious Studies (*Religionswissenschaft*) as "an interdisciplinary field

situated between the Humanities and Sciences [which] focuses primarily on the study of religious behaviour from the perspective of evolution theory."[7] An increasing number of scholars in the Anglophone world are beginning to adopt the same approach to Religious Studies as an evolutionary and be-havioral enterprise. Ethology is a biological study of behavior, emphasizing that the physiological basis of behavior has evolved and should be studied as an aspect of evolution. Its roots can thus be traced directly to Darwin, and to some extent, it overlaps other disciplines such as sociobiology, behavioral ecology, evolutionary psychology, human anthropology, and consciousness studies (Wunn 2005, 2867). Scholars who have applied this approach to reli-gion include Walter Burkert (1983, 1996), Frits Staal (1989), Weston La Barre (1972), Marvin Harris (1977, 1997), Robert Bellah (1970), and Roy Rap-paport (1999). The whole movement that is generally termed the cognitive science of religion (CSR), being primarily the application of evolutionary psychology to the topic of religious behavior, constitutes a very significant el-ement of the ethology of religion. Its proponents, from Scott Atran to David Sloan Wilson, can be counted as ethologists even though they seldom use the term.[8] It is in the ethology of art that the term has come into its own.

Although ethology is the study of evolved behaviors, it must be distin-guished from behaviorism. Behaviorism, properly speaking, is a group of doctrines related by their metaphysical concerns over dualism and their epistemological concerns over the status of mental terms and entities (Fla-nagan 1995). As it became increasingly radical, especially as expressed by B. F. Skinner (1904–1990), and sought to reject all reference to consciousness and all "mentalistic terms," such behaviorism was increasingly and right-fully rejected. However, the fact that the word "behaviorism" is most often associated with this extreme, impractical, and widely scorned position did not prevent the greater part of the more reasonable principles of Skinner's precursor, J. B. Watson (1878–1958), from being absorbed into psychology (Harzem 2004). The study of behavior constitutes a powerful focus without any need to *deny* the intentional states characteristic of mental phenomena associated with them. It does, as we will see, have certain implications about the nature of those states.

For my purposes the evolving unit is the human species with behavioral traits as part of its phenotype, rather than conceiving of religions, or some part of religious traditions such as rituals, as themselves evolving units.[9] Early the-orists who proposed "evolutionary" theories of religion, such as E. B. Tylor (1832–1917), R. R. Marett (1866–1943), and J. G. Frazer (854–1941), failed fully to understand or to apply a properly biological evolutionary under-standing to religion and not only assumed religions themselves to be evolving units but also understood evolution as "a process of progressive development" rather than "the adaptive modification of organisms through time by means of natural variability and selection" (Wunn 2003, 391). This assumption rei-fies religions and reduces the evolutionary approach to a rather inappropriate metaphor instead of pursuing an actual ethology. It is my hope, building on

the ethology of art, to outline an ethological approach to religion that is more flexible and more appropriately adaptable to its topic.

In Part I, "Theorizing Religion and Art," I lay out an understanding of the nature and the relation of art and religion, introducing its components sequentially to allow the ideas to grow organically. The chapter immediately after this general introduction describes the ethology of art, suggesting its utility to the study of religion. Although it is clearly relevant, the ethological approach to art is seldom applied to religion. The study of art as a behavior with adaptive evolutionary origins assumes that art must have made a positive contribution to survival and reproduction in the past since it has been selected for and become a universal human behavior. This not only explains a great deal about art but also shows significant promise as applicable to the analysis of religion. The Cognitive Science of Religion, discussed in the following chapter, studies religion as a product of natural, evolved cognition. That is, it takes an approach initially similar to the ethology of art, but, on the one hand, it largely fails to recognize religion as having developed as itself an adaptive behavior and, on the other, it aspires to be science rather than part of the humanities. If the insights of the ethology of art are integrated with insights from the cognitive science of religion, and if the resulting amalgam is allowed to be itself more of an art (a "liberal art") akin to literary criticism, there are significant implications.

The proposed integration implies specific theoretical definitions of art and religion that could prove useful. Chapter 4 therefore considers the nature, structure, and function of definition so that this claim can be properly understood. Various types of definition, including lexical, ostensive, and intensional definitions, and definition by genus and species are explained. Art itself has always been difficult to define although the cluster of concepts and functions with which it is associated have been much discussed. The ethology of art looks at art in a particular way, which results in a relatively clear, if perhaps unusual, definition. Religion has been even more excruciatingly difficult to define, for related reasons and with similar outcomes. The dimensions in which religion operates can be described, but fitting them together into a theoretical definition—one which serves as a summary of a more ramified theoretical understanding—has eluded scholars of religion. If a perspective integrating the ethology of art and the cognitive science of religion be adopted, then, following the definition of art adduced by the ethology of art, religion can be defined in a closely related fashion.

The following chapter, "Beauty and religion. Seeing the world better," observes that scholars from both the ethology of art and the cognitive science of religion have employed the idea of the "special" as the defining characteristic of their objects. Employing the word "beauty" to refer to the "special" in art, the chapter clarifies the identifying characteristics of beauty, contributing to an understanding of religion as a means of "seeing the world better." That is, perception of the environment as suffused with cognizable agency is modified by means of focused and prolonged concentration on objects and

actions representative of that agency, such that behavioral response becomes more consistent, assured, and persistent. The effect of art objects and events as things made and apprehended as special is considered from ethological and anthropological perspectives. The agency of art—what art *does*—must be understood to recognize art as an evolutionary adaptation. This modification of cognition through fascination is suggested to be the behavior ancestral to both art and religion. Art and religion are distinct but related species of a single genus.

As has been mentioned, Mircea Eliade wrote significantly on art and religion. Although "the sacred" as employed by Eliade is sometimes assumed to be equivalent to "God" or to some autonomous "transcendental" entity, it is more consistent with his writings to identify it as an intentional or attributed characteristic, like beauty. We do not consciously and deliberately attribute beauty. On the contrary, we are moved by it. It is the agent and we the patient. Chapter 6 argues that Eliade's analysis of the experience of the sacred in the profane is entirely consistent with the proposed ethological understanding. Just as "beauty" identifies that which is special in art, so too "the sacred" identifies that which is special in religion. Just as beauty is experienced—by some and not others—as inhering in, but not a simple property of, some entities and not others, so the sacred is differentially experienced for related reasons. Such experiences are products of an evolved capacity to detect, in a fashion that is faint and fallible but compelling, the promise of abiding benefit. "The perception of the sacred in the profane" can thus be identified with the paradoxical ability to "see the invisible" and "express the inexpressible" frequently attribute to the arts.

Chapter 7, "Wisdom and the personality of reality," renders more explicit the understanding implicit in the preceding chapters. The human ability to empathize, applied to material culture and extended to natural phenomena, responds to agency, animate and inanimate, and provokes a similar response to agents that show similar promise of sustainable benefit. Those who recognize such agency and respond specifically, persistently, and with a high degree of assurance are regarded as "wise," which is a universal category.

The concluding chapter of the first part gives a précis of the foregoing argument and an explicit statement of the understanding and the definitions it implies. According to ethologists and anthropologists of art, art behavior as an evolutionary adaptation has been practically beneficial in many ways. "Theory of mind" (the ability to attribute internal states such as beliefs, intentions, desires, emotions, or understanding, and to understand that others have internal states similar to one's own) produces behavioral responses including fascination with the beautiful and assured responses to charismatic performance, to artifacts, and to other agents in the environment. When either performances or products stimulate a similar response, commanding our attention and determining our behavioral response, we are confronted with "beauty," as described, induced by the "special" objects of art. When an extended matrix of such special objects induces persistent, focused behavior

we are dealing with "the sacred," provoked by the special objects of religion, prompting assured and persistent behavior.

The second part of the work substantiates this understanding with historical examples that can be explained and understood in its light and, in turn, shed further light on this understanding. Chapter 9, "Divination: the vanishing point of religion" argues that if "the sacred" has the capacity to induce assured, persistent, and sustainable behavior, we might expect religion to be associated with conscious attempts to determine behavior. This is indeed what we find in an inspection of divination. Divination is precisely a means of determining subsequent actions, and it is a prime example of religious behavior. It illustrates precisely how religion operates in the fashion proposed. The following chapter, "From caves to cities: religion and the earliest art" considers some of the oldest examples of human material production as conforming to the identification of art and religion as descendants of a common ancestor. There are inherent difficulties in studying prehistoric religion but studying external behavior as opposed to internal belief has advantages. There is an ongoing controversy over the "religious" nature of Paleolithic art but a strong case can be made for recognizing it as religious in the suggested manner. Early in the Neolithic period, from around 9,500 until perhaps 8,000 BCE, the monumental installations of Göbekli Tepe in Turkey provide examples of human behavior that is unquestionably both art and religion and which can best be understood as the behavior ancestral to both. About 600 kilometers west of Göbekli Tepe, the domestic settlement of Çatalhöyük flourished from perhaps 500 years after Göbekli Tepe and continued to be occupied until around 5,700 BCE. It produced art that sheds a great deal of light upon the nature and function of the art/religion complex under consideration. The combination of the monumental style of Göbekli Tepe with the domestic style of Çatalhöyük can be seen in the development of the world's earliest cities.

Since "the common ancestor of art and religion" is seen as a means of effective cognition inducing potentially persistent behavior, its association with occasionally rapid change must be explained. The processes that we now identify as art, as distinct from religion, increase awareness of potential innovation, while the processes that we now identify as religion, as distinct from art, organize those innovations into enduring structures of stylistically related objects and events that induce persistent, sustainable behavior.

Chapter 11 looks at Biblical prophecy in the mid-first millennium BCE as an example of the interaction of religion and art that provides compelling insight into the increasing success of the text as the exemplary sacred art. The following chapters, "Where is the Art we have Lost in Religion?" and "Where is the Religion we have Lost in Art?" give other examples of religion using the operations of art and of the importance of art and material culture to religious behavior. Chapter 12 looks at the operation of art objects and event in some of the other religions of the world. Hanumān, the eleventh avatar or incarnation of Śiva in the Hindu tradition, is considered

as particularly revealing of the attribution of "interiority" to religious representations. The example of the texts of Kongzi [Confucius] is drawn upon to clarify the similarity of ascriptions of personal and impersonal agency. The penultimate chapter considers the necessity of recognizing the importance of art and material culture in the study of religion through a consideration of two recent contributions to the field, *A History of Religion in 5½ Objects: Bringing the Spiritual to its Senses* by S. Brent Plate and *Envisioning Howard Finster: The Religion and Art of a Stranger from Another World* by Norman Girardot. Emphasizing the irreducibly creative nature of such a study, it nonetheless argues for the importance of integrating insights from the scientific study of cognition. It also insists that the arts in all of their forms serve a moral role that cannot be reduced to a morally neutral, "aesthetic" function.

Chapter 14 concludes the work. The working hypothesis that has been developed is that religion consists of the composite effects of art that "expresses the inexpressible," and allows "visions of the invisible" in a now specifically understood process. The human capacity for empathy or "theory of mind," applied to inanimate objects and environmental agents, gives a powerful sense of the nature, character, or personality of that to which we must respond. This is induced by artful representation that is found to be ultimately worthy of attention and of the investment of time, effort, and resources, which induces persistent and assured behavior in a fashion that must have been beneficial to our Pleistocene ancestors. Some potential benefits and significant implications of that hypothesis are considered. While not yet proven this hypothesis promises potential methodological improvements, a path to clinical research, and is consistent with a very wide range of observations.

Notes

1 Parts of this chapter were previously published as "The Sacred and Sacrality: from Eliade to Evolutionary Ethology," in *Religion* 47, no. 4 (2017): 663–687.
2 Donald Davidson, *Inquiries into Truth and Interpretation* (Oxford, 1984), 137 explains the philosophical justifications of such charitable reading.
3 Schilbrack speaks constantly of religion as "forms of practice" (31, 43, 127, etc.), as acts, without explicitly stating the importance of treating religion as *behavior*.
4 The idea of argument as a braid is taken from David Lewis-William's excellent discussion of the construction of arguments (2002, 102–104).
5 Rennie (2012, 2014, 2016).
6 White (2000, 392). See Kindi (2010) for a compelling discussion of the specter of science that haunts historiography.
7 Taken from http://ina-wunn.com/home.html March, 2019.
8 In Michael Stausberg's (2009) *Contemporary Theories of Religion*: 15 theories of religion published since 1980 are described, of which 12 can be recognized to constitute ethological studies in this sense although they are not identified as such.
9 In more recent work, Ina Wunn has attempted to describe religions as themselves evolving units ("What is Evolution and What Does Evolve?" Plenary address to the 2nd Evolution of Religion Conference, Santa Ana Pueblo, NM, November 14th, 2017). However, I am reluctant to follow this lead and continue to consider *homo sapiens* as the evolving unit of which religion is a behavioral trait.

References

Altshuler, David and Linda Altshuler. "Judaism and Art." In *Art, Creativity, and the Sacred: An Anthology in Religion and Art*, edited by Diane Apostolos-Cappadona, 155–163. New York: Continuum, 1984.

Apostolos-Cappadona, Diane, ed. *Art, Creativity, and the Sacred: An Anthology in Religion and Art*. New York: Continuum, 1984.

Bellah, Robert N. "Religious Evolution." *American Sociological Review* 29 (1964): 358–374. Also in *Beyond Belief: Essays on Religion in a Post-traditional World*, by Robert Bellah, 20–50. New York: Harper and Row, 1970.

Brennan, Marcia. *Curating Consciousness: Mysticism and the Modern Museum*. Cambridge, MA: MIT Press, 2010.

Burkert, Walter. *Homo necans: Interpretationen altgriechischer Opferriten und Mythen*. Berlin and New York, 1972. Translated by Peter Bing as *Homo Necans: The Anthropology of Ancient Greek Sacrificial Ritual and Myth*. Berkeley: University of California Press, 1983.

Burkert, Walter. *Creation of the Sacred: Tracks of Biology in Early Religions*. Cambridge, MA: Harvard University Press, 1996.

Carroll, Lewis. *Lewis Carroll's the Hunting of the Snark: The Annotated Snark*. Los Altos, CA: William Kaufmann, in cooperation with Bryn Mawr College Library, 1982.

Chidester, David. "Aesthetic Strategies in Western Religious Thought." *Journal of the American Academy of Religion* 51, no. 1 (1983): 55–66.

Cunningham, Cecilia Davis. "Craft: Making and Being." In *Art, Creativity, and the Sacred: An Anthology in Religion and Art*, edited by Diane Apostolos-Cappadona, 8–11. New York: Continuum, 1984.

DeConcini, Barbara. "The Crisis of Meaning in Religion and Art." *The Christian Century*, March 20–27 (1991): 323–326.

Descartes, René. *Discourse on Method*. Translated by F. E. Sutcliffe. London: Penguin Books, 1968.

De Staebler, Stephen and Diane Apostolos-Cappadona. "Reflections on Art and the Spirit: A Conversation." In *Art, Creativity, and the Sacred: An Anthology in Religion and Art*, edited by Diane Apostolos-Cappadona, 24–33. New York: Continuum, 1984.

Dissanayake, Ellen. *What Is Art For?* Seattle: University of Washington Press, 1988.

Dixon, John W. "Art as the Making of the World: Outline of Method in the Criticism of Religion and Art." *Journal of the American Academy of Religion* 51, no. 1 (1983): 78–103.

Dixon, John W. "Painting as Theological Thought: The Issues in Tuscan Theology." In *Art, Creativity and the Sacred*, edited by Diane Apostolos-Cappadona, 277–296. New York: Continuum, 1984.

Eliade, Mircea. "The Symbolism of Shadows in Archaic Religions." In *Symbolism, the Sacred, and the Arts*, edited by Diane Apostolos-Cappadona, 3–16. New York: Crossroad, 1986.

Elkins, James. *On the Strange Place of Religion in Contemporary Art*. New York: Routledge, 2004.

Flanagan, Owen. "Behaviorism". In *The Oxford Companion to Philosophy*, edited by Ted Honderich, 81–82. Oxford, UK and New York: Oxford University Press, 1995.

Gilkey, Langdon. "Can Art Fill the Vacuum." In *Art, Creativity, and the Sacred: An Anthology in Religion and Art*, edited by Diane Apostolos-Cappadona, 95–104. New York: Continuum, 1984.

Harris, Marvin. *Culture, People, Nature: An Introduction to General Anthropology.* New York: Pearson, 1975. 7th edition, 1997.

Harris, Marvin. *Cannibals and Kings: The Origins of Culture.* New York: Vintage, 1977.

Harzem, Peter. "Behaviorism for New Psychology: What Was Wrong with Behaviorism and What Is Wrong with it Now." *Behavior and Philosophy* 32 (2004): 5–12.

Hirn, Yrjö. *The Sacred Shrine: A Study of the Poetry and Art of the Catholic Church.* Boston, MA: Beacon, 1912.

Kierkegaard, Søren. *Of the Difference between a Genius and an Apostle.* Translated by Alexander Dru. New York: Harper Torchbooks, 1940.

Kindi, Vasso. "A Spectre Is Haunting History—The Spectre of Science." *Rethinking History* 14, no. 2 (2010): 251–265.

La Barre, Weston. *The Ghost Dance: Origins of Religion.* London and New York: Allen and Unwin, 1972.

Leach, Bernard. *Bernard Leach: 50 Years a Potter.* London: The Arts Council, 1961.

Lewis-Williams, D. *The Mind in the Cave: Consciousness and the Origins of Art.* London: Thames and Hudson, 2002.

McCutcheon, Russell. "Methods, Theories, and the Terrors of History: Closing the Eliadean Era with Some Dignity." In *Changing Religious Worlds: The Meaning and End of Mircea Eliade,* edited by Bryan Rennie, 11–23. Albany: State University of New York Press, 2001.

Morgan, David. "Toward a Modern Historiography of Art and Religion." In *Reluctant Partners: Art and Religion in Dialogue,* edited by Ena Giurescu Heller. New York: The Gallery at the American Bible Society, 2004.

Northrop, F. S. C. *The Meeting of East and West.* New York: Macmillan, 1946.

O'Meara, Thomas Franklin. "The Aesthetic Dimension in Theology." In *Art, Creativity, and the Sacred: An Anthology in Religion and Art,* edited by Diane Apostolos-Cappadona, 205–218. New York: Continuum, 1984.

Pilgrim, Richard B. "Foundations for a Religious-Aesthetic Tradition in Japan." In *Art, Creativity, and the Sacred: An Anthology in Religion and Art,* edited by Diane Apostolos-Cappadona, 138–154. New York: Continuum, 1984.

Rappaport, Roy. *Ritual and Religion in the Making of Humanity.* Cambridge, UK: Cambridge University Press, 1999.

Rennie, Bryan. "The History (and Philosophy) of Religions". *Studies in Religion/ Sciences Religieuses* 41, no. 1 (2012): 24–32.

Rennie, Bryan. "The Historical Method and the Study of Religion." In *Religion: Social Religion,* edited by William B. Parsons, 293–313. Farmington Hills, MI: Macmillan Reference USA, 2016.

Schelling, Friedrich Wilhelm Joseph von. *System of Transcendental Idealism.* Translated by Peter Heath. Charlottesville: University Press of Virginia, 1978.

Schilbrack, Kevin. *Philosophy and the Study of Religion: A Manifesto.* Chichester, UK: Wiley-Blackwell, 2014.

Schleiermacher, Friedrich. *On Religion: Speeches to Its Cultured Despisers.* Translated by John Oman, with an introduction by Rudolf Otto. New York: Harper, 1958.

Smith, Richard. *Fathoming the Cosmos and Ordering the World: The Yijing (I-Ching, or Classic of Changes) and Its Evolution in China.* Charlottesville and London: University of Virginia Press, 2008.

Staal, Frits. *Rules without Meaning: Ritual, Mantras, and the Human Sciences.* New York: Peter Lang, 1989.

Stausberg, Michael, ed. *Contemporary Theories of Religion: A Critical Companion.* London and New York: Routledge, 2009.

Tillich, Paul. "Art and Ultimate Reality." In *Art, Creativity, and the Sacred: An Anthology in Religion and Art,* edited by Diane Apostolos-Cappadona, 219–235. New York: Continuum, 1984.

van der Leeuw, Gerardus. *Sacred and Profane Beauty: The Holy in Art.* New York: Oxford University Press, 2006.

White, Hayden. "An Old Question Raised again: Is Historiography Art or Science?" (Response to Iggers). *Rethinking History* 4 (2000): 391–406.

Wunn, Ina. "The Evolution of Religions." *Numen* 50 (2003): 387–415.

Wunn, Ina. "Ethology of Religion." In *The Encyclopedia of Religion,* edited by Lindsay Jones, 2nd ed., 2867–2870. New York: Macmillan, 2005.

Part I

Theorizing religion and art

2 The ethology of art (and religion)[1]

It is possible to view human beings from an ethological perspective if one accepts—as seems undeniable—that man is an animal species who has evolved and whose behavior as well as his biological organs and systems has had adaptive or selective value in that evolution. Human ethologists propose that certain ubiquitous behavioral features or tendencies in man's life are an intrinsic, relatively unchangeable part of his nature and have arisen and been retained because they contribute positively to his evolutionary success, his survival as a species.

(Ellen Dissanayake, "Art as a Human Behavior:
Toward an Ethological View of Art," 398)

Even for those already familiar with the ethology of art, it will be worthwhile to explain precisely how I understand it in this context. Ethology is the general study of behaviors. The word comes from the Greek: ἦθος, ethos, "character"; and -λογία, -logia, as applied to all systematic studies. Properly speaking, it denotes the scientific study of animal behavior, a sub-topic of zoology. Applied to the study of culture and the arts, the ethological approach has gone by several names: biocultural criticism, a bioevolutionary approach, the adaptationist view, evolutionary aesthetics, literary Darwinism, and even "evocriticism" (Boyd 2009, 389). These often have more specific applications than the more general "ethology" that I prefer, but they all share the same assumption of Darwinian evolutionary theory. The more common "cognitive cultural studies" assumes that human cognition is a product of evolutionary processes and constitutes a very significant subset of the more general behavior of the species. The successful application of this ethological approach to literary criticism is a subset of its broader application to the arts in general.

The application of this approach to the study of art was pioneered by Ellen Dissanayake in her 1988 work, *What Is Art For?*, although with numerous precursors.[2] Since the appearance of Dissanayake's book, a growing number of scholars have become engaged with this approach.[3] More recently "cognitive cultural studies" has received significant attention (see, for example, Zunshine 2010). Despite risks, this "ethological" approach has much to contribute. In attaining a clear understanding of art and of religion the real

problem lies not so much with ethology, which can be quite clearly described, but with its proposed object, art (and my object "religion"), neither of which can be easily defined. I will eventually make an attempt to stipulate specifically what the words "art" and "religion" are used to signify in the context of this book. First the two major strands of my argument—the ethology of art and the cognitive science of religion—must be sketched.

The ethology of art

Ellen Dissanayake is by no means unique in taking this approach, as we have seen, but her 1988 *What Is Art For?* is early, foundational, and clear, and it provides an excellent exemplar. Her analysis establishes several fundamental principles: art as a human behavior is taken to be a much broader category than the art of galleries, museums, concert halls, and canonical literature. It has biological, evolutionary roots, and these roots must have been adaptive—that is, beneficial to the survival and reproduction of the species—or the behavior would not be universal. (As we will see, that is not the only reason that the adaptive value of art is regarded as established.) In his 2009 *The Art Instinct*, Denis Dutton (1944–2010) describes adaptation as "an inherited physiological, affective, or behavioral characteristic that reliably develops in an organism, increasing its chances of survival and reproduction" (90–91), and Brian Boyd in *On the Origin of Stories*, describes it as

> complex biological systems, physiological or behavioral, which through the cumulative Darwinian process of *blind variation and selective retention* have developed a *design* that reliably serves some *function*, in other words provides a sufficient solution to some problems a species faces to improve the chances of survival and reproduction.
>
> (2009, 381, emphasis original)

Ernst Mayr, one of the leading evolutionary biologists of the 20th century, explained the idea more fully as

> the morphological, physiological, and behavioral equipment of a species or of a member of a species that permits it to compete successfully with other members of its own species or with individuals of other species and that permits it to tolerate the extant physical environment.
>
> (1988, 135)

Most basically, evolutionary psychologist Leda Cosmides defines an adaptive problem as any "problem whose solution can affect reproduction, however distally" (Cosmides et al. 1992, 8, quoted in Baron-Cohen 1995, 12).

One important question that must be considered immediately is raised by Dutton, who argues that "it follows necessarily that explaining religion

in terms of an evolutionary source attacks religion at its core" (2009, 9–10). That is, he assumes that such analysis cannot be applied to religion without simply excoriating it. I believe otherwise, *if we are prepared to redefine religion in a way comparable to the way in which ethology redefines art,* considering both the common, evolutionary, behavioral roots of religion and what religion *does* (or can potentially do, or has done in the past) for people. Such an ethological approach is probably incompatible with the understanding of religion as a supernatural revelation of historical and metaphysical actualities concerning which "religions" make accurate truth claims. If, however, religion and art are seen to lie on a spectrum of human behaviors that help us navigate empirical experience via culture, effectively integrating the external and the internal, using both phenomena and phenomenology, and moving from subjective experience to objective behavior, they can *both* be analyzed without "attacking their core." If the physical and historical accuracy of representations of special or sacred realities can be seen to be relatively unimportant as compared to the effect of behaving *as if* these things are realities, then the effective contribution of religious behavior to human survival and reproduction can be more clearly understood. As Jeffrey Kripal has pointed out, "the sameness of the religions resides primarily in their *functions,* not in their content, teachings, or final states of salvation" (2014, 306, emphasis added). It seems undeniable that the common, modern, Western understanding of religion, just like the common, modern, Western understanding of art, is aberrant, local, and overly narrow. Dissanayake demonstrates this convincingly in relation to art and I contend that the same is true for religion.

Before the ethology of art can be applied to religion, however, it must be established precisely what "the ethology of art" is. Calling it alternately the biobehavioral view and the bioevolutionary approach, Dissanayake explains it clearly in her first chapter. Genes, she points out, as well as determining physical characteristics also "delineate a range of adaptive behaviors characteristic for each species ... Since emotions (feelings) are psychological correlates of physiological events, and vice versa, they are ultimately influenced by our biological make-up" (1988, 13, 17). Thus, patterns of behavior are similar to physical, anatomical structures as far as natural selection is concerned. That is, they are both determined by genes and are therefore amenable to differential survival and transmission (19). The influence of DNA

> is just as applicable in a purely mechanistic sense to behavior as to anatomy or physiology. ... if we grant that behavior arises from the activity of nerve cells, it is as susceptible to genetic influence as skeletal structure or physiological systems.
>
> (27)

Ethology is the study of such behaviors, and human ethologists—those who study human behavior—propose that "ubiquitous behavioral features or

tendencies in human life are an intrinsic, relatively unchangeable part of our nature and have arisen and been retained because they contributed positively to our evolutionary success, our survival as a species" (19). This evolutionary development occurred over the five million years before human language and speech emerged roughly half a million years ago "when humans and proto-humans lived in small and relatively isolated groups of gatherers and hunters" (25). So Dissanayake's ethology of art "refers to biological and not cultural evolution" (25) and considers art "as a general behavior (not specific acts of making or response, nor the products of that behavior), and … that its origin was 'pre'-cultural" (25). In order for such an approach to be relevant to the understanding of human behavior, "it is necessary only that we possess some genetically mediated tendencies to behave in particular fashions, such as to feel positive about certain things in preference to others" (27) and Dissanayake's approach "takes for granted that every organism, including human beings, tends to behave in ways that historically (that is, throughout time) have maximized the representation of its genes in subsequent generations" (28–29). Evolutionary behavioral traits may become maladaptive. Our contemporary fondness for fats and sugars, for example, shows "how certain behaviors can become maladaptive when the environment changes" (31). Just because a behavior was once adaptive and became genetically transmissible as an adaptation does not mean that it is necessarily still beneficial to the organism that transmits it. The science-fiction author and ecologist Douglas Adams gave the memorable example of the Kakapo, the flightless parrot of New Zealand, which evolved in an environment in which overpopulation posed its only danger. It developed mating behavior so complex and sensitive that its reproduction rate was severely curtailed. Unfortunately, in 2018 when its total population had declined to 149 individuals, its once adaptive reproductive behavior persists.[4]

One of the promising points of an ethological approach is that if "we see patterns of behavior that were adaptive in the original environment in which they evolved, and realize that they are maladaptive in present-day circumstances, we can set about trying consciously to change them (by cultural means)" (32). There is an intriguing tension here between a deterministic biological materialism and a cultural freedom to act that will, somehow, have to be resolved. There may be a means to effect that resolution, although the argument can only be gradually adduced. For ethology to gain real traction on any behavior, it is first necessary "*to describe a specific human ability or tendency that genes could transmit and environments could act upon*" (60, emphasis original). Ethologists must also

> be concerned with charting what happens when a species leaves the environment for which it was adapted for another one which it then tries to adapt to its own ends. In the case of our own species this is the story of human civilization.

(169)

This story can hardly be told omitting religious behavior.

Dissanayake recognizes that critics of such an approach may agree that there are trivial and uninteresting general biological needs such as the need for sleep but be very "reluctant to admit the possibility that psychological 'needs,' which are so obviously amenable to cultural conditioning, could be biologically programmed" (197). Nonetheless, she argues convincingly that tendencies that are seen in all human groups might well be presumed to be biological predispositions and she states as examples:

- the tendency to construct systems that explain and organize the world as perceived
- the tendency to require the psychological security of predictability and orientation
- the tendency to require psychological ratification by a group
- the tendency to bond to others
- the tendency to recognize and celebrate the extraordinary
- the tendency to engage in play and make-believe (197).

Such tendencies might well be seen to be universal, but they are evidently as much attributes of *religious* behavior as of "art behavior." It is clearly one of the driving forces in this ethological approach that, despite any postmodern attack on universals, global human attributes can be restored to acceptable and usable status when adjusted to avoid excessive or misapplied universalizing. As another writer in the field of biocultural criticism has it, "an evolutionary perspective, with its cross-cultural and cross-species comparisons, makes it hard to sustain the notion of only radical difference in human experiences as central as childhood and love, however variable to local circumstances" (Boyd 2009, 341–342) and such appeal to commonalities will become increasingly significant in the present analysis.

This same author, Brian Boyd, pointed out that the evolutionary approach to literary criticism,

> although it is informed by science, ... does not limit itself to scientific reduction, since art by its nature invites a creative and original response, to some degree subjective and open-ended, an aura of implication rather than an exact of transfer information.
>
> (2009, 390)

That is, imaginative creativity can, from both an earlier humanistic perspective on the study of religion and the perspective of this biocultural criticism or ethology of art, be seen to be an existentially valuable behavioral response to a challenging environment and, in academic terms, to contribute to an accurate and practical understanding of human behavior. It remains a *creative* hermeneutics, that is, an interpretive act rather than an act of technical quantification, an artistic activity involving the use of human skill rather than the

systematic and methodical application of a mechanical process. Hence my insistence that, despite the reliance upon scientifically proven and empirically investigable phenomena, the analysis of religion and art in this manner belongs among the humanities and does not become itself a science. It is *geisteswissenschaftliche* rather than *naturswissenschaftliche*. Nonetheless, it does have entailments that are empirically testable.

It must also be borne in mind that if, as I argue, the common understanding of religion is as fraught and provincial as the common understanding of art, then it is just as much in need of revision. The all-too-common understanding of religion as belief in specific doctrinal claims—and therefore fundamentally internal states expressed in language—is just as wrong as the understanding of art as commodified items of interest, "art objects," that promote detached aesthetic appreciation. Both of these identifications are to some extent accurate, but they are descriptions of situations native to the modern West and, while they do describe a local breed of religion and of art, they miss the broader characteristics of the species, as is seen in Dissanayake's analysis. One must ask what religion might be seen to be if it is subject to a similar analysis. How does one best describe religion as a behavior and a potentially heritable tendency responsive to the environment?

The evolutionary biologist, David Sloan Wilson, suggested that "supernatural agents and events that never happened can provide blueprints for action that far surpass factual accounts of the natural world in clarity and motivating power" (2002, 41, quoted in Boyd 2009, 205), and Boyd adds that

> [e]volution will favor belief in a falsehood if it motivates adaptive behavior better than belief in a truth ... It will favor beliefs in spirits that monitor human actions and that need to be appeased, if such beliefs reinforce cohesion.
>
> (2009, 205–206)

These agree with earlier appraisals of religion as paradigmatic or exemplary for conduct such as those of Karl Jaspers, Mircea Eliade, and Clifford Geertz.[5] The notions of the *imitatio dei*, or the *imitatio Christi* need no introduction to scholars of religion—there is a quite explicit strand of religious behavior that requires the imitation of divine exemplars. However, it also seems to indicate that imposing a strict categorical division between art behavior and religion behavior is an anachronistic imposition of recent and local developments—it must be recognized that there is a distinct overlap of these categories.

In a fascinating and important analysis of "Charisma and the Sublime in the Arts of the West," C. Stephen Jaeger (2012) focuses on charismatic art, which he sees as an aspect of the sublime style (2), which "conceals reality—or at least clothes it—in brilliance ... and exercises an 'enthralling' effect on the reader or viewer" (2). Thus "the influence of the hero on the audience of epic—or of any charismatic art—is exemplary (*vorbildlich*). Heroic action inspires imitation in the reader" (95). Although such *mimesis*, straightforward

imitation, has become a dominant concept in aesthetics this alone fails adequately to account for the *selection* of exemplary models for imitation—a process clearly worthy of detailed attention. Jaeger argues that art "exercises beguiling effects clearly parallel to the working of charismatic political and religious figures" (3) and that

> the ability of a living person to sustain charismatic effects in an audience or collection of fans, worshippers, or devotees is dependent on his or her ability to enter or appear to enter the condition of a work of art; and conversely the work of art that does not convey the sense of living a heightened form of life and promising to transport the viewer into that world cannot produce charismatic effects.
>
> (3)

He follows the anthropologist of art "Alfred Gell in proposing an 'agency' in art that aims at a variety of effects on the viewer, prominent among them a form of 'enchantment'" (5) and refers to

> a common idea of [W. J. T.] Mitchell and Gell ... that works of art possess a dynamism that has the qualities, or at least the effect, of living beings: will, desire, the ability to generate certain kinds of action in the viewer.
>
> (5 with reference to Mitchell 2006; Gell 1998)

These authors and their observations about commonalities between our reactions to art and to living beings are crucial to my analysis. However, for the moment, suffice it to note that art behavior, in this specific sense, performs an exemplary function closely parallel to religious behavior. This is not to say that there is no difference between the two—there is, now, and the difference can and should be maintained, but in other places, at other times, these differences did not hold and insisting upon such a distinction is ethnocentric, imperialist, and anachronistic (also, perhaps, anatopistic—it is out of place as much as out of time). Unfortunately, there is evidence that, despite their sensitivity to the contemporary Western misrepresentation of art, Dissanayake, Dutton, and Boyd take religion rather uncritically to be precisely equivalent to the contemporary Western notion of it that I suggest to be equally inaccurate. Boyd, for example, describes religion simply as "invented stories that people take as true" (2009, 199) and seems to share with Dutton the anticipation that an ethological approach to religion simply excoriates it. If, however, religion is given the same leeway as art to be understood in terms of evolved human behaviors rather than in terms of our own rather aberrant, locally, and chronologically specific, instantiations of those behaviors, then there are numerous implications, among which is the fact that we cannot take religion simply to be fictional stories wrongly assumed to be historically accurate and most frequently dismissed as such by the Cognitive Science of Religion— at worst as maladaptive, at best as a "spandrel" or accidental by-product of

other features that are genuine adaptations.[6] This is the standard, Western, post-Reformation, academic model of religion which I believe, like the gallery painting, "institutional" model of art, to be fundamentally misleading and cripplingly limited. Just as a Darwinian model requires a rethinking of art, so it requires a rethinking of religion.[7]

Those who apply ethology to art allow that creative fiction can accurately represent the real. It is thought to *improve* cognition, not to mislead it, and so in some circumstances fiction can meaningfully be argued to be, so to speak, hyper-real. Boyd says that fiction "extends our imaginative reach" and frees us from the here and now and from knee-jerk responses (2009, 198). Dissanayake insists that "*art exercises and trains our perception of reality, it prepares us for the unfamiliar*" (1988, 67, emphasis original). So art is not (nor, I argue, is religion) simply "invented stories that people take as true" but invented stories that, when "taken as true," somehow *improve our responses to the real*.

If religion behavior is seen to overlap art behavior in that they both use our fascination with skilled creativity (ποιητικη τεχνη, *ars poetica*) to improve responses to the real, by invoking the "*really* real," transcendent principles, or that which should be taken as true, that is, the hyper-real in the sense of intangibles such as values and ethics, imponderables such as the whole *gestalt* and *zusammenhang* of reality, unknowables such as the beginning and the end of all things and the values implied thereby, then the evolutionary analysis applied to the arts could be applied to religion without dismissing religion *a priori* as error or delusion. The believers' unshakable faith that their tradition is true in the sense that it represents the real (instead of simplistically just *being* the real, that is, literal, historical truth) could, to this extent, be justified and the history of religions could be more accurately represented and more equitably understood.

At the same time the dangers implied by Magritte's *La trahison des images*— the treachery of representation—can be avoided and the second commandment (according to the interpretation that I proposed above) can be observed just as long as no-one takes the representation to *be* the thing represented. It is worthy of note that Jaeger also argues that "the very reason gods forbid graven images" is that "the image, and not that which it represents, becomes the object of worship" (135), thus agreeing with this interpretation. The precise degree of historical truth in any given tradition is beyond determination and insistence upon it varies, as does the significance of that insistence among its adherents, but the major role of ritual traditions with all their involvement of art can be seen as striving to create, not so much an accurate representation of the really real—what Eliade called the sacred—but an appropriate *response* to it, involving a differential scale of the value of acts, objects, and events, the ethical scale that provides answers to the huge question concerning "confusion and uncertainty in choices available for action" (Dutton 2009, 120). So, where Boyd says that "storytelling power has often been commandeered by the apparent promise of explanation, cohesion, conformity, and control offered by fiction that has hardened into mythological and religious belief"

(2009, 206), the process is considerably more ramified: religious belief (*as we have recently come to identify it in the West*) may have hardened into the political and institutional structures that we now identify as "religious traditions," supported by the explanatory and cohesive powers of storytelling and all the accompanying arts. However, religion can equally be characterized by the effective and adaptive application of artistic or creative behavior that represents the hidden nature of reality (as opposed to empirically available phenomena) in such a way that we can respond to it appropriately.[8] Rather than thinking of religion in terms of reality, truth, and belief, which are essentially verbal constructs, specifically designed symbols, we need to follow the lead of ethologists of art and think of it in terms of behavior, of actions, of performance— particularly abilities and tendencies that could be transmitted. This does not remove the category of faith: as the German sociologist and systems theorist Niklas Luhmann (1927–1998) pointed out, faith is the medium of religion (1984, xli).[9] But one must ask, do artists have faith in their work? Do they need faith in order to work or perform? Do they have faith in themselves, in art as an essence (or genotype) manifest in their work (the phenotype)? I think that the answer is, in all cases, yes. This may appear to be a different type of faith than religious faith, but only when religious faith is considered as little other than a dogmatic insistence on affirmations of historical and metaphysical propositions—precisely the common Western misunderstanding of religion that I propose to rework.

Religion behavior certainly spans a spectrum on both sides of this divide— it both provides exemplars that motivate assured behavior and it involves verbal affirmations concerning historical actualities. According to Boyd, "Homer reinforces *xenía*, the Gods' role as arbiters of justice, and, ultimately, the principle of cooperation. Through his characters he repudiates and exorcises free riders, exalts punishers, and rebukes nonpunishers" (2009, 316–317). It is well known that in epic poetry the dividing line between the artistic and the religious is difficult, if not impossible, to draw. Both "art" and "religion" play a highly effective role in mediating and moderating human behavior. The religious only more recently became distinct via its identification with canonical and institutional social organizations at the same time as art was being "made to serve as 'art objects,' to be judged by aesthetic criteria alone, or appraised primarily for their power to evoke aesthetic enjoyment" (Dissanayake 1988, 41).

I do not mean to suggest that, in its overlapping role as religion behavior, art behavior simply and reliably reveals to us what is "really there," but that, just as our complex capacity of empathy enables us to experience an intuition of the inner state of the other, so both art and religion mediate an understanding, experienced as a perception, an insight, into the character of the reality beyond the phenomenal, into the "personality" of reality, so to speak. There is no merit in arguing that there *is* no reality "beyond the phenomenal." There is much that does not appear to the senses and the experienced perception of this is real, and that experience *does* something.

In his magisterial work on brain hemisphere asymmetry the psychiatrist and polymath Iain McGilchrist agrees with Dissanayake that regarding art and beauty "there is a general agreement across cultures ... None of this would be possible without the existence of non-socially constructed values ... There is a developing acceptance by psychology and the social sciences that human universals clearly do exist" (McGilchrist 2009, 421).[10] So, from very different perspectives, these two scholars follow the lead of ethology in recognizing universal human behaviors. I, in turn, follow their lead in accepting art to be a human universal behavior but insist that the same implications must be recognized for religion. McGilchrist points out that the French phenomenologist Maurice Merleau-Ponty, in *The Visible and the Invisible*, has argued that,

> if the flesh is viewed as wholly opaque—in other words, if we take into account only the realm of the visible—it acts as an obstacle, something that alienates the viewer from what is seen. But if viewed another way, seen *through* as much as seen, the "thickness" (*l'épaisseur*, implying something between transparency and opacity) of the flesh, far from being an obstacle, is what enables us to be aware of the other and of ourselves as embodied beings, and becomes the means of communication between the two.
>
> (McGilchrist 2009, 167 with reference to Merleau-Ponty 1964, 70)

"The flesh" here should be taken to refer both to the human body and to the whole of empirical nature. We may see it, but what matters most is what its behavior *implies*, what we see *through* "the flesh," the rules below the surface, the inner world. One might (poetically) say that it is the intentionality of the world as agent that we really need to know and which our evolved capabilities permit us, to some degree, to apprehend. The concepts of intentionality and agency and their complex relationship will become crucial to this analysis and must be considered in detail elsewhere. Justin Barrett defines an agent as "something that seems to initiate its own actions and does not merely respond mechanistically to environmental factors" (2004, 5). This must suffice for the moment.

During the Renaissance art was "seen as a spiritual revelation of what lies in nature" (McGilchrist 2009, 311). The beauty of the natural world was seen "as an indicator of something beyond. It was seen, but seen *through*" (312). This is what McGilchrist calls "semi-transparency." Similarly, for the English metaphysical poets, "the world is not a brute fact but, like a myth or metaphor, semi-transparent, containing all its meaning within itself, yet pointing to something lying beyond itself" (312). McGilchrist also cites E. H. Gombrich (1960, 389) as saying that "the true miracle of the language of art is not that it enables the artist to create the illusion of reality. It is that under the hands of a great master the image becomes translucent" (2009, 451). The religious equivalent is expressed by Huston Smith, who insists that "[t]he

symbolist vision sees the things of the world as transparent to their divine source" (1991, 241). However, it is not—it cannot be—simply the case that we see directly through "the things of this world" to some "spiritual" reality beyond. They are not transparent but "semi-transparent," translucent. Our apprehension or apperception of the "something lying beyond" is necessarily conditioned by our "personal experience and religious background" (Eliade 1978, 7, see Rennie 1996, 19–20, 31), and that conditioning can only itself come about by means of physical things, "things of the flesh." This, of course, is where the art comes into play in religion. It constitutes those elements of our experience which have been particularly skillfully worked in order to give the most effective and durable apprehension of the spirit, or character of reality, of the personality of the *Gestalt*, to speak in monotheist terms. By "effective" here, I mean only effective in determining subsequent behavior.[11] This does not come about by means of a simple written or spoken narrative but by exposure to the multimedia performative theater of the arts of religion as a panoply of movement, embodiment, sound, and vision. Just as cooked food gives more nourishment than raw food (see Wrangham 2010), so art objects as "cooked experience," that is, deliberately induced experiences of skillfully wrought objects, events, and representations, can provide more exemplary value than "raw" or unworked experience (although, of course, such raw experience remains the necessary source material).

This is why the enlightening value of the ethological study of *art* needs to be integrated into our understanding of religion. To some extent it must counter the (very much connected) ill-effects of misplaced scientism and skepticism concerning the potentially adaptive role of religion but also consider the influence of religion *as* behavior *on* behavior. I am not arguing that religion behavior is necessarily, or must always be, a positive good, but that it must have been in the past an evolutionary adaptation to have been selected for so as to become as prevalent and persistent—arguably universal—as it is. The exponents of the Cognitive Science of Religion, understandably anxious to disentangle themselves from the ill-defined and only vaguely knowable complexity of "religion" and correspondingly keen to engage some solid, well-defined "scientific" study,[12] seem to be reluctant to engage what they can only consider the equally amorphous and unscientific question of art.[13] On their side, the ethologists of art are already fully engaged with their own topic, and to some extent ignorant of the realities of the history and philosophy of religion, as is indicated by their tendency to conceive of religion in anachronistic and ethnocentric fashions. This culminates in the rather dismissive attitude exemplified by Dutton: "Religion by its very nature makes grand claims about morality, God, and the universe" (2009, 9). Once again assuming religion to be simply the doctrinal affirmation of metaphysical claims and resultant ethical injunctions, which is a recent and local understanding, Dutton assumes that the evolutionary approach simply dispenses with it. The occasional confusion in Dutton's understanding is shown by his insistence at one point that "[w]orks of art seldom make overt assertions of fact or instruct

people on how they must behave" (10) when he later recognizes that art provides answers to questions concerning "confusion and uncertainty in choices available for action" (2009, 120) and thus *does* inform people's behavior. Art includes the ongoing creative act of representing the "invisible order" and motivates responsive behavior that is apprehended as harmonious with that order. Dissanayake's aim of understanding art by considering what it does is transferable to religion. Despite the known weaknesses of functionalism as an explanation of the *origins* of religion (see, for example, Segal 2010), this approach has the advantage of assuming evolutionary origins for religious behavior and utilizing the functions of that behavior to explain its persistence and to clarify its origins and to accurately describe religious behavior.

To go further into another striking example mentioned earlier, in her fascinating book on the modernist museum curator and art critic, James Johnson Sweeney (1900–1986), *Curating Consciousness: Mysticism and the Modern Museum*, Marcia Brennan points out that Sweeney "claimed that modern Art and spiritual phenomena reveal 'the unseen through the seen,' just as works of art display the 'conception of a macrocosmic unity through an assimilable microcosm'" (Brennan 2010, 7 with reference to Sweeney 1967, 112, 33, 22, 73, 188). Brennan claims that more than half of the book (88–211), "can thus be viewed as comparative case studies in saying the unsaid and seeing the unseen through the prism of Sweeney's and the artists' mystical engagements with modernist aesthetics" (28). She also uses the expressions "the envisioning of the invisible" (23) and "making the invisible visible" (29). Sweeney portrayed Alberto Burri, an Italian abstract painter and sculptor (1915–1995) "as a modern mystic who made the unseen seen" (100), and his critical reading of Eduardo Chillida (1924–2002), a Basque sculptor, "resonated with the artist's own theoretical conceptions of the edge and the limit, just as this interpretation turned on the mystical paradox of making the visible invisible so that the invisible could become visible" (194–195).

While it is an understandable reaction to ask what such claims might mean, it can increasingly be seen that they cannot be dismissed as nothing more than Romantic paeans to the power of poetry; high-sounding but finally vacuous lyrics in praise of the divinity of art. They can now be suggested to be accurate descriptions of cognitive processes whereby our appreciation of art engages some cognitive capacity for empathy and imitation that produces a sensation—subjectively apprehended as a perception—of the hidden workings of our environment, producing behavior that has been selected for and so must have had an adaptive function contributory to the survival and reproduction of the species. The abilities of art behavior and religion behavior to induce a shared apperception of the hidden nature of reality (like language, this is necessarily a shared, group activity as it involves expression and apprehension by different individuals) are invaluable and indispensable and, initially, identical. You can't have the one without the other—despite the later, emergent, ability to differentiate the two once they have become "gallery art" and "institutional religion."

The problem has been that, until recently, none of these rather suggestive formulations about "seeing the unseen" was able to give the least hint as to how this might be accomplished or what it really means. Until recently, they have remained tropes, evocative figures of speech, but now we might begin to produce a description of how modification of behavior through cultural experiences, which in its specifically religious form is associated with the apprehension of an "unseen order," has come about through the history of religion. Looking more closely at the ethological approach to art and maintaining a focus on behavior, potential descriptions of this process appear. We apparently have very specific, evolved specialized functions of the brain dedicated to that very task—making the unseeable available to the calculating mind. Dutton's argument, perhaps more explicitly than the other ethologists' but in complete agreement with them, is that this function is particularly engaged during our appreciation of art behavior. As he says, "Stories are intrinsically about how the minds of real or fictional characters attempt to surmount problems, which means stories not only take their audiences into fictional settings but also take them into the inner lives of imaginary people" (2009, 118). Jaeger, Mitchell, and Gell agree "that works of art possess a dynamism that has the qualities, or at least the effect, of living beings" (Jaeger, 5). McGilchrist, like these other authors, argues that, as far as brain activity is concerned, our response to art is more like our response to other living things than to inanimate objects (2009, 96, 410).

Dutton points out that "[l]anguage puts minds on public display, where sexual choice could see them clearly for the first time in evolutionary history" (2009, 162, quoting Geoffrey Miller, 2000, 356). However, it is not just verbal language but all of the skillfully expressive modes of behavior we recognize as art that is apprehended as "putting minds on public display." "We find beautiful artifacts—carvings, poems, stories, arias—captivating because at a profound level we sense that they take us into the minds that made them" (Dutton 2009, 163). This can be modified by the observation from McGilchrist that "language originates as an embodied expression of emotion, that is communicated by one individual's 'inhabiting' the body, and therefore the emotional world, of another" (2009, 122). It is not primarily the semantic content or lexical reference of the language but the inducement of embodied empathy that activates this ability to "observe the mind" of the other.

This ability to "perceive the imperceptible" in the sense of perceiving the mind, character, or personality, of the initiating artist seems to be one of the enabling properties of both art and religion behavior, whose common core may well be this ability to render the invisible visible in the sense of rendering available through sensory perception that which cannot actually be empirically detected but the presence of which is nonetheless revealed through sight and sound—initially the subjectivity or intentionality of the other, which permits an anticipation of agency. It is not a long stretch from the ability to perceive "the mind of the artist" to the religious, even mystical,

phenomenon of the direct perception of "the spirit world"—God, the Dao, the sacred, or the transcendent, as the character of the totality, the personality of reality—especially considering the agency of inanimate objects. Barrett's definition of agency allowed that agents may "seem" to initiate their own actions and Jaeger, Mitchell, and Gell allow that art possesses agency (although Jaeger maintains "scare-quotes" around the term). The suggestion is that, by means of specific, humanly worked experiences of objects, acts, and events, which we have, only relatively recently, come to identify as "art," we become comfortable or assured in our behavior. That assurance is often expressed as the apprehension or perception—better "apperception," which involves more creative attribution rather than "passive perception"—of an orderliness to our experience and a chronic nature, character, or personality to that orderliness that we can, to some degree, anticipate, which thus increases the confidence of our response. Evidently, some such apperception, because of the assurance and consistency it lends to our response to our environment, but even more because of the social cohesion it lends to the response of a social group that shares the same apperception, constitutes an adaptation in the evolutionary sense. This is manifest in ensuing behavior as if the invisible were visible, as if our imaginative representations were simply independent realities. That is, in what we would now deem "religious" behavior.

This not only gives us a new and potentially enlightening approach to the understanding of religion, it also gives us some insight into the workings of, and our cognitive response to, works of art that engage and employ this complex phenomenon. Artists and their works (and I would emphasize that the concept of "individual works of art" is a hallmark of the modern Western conceptions of Gallery Art) attract the attention of the audience and engage a faculty or ability akin to our empathy for living beings. Furthermore, a complex matrix of interrelated art forms (more fully in keeping with the premodern and undifferentiated operations of both art behavior and religion behavior) can induce an apperception of the nature of the real that is no longer attributed to any *human* agency, but is seen as revelatory of a "superhuman" truth, at best channeled by or inspirational to the human medium, but by no means "created" by any of us. Such an apperception could not but manifest itself in the continuing behavior of those who experience it. It would change people's lives. One last point needs to be made before I continue with this emphasis on behavior in mind: I have already alluded to William James' understanding of religion as belief in an "unseen order" to which we must harmoniously adjust our behavior. That understanding plays a significant role. However, I must also mention here James' insistence that "to develop a thought's meaning we need therefore only determine what conduct it is fitted to produce; that conduct is for us its sole significance" (1902/1961, 427). This association of behavior (conduct) and meaning is also important, as we will see. However, before I can return to these points I need to consider the potential contribution of the cognitive science of religion to a solution to the puzzle of art and religion.

Notes

1 This chapter was published in part in *Studi e Materiali di Storia delle Religioni* 83, no. 1 (2017): 243–269.
2 Such as David Mandel, Alexander Marshack, Charlotte M. Otten, Morse Peckham, and Dan Sperber, among others. Dissanayake herself specifically champions the term, "ethology" (Dissanayake 2008, 7, n.3, 14).
3 Dissanayake (2008, 247) lists Nancy Aiken, Steven Brown, Joseph Carroll, Kathryn Coe, Brett Cooke, Ian Cross, Jonathan Gottschall and David Sloan Wilson, Edward Hagen and Gregory Bryant, Björn Merker, Geoffrey Miller, Steven Mithen, Iain Morley, Michelle Scalise Sugiyama, and Robert Storey.
4 The tale is told in "Heartbeats in the Night," the fourth chapter of *Last Chance to See* (Adams and Carwardine, 1992), but videos of Adam's lecture on the Kakapo can also be found online in many places. The current Wikipedia page at http://en.wikipedia.org/wiki/Kakapo is informative
5 One could multiply references to this kind of account of religion—see, for example, Waardenberg (1999), Whaling (1995). See also Rennie (2009).
6 For a discussion of Stephen Jay Gould's idea of "spandrels" including Steven Pinker's application of it, see Dutton (2009, 92–96).
7 Native American and many other indigenous cultures' attitudes to religious traditions are particularly useful correctives in such a rethinking, although there are others, and they will be discussed elsewhere.
8 I am overusing the word "appropriately" in a manner that is, I suspect, an obvious attempt to avoid describing such behavior any more specifically. Suffice it to say, for the moment, that what matters is the subjective assurance that the specific behavior produced in response to the religious tradition—including the verbal behavior associated with it—is somehow more correct or appropriate than any available alternatives. Further specification will emerge.
9 The theories of Niklas Luhmann on operatively closed systems of social organizations are particularly relevant here. See Luhmann (2000).
10 I am aware of the significant volume of wildly speculative theories that have arisen from the basic fact of brain hemisphere asymmetry—to the extent that I am reluctant even to mention it. However, McGilchrist is a very significant scholar and psychiatrist whose opinions are well supported by considerable evidence and experience.
11 That is, having "protention" and "retention" in the terms used by Alfred Gell, whose work will become increasingly important to my analysis (Gell 1998, xii, 239–242).
12 See the most recent publications of the International Association for the Cognitive Science of Religion (IACSR), for example: www.equinoxpub.com/equinox/books/showbook.asp?bkid=256&keyword=religious%20narrative
13 Of 67 papers delivered at the Second Evolution of Religion conference in New Mexico in November 2017, only one mentioned art in its abstract (Eveline Seghers, "The evolved complex of art, religion and the mind: a preliminary hypothesis").

References

Adams, Douglas and Mark Carwardine. *Last Chance to See*. New York: Balantine Books, 1992.
Baron-Cohen, Simon. *Mindblindness: An Essay on Autism and Theory of Mind*. Cambridge, MA: The MIT Press, 1995.
Barrett, Justin. *Why Would Anyone Believe in God?* Walnut Creek, CA: Altamira Press, 2004.

Brennan, Marcia. *Curating Consciousness: Mysticism and the Modern Museum.* Cambridge, MA: MIT Press, 2010.

Boyd, Brian. *On the Origin of Stories: Evolution, Cognition, and Fiction.* Cambridge, MA: Belknap Press of Harvard University Press, 2009.

Cosmides, Leda, John Tooby, and J. Barkow. "Introduction: Evolutionary Psychology and Conceptual Integration." In *The Adapted Mind*, edited by Jerome Barkow, et al., 3–18. Oxford, UK: Oxford University Press, 1992.

Dissanayake, Ellen. "Art as a Human Behavior: Toward an Ethological View of Art." *The Journal of Aesthetics and Art Criticism* 38, no. 4 (1980): 397–406.

Dissanayake, Ellen. *What Is Art For?* Seattle: University of Washington Press, 1988.

Dissanayake, Ellen. "The Arts After Darwin: Does Art Have an Origin and Adaptive Function?" In *World Art Studies: Exploring Concepts and Approaches*, edited by Kitty Zijlmans and Wilfried van Damme, 241–263. Amsterdam: Valiz, 2008.

Dutton, Denis. *The Art Instinct: Beauty, Pleasure, and Human Evolution.* New York, Berlin, and London: Bloomsbury Press, 2009.

Eliade, Mircea. *Mademoiselle Christina.* Paris: L'Herne, 1978.

Gell, Alfred. *Art and Agency: An Anthropological Theory.* Oxford, UK: Oxford University Press, 1998.

Gombrich, Ernst Hans. *Art and Illusion: A Study in the Psychology of Pictorial Representation.* New York: Pantheon Books, 1960.

Jaeger, C. Stephen. *Enchantment: On Charisma and the Sublime in the Arts of the West.* Philadelphia: University of Pennsylvania Press, 2012.

James, William. *Varieties of Religious Experience.* New York: Collier, 1902 (1961).

Kripal, Jeffery. *Comparing Religions.* Chichester, UK: Wiley Blackwell, 2014.

Luhmann, Niklas. *Religious Dogmatics and the Evolution of Societies.* Translated with an introduction by Peter Beyer. New York and Toronto: The Edwin Mellen Press, 1984.

Luhmann, Niklas. *Art as a Social System.* Stanford, CA: Stanford University Press, 2000.

Mayr, Ernst. *Toward a New Philosophy of Biology.* Cambridge, MA: Harvard University Press, 1988.

McGilchrist, Iain. *The Master and His Emissary: The Divided Brain and the Making of the Western World.* New Haven, CT and London: Yale University Press, 2009.

Merleau-Ponty, Maurice. *Le visible et l'invisible.* Paris: Gallimard, 1964.

Miller, Geoffrey. *The Mating Mind: How Sexual Choice Shaped the Evolution of Human Nature.* New York: Doubleday, 2000.

Mitchell, W. J. T. *What Do Pictures Want? The Lives and Loves of Images.* Chicago, IL: University of Chicago Press, 2006.

Rennie, Bryan. *Reconstructing Eliade: Making Sense of Religion.* New York: State University of New York Press, 1996.

Rennie, Bryan. "Myths, Models, and Metaphors: Religion as Model and the Philosophy of Science." *Religion* 39, no. 4 (2009): 340–347.

Segal, Robert. "Functionalism since Hempel." *Method and Theory in the Study of Religion* 22, no. 4 (2010): 340–353.

Smith, Huston. *The Illustrated World's Religions.* New York: HarperCollins, 1991.

Sweeney, James Johnson. *Vision and Image: A Way of Seeing.* New York: Simon and Schuster, 1967.

Waardenberg, Jacques. *Classical Approaches to the Study of Religion: Aims, Methods, and Theories of Research.* New York: Walter De Gruyter, 1999.

Whaling, Frank. *Theory and Method in Religious Studies: Contemporary Approaches to the Study of Religion.* New York: Walter De Gruyter, 1995.

Wilson, David Sloan. *Darwin's Cathedral: Evolution, Religion and the Nature of Society.* Chicago: University of Chicago Press, 2002.

Wrangham, Richard. *Catching Fire: How Cooking Made Us Human.* New York: Basic Books, 2010.

Zunshine, Lisa. *Introduction to Cognitive Cultural Studies.* Baltimore, MD: Johns Hopkins University Press, 2010.

3 The cognitive science of religion

An artless art

What unites them more fundamentally and significantly is, first, the centrality for their approaches of methods, studies, and theories drawn from evolutionary psychology and the rather sprawling field of "cognitive science" and, second, their more or less strenuous identification of their projects with "science," itself rather monolithically and sometimes triumphalistically conceived.

(Barbara Herrnstein Smith, *Natural Reflections*, 31)

Cognitive science—art or artless?

Although the potential contributions of the ethology of art to the study of religion do not seem to have been much recognized, it is hardly original to propose that an ethological approach *per se* be applied to religion. As I mentioned earlier, the widely used *Macmillan Encyclopedia of Religion* (the Second Edition of 2005) has an entry on the ethology of religion by Ina Wunn, and I need to consider that more closely before I move on to the specific interaction of the ethology of art and the analysis of religion. Wunn agrees that "both the behavior of humankind and its physiological basis have evolved phylogenetically and should be studied as an aspect of evolution" (2005, 2867), but she also points out that, despite its origins in Darwin's theory of evolution, the study of behavior was long dominated by psychologists who assumed that behavior was typically the product of learning, of environment and education, rather than having any evolutionary, biological roots. This entrenched position began to weaken when Karl Meuli (1891–1968) demonstrated that "religions as distinct from one another as the religions of ancient Greece, imperial Rome, recent arctic hunter-gatherers, and probably even prehistoric hunters, shared similar ritual customs" (Wunn 2005, 2867), which could not be explained by the hypothesis of learned behavior. Meuli realized that such similar practices must originate in innate behaviors acquired during evolution. Later Konrad Lorenz (1903–1989) and Nikolaas Tinbergen (1907–1988) investigated instinctive behavior in animals seen from this evolutionary point of view. Gradually, the study of *human* ethology began to apply these methods and this evolutionary perspective "to psychological, sociological and, finally,

even religious phenomena," and rituals came to be seen as "complex behavioral events" (Wunn 2005, 2867). Studies of human and primate behavior confirmed that certain human behaviors are indeed the result of phylogenetic adaptations. In human ethology, art history, and the history of religions, scholars analyzed the development of symbols and patterns in pagan art with remarkable results. For example, "the patterns on the boats of Mediterranean fishermen exemplifies the change of the image of the protective "staring eye" from representation into an abstract symbol," (2868) and Marquesan tattoos can be traced back to portrayals of the skulls of the deceased. The specific significance of these observations will be considered later, for now it suffices to note that representation, symbolism, and also complex rituals are expressive behavior that functions to communicate, which is adaptive.

Any behavior pattern is adaptive in the sense that it contributes to the reproductive success or to the survival of the individual, the group, or the species. In that sense, as the historian of ancient religions Walter Burkert (1931–2015) points out, well-adapted religious activities promote the success of a culture. He refers explicitly to the results of human ethology when tracing rituals and other activities within the scope of religious behavior to their supposed biological origins. Several basic elements of religious practice and thought, and, in particular, sacrifice, have to be seen as being inherited from the animal world, where they may contribute to the survival of the individual or the group in dangerous situations (Wunn 2005, 2868 with reference to Burkert 1996).

All of this raises the question of whether religious behavior could be understood as adaptation to a specific ecological niche. For example, since ritual and language evolved together, ritual may provide a necessary corrective to language-based difficulties, such as misinformation and misunderstanding, which could lead to disorder or violence. Ritual behavior supplies information about the social group, and the status and psychophysical characteristics of the participants. Participation in ritual both creates and demonstrates group commitment. Wunn suggests that "[r]ituals ... form the concepts that people consider to be religious, and therefore they have been central in the adaptation of the human species as part of a larger ecological whole" (2868) and thus that

> the origins of religion lie deep in inborn behavior patterns. Religions, which do not necessarily have doctrines and beliefs, originate in ritualization as observed in animal behavior. Only later does ritual become religious in the Western and monotheistic sense of the word, when provided with a religious interpretation that includes doctrine and the belief in an afterlife.
>
> (2869)

This ethological approach to religion seems to have little that distinguishes it from the ethological approach to art, and neither approach is without its critics. In the study of religion, ethology has been accused, not only of being overly materialistic, but also of becoming ahistorical as its emphasis on

human universals results in categories that are vague and unfalsifiable. However, Wunn concludes that it is "desirable to include not only ethological theory and terminology, but also ethological method, especially in small-scale research. Such an approach would surely lead to remarkable results in future research" (2869). Most importantly, from my perspective, the very existence of such a theory demonstrates that, once again, our common, contemporary concept of religion as fundamentally a matter of conceptual beliefs and truth claims about reality must be called into question.

More so than the ethology of religion, the so-called "cognitive science of religion" (often simply designated CSR) has become enormously influential, especially since the publication of E. Thomas Lawson and Robert McCauley's *Rethinking Religion: Connecting Cognition and Culture* in 1990. A branch of psychology emphasizing neuropsychology and having its roots in evolutionary biology, cognitive science often focuses on the contested idea of the evolution of mental "modules," which are complex cognitive functions that are performed unreflectively, usually unconsciously, by specialized areas of the brain.[1] In the study of religion, the focus of study is often on the operation of such modules in respect of "culturally posited supernatural agents" as invisible entities with which humans interact via ritual and ceremony. The success of CSR has resulted in the founding of the International Association for the Cognitive Science of Religion (IACSR) in 2006 and the launch in 2012 of the *Journal for the Cognitive Science of Religion*. Prior to that, in 2011, the journal *Religion, Brain & Behavior* appeared. All of these place a distinct emphasis on a very empirical "scientific" approach while the less "technical," less "scientific," more interpretive, approach to ethology taken by art historians and literary critics has not attracted much attention. The close connection between religion and art has hardly been investigated at all in respect of the cognitive science of religion. I hope to remedy this and to suggest some applications and considerations that have so far been overlooked.

A good general introduction to the early cognitive science of religion is E. Thomas Lawson's "Towards a Cognitive Science of Religion" (2000), in which he defines cognitive science as "the study of the set of processes by means of which human beings come to know the world" (344). Lawson anticipated the ability of cognitive science of religion to produce "explanatory theories of religion by scholars who are not only tuned to the sciences but also have a deep knowledge of religious traditions" (342). This, he explains, is of particular importance to the discipline of the history of religions because our study of religious traditions "has typically been long on interpretation and short on explanation" (342). He also points out that the "standard assumption in the social sciences and the humanities has been that only social and cultural methods can explain social and cultural facts" (338). This parallels Ina Wunn's observation that behavior was for too long interpreted by psychologists rather than biologists—these scientifically informed approaches can be highly instructive in areas where they have not been hitherto applied (Wunn 2005, 2867). Lawson explains that "the possibility of a cognitive science of

religion depends upon showing that cognitive explanations of socio-cultural facts not only are possible but have already happened" (338–339) and the example he gives is of linguistics since the work of Noam Chomsky. "A cognitive science of religion would be possible [says Lawson] if it could be shown that despite the obvious variability of religion across cultures and throughout history there lay a similar specifiable commonality" (340)—similar, that is to the variability of spoken languages. Since "cognitive science of language, an eminently cultural phenomenon, is in full bloom and has been since the fifth decade of the twentieth century" (339) then, Lawson reasons, a comparable cognitive science of religion is equally possible. Just as the seemingly endless variety and complexity of human language is increasingly seen as being based in a limited set of universal principles—a "Universal Grammar"—including select behaviors and cognitive capacities, so are religious phenomena.[2] Lawson gives the examples, specific to the cognitive science of religion, of important advances made through the work of Dan Sperber (1975), E. Thomas Lawson and Robert McCauley (1990), Pascal Boyer (1994), Justin Barrett and Frank Keil (1996), Robert McCauley (1998), E. Thomas Lawson (1999), and Justin Barrett (2000), based upon which he observes that "emerging cognitive science of religion has focused on three problems: (1) How do human minds represent religious ideas? (2) How do human minds acquire religious ideas? (3) What forms of action do such ideas precipitate?" (344).[3] These studies and their focus emphasize that religious representation and behavior is "natural" in the sense that it does not require any reference whatsoever to the *supernatural* to explain it: "our ordinary, natural cognitive resources are sufficient to account for religious ideas" (344, and see Boyer 1994; Clark 2006; Bloom 2007; McCauley 2013). I am content to accept that and will not quibble with it, except to add that the very concept of "supernatural" is largely incoherent, since it indicates that something exists "beyond" existence. That is, unless it simply posits something extremely "special," something totally beyond the bounds of normal experience, which is required for an explanation of something otherwise inexplicable, a transcendent principle—but if this last be adequate as a definition of the supernatural, then quarks and black holes would be supernatural. Finally, I would argue, "supernatural" is a word we would be better off avoiding entirely.[4]

One widely influential observation in the cognitive science of religion comes from Boyer who points out that we have natural—that is, biologically evolved—"intuitive ontologies," deeply rooted understandings and expectations about how the world works:

> In the terms of our intuitive ontologies the world is a place where solid objects do not pass through each other, where living things require food to survive and grow, where animate things have goals, where agents have thoughts, and where artificial things do not come naturally—they have to be made.[5]
>
> (Lawson 2000, 345, with reference to Boyer 1994)

Of course, anything that violates these expectations is "special" and so attracts our attention. One thing that

> Boyer and others have been able to show is that in the processes of cultural transmission counter-intuitive ideas have a *mnemonic advantage*. In simple terms, ideas in which certain properties of our intuitive ontologies are violated *are more memorable than ideas which contain no such violations*.
>
> > (Lawson 2000, 346, emphasis original,
> > see Atran 2006 on this)

Lawson and his co-author, Robert McCauley (1990),

> have shown that the representation of religious ritual action depends upon quite ordinary action representations. The main thing that distinguishes religious ritual action representations from ordinary action representations is the assumption that the agents involved in the action possess special qualities.
>
> > (346–347 see also 345)

These agents with special qualities are the "culturally posited supernatural agents" mentioned earlier. It is significant that Lawson and McCauley, like Ann Taves in *Religious Experience Reconsidered* (2009) and Dissanayake in *What is Art For?* (1988), invoke the "special" as a distinguishing feature of the religious. This seems unarguable, but the simple representation of an agent that is particularly memorable because it has "special" qualities, qualities that violate our intuitive ontologies, is hardly adequate as a description of religious behavior. The *successful*, unarguably *religious*, representation must have other features that distinguish it from the unsuccessful and the simply counter-intuitive. The question also arises, how can these qualities be described except *ex post facto*? The identification of such qualities can only be based retrospectively on the number of people who repeat the representation or the degree of piety (the cost) of its retention. As Taves points out, simple ascriptions of specialness build up to a complex or matrix of composite ascriptions so that some emergent property of the matrix—retained and repeated—distinguishes it from the merely fleeting play of the imagination (2009, 46–48). In ethological terms, this is "*a specific human ability or tendency that genes could transmit and environments could act upon*" (Dissanayake 1988, 60, emphasis original). That is, something in our evolutionary past that would have been a matter of differential survival, which appears to require more than the ability to produce, and the tendency to recall, representations of minimally counter-intuitive agents.

The kind of specialness that results from a violation of intuitive ontology will largely result from specifically *narrative* representation (Atran 2006, 192)—that is, *stories* about beings that pass through solid objects, animals that talk, invisible agents, etc. While clearly contributory to the success of

religious narratives, this largely fails to take account of special objects, actions, and events that are empirically available and rendered "special" not by the violation of intuitive ontology, but by an investment of human attention and skill. That is to say *non-verbal* material culture. The focus on "minimally counterintuitive agents" may be a result of ongoing logocentrism. The Modern Western mind remains all-too-easily convinced that *words* are somehow a more reliable and immediate presentation of the real than other skillful representations, and so the specialness that is conveyed through narrative representation tends to be accorded a primary role in Modern Western understanding that it may not deserve (I will return to this point later).

Even so: "[r]eligious representations make it possible for people to devise special ways of bringing about new ways of associating with each other in social ways, hence the widespread practice of rites of passage," according to Lawson (2000, 347). This echoes Dissanayake's early understanding of religion as making ceremonial and ritual behavior "special," but like it, neglects the cognitive improvements and self-gratifying components that Dissanayake later acknowledged. Religious representation, starting from things made special and representations of special things, can also bring about representations that communicate valuable perspectives—apparent misrepresentations that represent the really real (recall Boyd's claim that fiction extends our reach)—and can, furthermore, be apprehended as entirely self-gratifying, even if they bring about no apparent effect at all.

One further point that must be noted about the sort of cognitive science of religion that Lawson commends is the insistent concern that it is itself "a science." The application of scientific observations does not transmute all analysis *into* science. Brian Boyd's insistence should be borne in mind that "biocultural criticism" is *not* a science. The evolutionary approach that he takes toward literature,

> although it is informed by science, … does not limit itself to scientific reduction, since art by its nature invites a creative and original response, to some degree subjective and open-ended, an aura of implication rather than an exact transfer of information.
>
> (390)

which is reminiscent of Eliade's "creative hermeneutics." Furthermore,

> art appeals to our species preferences and our intuitions, often as they have been modified by local culture. Science rejects our species preferences and our intuitions, *even as* modified by local culture. It tests ideas not against human preferences but against a resistant world, and its methods of testing, by logic, observation, and experiment, encourage us to reject even ideas that seem self-evident and apparently repeatedly confirmed by tradition.
>
> (Boyd 411)

Boyd quotes Louis Menand, who "insisted that what humanities departments should definitely *not* seek was 'consilience, which is a bargain with the devil'" (338, Menand 2005, 14). Consilience, from the book of the same name by biologist E. O. Wilson, "is the idea that the sciences, the humanities, and the arts should connect with one another, so that science, especially the life sciences, can inform the humanities and the arts, and vice versa" (Boyd 338–339, E. O. Wilson 1998). Boyd insists that, to do its work well in literary criticism,

> [a]n evolutionary approach to literature can encourage literary scholars to learn from the strengths of science without abandoning their own expertise. Science advances by subjecting its hypotheses to hard testing against possible counterevidence. Literary studies can work in the same way.
>
> (386)

Maintaining the consanguinity of art and religion, I argue that such an approach can clarify religion as much as it can clarify art (literary or otherwise). However, as is common with so many of these scholars, Boyd does not seem to recognize this, apparently because he continues to apply the specifically Modern, Western misapprehension of religion:

> Religion partakes of elements of both art and science [he says]. It could not have begun without the understanding of false belief ... Nor could it have begun without the capacity for story that grew out of our theory of mind and our first inclinations to art ... The tales most often told not only involved agents with memorably exceptional powers but also helped to solve problems of cooperation by suggesting that we are continually watched over by spirits who monitor our deeds and punish or reward them.
>
> (Boyd 413, with reference to Boyer 2001;
> Barrett 2004; and D. S. Wilson 2002)

Boyd sees religion as something quite distinct from art, and closer to political power: "Religion and power commandeered art, not entirely, but substantially, for millennia. ... religion and power appropriated to their own ends art's ability to appeal to human imaginations" (414). Boyd here retrojects contemporary distinctions into a period when he himself recognizes that they were not distinct. Religion and art (and power) were not fully distinct until the post-Renaissance era, and to assume that one part of this undifferentiated group of behaviors could "commandeer" another is inconsistent.

It is possible to clarify the situation and to render it entirely consistent, but the confusion must first be understood before it can be clarified. Looking at a somewhat more recent work on cognitive science of religion, *The Evolution of Religion* (Bulbulia et al. 2008), it is immediately apparent in the prefatory "note from the publisher" by Dwight Collins, the president of Collins family

foundation, that the book is considered to be "an introduction to the science of the evolution of religion," which draws on "a range of research results and methods, propositions, apologies, rebuttals, and critiques" (11). The preface, co-authored by Russell and Cheryl Genet (2008), describes contributors as "experts on the scientific study of the evolution of religion" (13). Contributions came from *The International Conference on the Evolution of Religion* held in Hawaii in January 2007. This included "three scholarly groups who have otherwise had little sustained contact: religious studies scholars, cognitive scientists of religion, and evolutionary scientists interested in studying religion" (Sosis and Bulbulia 2008, 15) and called for a "more empirical and theory driven research" (16). From the outset, this seems to pose a problem: theory formation itself is not a scientific act—the "revolutionary science" that engenders paradigm change is not clearly and unambiguously "science" as much as is the "normal science" that proceeds from it. The creativity of theory formation seems to place the origins of science on a continuum with art and even religion—on what Michael Dowd, at the end of the same volume, calls the "night" side of human experience and language (402). Adducing a theoretical explanation that accounts for observable events is itself a form of "seeing the unseen" called "abduction." Robert Root-Bernstein has argued at length that "The Sciences and Arts Share a Common Creative Aesthetic," (1996) and that "Art Advances Science" (2000). One must ask whether any historiographical discipline, no matter to what extent it employs scientific methodologies, ever itself *becomes* "a science"?

Restoring the art to cognitive science: the ethology of art and religion

The Evolution of Religion—possibly precisely because of its intention to constitute a science—does not pay adequate heed to art, even though the introduction refers to concentrating, "on the penultimate day of the conference" on "the narratives through which religion is understood" (17). It focuses instead largely on such questions as whether or not religion should be considered an adaptation or a byproduct of other adaptations (18). Several of the contributing authors *mention* music, dance, and other creative artistic behaviors that should be classified as art. Kimmo Ketola discusses "Sankirtan," the practice of dancing and chanting in the Hare Krishna movement (89–92); David Kydd discusses the imitative behavior of *mimesis* and mentions "pantomime or rehearsal for skill activities like throwing or dance" (94); Richard Sosis considers the recitation of psalms—surely an artistic activity (103–109); Paul Wason looks at the massive stone circle of Avebury in Wiltshire (127–132)—and architecture, no matter how ancient, is an artform; Andrew Mahoney recognizes the "artful or creative use of theology" (165) and theology's potential status as an "artifact" worthy of preservation (166); Montserrat Soler describes how communication with the *orixàs*, the spirit-beings of Afro-Brazilian Candomblé, is achieved by means of an music-induced trance (168); Ilkka Pyysiäinen, in

considering the roles of ritual and agency in sexual selection points out that women tend to prefer *creative* males and good dancers as mating partners (175, 177); Dimitris Xygalatas considers the music and ecstatic dancing involved in a Greek firewalking ceremony (189–195); Jani Närhi considers "The Cognitive and Evolutionary Roots of Paradise Representations" (231–237), and representation is one of the primary characteristics of all the arts; Stewart Guthrie considers the evidence of some of the earliest Paleolithic art (240) and refers to Alfred Gell's 1998 *Art and Agency*; Candace Alcorta briefly considers "music and language development" (263–264) and recognizes that "newborns prefer songs to speech; this preference for song appears to be innate" (263); Tom Sjöblom writes on "narrativity" and storytelling (279–285). However, despite the haunting and pervasive presence of art behaviors none of the contributors explicitly pay any direct attention to the evolution of art-related behavior as worthy of consideration, and only one (Tom Sjöblom) makes a passing reference to Ellen Dissanayake and the ethology of art (281).

The contributors to this volume are accurately representative of cognitive science of religion in their focus on whether or not religion should be considered an adaptation or a byproduct. Many such theorists seem inclined to classify religion, as Boyd does, simply as "invented stories that people take as true" (2009, 199). As such, it is assumed to be maladaptive or at best a "spandrel" or accidental byproduct of other adaptations. Despite disagreements over the adaptive or merely coincidental status of religious behavior, cognitive theorists of religion agree that religion is in part produced by cognitive tools or mental "modules" devoted to specific tasks. The description of specialized functions of the brain as "modules" derives from Jerry Fodor's 1983 *Modularity of Mind* and there is considerable disagreement concerning the use of the term "module" here. Fodor's original sense was that such modules operate entirely autonomously, inaccessible to other functions of the brain. However, to give just one example, Vilayanur Ramachandran has described experiments that

> flatly contradict the theory that the brain consists of a number of autonomous modules acting as a bucket brigade. Popularised by artificial intelligence researchers, the idea that the brain behaves like a computer, with each module performing a highly specialised job and sending its output to the next module, is widely believed … But my experiments … have taught me that this is not how the brain works.
>
> (Ramachandran and Blakeslee 2005, 56,
> quoted in McGilchrist 2009, 225)

Armin Geertz (2008, 44) makes a similar protest against brain modularity. In the strict Fodorian sense of closed and inaccessible, autonomously functional units, these identifiable functions of the mind/brain are not genuinely modular. In his now classic study on autism and theory of mind, Simon Baron-Cohen identifies them as "'neurocognitive mechanisms,' rather than as

'modules' in the strict Fodorian sense" (57). Certainly these particular functions are performed somehow, and equally certainly they can be inhibited by localized brain damage. These identifiable, specialized functions appear to be based in neural networks that might be distributed throughout wide regions of the brain. Yet the term "modules" has stuck to such functions, accurate or not, and they continue to be most commonly called "modules" by contemporary evolutionary psychologists. Scott Atran refers to them as naturally selected cognitive faculties that are "activated by stimuli that fall into a few intuitive knowledge domains" and identifies those domains as "folk mechanics (inert object boundaries and movements), folk biology (species configurations and relationships), and folk psychology (interactive and goal-directed behavior)" (2006, 186). In common with the ethology of art, the cognitive science of religion has an interest in these faculties. Denis Dutton, for example, contends that our brains, determined by evolution and genes, can be seen to have a number of such faculties. These, he believes "account for the interests and capacities that best suited our Pleistocene ancestors" (43). He gives a list of 15 "innate, universal features and capabilities of the human mind" (43):

1 intuitive physics
2 a sense of biology
3 intuitive engineering
4 personal psychology
5 an intuitive sense of space
6 a tendency toward body adornment
7 an intuitive sense of numbers
8 a feeling for probability and frequency
9 an ability to read facial expressions
10 a precise ability to throw
11 a fascination with organized pitched sounds
12 an intuitive economics, "along with an associated sense of fairness and reciprocity"
13 a sense of justice, followed by
14 logical abilities, and, finally
15 the spontaneous capacity to learn and use language (43–44).

There seems to be a variety of problems with this specific list—#5, for example, the intuitive sense of space, seems to be necessarily involved in the "intuitive physics" given as #1, as does #10, the ability to throw accurately; #9, the ability to read facial expressions seems to be part of the "personal psychology" given as #4, with which it would combine to form "theory of mind"; #12, the intuitive sense of economics would seem necessarily to involve the differentiation of material value, but associating it with "fairness" extends it to include moral values, which confuses it with the next supposedly discrete feature, #13, the sense of justice. Thus one wonders if "intuitive economics" might camouflage a complex and significant function

of value-perception, including ideas of what is worthy of attention as well as worthy of effort or exchange. Shortly after this list, Dutton mentions "a strong sense of … purity or contamination" and one wonders why this is not seen as a separate faculty. Under what other feature would it be subsumed? The sense of biology, perhaps, but it clearly overlaps into the sense of justice and "what is deserved." Evolutionary psychologists, John Tooby and Leda Cosmides recognize an alternate list of such "modules" for facial recognition, spatial relations, the mechanics of rigid objects, tool use, fear, social exchange, emotion-perception, kin-oriented motivation, effort allocation and re-calibration, childcare, social inference, friendship, semantic inference, grammar acquisition, communication pragmatics, and theory of mind (Tooby and Cosmides 1992, 113). The lack of precision and consensus in such classifications does not render them useless, but it does militate against the properly scientific status of such studies. No matter the specifics of such categories, at this point the important thing is to note that these and other such candidates for universal human capacities and tendencies are seen as developed via genetic evolution for adaptive purposes and are assumed by both the ethology of art and the cognitive science of religion to be constitutive of the behaviors that we recognize as art and religion.

For current purposes, it is important to gain a thorough grasp of the idea of what is meant by what Dutton here calls "personal psychology" and Tooby and Cosmides call "theory of mind." In the previously mentioned volume on *The Evolution of Religion*, Emma Cohen uses the expression "naïve psychology" for "folk psychology" or "theory of mind" (2008, 250), Gretchen Koch mentions that an earlier author, Uta Frith (1989), "calls our ability to attribute invisible causal forces to other people (that is, beliefs, emotions, desires) 'mentalizing,' and it is a capacity in which she has found people with autism to have a notable deficiency" (261). This is another in the list of terms for this capacity, which Koch herself calls "cognitive empathy" (261) and Daniel Dennett calls "the intentional stance" (1987, and, for example, 2006, 108). That there is no settled vocabulary in this area adds to the confusion. However, as mentioned above, Iain McGilchrist gives a relatively simple description of "theory of mind"—whatever we choose to call it—as: "a capacity to put oneself in another's position and see what is going on in that person's mind" and also "the ability to attribute mental states to others" (2009, 57 and 108). One of the earliest descriptions of theory of mind can be attributed to David Premack and Guy Woodruff (1978):

> an individual has theory of mind if he imputes mental states to himself and others. A system of inferences of this kind is properly viewed as a theory because such states are not directly observable, and the system can be used to make predictions about the behavior of others … for example, purpose or intention, as well as knowledge, belief, thinking, doubt, guessing, pretending, liking, and so forth.
>
> (515)

It was this capacity that I intended when I used the word "empathy" in the preceding chapter. Now, however, the understanding arises that this is not just some vague emotional sensation but a highly specialized (although probably not "modular") neurological function that has evolved over the history of our species. This ability indirectly to "perceive" the subjectivity of the other is best characterized as an example of "abduction," defined as a logical inference that constructs a hypothesis from observed data in an attempt to explain the observation. It is, however, experienced as a direct perception: the subjective sensation is of simply "seeing" the other's happiness or anger. The capacity appears to be particularly active in the processes that come to be known as art behavior and, I will I argue, in religious behavior, and we need to bear this in mind as we apply the ethology of art to the cognitive science of religion. Dutton, very reasonably, considers "Homo sapiens cooperating with each other to maximize species survival" (45), and his analysis clearly favors the idea of group adaptation over individual adaptation, as does, it now appears, E. O. Wilson in certain circumstances, David Sloan Wilson, and McGilchrist (see Bulbulia and Frean 2009, 173–194; McGilchrist 2009, 123; Lehrer 2012).

Among the aforementioned cognitive theorists of religion who also make much of such particular mental faculties ("modular" or not) is Justin Barrett. Barrett makes distinctions between a variety of mental functions such as the "agency detection device," and "agent describer" (yet another term for "theory of mind") as if they were all separate, distinct, identifiable entities. Such hypothetical sub-division is somewhat dubious as they are all components of the same mental domain of folk psychology, involving the identification and recognition from observation of natural events of the existence, nature, and character of other agents comparable to ourselves. Although their existence might be empirically observed, their "nature" and "character" cannot. Scott Atran concludes that the function that recognizes other agents "evolved hair triggered in humans" (2006, 188). Barrett informs us that the agency detection device is "hyperactive" and he thus names it HADD. It "registers the event as caused by agency and passes the word on to ToM [theory of mind]" (2004, 35). These and other cognitive theories were subject to scathing critique by Barbara Herrnstein-Smith (2009). Nonetheless, the insight that these functions are performed heuristically and automatically by evolved, dedicated processing elements of the human brain, "modular" or not, remains of considerable importance. Such functions are precisely the sort of things that ethology can work with: "*a specific human ability or tendency that genes could transmit and environments could act upon*" (Dissanayake 1988, 60, emphasis original). The agency detection device is evidently adaptive because assuming the presence of an agent that is potentially either dangerous or helpful is more conducive to survival than assuming its absence or failing to register its presence.

Barrett says that

> the agent describer, better known as the theory of mind (ToM), kicks
> into action once the agency detection device recognizes something that

seems to initiate its own actions and does not merely respond mechanisti-cally to environmental factors. The ToM then attributes a host of mental properties to the agent in question—percepts that enable it to negotiate the environment, desires that motivate actions, thoughts and beliefs that guide actions, memory for storing percepts and thoughts, and so forth.

(2004, 4–5)

Thus, perceiving that other agents are possessed of minds similar to one's own but with their own beliefs, desires, and intentions is a particular cogni-tive function. According to Barrett, theory of mind "may have its origins in the first three years of life but does not consistently approximate how adults reason until age four or older" (6) and it becomes active when an object is identified as an agent, which is the role of the agency detection device. The agency detection device, he believes, "suffers from some hyperactivity, making it prone to find agents around us, including supernatural ones, given fairly modest evidence of their presence" (31). Barrett refers to this as "the nonreflective detection of the agency in the environment" (31). This function appears to begin relatively simply; it "appears to register non-inertial, goal directed movement as caused by an agent and then searches for a candidate agent" (32). Despite its simple origins, the function attains a high degree of sophistication. It may begin by simply registering motion as indicating poten-tial agency but it rapidly progresses—from our need to *predict* the activities of agents—to identifying the *nature and character* of the agent.

> In identifying traces as the consequence of agency, HADD pays spe-cial attention to whether the trace (including objects) might be purpose-ful. This ability to discern purposefulness (accurately or inaccurately) sometimes carries the name *teleological reasoning* and permeates intuitive thought about artifacts and living things ... As the possession of the use-ful or purposeful features (such as in artifacts) typically signals design by some intentional agent (such as by humans), detection of purposefulness excites HADD.
>
> (38)

Naturally, to recognize—and especially to *predict*—design, intention, or pur-posefulness is highly adaptive, and to do so effectively this brain function must gain some reliable insight into the inner workings or mind of the ob-served agent.

What the cognitive science of religion needs to learn from the ethology of art is that art objects and events give us a peculiarly strong sense of insight into agency. Currently we think primarily of the agency of the originating agent or artist, but this can evidently be extended to fictive or hypothetical agents and eventually to "transcendental" agency. Gell, Dutton, and McGilchrist all argue that works of art are very specifically "windows into the mind" of an-other being. Art performance ineluctably communicates the *personality* of an

agent and this is crucial in what Dutton calls the "expressive individuality" of art. Dutton considers works of art to be windows into the mind of another human being so that the history of painting is not a history of how things once actually appeared, but "of innumerable human visions of the world." It is of immense importance that art gives us "ways of looking into human souls and thus expand our own outlook and understanding" (Dutton 2009, 192). As far as brain activity is concerned, our response to art is more like our response to other living things than to inanimate objects, and art "puts minds on public display, where sexual choice could see them clearly for the first time in evolutionary history" (Dutton 2009, 162, quoting Miller 2000, 356). "We find beautiful artifacts—carvings, poems, stories, arias—captivating because at a profound level we sense that they take us into the minds that made them" (Dutton 2009, 163).

Authenticity in the arts "means at the most profound level communication with another human soul, [and] is something we are destined by evolution to want from literature, music, painting, and the other arts" (Dutton 2009, 193). One of the main things that draw us to art is the manifestation of a *personality*. "The artists whose work has survived and achieved wide cross-cultural appeal are people whose output is marked by a persistent, distinct emotional tone, within individual works and also across a whole output" (Dutton 2009, 233). The arts can generate "the emotional feeling, the tone, the sense of a distinct outlook, the sense of entering into the feelings of a mind that is not your own" (Dutton 2009, 233–234) and

> a sense of emotional expression derived from the experience of a complex aesthetic structure created by another human being. To speak in metaphors, the work of art is another human mind incarnate: not in flesh and blood but in sounds, words, or colors.
>
> (Dutton 2009, 234–235)

Art behavior can thus establish "a strong and distinctive mood in the mind of the listener, the mysterious sense of an individual ... personality" (Dutton 2009, 235).

Dutton believes that our intense interest in art derives from the desire to experience and thus gain knowledge of another personality. Furthermore, then, "talking about art becomes an indirect way of talking about the inner lives of other people" (2009, 235). Boyd agrees: "*Storytelling* appeals to our social intelligence. It arises out of our intense interest in monitoring one another and out of our evolved capacity to understand one another through *theory of mind*" (2009, 382, emphasis original). So "theory of mind" appears to be a highly complex adaptive mental function that enables our ability to read the "inner state" of the other through observed events and objects and thus both to anticipate their future behavior and appropriately produce our own. According to Barrett, theory of mind "concerns how children come to predict and explain human action in terms of mental states, such as percepts, beliefs,

and desires" (2004, 77–78). This function intuitively "assumes that agents may freely choose how to behave" (86). Obviously, theory of mind is a lot more than agency detection and description based on direct observation. As Barrett says, "purposeful and self-propelled action triggers HADD to recognize these animals as agents with minds. ToM automatically fills in the details" (103), and "filling in the details" requires a great deal of complex, creative processing.

Another cognitive theorist of religion who uses the idea of the specialized function of "theory of mind" is Pascal Boyer, who says that he

> simplified matters a great deal when I said that we have a system that computes mental states like *knowing, hoping, perceiving, inferring*, etc., and produces descriptions of these states in other people's minds, as an explanation for (and prediction of) their behavior. My description was simplified in that this intuitive psychological system is in fact composed of a variety of subsystems.
>
> (2001, 102)

Grasping some aspects of what is going on in other people's minds: according to Boyer, is only possible because of specialized mechanisms that

> constantly produce representations of what is going on inside people's heads, in terms of perceptions, intentions, beliefs, etc. That this requires subtle and specialized machinery is made obvious, indeed spectacularly so, by the fact that a part of this machinery is impaired in some people. They can compute the trajectories of solid objects and their causal connections, predict where things will fall, identify different persons, etc., but the simplest psychological processes escape them ... the autistic have a rather different pattern of activation, which would indicate that their "theory of mind" mechanism is either not functioning or functioning in a very different way.
>
> (103)

Boyer further explains that "[h]umans depend upon information and upon cooperation, and because of that they depend on *information about other people's mental states*—that is, what information they have, what their intentions are" (122, emphasis original) and this is how our "intuitive psychology" or "theory of mind" has developed as a federation of structures and functions each of which is specialized in particular tasks (123). Given the rather obvious fact of our dependence on such information, it is not surprising that evolutionary selection would produce and condition a faculty that assists us in determining such information:

> what we call "intuitive psychology" or "theory of mind" is a federation of brain structures and functions each of which is specialized in particular tasks: detecting the presence of animate agents (which may be predators

or prey); detecting what others are looking at; figuring out their goals; representing their beliefs ... chimpanzees can certainly follow another agent's gaze, but they do not seem to have a rich representation of the agent's *intentions* as revealed by gaze direction.

(123)

As well as the specific function identified as "theory of mind," there are others for producing causal narratives, describing the events of the natural world in comprehensible and predictable terms (sometimes called "causal reasoning"). We habitually supply narrative explanations of events. Special, "supernatural" agents provide excellent *dei-ex-machina* to suit that purpose. Where no other rational explanation can describe events satisfactorily, our causal reasoning function is more comfortable with *some* explanation, no matter how imaginative, rather than none. Such thought has given rise to cognitive explanations of religion including Stewart Guthrie's influential theory that religion is an aspect of a broad, elaborate, and universal cognitive phenomenon that he identifies as "anthropomorphism," a tendency to ascribe human attributes promiscuously to non-human phenomena (Guthrie 1993). Another influential theory is that of Harvey Whitehouse, who identifies two "modes of religiosity," the imagistic and the doctrinal, which arise in response to the distinct cognitive processes of episodic as opposed to procedural or semantic memory. The former stores "flashbulb" recollections of intense experiences and so gives rise to infrequent, high-arousal rituals like initiation rites that generate precisely those kind of memories. The latter stores recollections that have been carefully induced by repetitive experiences and so gives rise to frequent but low frequency rituals like daily recitations or prayers (Whitehouse 2004). Ann Taves in her 2009 volume *Religious Experience Reconsidered: A Building Block Approach to the Study of Religion and Other Special Things* proposes that the attribution of religious meaning or "specialness" to phenomena deemed religious can be explained as a function of cognition. More of all of these later.

As we have seen, Ellen Dissanayake, Brian Boyd, and Denis Dutton (among others) have applied the bioevolutionary or ethological approach very effectively to art (including the narrative and literary arts) and made, I would argue, better progress than those who apply the ethological approach in the form of "cognitive science of religion" to religion. However, both groups seem to assume *a priori* that the two categories—art and religion—are so fundamentally distinct that the close consideration of either one in the study of the other is habitually avoided. However, the current, Western notion of religion is, like the present-day Western concept of art, a mess. Art cannot be understood as a human behavior if it is considered a matter of "whatever is exhibited in galleries in major cities, bought by museums of contemporary art, shown in biennales and the Documenta, and written about in periodicals such as *Artforum, October, Flash Art, Parkett* or *Tema Celeste*" (Elkins 2004, 1). Religion cannot be properly understood if considered a matter of mental

states (beliefs) and invented stories that people take as true (certainly not in the sense of truth as an affirmation of the accuracy of historical description and metaphysical claims). If we want to understand the nature, origin, and function of art and of religion as evolved and ubiquitous human behaviors we must redefine them both. Religion may be a matter of "Culturally Posited Supernatural Agents," but how and why did we ever come to "posit" the specific ones that we do? The minimal violation of intuitive ontologies may make these agents "special," but why is their postulation culturally universal and doggedly persistent despite their continuing violation of our intuition? One way forward is to follow the lead of the ethologists of art and reconsider our understanding of religion, and that this leads us to considering religion and art *together*—on some level ineluctably linked. It also leads to a clearer understanding of the ideas of "seeing the unseen" and, ultimately, of "perceiving the sacred in the profane," as we will see.

Notes

1 The specifically "modular" nature of these capacities is much debated, as we will see, although the capacities certainly exist as described. One such capacity is "theory of mind," which has been described as "a capacity to put oneself in another's position and see what is going on in that person's mind" (McGilchrist 2009, 57). This capacity plays an important role in this analysis.
2 I recognize the criticisms that have been leveled against "universal grammar," which merely serves as an analogy at this point. The model that I will propose is considerably simpler than any "universal grammar" and so escapes many of the criticisms against this latter.
3 There may be several problems with Lawson's formulation. First it assumes that there are ideas that are specifically religious, which some have called into question (for example, McCutcheon 2003); second it assumes that ideas precipitate actions, which, in the context of ethological thinking, may be somewhat naive. Nonetheless, it does accurately represent common assumptions at the core of CSR.
4 Jeffrey Kripal's reinstatement of the term as "super natural" is more acceptable and closely parallels what I am trying to argue here:

> With this simple little space between two letters, we can now begin to recognize that the religious experience of the natural world is seldom a form of "idolatry," … Rather it is more often the case that the sacred is manifesting itself *through* the natural world and its various objects.
>
> (Kripal 2014, 146ff., 172)

Of course, a great deal depends here on the understanding of "the sacred." In any case, it must be understood as something other than "supernatural."
5 As we will see, one particular expectation—that agents have thoughts—is significantly open to question, especially in the area of art.

References

Alcorta, Candace. "IPods, Gods, and the Adolescent Brain." In *The Evolution of Religion*, edited by Joseph Bulbulia et al., 263–269. Santa Margarita, CA: Collins Foundation Press, 2008.

Atran, Scott. "The Cognitive and Evolutionary Roots of Religion." In *Where God and Science Meet: How Brain and Evolutionary Studies Alter Our Understanding of Religion*, edited by Patrick McNamara, vol. 1, 181–207. Westport, CT: Praeger Publishers, 2006.

Baron-Cohen, Simon. *Mindblindness: An Essay on Autism and Theory of Mind*. Cambridge, MA: The MIT Press, 1995.

Barrett, Justin. "Exploring the Natural Foundations of Religion." *Trends in Cognitive Sciences*, 4, no. 1 (2000): 29–34.

Barrett, Justin. *Why Would Anyone Believe in God?* Walnut Creek, CA: Altamira Press, 2004.

Barrett, Justin and Frank Keil. "Anthropomorphism and God Concepts: Conceptualizing a Non-Natural Entity." *Cognitive Psychology* 31 (1996): 219–247.

Bloom, Paul. "Religion Is Natural." *Developmental Science* 10 (2007): 147–151.

Boyd, Brian. *On the Origin of Stories: Evolution, Cognition, and Fiction*. Cambridge, MA: Belknap Press of Harvard University Press, 2009.

Boyer, Pacal. *The Naturalness of Religious Ideas: A Cognitive Theory of Religion*. Berkley: University of California Press, 1994.

Boyer, Pacal. *Religion Explained: The Evolutionary Origins of Religious Thought*. New York: Basic Books, 2001.

Bulbulia, Joseph and Marcus Frean. "Religion as Superorganism: On David Sloan Wilson." In *Contemporary Theories of Religion: A Critical Companion*, edited by Michael Stausberg, 173–194. London and New York: Routledge, 2009.

Bulbulia, Joseph, Richard Sosis, Erica Harris, Russell Genet, Cheryl Genet, and Karen Wyman, eds. *The Evolution of Religion: Studies, Theories, and Critiques*. Santa Margarita, CA: Collins Foundation Press, 2008.

Burkert, Walter. *Creation of the Sacred: Tracks of Biology in Early Religions*. Cambridge, MA: Harvard University Press, 1996.

Clark, Richard. *The Multiple Natural Origins of Religion*. Oxford, UK: Peter Lang, 2006.

Cohen, Emma. "Not Myself Today: A Cognitive Account of the Transmission of Spirit Possessin Concepts." In *The Evolution of Religion*, edited by Joseph Bulbulia, et al., 249–255. Santa Margarita, CA: Collins Foundation Press, 2008.

Dennett, Daniel. *The Intentional Stance*. Cambridge, MA: MIT Press, 1987.

Dennett, Daniel. *Breaking the Spell*. New York: Viking, 2006.

Dissanayake, Ellen. *What Is Art For?* Seattle: University of Washington Press, 1988.

Dowd, Michael. "Thank God for Evolution." In *The Evolution of Religion*, edited by Joseph Bulbulia, et al., 401–406. Santa Margarita, CA: Collins Foundation Press, 2008.

Dutton, Denis. *The Art Instinct: Beauty, Pleasure, and Human Evolution*. New York, Berlin, and London: Bloomsbury Press, 2009.

Elkins, James. *On the Strange Place of Religion in Contemporary Art*. New York: Routledge, 2004.

Fodor, Jerry A. *Modularity of Mind: An Essay on Faculty Psychology*. Cambridge, MA: MIT Press, 1983.

Frith, Uta. *Autism: Explaining the Enigma*. Oxford, UK: Blackwell, 1989.

Geertz, Armin. "From Apes and Devils to Angels: Comparing Scenarios on the Evolution of Religion." In *The Evolution of Religion*, edited by Joseph Bulbulia, et al., 43–49. Santa Margarita, CA: Collins Foundation Press, 2008.

Gell, Alfred. *Art and Agency: An Anthropological Theory*. Oxford, UK: Oxford University Press, 1998.

Genet, Russell and Cheryl Genet. "Preface: Bringing *The Evolution of Religion* into Being." In *The Evolution of Religion*, edited by Joseph Bulbulia, et al., 13–14. Santa Margarita, CA: Collins Foundation Press, 2008.

Guthrie, Stewart. *Faces in the Clouds: A New Theory of Religion*. Oxford, UK: Oxford University Press, 1993.

Guthrie, Stewart. "Spiritual Beings: A Darwinian, Cognitive Account." In *The Evolution of Religion*, edited by Joseph Bulbulia, et al., 239–245. Santa Margarita, CA: Collins Foundation Press, 2008.

Ketola, Kimmo. "Cultural Evolution of Intense Religiosity: The Case of 'Sankirtan Fever' in the Hare Krishna Movement." In *The Evolution of Religion*, edited by Joseph Bulbulia, et al., 87–92. Santa Margarita, CA: Collins Foundation Press, 2008.

Koch, Gretchen. "Dualism, Moral Judgment, and Perceptions of Intentionality." In *The Evolution of Religion*, edited by Joseph Bulbulia, et al., 257–262. Santa Margarita, CA: Collins Foundation Press, 2008.

Kydd, David. "Supernatural Niche Construction Incubates Brilliance and Governs the Ratchet Effect." In *The Evolution of Religion*, edited by Joseph Bulbulia, et al., 93–100. Santa Margarita, CA: Collins Foundation Press, 2008.

Lawson, E. Thomas. "Religious Ideas and Practices." In *MIT Encyclopedia for Cognitive Science*, edited by Robert A. Wilson and Frank C. Keil. Cambridge, MA: Cambridge MIT Press, 1999.

Lawson, E. Thomas. "Towards a Cognitive Science of Religion." *Numen* 47, no. 3 (2000): 338–349.

Lawson, E. Thomas and Robert McCauley. *Rethinking Religion: Connecting Cognition and Culture*. Cambridge, UK: Cambridge University Press, 1990.

Lehrer, Jonah. "Kin and Kind: Evolution and the Origins of Altruism," *The New Yorker*, March 5 (2012): 36–42.

Lorenz, Konrad. *Über Tierisches und Menschliches Verhalten: Aus dem Werdegaftg der Verhalteltslehre*. Munich: Piper Verlag, 1965.

Mahoney, Andrew. "Theological Expression as Costly Signals of Religious Commitment." In *The Evolution of Religion*, edited by Joseph Bulbulia, et al., 161–166. Santa Margarita, CA: Collins Foundation Press, 2008.

Menand, Louis. "Dangers Within and Without." *Profession* (2005): 10–17.

McCauley, Robert N. "Comparing the Cognitive Foundations of Religion and Science," Report # 37, Department of Psychology, Emory University, Atlanta, Georgia, 1998.

McCauley, Robert N. *Why Religion Is Natural and Science Is Not*. New York: Oxford University Press, 2013.

McCutcheon, Russell T. *The Discipline of Religion: Structure, Meaning, Rhetoric*. London and New York: Routledge, 2003.

McGilchrist, Iain. *The Master and His Emissary: The Divided Brain and the Making of the Western World*. New Haven, CT and London: Yale University Press, 2009.

Meuli, Karl. "Griechische Opferbräuche." In *Phyllobolia (Festschrift Peter von der Mühll)*, 185–288. Basel, Switzerland, 1946; reprinted in Karl Meuli, *Gesammelte Schriften*, vol. 2, 907–1021. Basel, Switzerland, and Stuttgart, Germany: Schwabe, 1975.

Meuli, Karl. "An Karl Schefold." In *Gestalt und Geschichte (Festschrift Karl Schefold zu seinem sechzigsren Geburrstag am 26. January 1965)*, 159–161. Bern, Switzerland, 1967; reprinted in Karl Meuli, *Gesammelte Schriften*, vol. 2, 1083–1092. Basel, Switzerland, and Stuttgart, Germany: Schwabe, 1975.

Miller, Geoffrey. *The Mating Mind: How Sexual Choice Shaped the Evolution of Human Nature*. New York: Doubleday, 2000.

Närhi, Jani. "The Cognitive and Evolutionary Roots of Paradise Representations." In *The Evolution of Religion*, edited by Joseph Bulbulia et al., 231–237. Santa Margarita, CA: Collins Foundation Press, 2008.

Premack, David G. and Guy Woodruff. "Does the Chimpanzee Have a Theory of Mind?" *Behavioral and Brain Sciences* 1 (1978): 515–526.

Pyysiäinen, Ilkka. "Ritual, Agency, and Sexual Selection." In *The Evolution of Religion*, edited by Joseph Bulbulia, et al., 175–180. Santa Margarita, CA: Collins Foundation Press, 2008.

Ramachandran, Vilayanur S. and Sandra Blakeslee. *Phantoms in the Brain: Human Nature and the Architecture of the Mind*. London: Harper Collins, 2005.

Root-Bernstein, Robert. "The Sciences and Arts Share a Common Creative Aesthetic" In *The Elusive Synthesis: Aesthetics and Science*, edited by Alfred I. Tauber, 49–82. Dordrecht: Kluwer, 1996.

Root-Bernstein, Robert. "Art Advances Science." *Nature* 407, no. 6801 (2000): 134.

Sjöblom, Tom. "Narrativity, Emotions, and the Origins of Religion." In *The Evolution of Religion*, edited by Joseph Bulbulia, et al., 279–225. Santa Margarita, CA: Collins Foundation Press, 2008.

Smith, Barbara Herrnstein. *Natural Reflections: Human Cognition at the Nexus of Science and Religion*. New Haven, CT and London: Yale University Press, 2009.

Soler, Montserrat. "Commitment Costs and Cooperation: Evidence from Candomblé, an Afro-Brazilian Religion." In *The Evolution of Religion*, edited by Joseph Bulbulia, et al., 167–174. Santa Margarita, CA: Collins Foundation Press, 2008.

Sperber, Dan. *Rethinking Symbolism*. Cambridge, UK: Cambridge University Press, 1975.

Sosis, Richard. "Pigeons, Foxholes, and the Book of Psalms: Evolved Superstitious Responses to Cope with Stress and Uncertainty." In *The Evolution of Religion*, edited by Joseph Bulbulia, et al., 103–109. Santa Margarita, CA: Collins Foundation Press, 2008.

Sosis, Richard and Joseph Bulbulia. "Introduction: Religion in Eden." In *The Evolution of Religion*, edited by Joseph Bulbulia, et al., 15–19. Santa Margarita, CA: Collins Foundation Press, 2008.

Taves, Ann. *Religious Experience Reconsidered: A Building-Block Approach to the Study of Religion and other Special Things*. Princeton, NJ and Oxford, UK: Princeton University Press, 2009.

Tooby, John and Leda Cosmides. "The Psychological Foundations of Culture." In *The Adapted Mind: Evolutionary Psychology and the Generation of Culture*, edited by Jerome Barkow, Leda Cosmides, and John Tooby, 19–136. Oxford, UK: Oxford University Press, 1992.

Wason, Paul. "Religion, Status, and Leadership in Neolithic Avebury." In *The Evolution of Religion*, edited by Joseph Bulbulia, et al., 127–132. Santa Margarita, CA: Collins Foundation Press, 2008.

Whitehouse, Harvey. *Modes of Religiosity: A Cognitive Theory of Religious Transmission*. Walnut Creek, CA: Altamira Press, 2004.

Wilson, David Sloan. *Darwin's Cathedral: Evolution, Religion and the Nature of Society*. Chicago, IL: University of Chicago Press, 2002.

Wilson, Edward Osborne. *Consilience: The Unity of Knowledge.* New York: Knopf, 1998.

Wunn, Ina. "Ethology of Religion." In *The Encyclopedia of Religion*, edited by Lindsay Jones, 2nd ed., 2867–2870. London and New York: Macmillan, 2005.

Xygalatas, Dimitris. "Firewalking and the Brain: The Physiology of High Arousal Rituals." In *The Evolution of Religion*, edited by Joseph Bulbulia, et al., 189–195. Santa Margarita, CA: Collins Foundation Press, 2008.

4 Skill and the sacred

Redefining art, redefining religion

> Artworks are never just singular entities; they are members of categories of
> artworks, and their significance is crucially affected by the relations which
> exist between them, as individuals, and other members of the same category
> of artworks, and the relationships that exist between this category and other
> categories of artworks within a stylistic whole—culturally or historically
> specific art-production system.
>
> (Alfred Gell, *Art and Agency*, 153)

The ethology of art and the cognitive science of religion are closely related
fields in that they both adopt an evolutionary approach and consider art and
religion to be natural products of human cognitive evolution. The former
assumes its object—art—to be an adaptation, that is, a tendency that genes
can transmit and which has been universally transmitted because it made—
at least in our Pleistocene past—a positive contribution to survival and re-
production. The latter questions the adaptive nature of religious behavior,
holding open the question of its adaptability or possible parasitism. That is,
the cognitive science of religion remains open to the possibility that religious
behavior may be a maladaptive by-product of other actual adaptations such
as the "agency detection device." So the cognitive science of religion seldom
considers religious behavior per se as *"a specific human ability or tendency that
genes could transmit and environments could act upon"* as Dissanayake considers
art (1988, 60, emphasis original). Integrating the insights of the ethology
of art with the cognitive science of religion, however, not only unravels
the rather mysterious relationship of art and religion, potentially explaining
claims to "see the invisible," but also implies a general theoretical under-
standing of religious behavior. Such an understanding necessarily entails—at
least implicitly—a theoretical *definition* of religion, which has been alter-
nately the *bête noir* and the Holy Grail of the study of religion. I hope to make
that definition more than just implicit, but before I do so, I need to look at
the nature of definition itself.[1]

Definition

The ethology of art requires a redefinition of art as something other than the institutional definition of "gallery" art. If the institutional definition of art is to be rejected and replaced, and some working definition of religion is to be adopted along the same lines, so as to clarify the relation of the two, then the whole issue of definition must be dealt with at some length, requiring a discussion of both definition in general and the specific definition of each category. The proposed relationship of art and religion entails specific modifications in the definition of each.

Concerning definition, it must always be borne in mind that "definitions are definitions of *symbols* (not of objects), because only symbols have the meanings that definitions may explain" (Copi, Cohen, and MacMahon, 79) and also that the process of definition can be used in a variety of ways. There are stipulative, lexical, precising, and theoretical definitions, among others. That is, definitions that can assign meaning to a term, report how a term has in fact been used earlier or by others, seek to eliminate a term's vagueness or ambiguity, or propose some comprehensive understanding of an entity—the proposed definition serving as a summary of that understanding (Copi, Cohen, and MacMahon, 79–85). Ostensive and intensive (or intensional) definitions seek, respectively, to define a term by enumerating examples of the class (for example, "whatever is exhibited in galleries in major cities, bought by museums of contemporary art, shown in biennales"—Elkins 1), or correctly to identify members of the class by specifying the necessary and sufficient properties of the term and the conditions required to belong to the class it denotes.[2]

One basic strategy in constructing an intensional definition is to identify the "genus and difference" of the term, sometimes referred to as genus and species. That is to say, to identify the class to which the term belongs and the characteristics, the categorical concepts, that differentiate the term from other members of the same class. In order to define a bed, I could say that it belonged to the genus "furniture" and is distinguished by a specific *differentia*—its purpose being for sleep. So "sleep" is the concept that is categorical for the definition of "bed." Ultimately, the goal is to describe a class or category that is mutually exclusive of all other species of the same genus in terms of characteristics that are jointly exhaustive of that class. The ethological approach commits us to identifying both religion and art as members of the class of human behavior, but what differentiates these particular behaviors from other behaviors, and what differentiates them from one another? What are the concepts categorical to art and to religion?

Defining "art"

Bearing in mind that "a definition is not more or less true, only more or less useful," as sociologist Peter Berger pointed out (1967, 175), an attempt to define art is itself an attempt to *accomplish* something rather than simply to find

what is already there. In order to be useful any proposed definition must be applicable to a recognizable extension of the term. Thus, a consideration of the past application of the term "art" is required to establish an initial understanding of its *differentia*—bearing in mind that our understanding will shift as we progress. In his attempt to define "art," the English philosopher and historian R. G. Collingwood (1889–1943) pointed out that the "aesthetic" sense of the word "art" is very recent in origin. "*Ars* in Latin, like τεχνη [*techne*] in Greek, means something quite different. It means a craft or specialized form of skill, like carpentry or smithying or surgery" (1938, 5). We must be alert from the outset concerning the shifting significance of the symbol "art" since people in different periods and contexts use it differently. Given the present ethological emphasis on art (and religion) as behavior conditioned by our evolutionary past, I am less interested in recent uses of the term, and, therefore in lexical definitions, than in the ancestral activities that gave rise to associated behaviors. The definition I seek is stipulative, precising, theoretical, and intensional.

That English etymology derives "art" from "skill or its application" indicates a great deal about the intension of the term. The Greek τεχνη had the common sense of artificial contrivance or something cunningly devised, which leads conceptually to the Latinate words artifice, artificial. *Technastos* was used of shipwrights. It was used of Hephaestus, the god of metallurgy, etc., but it was also used of all wiles, craft, or cunning. Latin *Ars* was likewise used of professional or technical skill as something acquired and practiced; skilled work, and craftsmanship, as well as artificial methods and all human ingenuity, such as a cunning trick or a clever military tactic. The close connection between art and skill is crucial to my analysis, so a word of warning is necessary here. When we think of the skill involved in the arts, we generally think of the skill of the artist in producing or performing the art. This may be called the skill of production, or better yet, the *skill of representation*. Yet this is by no means the only type of skill involved. Artists are also required to have a closely related *skill of cognition* or discernment. They must be able to "see" what it is that they *want* to produce before they produce it. I do not mean this in any naïve sense of entertaining a fully formed mental image of a piece or performance before it is produced, but of cognizing what is suggested by the environment as worthy or even as demanding of the effort—that which was characterized by the Greeks as sensitivity to the prompting of the Muses. Nor is it only the artist's skills of representation and cognition that are involved. The most beautiful of poetry might leave one unmoved if it is in an unfamiliar language. The greatest music of another culture may seem discordant to the unaccustomed ear. There is also a requisite *skill of reception*. Any audience, including artists themselves, must be appropriately trained in some way to recognize and appreciate the qualities of the art.

The modern, "aesthetic" sense of art as a detached appreciation of higher-order sensitivities is part of the "institutional" understanding of art against which ethologists of art militate, and it tends to emphasize the skill of reception. "Aesthetic" is from the same word as "anaesthetic," concerning sensory

perception or sensitivity, and it was applied to the theory of taste in the 18th century by Alexander Baumgarten (1714–1762).[3] Collingwood points out that

> [t]he Greeks and Romans had no conception of what we call art as something different from craft; what we call art they regarded merely as a group of crafts, such as the craft of poetry (ποιητικη τεχνη, *ars poetica*), which they conceived, sometimes no doubt with misgivings, as in principle just like carpentry and the rest. ... [It is] the power to produce a preconceived result by means of consciously controlled and directed action.
>
> (5, 15)

It is notable here that Collingwood's definition of art (for the ancients) would serve as a definition of *skill* (for us): "the power to produce a preconceived result by means of consciously controlled and directed action." *Ars* in Medieval Latin, like "art" in early modern English, which borrowed both word and sense, also meant any specialized form of learning, such as grammar or logic, magic or astrology. It was later used of a systematic body of knowledge and practical techniques, and so became cultural studies or the "liberal arts." The Renaissance, however, first in Italy then elsewhere, utilized the older meaning in that Renaissance artists thought of themselves as craftsmen— engineers and architects—as much as artists in the sense of refined aesthetes. The Renaissance was a revival of learning following the "Middle Ages" beginning in Italy in the 14th century, which saw the discovery of new continents, the replacement of the old Ptolemaic astrology with the Copernican, the development of the moveable type printing press, the magnetic compass, gunpowder, the breakdown of the old feudal system and the development of a monetary economy, national languages, and later of nations, and the growth of humanism. (The term "Middle Ages" was coined later to indicate the period between the downfall of the classical world of Greece and Rome and the Renaissance.) Brunelleschi, Leonardo da Vinci, Botticelli, Raphael, Michelangelo, Titian, and Tintoretto were all "Renaissance men," who embodied the basic tenets of Renaissance humanism of aspiration and the dignity of humanity. Collingwood goes on to point out that

> [i]t was not until the seventeenth century that the problems and conceptions of aesthetic began to be disentangled from those of technic or the philosophy of craft. In the late eighteenth century the disentanglement had gone so far as to establish a distinction between the fine arts and the useful arts; where "fine" arts meant, not delicate or highly skilled arts, but "beautiful" arts (*les beaux arts, le belle arti, die schönen Künste*). In the nineteenth century this phrase, abbreviated by leaving out the epithet and generalized by substituting the singular for the distributive plural, became "art."
>
> (6)

This led to the development, in the mid-20th century, of theories like Colling-wood's of a radical distinction of Art *per se* from other forms of behavior.

It is only natural that words precede their definition and originate from a variety of sources. *Art* comes from the Latin *ars* and *craft* from the Indo-European root *kr*, to make or to act. Because we have more than one word for a group of similar behaviors we seek to apply these distinct terms to mean-ingful distinctions. The Latin and Greek texts on *techne* and *ars* provide the rudiments of a distinction between art and craft, and Collingwood formal-izes the implications of that distinction. Denis Dutton, however, applying the ethological approach to art, argues that "thinking that the arts are beyond the reach of evolution is a mistake overdue for correction" (2), and his aim is "to elucidate general characteristics of the arts in terms of evolved adaptations" (236). Dutton avoids attempting to "define" the word "art," claiming that this is unnecessary since "[f]rom Lascaux to Bollywood, artists, writers, and musicians often have little trouble in achieving cross-cultural aesthetic un-derstanding. The natural center on which such understanding exists is where the theory must begin" (51), and he considers this center to reveal art to be a "cluster concept." That is,

> [t]he arts must be understood in terms of a cluster of features—skill dis-play, pleasure, imagination, emotion and so forth—that normally allow us to identify art objects and artistic performances through history and across cultures. These features are persistent in human life and arise spontaneously wherever artistic forms are adapted or invented, whether for instruction or amusement.
>
> (4)

Dutton argues that creative storytelling, which he considers to be "perhaps the oldest of the arts—is found throughout history and, like language it-self, is spontaneously devised and understood by human beings everywhere" (5). While I agree with the universality of storytelling, I advise caution in the identification of oral storytelling as the oldest of the arts. There seems to be good reason to see music and dance as older than verbal narratives and it should not be forgotten that they, too, tell stories (see, for example, McGilchrist 2009, 105, 111; Mithen 2005, *passim*).

It is an important feature of Dutton's ethology of art to emphasize that "Darwin himself knew that many of the most visibly striking features of animals are products not of natural selection for survival against the rigors of nature but of sexual selection" (5). Dutton adopted this position from the writings of Geoffrey Miller (1999, 2000a, 2000b, 2001, 2007) and this insight was accepted by Ellen Dissanayake in her later work. Based on this, many of the features of art behavior are seen as sexually selected, which renders more complex the question of their adaptive function. It also corroborates the ob-servation that this whole approach is not so much interested in any lexical definition of the way that the word "art" has recently been used, but in the

ancestral behaviors that have led to current behaviors that are so designated. Identifying the genus (what Dutton calls the "natural category populated by indisputable cases," 48) to which art belongs, without specifying the *differentia* that distinguishes the species from other species in that genus would leave the theoretical elaboration incomplete. Dutton does go on to identify such *differentiae*, and so he does, at least implicitly, suggest a definition of the term.

In common with other proponents of this ethological approach, he claims that art behavior is a human universal—not that every single individual necessarily engages in it, but that no known culture lacks it, and he makes the precision that

> the art instinct proper is not a single genetically driven impulse similar to the liking for sweetness but a complicated ensemble of impulses—sub-instincts, we might say—that involve responses to the natural environment, to life's likely threats and opportunities, the sheer appeal of colors or sounds, social status, intellectual puzzles, extreme technical difficulty, erotic interests, and even costliness. There is no reason to hope that this haphazard concatenation of impulses, pleasures, and capacities can be made to form a pristine rational system.
>
> (6)

Nonetheless, "[t]he universality of art and artistic behaviors, their spontaneous appearance everywhere across the globe and through recorded human history, and the fact that in most cases they can be easily recognized as artistic across cultures suggests that they derive from a natural innate source: a universal human psychology" (30).

For Dutton, the characteristic features of the arts can be reduced to a list of 12 core items that define art in terms of a set of "*cluster criteria*" (51). These are:

1 **Direct Pleasure**—"The art object—narrative story, crafted artifact, or visual and aural performance—is valued as a source of immediate experiential pleasure in itself, and not essentially for its utility in producing something else that is either useful or pleasurable" (52).
2 **Skill and Virtuosity**—"The making of the object or the performance requires and demonstrates the exercise of specialized skills. These skills are learned in an apprentice tradition in some societies or in others may be picked up by anyone who finds that she or he 'has a knack' for them … The demonstration of skill is one of the most deeply moving and pleasurable aspects of art" (53).
3 **Style**—"Objects and performances in all art forms are made in recognizable styles, according to rules of form, composition, or expression. Style provides a stable, predictable, 'normal' background against which artists may create elements of novelty and expressive surprise" (53).
4 **Novelty and Creativity**—"Art is valued, and praised, for its novelty, creativity, originality, and capacity to surprise its audience. Creativity

includes both the attention-grabbing function of art (a major component of its entertainment value) and the artist's ... capacity to explore the deeper possibilities" (54).

5 **Criticism**—"artistic forms ... exist alongside some kind of critical language of judgment and appreciation ... Professional criticism, including academic scholarship applied to the arts where it is evaluative, is a performance itself and subject to evaluation by its larger audience" (54).

6 **Representation**—"art objects ... represent or imitate real and imaginary experiences of the world. As Aristotle first observed, human beings take an irreducible pleasure in representation" and Dutton distinguishes between pleasure taken in the skill of representation and pleasure taken in the subject matter represented (55).

7 **Special focus**—that is, "a sense that the work of art, or artistic event, is an object of singular attention, to be appreciated as something out of the mundane stream of experience and activity" (55–56).

8 **Expressive individuality**—"the emotional tone ... is not generic ... but usually described as unique to the work—the work's emotional contour, its emotional perspective" (56).

9 **Emotional Saturation**—"the experience of works of art is shot through with emotion" (56). "Direct pleasure" is itself an emotional response, however, here it is the particular *tenor* of the emotional response implied by the expressive individuality of the work that yields the particular and specific "emotional tone" (57) of each art experience.

10 **Intellectual challenge**—"Works of art tend to be designed to utilize the combined variety of human perceptual and intellectual capacities to the full extent; indeed, the best works stretch them beyond ordinary limits" (57).

11 **Art traditions and institutions**—"Art objects and performances, as much in small-scale oral cultures as in literate civilizations, are created and to a degree given significance by their place in the history and traditions of their art" (58).

12 **Imaginative experience**—"objects of art essentially provide an imaginative experience for both producers and audiences ... the experience of art is notably marked by the manner in which it decouples imagination from practical concern, freeing it ... from the constraints of logic and rational understanding" (58, 59).

For Dutton, this cluster of concepts "help to answer the question of whether, confronted with an artlike object, performance, or activity—from our own culture or not—we are justified in calling it art" (59) and gives some idea of his theoretical understanding and practical application of the symbol "art": art is a behavioral propensity selected for in Darwinian evolutionary terms, significantly through the processes of sexual selection rather than simple natural selection (135–141), and it is one that involves some or all of the identified criteria. It is important to note that Dutton claims of his approach to art that

[i]t follows from my approach that after the analysis is done, the aes-
thetic masterpieces we love so much lose nothing of their beauty and im-
portance. This makes *The Art Instinct* different from recent evolutionary
treatments of religion. Religion by its very nature makes grand claims
about morality, God, and the universe. It follows necessarily that ex-
plaining religion in terms of an evolutionary source attacks religion at its
core. Works of art seldom make overt assertions of fact or instruct people
on how they must behave. Art's world of imagination and make-believe
is one where analysis and criticism spoil none of the fun.

(9–10)

This might seem true after the reductionist approaches of the cognitive sci-
ence of religion as practiced by, for example, E. Thomas Lawson and Robert
McCauley (1990), Pascal Boyer (1994, 2001), Stewart Guthrie (1993), Scott
Atran (2006), David Sloan Wilson (2002). But is it necessarily the case? Can it
be remedied? Is it possible that *religions* can be analyzed in this way and "lose
nothing of their beauty and importance"? It seems to me that the problem of
"attacking religion at its core" arises from seeing religion in strictly historicist
and literalist terms—as do so many of the protagonists of the "new atheist
debate" and so many modern (and post-modern) agnostics. That is, assuming
that the "truth" of religion resides in its historical and metaphysical accuracy
("overt assertions of fact") and its normativity ("instructing people on how
they must behave"). However, this is precisely the recent and contemporary
usage of the term "religion"—equivalent to the institutional definition of art.
We have to set *both* aside if we are to understand the development of these
behaviors aright. Assertions of fact are not required by all understandings of
religion—ritual, myth, and doctrine continue to give rise to ethics, social
cohesion, and reports of religious experience whatever the historical accu-
racy of the claims involved. Creative behavior in the service of salvation (or
enlightenment, or liberation, or becoming an immortal sage) is still deemed
to save, enlighten, liberate, or harmonize with the Dao, etc. Dutton also con-
trasts religion and art with the assertion that "works of art seldom … instruct
people on how they must behave" (10)—not only does religion necessarily
make such overt assertions, but art also often *does* instruct people on how to
behave.

Redefining "art"

Considerable assistance in resolving these difficulties is provided by Dissan-
ayake's work. Although Dutton's monograph only mentions her three times
(55, 224, 257), he cites three of her books and one article, and seems to have
been influenced by her approach. Dissanayake and Dutton agree that one of
the characteristics of the contemporary Western concept of art is that we are
expected to appreciate "its place in history and tradition" (Dissanayake 1988,
183, cf. Dutton's characteristics 5 and 11 above). Dutton explains that "this

single feature is the basis of the so-called institutional theory of art, which argues that once any object has met this criterion it need meet no others on the list: institutional validation alone can make absolutely anything ... a work of art" (Dutton 2009, 199–200). This one feature is "the basis of the institutional theory of art," and it is significant that Dutton finds it *dispensable*, whereas the institutional definition of art (such as invoked by Elkins) finds it the necessary and sufficient condition for the identification of art. It is symptomatic of an ethnocentric identification that what is only one out of a possible constellation of contingent attributes is taken to be the "essential" attribute, and this is certainly true when institutional, gallery art is taken as paradigmatic of all "true" art. As Dissanayake succinctly puts it concerning our current understanding of art, "we mistakenly infer the nature of human nature from our own. Yet it seems self-evident that one cannot expect to understand the nature of any creature by considering it only as it appears at one minute of one day—the most recent—of its life, and ignoring its previous history" (195). This is a problem common to both art and religion. William Paden pointed out, with good reason, that "one cannot generalize about religion on the basis of the language and norms of just a single case" (2005, 208). We mistakenly infer so much about unfamiliar things from local, familiar things. We infer the nature of art from the art that we know and of religion from the religion that we know and, often, this leads us into parochialism that simply blinds us to reality. Dissanayake leads with the claim that,

> the present-day Western concept of art is a mess ... Our notion of art is not only peculiar to our particular time and place, but, compared with the attitude of the rest of humankind, aberrant as well. No wonder we founder so badly when we try to generalize our ideas about art to encompass the arts everywhere.
>
> (5)

Our present-day concept of religion—the very one that Dutton applies—is at least equally a mess, and for intimately connected reasons: the limitation of our understanding of art produces and is produced by a similar limitation in our understanding of religion. Our understanding of art as a "functionally closed system" (see Luhmann 2000, 1) has tended to isolate the functions served by the arts from the domain of religion, which is then likewise seen as a closed system, with similar results. Dissanayake deals directly with "the ways in which modern Western aesthetic sensibility differs from the rest of humankind" (1988, 159). One of these is that "all human societies, past and present, so far as we know, make and respond to art" (x). Another is that, although in its most common use, the word "art" refers to painting, the arts include not only visual objects but also music, dance, poetry, drama, and so on (4). She argues that the arts might be a cultural phenomenon, but "[a]rt might profitably be viewed as a prior, biological one" (4) and so, "if we presume to speak about art, we should try to take into account the representatives

of this category created by all persons, everywhere, at every time" (5). She sees "art as a realm of human activity" (7) and it is this emphasis on art as an *activity*, a class of human behaviors, which Dutton, and others, have adopted. We need to follow suit with religion. As Dissanayake says, "perhaps it is our modern notion of art that is the problem. Easel painting and ballet may not be necessary, but some broader, more inclusive activity may be" (35). Thus, she identifies and strives to correct a significant problem and inaccuracy in our contemporary understanding of what "art" is taken to be. The types of activities that we most commonly recognize as art, like "easel painting and ballet," do not appear to be necessary to contemporary life, and we assume this to be the common, if not the essential, characteristic of art. But what if, as she says, other, more typical representatives of art, generally *are* necessary in some way?

In common with Schleiermacher, Kierkegaard, Hirn, Van der Leeuw, and Brennan Dissanayake agree that in the past art and religion were not entirely distinct and may still be more closely related than we allow: "Medieval European aesthetics was not separable from cosmology and theology—much the same interconnectedness as found in the complex world views of the Australian aborigines, the Navajo, or the Dogon" (1988, 36). Could it be that cosmology and theology—some representation of reality as a whole, which encompasses and thus renders comprehensible the whole of one's experience—*is* necessary for us in some way? It might certainly be seen to be necessary to a consistent and coherent response *to* that experience. How is one to know how to respond to one's environment, how best to behave within it, if one has no theoretical comprehension or operative cognitive schema of that environment as a whole?

Dissanayake devotes a corrective section (40–42) to this "institutional" understanding of art in which she points out that

> [i]t would seem that our general, unexamined, imprecise idea of art ... is a peculiarly culture-bound view, as vague yet ultimately pervasive and influential as the not dissimilar Polynesian concept of *mana*. For no other society or group of human beings has ever held the view (one could call it an ideology) of art that now prevails, rarely completely articulated but everywhere presumed, in most educated, cultured, modern European and European influenced society ... Yet neither in classical medieval times, nor indeed in any other civilization or traditional society that we know, have works been made to serve as "art objects," to be judged by aesthetic criteria alone, or appraised primarily for their power to evoke aesthetic enjoyment. Even though aesthetic excellence in a work may have been obligatory, this was so because the object or performance was already intrinsically important for other reasons and thus required to be done beautifully, appropriately, or correctly. Until the nineteenth century, beauty (at least in the man-made world) was *not* its own excuse for being.
>
> (40, 41)

This last phrase, beauty as its own excuse for being, refers to the well-known, *ars gratia artis*, "art for art's sake," expressing the idea that art needs no justification, no other reason to exist, beyond its simple being as art. Despite its Latin expression, this slogan does not derive from the works of any classical author but was adopted as a creed by the Bohemian counter-culture of the 19th century. One Théophile Gautier (1811–1872) adopted the phrase, "*L'art pour l'art*," as a catchphrase and publicized it widely through the review *L'Artiste*. It was widely taken up by, for example, Edgar Allan Poe (1809–1849), who said "there neither exists nor can exist any work more thoroughly dignified, more supremely noble, than this very poem, this poem *per se*, this poem which is a poem and nothing more, this poem written solely for the poem's sake" (Poe 1850, paragraph 11). However, and most importantly,

> art as it is thought of today is not considered to encompass the often banal and inept activities that an ethological view such as the present one includes as instances of a behavior of art (e.g., home decor, personal adornment, window displays). Rather, the word and concept has acquired a classic capital A, and as such is regarded as an elite activity performed and appreciated by the few and existing only "for its own sake."
>
> (Dissanayake 1988, 167–168)

Once attention is directed to it, it becomes quite obvious how

> [a]rt in its most conventional modern sense, the kind of art that is bought and sold or appreciated in museums, has become increasingly a private predilection, separated from primary lived experience. Whereas in non-literate society virtually everyone was a participant in and appreciator of art, in modern society, even when the public has learned that art is a good and desirable thing and dutifully throngs to certain well-advertised extravagant exhibitions, art remains an elitist activity, made and, more important, consecrated by the few.
>
> (183)

As Collingwood explained, our contemporary use of the word "art" has come to be shorthand for "the fine arts." In order to understand art properly, we must see "the often banal and inept activities" such as "home decor, personal adornment, window displays" as possibly *more* typical and better representative of art behavior. One of the entailments of identifying art in the Modern, Western way as "gallery art" or "institutional art" is that

> [t]he required response to what is regarded as art in modern times is not direct psychophysical reaction to rhythm, tension and release, or association with powerful cultural or biological symbols (the "ecstasy" of communal participation), but a detached cognitively mediated "appreciation"

of its internal relationships, its place in history and tradition, and its implications and ramifications outside itself (the "aesthetic experience").

(Dissanayake 1988, 183)

In other words, Dissanayake also implies that we no longer *respond* to art as powerfully as people once did. With this in mind then, she suggests that "perhaps if we examine what the arts *do for* people (rather than what they appear to *be* in their various manifestations), we might find a satisfactory starting point from which to understand and describe art as a general human endowment" (60). As far as Dissanayake is concerned,

> [t]he answer to that question [what does art do?] is what we are after: whether or not a general behavioral propensity "art" can be identified that suffuses or characterizes the arts. Is the art in the arts necessary? By phrasing the question this way, and examining the proposals that have been made to support affirmative answers, we might be able to understand what art is and is for by what art does.
>
> (64)

Considering what art *does* for people and recognizing everyday instances of art behavior tends to challenge the distinction of art and religion and to suggest that their radical differentiation is a product of their present-day, conventional, modern Western (and messed-up) understanding.

In her early work, Dissanayake considered eight possible functional understandings of art (1988, 64–71):

> Art echoes or reflects the natural world of which we are a part (64)
>> Art is therapeutic (65)
>> Art allows direct, 'thoughtless' (or unself-conscious) experience (66)[4]
>> Art exercises and trains our perception of reality; it prepares us for the unfamiliar (67)
>> Art assists in giving order to the world (69)
>> Art functions for "dishabituation," that is, "it provides the sense of new possibilities that encourages potential adaptive behavior when old solutions are found no longer to be effective" (69–70)
>> Art provides a sense of meaning or significance or intensity to human life that cannot be gained in any other way (70)
>> Art functions towards various social ends (71)

One of the problems that Dissanayake confronts in attempting to establish what art is by what art does, is that many of the functions of art, such as its therapeutic benefits, might just as well be gained by activities that are not usually called art (such as religion). Nonetheless, this consideration is enough to establish that the term "art," when applied purely to the art of galleries, museums, concert halls, and the literary canon, conceals the nature of art as

a behavior. Art is not so easily detached and dissociated from other human activities and behaviors.

Dissanayake is less timid than Dutton about defining "art," and I hope to follow her lead in attempting to produce a comparable definition of religion that is a theoretical definition, one that serves as a summary of a more ramified theoretical understanding of the category. Dissanayake's understanding of art as a behavior, whose evolution she hypothetically reconstructs, recognizes a fundamental behavioral tendency that she proposes to lie behind all art. The heart of Dissanayake's thesis is that art is *making special*, and she claims "that it is as distinguishing and universal in humankind as speech or the skillful manufacture and use of tools" (92). "Making special is to be distinguished from 'marking,' because it seeks to shape and embellish reality (or experience) so that it appears otherwise additionally or alternatively real ... and we will probably respond emotionally with stronger feelings than we would to 'non-special' reality" (95). Although she argues that "making special" "must not be considered to be synonymous with a behavior of art, it is certainly a major ingredient of any specific instance of it, and 'art' can be called an instance of 'making special'" (99). Crucially,

> [a]s an essential feature of a behavior of art, as well as characterizing ritual and play, the tendency to make special would be an inherited predisposition, selected for according to Darwinian principles. Although traits as complex as human behavior are influenced by many genes, each of which shares only a small fraction of the total control of the expression of the behavior, natural selection can still affect whether or not a certain predisposition is retained and often for the ways in which it is manifested. What is inherited is a capacity or a tendency to behave one way rather than another. The genetic predispositions and the constraints of the environment together guide the developing behavior; if it confers greater selective fitness, it will in the long run be retained. We could postulate that societies whose members tended to make things special or recognize specialness survived better than those who did not.
>
> (103)

So the tendency to make certain things special can be said to have evolved and to have adaptive value. "This behavior of art might be described as *the manufacture or expression of what are commonly called 'the arts,' based on the universal inherited propensity in human nature to make some objects and activities special*" (107). The initial adaptive value of this behavior—what it does and the reason that it has been retained and transmitted—is that "[a]ctivities that are suffused with bodily, sensual pleasure are likely to be repeated, and investing necessary but routine acts with pleasure would increase the likelihood of their being performed" (152). So making socially important activities gratifying, physically and emotionally, is what art is for (152). This is the core of Dissanayake's theoretical understanding and thus of her understanding of art.

"Making special" is a species of the genus of human behavior. Art is a species of the genus of behavior that makes special, the manufacture or expression of the universal human propensity to make selected objects and activities special so as to make "socially important activities" special, thus increasing the likelihood of certain other performances or behaviors. I propose a somewhat more ramified definition: art is creating, making, or doing things beautifully, where "beauty" (as will be explained in the following chapter) is attracting and retaining the attention so as to change behavior. (It has already changed behavior by the fact that we pay attention alone.)

Defining "religion"

The critical analyst of religion and religious studies, Jonathan Z. Smith, has insisted that one of the basic rules of teaching an introductory religious studies course is, "always begin with the question of definition, and return to it" (in Lehrich 2013, 3). He has also said,

> there is no more pathetic spectacle in all of academia than the endless citation of the little list of 50 odd definitions of religion from James Leuba's *Psychology of Religion* in introductory textbooks as proof that religion is beyond definition, that it is fundamentally a *mysterium*. Nonsense! We created it and … we must take responsibility for it.
> (In Lehrich, 80, originally in *Soundings* 61, no. 1 (1988): 231–244)

Smith's point, frequently cited by subsequent scholars,[5] is that "religion is solely the creation of the scholar's study. … Religion has no independent existence apart from the Academy" (1982, *xi*). However, this must be considered very carefully. The *classification* "religion" may be a creation of the scholar's study. The class or category referenced by the word "religion," may have no independent existence apart from the academy, but the objects and behaviors in the world subsumed by the category *are* real, and classifying them as "religious" does not necessitate any specific assumptions concerning their significance. While Smith rightly insisted that "'religion' is not a native term; it is a term created by scholars" (1982, xi) when he repeated that claim 16 years later, he went on to say that it "plays the same role in establishing a disciplinary horizon that a concept such as 'language' plays in linguistics or 'culture' plays in anthropology" (1998, 269). Language and culture *as categories or taxons* are constituted as they are, as classes, by scholarly activity. The classes nonetheless contain real objects and real behaviors, and so does "religion"—without assuming any necessary truth-value to claims made within the class. That is, accepting that "religion" refers to a specific class of real objects and behaviors, which includes, say, the Buddhist claim that Siddhartha belongs to a class of fully enlightened beings, or the Christian claim that Jesus is God Incarnate, in no way necessitates any specific assumptions concerning the nature of those specific claims.

That said; let us remain mindful that attempts to define religion are attempts to define the symbol, "religion." As Smith indicates, Leuba's *Psychology of Religion*,[6] suggests some 50 definitions of religion, none of which were without significant problems. Definitions did not cease to appear after that date but proliferated, with no greater success. By 1962 another Smith, Wilfred Cantwell Smith, proposed that finally, perhaps,

> the sustained inability to clarify what the word "religion" signifies, in itself suggests that the term ought to be dropped; that it is a distorted concept not really corresponding to anything definite or distinctive in the objective world. The phenomena we call religious undoubtedly exist. Yet perhaps the notion that they constitute in themselves some distinctive entity is an unwarranted analysis.
>
> (17)

Nonetheless, Smith (W.C.) goes on to say that this is too extreme a conclusion, and

> an alternative suggestion could be that a failure to agree on definitions of religion may well stem from the quality of the material. For what a man thinks about religion is central to what he thinks about life and the universe as a whole. The meaning that one ascribes to the term is a key to the meaning that one finds in existence.
>
> (18)

This may be one of the reasons that, as John Lyden points out, "we have a tendency to limit what we view as religion to that which is recognized as such by us in our own culture" (Lyden 2003, 2). However,

> one cannot generalize about religion on the basis of the language and norms of just a single case, just as geologists do not construct a geology on the basis of the rocks that merely happen to be in one's neighborhood. The neighborhood rocks, analogues to one's own local religion, are themselves instances of certain common, universal properties.
>
> (William Paden 2005, 208)

Despite his misgivings in 1962, Wilfred Cantwell Smith did not drop the term, "religion." His penultimate monograph, *Towards a World Theology: Faith and the Comparative History of Religion* (1981) used the term it in its title. However, scholars were now alerted to the problematic nature of the definition of religion, and it was arguably in response to this that Ninian Smart began the attempt to resolve the difficulties of definitions of religion that were "minimalist" (excluding too many traditions that scholars recognized as religions) or "maximalist" (admitting too much that was not) by identifying the religious by its component "dimensions." Smart was a student of philosophy

under J. L. Austin at Queen's College, Oxford, and author of over 23 books on religion. He first published a significant book on religion, *Reasons and Faiths*, in 1958 and was president of the American Academy of Religion in 2000, and his analysis is significant. He first attempted to delineate religion in six dimensions; those of Ritual, Mythology, Doctrine, Ethics, Society, and Experience (1969, 15–25). In *The World's Religions* in 1989 Smart introduced a seventh "material" dimension and used the term "artistic" as synonymous with "material" (1989, 25). In *Dimensions of the Sacred* (1996) Smart continued his elaboration and added another two dimensions, the political and the economic (10). So he added three to his original six, whose titles he expanded to the Practical and Ritual, the Experiential and Emotional, the Narrative or Mythic, the Doctrinal and Philosophical, the Ethical and Legal, and the Social and Institutional (1989, 12–21). The expansion of the experiential dimension into the experiential *and emotional* dimension raises an important point. Experience would normally be seen as a datum. An experience *of* an object or event—call it *x*—is either experienced or it is not. An emotion is different. It is the emotion itself *that* one experiences. The emotion may be *in response to x*, certainly. However, the emotion is not simply *of x*. The perception is a sensory experience of an objective presence. The response is an internally determined *reaction* to the perception. One may infer that for Smart the experiential dimension is the combination of sensory perception *and* emotional response. Certainly, in his description of the experiential and emotional dimension in *The World's Religions*, Smart describes what would be considered *responses* rather than perceptions: "awe," "fear," and "feelings aroused by" certain experiences (1989, 13). The "invisible world" to which these dimensions all clearly referred in the earliest work, however, had become severely attenuated in the latter.[7]

Dutton's "cluster concept" and Smart's "dimensional model" avoid some of the difficulties of attempting to state a shorter and more concise intensional definition; however, they also avoid the full elaboration of their own theoretical implications. Dutton does not tell us how his 12 cluster criteria arise or are related. In Smart's case, there is a lack of definition of "the invisible world" to which the religious dimensions refer (and once again here is the as-yet-unexplained implication that material products and manifest behavior induce some kind of "perception of the imperceptible"). In a more recent attempt to return to a concise and categorical, intensional, definition of religion Kevin Schilbrack has suggested that religion is constituted by "normative practices that at least implicitly make ontological claims in terms of which the practical norms are authorized" (2014, 129) and by "practices, beliefs, and institutions that recommend normative paths based on superempirical realities" (135). He goes on to claim that these practices "put people in touch with reality" (151) and later calls religion "forms of life predicated upon the reality of the supernatural," since religious communities "hold that they are in touch with something real" (171). This shares something in common with Smart's dimensional model in that ontological claims about superempirical

or supernatural realities (what Smart calls the mythical, experiential, and doctrinal dimensions) are connected to practices and behaviors deemed to be normative (Smart's ritual, ethical, and social dimensions). None of this requires that religious truth be synonymous with historical accuracy ("make overt assertions of fact"), because claims to ontology can still be used to warrant normative practices, even if those claims prove physically inaccurate.

We can share these glimpses of the behemoth in the mist, but as one characteristic comes to light it casts a new shadow, threatening to obscure further insight. Art may be a case of making special, but what are the specific characteristics of such specialness? Are they physically instantiated in the special item in some way? Or only in the response to it? Ritual may be felt to give access to an invisible world, or to superempirical realities, but how? What does this mean? The demonstration of skill may be deeply moving and pleasurable, but why, when the employment of that skill has no practical value? Can these and the host of related questions be answered?

Redefining religion

Certainly none of the above implies that either art or religion is indefinable. As J. Z. Smith (1938–2017) said, religion is not a *mysterium*, and neither is art. We must take responsibility for our use of the terms. The fact is that there is currently considerable confusion and therefore considerable room for improvement and freedom to make that improvement. Given the above discussion of the definition of art and of religion, and the uses to which these verbal and written symbols have been put, I would suggest that the "ethological" approach taken to art can be productively applied to religion and now is the time to do so.

By identifying the referents of any given term as members of a known genus and by further identifying them as distinct from other species of the same genus, one can effectively define the term. If both art and religion are to be seen as members of the genus of human behavior, then defining them requires an explanation that differentiates these behaviors from one another and from other non-religious and non-art behaviors. Dissanayake's ethology of art requires that art is a species of the genus of human behavior, further specified as expressing the tendency to "make special," yet further specified as making special in such a way as to (1) make socially important activities gratifying, (2) reflect the natural world, (3) function therapeutically, (4) allow unself-conscious experience, (5) train our perception and prepare us for the unfamiliar, (6) assist in giving order to the world, (7) provide a sense of new possibilities and encourage adaptive behavior, and (8) provide a sense of meaning. This specific kind of "specialness" is the concept that is categorical for Dissanayake's understanding of art. Given its complexity, we might expect that this particular *type* of specialness could be further specified. I propose that the term "beauty" be used to refer to the specific type of "art-specialness" (bearing in mind that this requires that the term "beauty"

must itself be redefined appropriately, as I will in the following chapter). This will require some modification of Dissanayake's list of functions as some of them apply more appropriately to religion than to art.

In *Beauty Restored*, a significant work on philosophical aesthetics, Mary Mothersill argued that all alternatives for the definitive characteristic of art, such as merit, value, salience, or institutional recognition, "must actually function *logically* as synonyms for beauty … the concept of beauty (or its synonyms) is indispensable, because there is a particular complex capacity, that of taking various items to be beautiful, which is central to our form of life" (Mothersill 1984, 277, 271, quoted in Martin, 173). Following Mothersill, American philosopher of religion, James Alfred Martin, argued that, *beauty* is the categorical concept for the definition of art (that is, the *differentia* that distinguishes art behavior from other members of the genus of human behavior). Beauty is the specific type of specialness that distinguishes art from other forms of behavior, but note that the particular complex capacity involved is that of *taking* something to be beautiful. It is an attribution or ascription.

If religion is also most appropriately viewed as belonging to the genus of human behavior, then, in order to comprehend, define, and distinguish religion adequately I must propose a *differentia* that distinguishes *religious* behavior from non-religious behavior—from drama or politics, for example. The *differentia* that is often proposed, because it appears to be most specific to religious behavior, is that of response to "the sacred." Just as governing human societies constitutes the *differentia* that distinguishes politics as species of human behavior, so the response to the sacred constitutes the *differentia* that distinguishes religious behavior. No doubt any attempt to employ the term "sacred" in the study of religion will meet with vigorous resistance from some quarters because of apparently insuperable difficulties that it has in the past generated: either the concept of the sacred is simply vacuous, leading to a viciously circular and thus meaningless definition; or it is ineluctably theological, permitting the hegemony of local and ethnocentric "revelations" of the sacred and leading to inaccurate and self-serving definition; or it introduces a "supernatural" understanding that obviates any possibility of a natural and empirical understanding of religion. If we do not articulate precisely what "the sacred" is so as to avoid these difficulties, there is no point in attempting to define religion this way. The involvement of the sacred as *differentia*, when it is conceived of either as viciously circular or as a supernatural entity, has long been a problem for the religion academy. However, if "the sacred" can also be defined by genus and difference in a way that is neither circular nor "supernatural," real progress could be made. If a proposed concept of the sacred, such as I will elaborate in Chapter 6, can avoid such problems it would hold out the best promise of a natural understanding of religion without obscurantism, without prejudice or provincialism, and without emptying the term of meaning. It could constitute adequate and academically viable *differentia* for religion.[8]

In her 2009 volume, *Religious Experience Reconsidered*, Ann Taves followed Émile Durkheim's well-known definition of a religion as "a unified system of beliefs and practices relative to sacred things, that is, things set apart and forbidden" (Durkheim 1912/1995, 44). Taves "simplifies and clarifies" Durkheim's reference to "sacred things" by using "specialness as a generic ascription" (Taves 26), recommending that we can

> refer simply to things that are more or less special, things that are understood to be singular, and things that people set apart and protect with prohibitions ... we can use the idea of "specialness" to identify a set of things that includes much of what people have in mind when they refer to things as "sacred," "magical," "mystical," "superstitious," "spiritual," and/or "religious."
>
> (27)

One of the things that this specifically *religious* "specialness" involves is the recognition of "where value is or ought to be placed in relation to concrete objects, relationships, and abstractions" (29). At the time of the publication of the volume, Taves was unaware of Dissanayake's work. Nonetheless, just as "making special" becomes definitive of art behavior for Dissanayake, so "special things" become definitive of religious behavior for Taves.

As we have seen, James Alfred Martin identifies beauty as the specific type of specialness that distinguishes art from other forms of behavior. He also argues that holiness or the sacred is the categorical concept for the definition of religion (that is, the *differentia* that distinguishes religious behavior from other members of the genus of human behavior). Following this suggestion, "beauty" can be used to refer to the apperception of the "special" in art, and "the sacred" or "sacrality" for the apperception of the "special" in religion.

In the ethology of art and in Taves' *Religious Experience Reconsidered*, the specialness of both art and religion is an *apperceived, attributed*, or *ascribed* characteristic rather than an objective characteristic of material objects. "The sacred" and "beauty" are characteristics that we ascribe to certain phenomena, and the "specific human ability or tendency" to ascribe both beauty and sacrality can be seen to be something "that genes could transmit and environments could act upon," a "genetically mediated tendency ... to feel positive about certain things in preference to others" (Dissanayake 1988, 27). But what is the difference between beauty and the sacred? What is it that we are ascribing to these phenomena? What is it that we think that we are "seeing" in beautiful or sacred things? How do we respond to our own ascription, and why do we respond in this way? Do "beautiful" or "sacred" things have any consistent *objective* characteristics? How could such a cognitive tendency have contributed to survival and reproduction?

If religion can be defined as belonging to the genus of human behavior, to the subset of "making special," and to the more specific subset of the

attribution of sacrality (as distinct from beauty), a working theoretical defi-
nition could be adduced. I propose that it can be. Attribution of the special
can be differentiated as an apprehension of vital but ineffable virtue, worth,
importance, salience, and significance such that people are drawn to cultivate
this experience and to organize their lives and actions with reference and in
response to the experience. When an experience makes us stop and focus
upon it, and focus our ensuing behavior around it, when it makes us value it
and want it, venerate it and protect it, retain it, cultivate it, exchange mate-
rial resources for it, and repeat our experience of it—in short, to adore it or
worship it—then "the sacred" is present and active and the behavior is reli-
gious. It challenges our freedom by determining our response. This "sacred"
may dominate and control, but we experience it as *worthy* of such responses
(it is notable that "worthy" is the Old English root of the word "worship").
This sacred, like Smart's experiential and emotional dimension, necessarily
involves an objectively experienced reality and a subjectively experienced
emotional reaction to it.

If we analyze the sacred in terms of items and events that solicit such a
reaction and recognize that art becomes sacred art when we begin to wor-
ship it, and that worship involves paying close and sustained attention to
objects, acts, or events; concerning oneself intensely with them, cultivating
that concern, directing others to pay attention to the same objects, learning
from one's interaction with them, and looking to them for meaning and es-
pecially for guidance, then this allows the use of the term "sacred" without
the pitfalls of supernaturalism, circularity, or obfuscation. The term can be
granted meaning without necessarily assenting to any specific tradition of
"supernatural" revelation, "without implying anything about 'The Sacred'
as a metaphysical referent," as Paden puts it (208). That is, without assuming
any "supernatural" implications. This can be expressed as a modification to
Schilbrack's aforementioned definition. Religion consists of practices, beliefs,
and institutions that generate normative paths based on reactions to special
realities; forms of life predicated upon the special, where "special" is synon-
ymous with "sacred" without any "supernatural" or "superempirical" impli-
cations, simply allowing that these realities are apprehended as special enough
to warrant the persistent performance of the associated practices, that is, they
induce a sense of assurance in persistent behavior. Religion is a pattern of
persistent behavior induced by an extended matrix of "artified" experiences
so as to perpetuate and propagate those experiences. When organized by such
an extended matrix into persistent and self-protective patterns, the beautiful
becomes the sacred.

Absorbing the insights of the ethology of art allows us to redefine religion
in such a way that it is seen as persistent behavior motivated by experiences of
"special" sacred experiences (that is, experiences of both objects and events)
that involves a class of cognitions concerning the normativity of future be-
havior (thus answering questions characteristic of divination), and thus de-
termining future behavior. Such a complex of persistent behavior could be

immensely useful and beneficial when used with skill. Like all such behaviors, it is capable of manifesting pathologies, such as obsessive persistence and megalomaniacal self-righteousness. However, under normal circumstances, persistence and confident assurance are adaptive rather than maladaptive behaviors, and they answer the question of the contribution of such behavior to survival and reproduction. Not only do they contribute positively to the technical achievements of human societies, but they are also highly effective in mate selection. The stimulation of such behavior cannot be dismissed as nothing, or as a mere creation of scholars, a discursive formation and nothing more, nor can it be protected behind a curtain of supernaturalist obfuscation—it is real and it remains entirely natural. It can be further studied and understood and refined.

No doubt this approach requires further refinement. The question remains of maintaining an adequate distinction between religion and art and the wide variety of other behaviors involving a persistent response to experiences perceived as special, such as sport and play. The historical inspection of religious behavior indicates that there is a determinate relation between these categories of behavior, which have only relatively recently emerged as distinct. Such difficulties are only to be expected in the early stages of a novel approach and may be resolved by a sort of "cladistics" of the sacred. Cladistics (from Greek κλάδος, "branch") is an approach to biological classification in which organisms are categorized based on shared derived characteristics that can be traced to a group's most recent common ancestor. As we have seen, both art and religion can be seen to be subsets of the genus of a behavior of "making special." So religion and art, and sport and play, form a clade or group of related behaviors descended from a common behavioral trait of cognitive fascination, experienced as a perceived attraction (comparable to sexual attraction), to objects and events experienced as "special," that is, salient for no readily apparent practical reason but which thus encourage specific behavioral responses in a way that has allowed these traits to become hereditary. "The sacred" or, better, sacrality, would be a subset of "specialness" that is more compelling than "beauty" because it involves the *composite* ascriptions of specialness as identified by Taves (2009, 46–48), organized into an extended matrix of related and reciprocally reinforcing sacred objects and activities that are productive of particularly persistent patterns of behavior.

If this approach is to avoid the fate of earlier would-be evolutionary theories of religion—that is, to avoid becoming nothing more than an inappropriate analogy—then these behaviors and the cognitive ascriptions associated with them all need to be more closely studied and more precisely defined. This has certain specific implications for the relationship of, and distinction between, religion and art that will have to be teased out gradually in the following chapters. First I need to move to a more detailed consideration of the concepts of beauty and the sacred as categorical concepts in the understanding of both art and religion.

Notes

1 Recent discussions of the problems of definition in the study of religion can be found in Schaffalitzky de Muckadell (2014) and Hanegraaff (2016).
2 The *intension* of a term—not to be confused with intention—is the sum of properties or characteristics connoted by that term, whereas its *extension* is the set of all entities to which the term might be correctly applied.
3 Alexander Baumgarten, *Aesthetica*, 1750, §1: "Aesthetices finis est perfectio cognitionis sensitivae." See Baumgarten (2013).
4 "David Mandel (1967) suggests that art museums or concert halls might be called spiritual gymnasia where people stretch and develop their consciousness on works of art" (Dissanayake 1988, 67). Marcia Brennan (2010) characterizes the modern art museum as a place of mystical experience.
5 For example, it is quoted by William Arnal and Willi Braun (2012: 237) and by Darlene Jushka in the same volume (51). A later form (from Smith 1998) is used by Johannes Wolfart (ibid. 106).
6 Actually, *A Psychological Study of Religion, Its Origin, Function, and Future*, first published in 1912, New York: Macmillan.
7 For a more detailed discussion of Smart's dimensions and their reference to an invisible world, see Rennie (1999).
8 It would also settle the "*sui generis*" controversy: all entities that are defined by genus and difference are defined as a species of a higher genus, which species then becomes the genus of its own members and thus *sui generis*. On the *Sui Generis* controversy in the study of religion, see Rennie (2014).

References

Arnal, William, Willi Braun and Russell McCutcheon, eds. *Failure and Nerve in the Academic Study of Religion*. Sheffield, UK and Bristol, CT: Equinox Publishing, 2012.

Atran, Scott. "The Cognitive and Evolutionary Roots of Religion." In *Where God and Science Meet: How Brain and Evolutionary Studies Alter Our Understanding of Religion*, edited by Patrick McNamara, vol. 1, 181–207. Westport, CT: Praeger Publishers, 2006.

Baumgarten, Alexander. *Metaphysics. A Critical Translation with Kant's Elucidations, Selected Notes, and Related Materials*. Translated and edited by Courtney D. Fugate and John Hymers. London and New York: Bloomsbury Publishing, 2013.

Berger, Peter. *The Sacred Canopy*. New York: Doubleday, 1967.

Boyer, Pascal. *The Naturalness of Religious Ideas: A Cognitive Theory of Religion*. Berkley: University of California Press, 1994.

Boyer, Pascal. *Religion Explained: The Evolutionary Origins of Religious Thought*. New York: Basic Books, 2001.

Brennan, Marcia. *Curating Consciousness: Mysticism and the Modern Museum*. Cambridge, MA: MIT Press, 2010.

Collingwood, Robin G. *The Principles of Art*. Oxford, UK: Clarendon Press, 1938.

Copi, Irving M., Carl Cohen, and Kenneth MacMahon. *Introduction to Logic*, 14th ed. London: Routledge, 2011.

Dissanayake, Ellen. *What Is Art For?* Seattle: University of Washington Press, 1988.

Dutton, Denis. *The Art Instinct: Beauty, Pleasure, and Human Evolution*. New York, Berlin, and London: Bloomsbury Press, 2009.

Elkins, James. *On the Strange Place of Religion in Contemporary Art*. New York: Routledge, 2004.

Gell, Alfred. *Art and Agency: An Anthropological Theory.* Oxford, UK: Oxford University Press, 1998.

Guthrie, Stewart. *Faces in the Clouds: A New Theory of Religion.* Oxford, UK: Oxford University Press, 1993.

Hanegraaff, Wouter. "Reconstructing 'Religion' from the Bottom Up." *Numen* 63, nos. 5–6 (2016): 577–606.

Hirn, Yrjö. *The Sacred Shrine: A Study of the Poetry and Art of the Catholic Church.* Boston, MA: Beacon, 1912.

Kierkegaard, Søren. *Of the Difference between a Genius and an Apostle.* Translated by Alexander Dru. New York: Harper Torchbooks, 1940.

Lawson, E. Thomas and Robert McCauley. *Rethinking Religion: Connecting Cognition and Culture.* Cambridge, UK: Cambridge University Press, 1990.

Lehrich, Christopher, ed. *On Teaching Religion: Essays by Jonathan Z. Smith.* New York: Oxford University Press, 2013.

Leuba, James. *A Psychological Study of Religion, Its Origin, Function, and Future.* New York: Macmillan, 1912. Luhmann, Niklas. *Art as a Social System.* Stanford, CA: Stanford University Press, 2000.

Lyden, John. *Film as Religion: Myths, Morals, and Rituals.* New York: New York University Press, 2003.

Mandel, David. *Changing Art, Changing Man.* New York: Horizon Press, 1967.

Martin, James Alfred. *Beauty and Holiness: The Dialogue between Aesthetics and Religion.* Princeton, NJ: Princeton University Press, 1990.

McGilchrist, Iain. *The Master and His Emissary: The Divided Brain and the Making of the Western World.* New Haven, CT and London: Yale University Press, 2009.

Miller, Geoffrey. "Sexual Selection for Cultural Displays." In *The Evolution of Culture: An Interdisciplinary View,* edited by Robin Dunbar, Chris Knight, and Camilla Power, 71–91. Edinburgh, UK: Edinburgh University Press, 1999.

Miller, Geoffrey. "Evolution of Human Music through Sexual Selection." In *The Origins of Music,* edited by Nils L. Wallin, Björn Merker, and Steven Brown, 329–360. Cambridge, MA: MIT Press, 2000a.

Miller, Geoffrey. *The Mating Mind: How Sexual Choice Shaped the Evolution of Human Nature.* New York: Doubleday, 2000b.

Miller, Geoffrey. "Aesthetic Fitness: How Sexual Selection Shaped Artistic Virtuosity as a Fitness Indicator and Aesthetic Preferences as Mate Choice Criteria." *Bulletin of Psychology and the Arts* 2, no. 1 (2001): 20–25.

Miller, Geoffrey. "Sexual Selection for Moral Virtues." *Quarterly Review of Biology* 82, no. 2 (2007): 97–125.

Mithen, Steven J. *The Singing Neanderthals: The Origins of Music, Language, Mind, and Body.* London: Weidenfeld and Nicholson, 2005.

Mothersill, Mary. *Beauty Restored.* Oxford, UK: Clarendon Press, 1984. Reprinted New York: Adams, Bannister, Cox, 1991.

Paden, William. "Comparative Religion." In *The Routledge Companion to the Study of Religion,* edited by John Hinnells, 208–225. London: Routledge, 2005.

Poe, Edgar Allen. "The Poetic Principle." *The Home Journal,* 238, no. 36 (1850): 1–6.

Rennie, Bryan. "The View of the Invisible World: An Elaboration on Ninian Smart's Analysis of the Dimensions of Religion and of Religious Experience." *The Bulletin of the Council of Societies for the Study of Religion* 28, no. 3 (1999): 63–68.

Rennie, Bryan. "The *Religio non est sui generis* Confession: Once more unto the Religious Studies/Theology Divide." *The Toronto Journal of Theology* 30, no. 1 (2014): 101–110.

Schaffalitzky de Muckadell, Caroline. "On Essentialism and Real Definitions of Religion." *Journal of the American Academy of Religion* 82, no. 2 (2014): 495–520.

Schilbrack, Kevin. *Philosophy and the Study of Religion: A Manifesto*. Chichester, UK: Wiley-Blackwell, 2014.

Schleiermacher, Friedrich. *On Religion: Speeches to its Cultured Despisers*. Translated by John Oman, with an introduction by Rudolf Otto. New York: Harper, 1958.

Smart, Ninian. *Reasons and Faiths: An Investigation of Religious Discourse*. London: Routledge & Paul, 1958.

Smart, Ninian. *The Religious Experience of Mankind*. New York: Charles Scribner's Sons, 1969.

Smart, Ninian. *The World's Religions*. New York: Cambridge University Press, 1989.

Smart, Ninian. "Theravada Buddhism and the Definition of Religion." In *The Notion of* Religion *in Comparative Research: Selected Proceedings of the XVIth Congress of the International Association for the History of Religions*, edited by Ugo Bianchi, 603–606. Rome: "L'Erma" di Bretschneider, 1994.

Smart, Ninian. *Dimensions of the Sacred: An Anatomy of the World's Beliefs*. Berkeley and Los Angeles, CA: University of California Press, 1996a.

Smart, Ninian. *The Religious Experience*, 5th ed. Upper Saddle River, NJ: Prentice Hall, 1996b.

Smith, Jonathan Z., *Imagining Religion: From Babylon to Jonestown*. Chicago, IL: University of Chicago Press, 1982.

Smith, Jonathan Z. "Religion, Religions, Religious" In *Critical Terms for Religious Studies*, edited by Mark C. Taylor, 269–284. Chicago, IL: University of Chicago Press, 1998.

Smith, Wilfred Cantwell. *The Meaning and End of Religion*. New York: Macmillan Company, 1962.

Smith, Wilfred Cantwell. *Towards a World Theology: Faith and the Comparative History of Religion*. Maryknoll, NY: Orbis Books, 1989.

Taves, Ann. *Religious Experience Reconsidered: A Building-Block Approach to the Study of Religion and other Special Things*. Princeton, NJ and Oxford, UK: Princeton University Press, 2009.

van der Leeuw, Gerardus. *Sacred and Profane Beauty: The Holy in Art*. New York: Oxford University Press, 2006.

Wilson, David Sloan. *Darwin's Cathedral: Evolution, Religion and the Nature of Society*. Chicago, IL: University of Chicago Press, 2002.

5 Beauty and religion. Seeing the world better[1]

> The real value of such a work of art will lie in its new song, for more important than all these will be the new thing that the artist has brought out of the void, something which, previously, did not exist.
>
> (Giorgio de Chirico, *Éluard-Picasso Manuscripts*, 1911–1915, Fonds Picasso, Musée National Picasso, Paris)

Beauty as the special in art

The goal of this chapter is to provide the reader with a sense of the relation of, and the distinction between, art and religious tradition through a consideration of beauty as the "special" in art. Although beauty is a fraught and, some would argue, outdated concept, it has long been closely associated with art and still, as I will demonstrate, has its uses. Further considering the operation of beauty in religion allows a closer description of the "specific human ability or tendency that genes could transmit and environments could act upon" that we seek in order to distinguish religion from other species in the genre of "making special." The number and significance of the cohabitations of beautiful art and religion are impossible to exaggerate. To give just a few, more-or-less random, examples, the Egyptian Pharaohs of the eighteenth dynasty (1539–1514 BCE), which included Amenhotep, Nefertiti, and Tutankhamen, used the beautiful art of their culture "in the service of religion and the state" (Freed 1999, 110). Magnificent temples and cathedrals have been built in honor of the gods from the sacred Eanna precinct in Uruk—possibly the first human city dating from approximately 3,000 BCE, which was of "extraordinary grandeur and technical accomplishment" (Liverani 2006, 2). The Spanish architect Antoni Gaudí's (1852–1926) Sagrada Familia church is under construction in Barcelona to this day. Statues from Gandharan Buddhas to Renaissance pietàs are also examples of beauty in the service of religion. Beautiful music has been performed in connection with religion, from Hindu and Sikh kirtans and Muslim Qawwali to European choral masses. Visual arts range from Tibetan Buddhist sand mandalas to Bahá'i floral gardens, and dances range from Bharatanatyam temple dancing to Native American Fancy Dancing. There are also South African basketwork, Polynesian moko

tattooing, and a host of originally sacred sporting activities from the ancient Olympics to Native American stickball. Other examples include architecture, statuary, music and song, dance, painting, gardening, cooking, basket-weaving, clothing and other bodily adornment, and the attribution of religious associations to sites of natural beauty—the list could go on forever. There is no known art or ability that has not been used to produce objects or events of compelling beauty that have been associated with religions. Unfortunately, the relationship of art and religion remains under-theorized with the cognitive science of religion neglecting its counterpart, the ethology of art, and failing to recognize the potential of using cognitive approaches to art in the study of religion. Thus there is as yet no accepted theory that might explain either that relationship or the repeated claims to "express the inexpressible" and "make visible the invisible" in such a way as to provide a compelling sense of how to think about the role of beauty in respect of religion.

In the literature on beauty, there is little in the way of satisfactory descriptions, much less explanations, of the operation of beauty in religion, although there are frequent observations concerning it. As has been remarked, the most common observation concerning art and religion is that art enables vision of the invisible. This most often occurs as some form of the statement made by Friedrich Schelling (1775–1854) in his *System of Transcendental Idealism*, that "the infinite finitely displayed is beauty" (1880, 225). This refrain has been persistently adopted and repeated in some modified form or other. In general, there is an agreement that the beautiful gives perceptible form to the imperceptible, revealing "the unseen through the seen," allowing us to "hold the unholdable" or "say the unsayable" (Brennan 2010, 7, 5, 23). This might be taken in the simple sense, in which, for example, angels may be thought to be invisible, but if one looks at Gustave Doré's breathtaking illustrations of Dante's *Divina Commedia*, one can now see these invisible beings. That, however, does not "express the infinite," and so forth. How beauty succeeds (or is thought to succeed) in expressing the infinite, and what it actually *means* to say that beauty allows the invisible to be seen or enables the perception of that which is imperceptible, is now something that might be explained via a combination of cognitive science of religion and ethology of art, rather than leaving it to the vagaries of poetic suggestion. While we must never underestimate the importance of poetic suggestion, the problem is that one may or may not "get it." That is, such suggestion does not communicate a sense of how to understand the role of art in religious tradition but relies on the invocation of some such already-existing sense.

A significant part of the problem of relating art and religion has come about because, since the advent of modern scholarship from the 16th century onward, the most substantial consideration of beauty has been in the realm of aesthetics. Philosophical aesthetics focuses on humanly produced examples of the beautiful and on those examples valued for public display in galleries and museums. It thus relies almost entirely on the "institutional" understanding

of art so roundly rejected by the ethologists of art. One effect of this focus on "gallery art" was to see the art piece as an individual and autonomous entity, a single separable item that is beautiful to a greater or lesser degree entirely in its own right. This seems to have been an effect compounded out of the development of accurate principles of perspective in the Italian Renaissance and the concurrent commodification of art. Two-dimensional painting in Europe developed under the pressure of competition for patronage. Painters—initially working on walls and permanent surfaces to decorate and enhance already existing structures—sought to bring greater impact and presence to their work to win greater acclaim—and more commissions. Between the time of the Italian Renaissance artists Duccio di Buoninsegna (c. 1255 to c. 1319) and Giotto di Bondone (c. 1266–1337), Italian painters show a movement toward a singular perspective in their work that added power and presence to their images (Dixon 1984, 277–296).

However, not until Filippo Brunelleschi (1377–1446), one of the foremost architects and engineers of the Italian Renaissance and an accomplished sculptor, helped formalize the rules of perspective could truly compelling images of three-dimensional objects be once again rendered in the two-dimensional plane as they had by the quasi-legendary artists of the ancient world. This led to significant developments in the history of art that changed the way that art and beauty were conceived in Europe. Painting has only recently become the exemplary art form, but now, most nonspecialists questioned about art will generally respond specifically in terms of painting and one can see that even some specialist use "art" as synonymous with "painting."

Instead of being done almost exclusively on walls and ceilings, paintings were from then on more often done on portable panels or canvases that could be moved from place to place; bought and sold; and hung in homes, salons, and galleries. The development of perspective and the tendency to see painting as the most exemplary of the arts contributed to the commodification of art, to the development of "gallery art," and to the modern understanding of art as the autonomous and self-sufficient production of independent pieces of "art" of immense value to the wealthy. As mentioned in the preceding chapter, the doctrine of "art for art's sake" was not a classical concept and was not adopted until the 19th century. This conviction that art serves no purpose other than aesthetic gratification, that it *must* serve no purpose other than to exist as art, accompanied the concept that a single, individual, and autonomous entity, the art piece, displayed beauty in and of itself—that it was beautiful by itself because of inherent physical properties, which the properly cultivated viewer could recognize. This deflects consideration of any possible practical function of beauty. It relegates the complex and cumulative nature of the recognition of beauty to a position subordinate to formal properties, and it eliminates the consideration of popular "folk" art. Art does not, however, work in isolation; art functions because its expressions "cooperate synergistically with one another" (Gell 1998, 163). It is only modern "gallery art" that, generally speaking, seeks to be secular, that is, deliberately

Figure 5.1 The development of perspective. From left: *The Feeding of the Five Thousand* (c. 1220) from an English prayerbook; *The Entry into Jerusalem* by Giotto (1305—Arena Chapel, Padua); *The Entry into Jerusalem* by Duccio (1308–1311—Siena, Opera del Duomo); *The Supper at Emmaus* by Caravaggio (1601—National Gallery, London).

non-religious (Glassie 1989, 128–129). Folk art does not, and it is of immense importance to any ethological study of the category.

The choice of examples of any property under investigation predetermines the outcome of the investigation. This is the problem of ostensive definition. What one chooses to pay attention to determines what one sees, and the choice to focus upon extremely specialized artful products of human contrivance as the prime exemplar of beauty, seen as independent, inherently beautiful, and serving no practical function, has contributed to the confused and inadequate understanding of art and of art's relation to religion in the contemporary world. The history of philosophical aesthetics is long, complex, and unresolved and cannot be considered in detail in this context. However, concerning philosophical aesthetics two things must be borne in mind. First, even here, the beautiful is variably susceptible to cultural influence. That is, one has to be appropriately acculturated to acquire the appropriate skill of reception, properly to appreciate the beauty of modern jazz, Italian opera, Indian ragas, or Japanese koto music. To the uninitiated, on first exposure such forms may seem profoundly odd and even dissonant. Conversely, the beauty of large-scale architecture, from Aztec pyramids to Zoroastrian fire temples, seems universally obvious. Second, beauty in this sense was not thought to be the primary distinguishing feature of art until the 18th century. Difficulties in aesthetic theory arising from observations that such beauty is not essential to art, and that the perception of beauty is culturally conditioned, has contributed to a significant diminution of the consideration of beauty in contemporary Western theories of art.

A large part of the problem is the widespread misconception of beauty simply as the pleasant or sensually enjoyable and, to a lesser extent, as visual. The unwarranted emphasis on the visual should be easily overcome. It is evident on a moment's reflection that beauty is experienced in many other ways. Nonetheless, the tendency to see painting as the exemplary art form reinforces the primacy of the visual (as does the ease with which visual examples can be given in a book such as this). More resistant is the tendency to conceive of beauty as immediately pleasant. The Christian theologian and saint, Thomas Aquinas (1225–1274), in his *Summa Theologiae*, was of the opinion that "beauty is that which gives pleasure in the very act of being perceived" (II, 27), and this remains a common (mis)understanding. Such usage yields a concept that is finally inadequate in aesthetic theory. The word is, in fact, used this way and the actual use of a word determines its "dictionary," or lexical definition. So it is not *incorrect* to define beauty this way, but this, the most popular and most easily glossed use of the term, is also the most oversimplified and inadequate. Words are amenable to varying degrees of specification and the outer shell of popular usage can contain more specialized meanings so that what is apparently a single word functions as a series of nested homonyms: a single name signifying a series of alternatives in different contexts. This makes such terms difficult to define because they have a variable spectrum of meaning. However, a definition of beauty may be proposed,

recognizing that the target here is beauty as the special in the proposed ethological understanding of art (and of religion), and that the word can and does have other referents.

Characteristics of beauty such as grandeur, being overwhelming or stunning—even brilliance or radiance—spill into areas other than the pleasant (that which shines too brightly is blinding). Other-than-pleasant senses of beauty abound (especially in relation to religion) and must be taken into account. The Austrian poet and novelist, Rainer Maria Rilke (1875–1926), said "beauty is nothing but the beginning of terror, which we still are just able to endure, and we are so awed because it serenely disdains to annihilate us" (*Duino Elegies*, 1). In a thoroughgoing consideration of beauty, any one-sided consideration of beauty as primarily visual, simply pleasurable, and physically inherent in objects must give way to recognition of greater ambivalence and complexity. In specific relation to religion, this is consistent with the analysis of the German Lutheran theologian, Rudolf Otto (1868–1937), who characterized "the Holy" as the *mysterium tremendum et fascinans*, "the mystery that is both terrifying and fascinating." In his impressive work on the beauty of the Qur'an, German scholar Navid Kermani insists on reintegrating the *tremendum* and the *fascinans* in his analysis of sacred beauty.

In his work on *Beauty and Holiness* (1990), James Alfred Martin, following Mary Mothersill, argues that the separation of the beautiful from the "sublime," proclaimed by the German philosopher Immanuel Kant (1724–1804), promoted an oversimplified and misleading understanding of beauty as simply pleasant, separating it from the awesome and the terrifying. The characteristics of the sublime proposed by Kant fall under the concept of beauty as described by Rilke, Kermani, and Martin: agreeable terror, negative pleasures, the awe-inspiring, melancholic, and tempestuous. The compellingly strange, amazing, uncanny, and the eerie also fall under that rubric. Ultimately, any claim that phenomena that are not pleasant cannot be beautiful is simply incorrect. There have been many attempts to find a better term than beauty, but Mothersill argues that all suggested alternatives—aesthetic merit, satisfaction, value, the salient (that which attracts attention), the significant, the sublime, the expressive, or the exotic, and the surprisingly moving—and now we add the "special"—all of these inevitably function as synonyms for beauty, terms that are functionally equivalent to it because they finally signify the same characteristics. The concept of beauty, when its complexity is recognized and it is restored to its full sense including the awesome and occasionally terrifying, is indispensable to any consideration of art. When the synergistic cooperation of related items experienced as beautiful in this way is considered, it is equally indispensable to any consideration of religion, but a comprehensive reconsideration of beauty as the special in art is first required before considering its contribution to religion.

It is common in any consideration of beauty to note that a remarkably wide variety of objects and events can be experienced as beautiful. A person, animal, building, symphony, sunset, dance, fragrance, landscape (actual

or represented), stratagem, belief, idea, mathematical proof, meal, a play in sport, or an automobile all may be experienced as "beautiful." Therefore, the questions arise, what characteristics could such a variety possibly share or all of its members possess? What of the possibility that some of them are not, properly speaking, beautiful at all? Consensus has not been achieved and these remain open questions. One relatively simple initial approach (which cannot be a complete solution, as we will see) is to suggest that beautiful objects and events do not need to share any inherent characteristics if they solicit a common *response* in the viewer. This takes seriously the adage, "beauty is in the eye of the beholder." The way that certain objects and events make us *respond* is what identifies them as beautiful. From this perspective, the task is to analyze the response rather than the characteristics of the perceived object or event. One advantage of initially adopting this approach is that no matter how a given object or event may strike the analyst, the fact that some significant audience responds to it as special is an objective datum. It might be argued that a given object, let's say an impressive pass in football, an automobile, or a religious icon, is not "really" beautiful, but once we identify the common response we cannot deny that certain people do respond as if it were. They ascribe beauty to it. They experience it as special in this particular fashion.

If one temporarily set aside the question of inherent attributes or arrangements of attributes that might be common to an alluring body, the most high god, an eloquent oration, a Caravaggio painting, and a spectacular sunset, and consider instead human responses to these things, one begins with the largest possible set of examples, which provides an initial foundation for the development of a more precise and satisfactory understanding. How *does* one respond to beauty as the special? It is common to speak of the beautiful as attractive (the "comely" makes us come to it). The beautiful engenders love ("loveliness" is that which makes us love). The Greeks considered love the appropriate response to beauty and beauty as that which inspired love. Kermani informs us that the response to the beauty of the Qur'an is love: to love the recitation, to love the prophet, and to love God (15). Beauty exerts intense affect and influence upon us (hence descriptions such as charming, spell-binding, or enchanting for the beautiful). We tend to want to be more like the beautiful object—to be graceful and free and powerful, like natural beauty, or attractive and alluring like the erotically beautiful. We feel affection for the beautiful. We desire to be attractive as the beautiful is attractive, that we might be loved in return as we love, and that we might remain in the presence of the beautiful, of the beloved. However, as we have seen there is more to beauty than the pleasantly attractive: that which is beautiful may be awesome and amazing. It fascinates us, and it attracts and holds our attention. It makes us stop and focus upon it, and focus our behavior around it. It makes us value it and want it, adore it and protect it, retain it, cultivate it, preserve and repeat our experience of it. It challenges our freedom by determining our response. It dominates and controls us to some degree. That is how we

respond to the special in art. It is in terms of items and events that solicit such a response that one can best begin to envision, think about, and analyze beauty and the beautiful. Critics may protest that such an approach extends the category of the beautiful much too widely, embracing a triple play in baseball and the 1964 E-type Jaguar as things of beauty, which, some argue, they are not—such uses of the term are just a weak analogy to true beauty. However, until we have a more adequate intensional definition, how can we claim to know what "true" beauty is? Before we can identify "false positives" (that is, inappropriately responding to things that are not beautiful as if they were), we must establish a more adequate understanding of beauty.

The question of the inherent characteristics of beautiful things cannot be entirely forgotten—eventually one needs to integrate beauty as an objective property with beauty as a subjective response to avoid difficulties that soon become apparent. Aesthetic relativism cuts both ways. It may avoid forcing the scholar's own pre-existing, biased, and unavoidably ethnocentric values onto the object of study and overly narrowing the set of examples, but it appears to force a transfer of values in the opposite direction. For example, must we insist that Padaung women who wear brass rings to elongate their necks really *are* beautiful no matter how their appearance strikes us? Or that soccer really is "the beautiful game"? These questions must be taken seriously.

As we have seen, the attempt to attain an understanding of a class or category by adducing examples that belong to that class, thereby revealing its characteristics, is known as an ostensive or extensional definition, and it suffers from a significant problem. We must identify certain objects or events as exemplary before having any solution to the problem of false positives and everything depends on what one identifies. Example choice determines the outcome of analysis because we necessarily apply some pre-existing, latent understanding of beauty to identify instances of the type. Usually it is the simple test of "does it appear beautiful to me?" or, failing that, have the experts—the artists and gallery owners, the patrons and critics—agreed that this or that item is beautiful? Either criterion can only reinforce the provincial, ethnocentric, and "institutional" concepts of art that are inadequate to an ethological approach. Such extensional or ostensive definition is more effective in "establishing and rendering permanent the errors which are based on vulgar conceptions than for finding out the truth; so that it is more harmful than useful" (as Francis Bacon said of the Aristotelian deductions of the Medieval Schoolmen in *Novum Organum* 1, 12).

In discussing beauty, the ancient Greeks had a marked tendency to choose erotic attraction—the beauty of the comely human, the sensuous allure of other people—as the most obvious example of beauty. It is an easy example to understand, and it can be used to great effect. Most of us are familiar with sexual attraction. Hebrew tradition was familiar with the sense of erotic beauty (usually rendered by *yophee*) and was not immune to the attraction of the nubile body, as the Song of Solomon attests. However, it was the beauty of God as magnificence and splendor (*hadar, no'am*) and the beauty

of holiness (*hadar kodesh*) that is emphasized in Hebrew scripture, and that seems to be quite another thing. It is accompanied by references to the fear of God, particularly the significant epithet of God as "the fear (*pachad*) of Isaac" at Genesis 31:42 and 53. The beauty of God is fearful. The exemplary mode of beauty in the Arabic world has long been the formally structured spoken word or recitation (*qur'an*). Here poetry is regarded as the paradigm of beauty (*hasan*) and especially the "well-formed" (*ahsan*). Kermani points out that some Muslims reserve the term *raw'a* for that beauty (225). *Raw'a*, can be translated as "shiver" in a sense that connotes both pleasure and fear, indicative of a profoundly moving splendor that generates fascination and dread and is better translated "awe." In Chinese aesthetics the beauty of the natural world has been the exemplary mode of the beautiful. Nature, "red in tooth and claw," is, of course, terrifying in its beauty, attested in Hinduism by the figure of Kālī as the sensuous but bloodthirsty mahādevī (every Hindu deva has their *ghora* or terrifying aspect).

Not only might there be true and false attributions of beauty, but it can be subdivided into attractive, terrifying, erotic, sacred, poetic, and natural. Are all of these modes of beauty the same characteristic? Or are they distinct characteristics that solicit a similar response? Certainly, they are all special. The Greek model seems primarily visual, the Hebrew model seems primarily conceptual or narrative, and the Arabic model is a combination of sonorous and semantic. Artistic or poetic beauty involves human skill and contrivance, whereas natural and erotic beauty do not (although they may be represented artistically), and both natural and artistic beauty may or may not be erotic. Considering primarily one specific mode of the perception and reception of beauty will inevitably influence the outcome of any analysis. Considering beauty as primarily a product of human skill will tend to a different analysis than considering beauty as a natural characteristic of bodies, which differ from landscapes. Can we really hope to comprehend beauty in all of its modes as a single category? Certainly not by any aesthetic theory that investigates beauty solely by means of gallery art, which narrows the sample set to something that has been predetermined by a specific culture and so misses crucial examples. Understanding beauty as defined entirely by specific human responses widens the sample set to include all, including potentially "false" responses, and including phenomena that may not be authentically exemplary. Both are forms of ostensive definition that rely on accepting examples already identified as beautiful before making explicit the defining characteristics of beauty.

Something more is needed that might provide a response to the question of the objective characteristics of beauty, identifying and accounting for false positives and explaining the response. That is, a definition is required that gives the meaning of the term by specifying its properties and the conditions required properly to belong to the category, thus permitting an accurate identification of examples. Previously cited developments in cognitive and evolutionary theory applied to the analysis of art, that is, the ethology of art,

contribute to such a definition. Dissanayake defines art as the manufacture or expression of "specialness" to certain functional ends. This broadens the category to include not only primitive art, tribal art, children's art, folk art, psychotic art, naïve art, craft art, outsider art, and self-taught art, but arguably also things such as sports and automobiles, which can certainly be "made special." It can also be understood as investing the "artified" item that is made special with whatever it takes to make people respond to it in the suggested fashion, which is, by definition, to provoke the apprehension or attribution of beauty. In this way, making special as the identifying characteristic of an evolved art behavior can be expressed in terms of beauty. This specific "specialness" is functionally equivalent to beauty: beauty is a name we can give to the characteristics that make anything special in this way: to things that fascinate us and attract and hold our attention, that make us stop and focus upon them, and that focus our behavior around them. We value and want them, adore and protect them, retain, cultivate, preserve, and repeat our experiences of them.

Dissanayake's bioevolutionary approach considers art as a general behavior, rather than starting with specific examples of art, and it considers this behavior as originating in human evolution. Genes determine the behaviors characteristic of every species, including humanity, because, as far as natural selection is concerned, a pattern of behavior is no different than an anatomical structure—inheritance from successful ancestors determine them both. Universal behavioral tendencies in human culture that are an intrinsic and relatively unchanging part of our nature must have arisen and been retained because they contributed positively to survival and reproduction. Any tendency that is seen in all human groups might be presumed to be genetic predispositions. As examples of universal tendencies, Dissanayake suggests the construction of systems that explain and organize the perceived world, the requirement for psychological security, predictability and orientation, the requirement for psychological ratification by a group, bonding with others, the recognition and celebration of the extraordinary, and engaging in play and make-believe (1988, 197). These tendencies do indeed appear universal, and—importantly for my argument—they appear to be as much attributes of religious behavior as of the "art behavior" that is Dissanayake's focus.[2] She explicitly opposes the idea of either beauty or skill as the essential characteristic of art, insisting instead that the essential characteristic is "making special" (2008, 12). We need to identify what this term "special" signifies. In "A Darwinian Theory of Beauty," a TED talk in February 2010, Denis Dutton defined beauty as "an adaptive effect which we extend and intensify in the creation and enjoyment of works of art and entertainment" and argues that, "beauty is nature's way of acting at a distance." That is certainly special.

Beauty exercises a kind of pull or attraction that exerts a certain influence on exposure. Dutton began his 2009 book, *The Art Instinct: Beauty, Pleasure, and Human Evolution*, with a consideration of an art project that sought to determine

Figure 5.2 Vitaly Komar and Alexander Melamid, top, *America's Most Wanted* and *America's Most Unwanted* (1994); middle, *France's Most Wanted* and *France's Most Unwanted* (1994); bottom *Iceland's Most Wanted and Iceland's Most Unwanted* (1995) from www.diaart.org.[3]

the aesthetic preferences (in terms of painting) of close to two billion people worldwide. Russian-American conceptual artists, Vitaly Komar and Alexander Melamid, created the "Most Wanted" and "Least Wanted" images of some 15 countries around the world, using professional polling companies between 1994 and 1997. The results revealed a "remarkable uniformity of sentiment" and the fact that "people in very different cultures around the world gravitate towards the same general type of pictorial representation" (2009, 14). Such landscape representation preferences have now been "subject to extensive empirical research" (21). Dutton's conclusion is helpful: it is that the widespread and interculturally positive response to certain representations of landscapes was formed in the human Pleistocene past (the Pleistocene being from roughly 2.5 million years ago to c.

12,000 years ago) by the survival and reproduction of ancestors who could recognize and take advantage of the most beneficial landscapes. Even today

> such scenes can cause people to stop in their tracks, transfixed by the intense sense of longing and beauty, determined to explore that valley, to see where the road leads. We are what we are today because our primordial ancestors followed paths and riverbanks over the horizon.
>
> (Dutton 2009, 27–28)

Those who were most adept in recognizing and following the best paths (both metaphorically and literally) survived and reproduced, and what we still see in such landscapes is experienced as beauty.

Dutton's explanation might appear adequate for natural beauty, in which human contrivance is absent, and even for erotic beauty, in which it is commonplace to see the workings of genetic predisposition. We are attracted to the child-bearing promise of the mother, the independence and prowess of the providing father, the flawless perfection of the nubile potential mate, and the potential for enjoyable intimacy. Such attraction is experienced as beauty. Art that simply imitates pre-existing natural or erotic beauty can harness these genetic predispositions, but what of the beauty perceived in profoundly acculturated objects and events? What of the beauty of music and poetry and of storytelling, dance, architecture? And what of the beauty of holiness?

Biocultural critics such as Dissanayake, Dutton, Boyd, and a growing number of others (Dissanayake gives a partial list, 2008, 7) argue that inherited predispositions can account for the entirety of what Dutton calls "the art instinct" and thus of the perception of the special and the sensation of what I am calling beauty. Their argument depends on the claim that "making special"—singing, dancing, decorating, elaborating, entertaining, and displaying skill—contributed to human survival and reproduction in our Pleistocene past and so was genetically transmitted and continues today. Although the ability to make useful items such as dwellings, weapons, vessels, and tools obviously contributes to survival, the painstaking decoration of such objects seems to require time and effort that would be better used elsewhere. That is, the arts are costly and demanding activities without readily apparent benefits. Nonetheless, they argue, art behavior is adaptive—it has been developed, retained, and transmitted because of its positive contribution to our survival. This is evident in the fact that such behavior is universal in human cultures. It is evident in the fact that it is recognizable in our ancient past. It is evident in the fact that it is displayed by and easily enhanced in our young. It is evident in the fact that it is generally apprehended as attractive and is considered an immediate source of pleasure or fulfillment. It is evident in the fact that it is commonly connected to important life events such as births, marriages, and coming of age. The very fact that it is a costly behavior is akin to other genetically inherited behaviors such as mating, food preparation and consumption, and socialization. I would add that it is also evident in the existence of those forms of art variously identified as "outsider," "visionary," "self-taught,"

"psychotic," or *art brut*. People compulsively produce art with no inducement and no reward and no connection to the worlds of the gallery or museum.

Such considerations can be used to establish both the probable adaptive nature of art behavior and the precise nature of the special as beauty, and they appear to apply at least equally to religious behavior. They imply that art and religion could have adaptive functionality in the four areas that Dissanayake identifies: (1) Improving cognition: the arts contribute to problem-solving and making better adaptive choices. For example, storytelling safely communicates the experience of usable information gained in dangerous encounters. It encourages foresight, planning, and empathy, and provides risk-free practice for the future when comparable circumstances might arise. (2) Propaganda: the arts can be used to manipulate, deceive, indoctrinate, or control other people. (3) Sexual display: the arts promote sexual opportunities by displaying desirable qualities such as physical beauty, lack of defects, intelligence, creativity, or social prestige, all of which connote reproductive fitness. The most popular and influential evolutionary explanation of the adaptive value of art is currently the sexual selection hypothesis, derived from Charles Darwin's speculations about the extravagant plumage or elaborate songs of some male birds (Darwin 1871). The ornamental character of plumes, crests, tails, and songs provides an obvious analogy with human art because the strength, vitality, intelligence, skill, and creativity required for their display cannot be faked by those who are less well endowed. Finally, (4) Reinforcing sociality: the arts enhance cooperation and contribute to social cohesion and continuity (Dissanayake 2008, 7–9). Propaganda value and the reinforcement of sociality are functions at least as commonly associated with religion as with art. The sexual selection hypothesis has been independently applied to religion, for example, by Andrew Mahoney, Ilkka Pyysiäinen, and D. Jason Slone in their contributions to *The Evolution of Religion* (Bulbulia et al. 2008). The apprehension of beauty in religious traditions can also be seen as contributing to "improving cognition" in similar ways. Therefore, the argument can once again be seen to apply at least as well to religious behavior as to art behavior.

Whatever the inner, subjective response to the special as beauty, the outer, objective, behavioral response is to pay close and sustained attention to objects and activities that manifest it, to concern oneself intensely with them, to cultivate that concern, directing others to pay attention to the same objects. In his biobehavioral analysis of storytelling and the literary arts, Brian Boyd places an instructive emphasis on attention. He points out that the key problem facing storytellers (and by extension artists in every other medium) is the need to secure and maximize their audiences' attention (2009, 323). Attention requires effort, and the audience experiences successful art, not only as worthy of that effort, but as actually overcoming the need for effort and actively conjuring attention.

Although the adaptive benefit of art as described might ultimately make it worthy of our attention, we usually remain unaware of this. It is instead an immediate, proximate motivation that moves us. With sexual motivation we are not consciously aware of, usually we are unconcerned with, the parenting

potential of a sexually attractive person, but we are drawn to what is experienced as the immediate attraction of their presence. We are not drawn to sugar because of its ultimate benefit as readily converted energy, but because of its proximate benefit—its sweet taste. The audience experiences a proximate attraction to art. Beauty is what we call the characteristics that engage that attention. According to American cognitive psychologist, Harold Pashler, attention means that "the mind is continually assigning priority to some sensory information over others, and this selection process makes a profound difference for both conscious experience and behavior" (1999, 2). The proposed analysis of art and religion is closely connected with this understanding of the process of attracting and retaining attention. Worship can be seen as paying close and sustained attention to the objects of worship, concerning oneself intensely with them, cultivating that concern, directing others to pay attention to the same objects, learning from one's interaction with them, and looking to them for meaning and guidance. The attraction of attention is central in both art and religion. Grünewald's Isenheim altarpiece may not be pleasant, but it certainly gets our attention, as does much outsider art, which can be downright "bad and nasty" (see Norman Girardot 2015, Chapter 7: "The Strange Beauty of Bad and Nasty Art"). Boyd points out that our species has a remarkable and unique capacity to share attention. Childhood play and storytelling engage attention compulsively because of our need to comprehend events and to monitor social activity. Story and play use repetitive structures that, over time, develop our facility for complex situational thought. We benefit from paying attention to the right things.

> Fiction specifically improves our social cognition and our thinking beyond the here and now. Both invite and hold our attention strongly enough to engage and reengage our minds, altering synaptic strengths a little at a time, over many encounters, by exposing us to the supernormally intense patterns of art.
>
> (Boyd 2009, 209)

But why do we hold in high esteem and pay close attention to objects, acts, and events that have no inherent, intrinsic, or obvious pragmatic value? The answer proposed is that their value is latent; that is, it is real but not readily apparent, similar to the ultimate benefits of other adaptive behaviors. There are complex cognitive and neurological processes, most often communicated and propagated nonverbally, that determine the focus of our attention and our immediate apprehension of value. This apprehension is neither voluntary nor conscious and is locally culturally modified based on species-wide genetic predispositions. It is apprehended as a self-evident, immediate, perceptual experience. Beautiful things are not alone in getting our attention. We obviously pay attention to clear and present dangers and promises of immediate reward. Art relies on the engagement of attention to less obvious items and events through an appeal to certain genetic predispositions. Why? Because as

long as the immediate experience rewards us enough to hold our attention, it can significantly affect our behavior and thus alter our relation to the world. By focusing our attention away from the actual world to imagined worlds, such experience can make a real difference. In the understanding proposed, the response to beauty, to art, and eventually to religion results from attention being engaged in this way.

So far we remain at a purely subjective interpretation of beauty—if an object or event engages our attention in this way, then it seems that it must be "really" beautiful. That is, so far, there is still no possibility of identifying "false positives" and distinguishing the merely meretricious from the truly beautiful. Do such things have any objective characteristics?

The anthropology of art: beauty and agency

A further contribution to a more adequate understanding of beauty and its role in both art and religion comes from the anthropology of art. Similar to the bioevolutionary approach, this insists that art behavior can only be properly understood if it is significantly widened beyond gallery art. The anthropologist of art, Alfred Gell (1998), argued that artified objects possess agency. That is, that beautiful entities *do* things to people, and those who are affected by them apprehend them as agents. This gains further support from the observation that, for example, the perception of both food items and music or even musical instruments (items closely allied with "making special" and creating beauty) stimulate areas of the brain normally associated with interaction with living beings (McGilchrist 2009, 55, 96, 410). The perception of any object or event as beautiful involves an attribution of agency, even to inanimate objects.[4] *They* move *us*. Such attribution brings into play our most sophisticated and highly evolved forms of intelligence—social, emotional, and interpersonal intelligence, or "theory of mind." Gell points out the error of invariably identifying agency with intentionality (that is, the operation of an animate and sentient mind). Although there is a strong tendency to perceive anything that can act upon us and change the environment around it as having a mind of its own, it ain't necessarily so. Any inanimate object that is "made special," decorated, or enhanced by deliberate human design is a display of the skill of the artist and is in fact an index of (that is, something that indicates) intentional agency (Gell 1998, 14–23). Inanimate objects that indicate intentional agency are highly salient for obvious adaptive reasons. There is a great deal of evolutionary, adaptive advantage in being keenly aware when there is another intelligence at work attempting to accomplish its own ends, which may conflict with or contribute to our own ends.

Possibly more importantly, we human beings are not possessed of a preexisting, precisely delineated set of genetic skills; instead, we need to focus our attention on objects and events that will help us develop new, specific, beneficial skills in a wide variety of circumstances. As Dissanayake states, "humans, more than other animals, use wits rather than instincts to address

the problems of their lives. For our species, what to do and how to live are rarely instinctive, but must be learned" (2008, 18). It is our defining behavioral feature that we are capable of learning and perfecting a wide range of new and different skills, skills with which we are not born. This has enabled us to survive and prosper in radically different environments and thus to populate every known area of the globe. To do this we are genetically predisposed to pay close attention to (to experience as beautiful) displays of skill so that we can identify them for what they are—highly developed and specialized abilities that allow the effective achievement of a desired end with relatively reduced effort. There is adaptive advantage in being attracted to such skills, to recognize them as valuable, to imitate them, adapt them, and learn to use them ourselves; and to benefit from them as we might benefit from the beautiful landscape or the attractive mate. The apprehension of any display of skill as beautiful in this way is the proximate effect of an ultimate goal—survival and reproduction. The perception of the inanimate products of such skill as beautiful engages complex and highly sophisticated mechanisms that immediately attract our attention but ultimately allow us to intuit the potential value of the item apprehended as beautiful and to focus persistent attention on it so that we might learn to interact with it to our own benefit. The extension of that ability from persons to their products and from those inanimate artifacts to the natural environment enables the most effective application of our native, evolutionarily adapted abilities to cognize people and things as worthy of the investment of our attention and effort. Beautiful things are things worthy of attention.

In instances of gallery art, the audience might be keenly aware of the extent to which the skill of the artist dwarfs their own abilities. Precisely because we can all draw stick figures and smiley faces, we can be conscious of Rembrandt's (1606–1669) unbelievable ability to instill intense emotional expression into a portrait. The presence of such complex skill can be recognized in the performance that produced the agency of this inanimate residue. It is immediately and intensely attractive of our attention and engages our social intelligence. This ability has an ultimate evolutionary payoff. Only sustained attention and the engagement of emotional intelligence can enable our appreciation and motivate persistent emulation, so that we might recognize the value of, and even ourselves develop, comparable skills. It effectively amplifies and accelerates the development of human potential. Even if we cannot develop such abilities ourselves, we are motivated to support and encourage those who can. Although this dynamic seems more obvious with the representative arts, even conceptual art, for example, the work of Franco-American conceptual artist Marcel Duchamp (1887–1968), such as his 1917 *Fountain*, displays remarkable skill of cognition. It takes talent to think of something that no one has previously thought of; something that will irresistibly grab the attention of the art world.

The inanimate products of human skills may communicate the intentional agency of their creators, but what of natural beauty, in which there is no

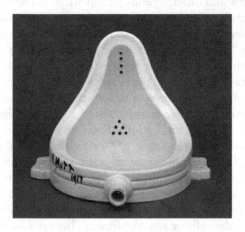

Figure 5.3 Fountain by Marcel Duchamp (1917—Tate Gallery, London). © Photo
© Tate, used by permission of Tate Images.

artifice or contrivance? Both begin with the same genetic predisposition to pay
close attention to agency that moves us, particularly to be attracted to things
that promise potential long-term benefit. The process can, in fact, be seen
to be extremely similar in the appreciation of natural beauty and products of
human skill. The ability to appreciate the beauty of the unfamiliar landscape
requires more than rational intelligence. This is a landscape that one has not
seen before. It is not known. We cannot simply weigh its pros and cons. Just
as with the ability to recognize the beauty of a potentially viable mate, it is
far more complex than we can consider consciously. In the end both abilities
demand the impossible—they require that we predict the future—which task
requires more than rational intelligence. Mate selection (both sexual pairing
and all other forms of close collaboration) unquestionably involves the op-
erations of evolved social intelligence—the ability to analyze, understand,
anticipate, and effectively interact with our fellow humans. Interaction with
art objects, things made special, activates emotional intelligence in respect
of inanimate entities. It extends our theory of mind from our fellow human
beings to their material products and to other natural phenomena. The ap-
prehension of natural beauty ("specialness") harnesses the same mechanisms.
The adaptive ability to recognize the remote agency in inanimate artifacts is
paralleled by a tendency to ascribe agency to the natural world. The natural
world *is* an agent that has massive effects on our lives (theists are those who
insist that such agency is the product of an intentional mind). Responding to
the natural world *as if* it were a product of some kind of skill—understood
as a highly developed and specialized ability effectively to achieve a desired
end—is neither entirely inaccurate nor maladaptive. Natural selection is
a remarkably efficient process of producing highly developed and special-
ized adaptations to every environment and of finding ways to apply those

adaptations to new and different ends ("exaptation"). The natural world may or may not be produced by anything immediately analogous to human skill, but we get the "feel" of the environment, we read its "personality" and come to understand its "character," via the same processes through which we interact with "art," which are the same processes through which we interact with our fellow humans. We perceive the beauty of, and are drawn to the benefits of, both. The human experience of beauty is a manifestation of a complex system of perception utilizing emotional and social intelligence and theory of mind. This, in its social application, allows us to perceive people's personality (which is precisely an example of "seeing the unseen"). This permits a glimpse into the future, in the sense of granting some effective anticipation of future behavior. To some limited extent, it allows us to perceive what is going to work best by recognizing, being attracted to, and being inclined to cultivate, the promise of benefit. The future is invisible and infinite. Glimpsing it at all brings the infinite into the finite. There is a concomitant drive to enhance such glimpses, to clarify them and make them available to others, to make special the bearers of significant messages so that others will attend to them (and so cooperate with us).

Thus, the apprehension of beauty has adaptive benefit. The subjective sensation of beauty is the proximate effect; it is attraction, compulsion, and the capture of attention, which results in objective responses of resource allocation. The objective characteristic of beauty is initially the power to induce that sensation but ultimately the promise of benefit, the (pre)cognition of behaviors worthy of attention, effort, and development, thus enhancing potential. The process consists of an attribution of differential value: assigning priority to some sensory experiences over others, which changes attention, consciousness, and behavior. We recognize some aspects of our experience as attractive and compelling whereas others are not; thus, we pay attention to and cultivate, approach, repeat, encourage, emulate, and imitate those aspects. The phenomenon is seen in art, sport, and technology (*techne*). In these things we assign value to displays of skill and their products, and encourage and emulate such behavior, which propagates and develops those skills.

In the erotic mode we are attracted to the potential mates in whom we detect the promise of sexual gratification, effective parenthood, and long-term cohabitation. In the aesthetic mode we are attracted to and pay close attention to products of human skill, which can improve our own skills in various ways. In its natural mode we are attracted and devote attention to perceptions of the immense power and agency of our physical environment where it holds out the promise of enhanced survival, safety, and comfort, but also where it is apprehended as revealing the character of the environment so that we might best predict and utilize it. Just as our ability allows us to "read" the personality of our fellows and predict their future behavior from their present disposition, so too we intuitively sense the "personality" of reality, the nature of nature, and use this ability to interact effectively with our environment by predicting its

behavior. Obviously, this ability is limited, flawed, and potentially maladaptive. We might invest attention and effort in attractive people, displays of skill, or natural phenomena that hold out no real promise of sustainable utility at all, or, more likely, that promise only short-term gratification that is not ultimately beneficial. We can now define and identify "false positives" and distinguish the meretricious from the beautiful. Nonetheless, any creature that has such ability to the slightest degree will have an adaptive edge over those that do not. The sort of edge that leads to the inheritance of behavioral predispositions.

The ultimate benefits of such predispositions can most generally be described as assurance, persistence, and sustainability rather than more proximate benefits such as the gratification of appetites. In pursuit of such beauty we are assured that we are doing the right thing, behaving the right way, and following the right path, and we are encouraged to persist in that behavior. We persist in courting desirable mates, nurturing beneficial social relations, utilizing our environment. We persist in cultivating beauty. Simple persistence is itself an adaptive behavior in a species such as ours. Think of the San tribesman running down an antelope by sheer persistence. Think of the millions of years during which we banged rocks together to produce sharp-edged stone tools until we were skilled enough to make Acheulean stone axes so well they might be considered "sexy" (Kohn and Mithen 1999; Mithen 2005, 188–191). The apprehension of beauty motivates such persistence, never forgetting that adoration is closely connected with fear, which is also an excellent motivator. Knowing—or rather *behaving as if* we know—what will prove worthy of persistent attention is invaluable. When we can see the world this way, we see how to make it better. The world is improved when we see it this way. We see the world better.

The ascription of specialness as the common ancestor of art and religion

Making sense out of beauty considered as the special in art, invokes the proximity of art and religion before their modern separation. The insights of the ethology and the anthropology of art occur where they overlap with religious behavior. Behaviors that have now become separable—religion and art—evolved under the pressures of natural selection to endow human beings with an ability to engage highly sophisticated and sensitive modes of emotional or social intelligence and theory of mind to address immensely complex problems in recognizing and following complex but effective paths to future benefit. In the instances of the potential mate and the natural landscape, the idea of beauty as a means of identifying and motivating persistent pursuits of worthwhile future benefit is relatively easy to comprehend. Hopefully this chapter has explained how artistic beauty can be similarly understood. The relatively recent distinction of art from religion has given rise to difficulties in properly identifying either. When art and religion are seen as closely related in terms of such behavior as their common ancestor,[5] as both species of the

genre of "making special," their relationship can be more clearly defined, although it still remains for the role of the special in religion to be further distinguished and analyzed.

Dissanayake points out that "the most conspicuous occasion for the arts in small-scale societies of today is in ritual ceremonies," and this association of art and ceremony is a clue to the original motivation of ancestral humans for their development of religious and artistic behavior (2008, 18). Ceremonies are usually about things that are important to human life, such as providing food, finding safety, promoting fertility, ensuring health and prosperity, and dealing with bodily changes and the emotional and social concomitants of sexual maturity, pregnancy, birth, and death. All of these are times of change and uncertainty (2008, 19). Being unsure how to respond in a potential crisis precisely because of the wide range of behaviors available to us was what made the development "of religion and its behavioral expression, making special" adaptive (2008, 19). Beauty in art, the perception of things as special, makes us keenly aware that we are "on the right track" so as to motivate a clear and consistent response. People in groups that responded to uncertainty with assurance and persistence would have gained a survival advantage over groups in which people acted less so (2008, 20). The perception of such beauty helps us to cope with uncertainty and steers us toward the good. In religious ceremonies, beauty attracts attention, sustains interest, and ensures participants that their responses are appropriate, "plausibly implying that the arts arose in human evolution as adjuncts to ceremonial behavior rather than as independently-evolved activities" (2008, 21). Ultimately, Dissanayake "view[s] ceremonial arts as the behavioral counterpart of religious beliefs" (2008, 22) and concludes that "art-filled ceremonial practices … give emotional force to explanations of how the world came to be as it is and what is required to maintain it" (2008, 22). These effects contribute to what she calls "psychobiological homeostasis" (2008, 22). That is, participants can sustain their present course with subjective assurance and objective persistence without encountering psychological or physical cause for change. Hence the intimate connection of art with religion and religion with divination and the search for wisdom: we appeal to our religions, and to the wise who know what to do in any and all circumstances, to guide future behavior.

This is why religious art need not represent anything specific about the religion. The cathedral need not necessarily represent the glory of God, nor need the Baha'i gardens represent any component of Baha'i theology. All they need to be is productive of the special sensation of beauty in association with the tradition. Illuminated manuscripts were not so much to give visual representation to the illiterate, as to render the text beautiful so as to reinforce the response of persistent cultivation. The experience of such beauty creates a sense of assurance—believers go not astray but follow the straight path, guided to salvation by the beauty of the tradition. This is an evolutionary adaption in that it gives to the human species—a species with open-ended behavioral traits and therefore an almost infinite variety of possible behaviors

to choose among—an identifiable path to choose and relief from the anxiety that results from doubting the right choice.

Some form of the idea that beauty leads to the good has been widespread and common. According to Plato, beauty is the main preliminary to the good (*Symposium* 210a–212c), and its recognition is a practical virtue. Love begins as love of the beautiful in particular form but ascends to love of beauty in general; thence to appreciation of the beauty of observances, laws, and kinship; thence to the beauty of knowledge; and finally to the love of the perfect beauty of the form of the Good. The form of the Good is that by participation in which all good things are good. One may disagree with Plato's ontology and epistemology, but that he sees beauty as marking the path to the good is undeniable. Likewise, the Arabic *ḥasan*, although it is usually translated "beauty," has, according to Kermani, "the semantic field 'good, excellent, beautiful, comely'; [and] it encompasses both moral and aesthetic senses" (2015, 10). Although the modern popular usage suggests outward attraction, in Arabic, beautiful "can just as well be understood in the sense of 'morally good'" (Kermani 2015, 10). The component parts of the Chinese character, *mei*, usually translated "beauty," suggests external form or appearance, but it also denotes goodness. In the *Analects* of Confucius we read "[t]he master said, it is goodness that gives to a neighborhood its beauty," and "in the usages of ritual it is harmony that is prized; the way of the former kings from this got its beauty" (*Analects*, IV, 1; I, 12 Waley's translation), which indicates that beauty is used interchangeably with goodness (*shan*) and harmony (*ho*) (Huang 1976, 413–414). Once again, beauty and practical benefit are associated.

The experience of beauty in religion does not occur in isolation. Consider Michelangelo's Pietà (he created several but the most famous is the 1498 version housed in St. Peter's Basilica in Rome). This is an exquisitely wrought marble of Mary, the mother of Jesus, holding the dead Christ, recently removed from the cross. As a display of the skill of the artist alone it engages the attention and demands admiration. As a representation of a woman holding a dead man it engages emotion and empathy (Who are they? Are they related? How did he die?). However, as an expression of the Christ myth its emotional affect attains a superordinate power: no longer simply a woman, she is now the sinless mother of God, informed at the Annunciation that she would bear the savior of the world, now holding her dead son, the perfect incarnate form of the living God, falsely accused and tortured to death by wicked humanity (but fear not, true believer, for He is risen and offers you the salvation of his grace). The enhanced power is undeniable. The gospel narrative is an artistic object of remarkable skill and beauty. Whatever its historical accuracy, its compulsion as a narrative and its ability to attract and retain the attention of a multitude and to engender passionate cultivation is beyond doubt. Associating one piece of art, the narrative, with the other, the sculpture, enhances the emotional effect of them both, and locating them in the extended matrix of all Christian art does so to the highest degree. In religious traditions every single expression is associated with every other,

including narrative "explanations of how the world came to be as it is and what is required to maintain it."

The beauty of the Qur'an can be readily appreciated by anyone who visits an online Qur'an (such as Qur'an Explorer) and plays the opening Surah, Al-Fatiha. (My favorite recitation is that of Mishari-Rashid.) Even if one knows not a word of Arabic, the sonorous nature of the recitation is compelling. Non-Muslims can only imagine—whereas the faithful know—how that beauty increases with understanding:

> In the name of Allah, the Beneficent, the Merciful. Praise be to Allah, the Cherisher and Sustainer of the Worlds, Most Gracious, Most Merciful, Master of the Day of Judgment. Thee do we worship, and Thine aid we seek. Show us the straight way. The way of those on whom Thou hast bestowed Thy Grace, those whose portion is not wrath and who go not astray.

Compounded with a lifetime's familiarity through daily prayer and enhanced by an understanding of Islamic theology and exposure to Islamic architecture and calligraphy, it is little wonder that there are common legends in Islam of people passing out, even dying, overwhelmed by the sheer beauty of the recitation (Kermani 2015, 303–311).

Institutional religions are extended matrices of related art objects with enhanced ability as agents to engender the sensation of beauty and persistent behavior, increased by their location in that matrix and their mutually enhancing association. They present an experience of the world as an integrated whole to which we can respond with confidence. Suggesting a glimpse of the personality of reality—the nature of nature—amplifies inner assurance and ensures outer persistence, allowing adherents to face an uncertain future coherently and consistently. The tendency to "make special" is thus the common ancestor of both art and religion—the genus to which both belong—but the expression of its products in an extended matrix of mutually reinforcing acts and entities that are forcefully evocative of persistent and sustainable responses distinguishes the latter from the former. Mutual relations enhance the attractive and compulsive virtue of associated behaviors, and people are increasingly persistent in their production, retention, and cultivation. The widespread use of religious relics is highly instructive in this. Natural objects such as bodily remains—bones, skulls, hair—or practical artifacts such as old clothes, eating utensils, a staff or walking stick, or trivial art objects, such as decorated containers, can attain the same status as unique art objects, manifesting an enhanced beauty because of their location in such a matrix— that is, their integration with narratives, poems, visual representations, and other arts. Such use of relics is symptomatic of the transition from art to religion and indicates why art may be novel but religion will always tend to be conservative.

In its particular role in organized religion the experience of beauty will be particularly intense and highly dependent on cultural conditioning because of such location in a matrix of culturally related items. This leads to a lack of emphasis on originality and novelty in religious art: consider the stylized reproduction of Eastern Orthodox icons, Hindu murtis, or tribal totems. It also leads to the perception of one's own tradition as exceptionally, possibly exclusively, beautiful. Consider van der Leeuw's insistence that

> the Christian theologian can find the unity of art and religion where alone we know unity: in the doctrine of the Incarnation. As believers we find the possibility of complete beauty in him in whom we find everything, in the divine figure, in the son of Mary, in the son of God, who is the most beautiful. And, with the old folk song we say: "All the beauty of heaven and earth is contained in thee alone."
>
> (2006, 340)

Passionate adherents of any religious tradition will tend to find the beauty of their own focus of worship immeasurably more potent and quantitatively, if not qualitatively, different from all others. Even secular perceptions of beauty, not just the preternaturally powerful examples of religious beauty, can be said to make the invisible visible. Explaining the beauty of the Qur'an, Kermani insists that

> one of the fundamental purposes of poetry or art is to transcend realties, to create a new, personal reality out of them and in them, and so to attain perceptions that are not accessible to us in day-to-day contexts—that is, to make the invisible visible.
>
> (2015, 276)

The beauty of religious arts serves to provide sensory experiences that sanction and corroborate the status of culturally postulated entities and values and thereby to give some ability to glimpse the future benefits of valorizing them. The Arabic poet-prophets are "concerned with communicating supernatural knowledge [but] … 'the poetic' in Muhammad's inspiration and teaching is not a specific 'quality' of Islam but a natural facet of all prophecy" (Kermani 2015, 277). The beauty that is a product of human genius may not be derived from a supernatural source, but it is open, suggestive, and requires interpretation. It is not categorical, clear, or unequivocal. It is the most contingent of all perceptions; some will apprehend it and others will not. Because of specific associations, sacred places may be apprehended as beautiful by some but not by others. This does not render the apprehension of such beauty wholly subjective. The element of promise, of exemplary agency from which we can learn and benefit, is an objective presence, even though it may be discernible only by certain persons or groups. In providing assurance, encouraging

persistence, and showing a clue to a sustainable path, this discernment has apparently been an adaptive behavior contributory to our survival and reproduction. Kierkegaard saw suggestions of the affinity of art and religion as threatening to rob Christianity of its power and of privilege, and he was not entirely wrong. The apprehension of such beauty as the common ancestor of art and religion denies the *exclusive* privilege implied by the perceived uniqueness of Christianity—as it denies the uniqueness and exclusivity of all traditions—but it also explains and supports the source of their power.

The *beaux arts* (fine arts), whose end is often said to be the production of beauty, are inextricably bound up with religious traditions. The focus on beauty as specifically, if not exclusively, the product of the fine arts has, to some extent, hampered our understanding of the role of beauty in religious traditions, as has the notion that beauty is necessarily pleasant and primarily visual. The awe-inspiring and potentially terrifying aspect of beauty—as well as natural, including erotic, beauty—must be included in order properly to understand its religious function. In fact, understanding beauty's role in religion requires a comprehensive reconsideration of beauty, of art, and of religion. Beauty attracts and retains the attention and focuses behavior because such focus can be beneficial and is therefore worthy of attention. The cognition of skill in the animate and the ascription of agency to the inanimate modifies our perception of reality in such a way as to allow us to improve it, or, rather, to improve our response to it.[6]

These considerations suggest a coherent understanding of art and of religion. The association of mutually enhancing items of beauty in a religious tradition augments the apprehension of the tradition as itself a thing of beauty and induces the production, retention, and cultivation of further associated items and behaviors and the assurance and persistence of devotees in their devotion. Adherents experience their own tradition as a source of incomparable beauty. The sonorous beauty of the Qur'an, the narrative beauty of the Gospel, the physical beauty of Krishna Gopala. Although they may be lost on those of other faiths, the culturally enhanced apprehension of the beauty of each is based on the same underlying processes and produces similarly persistent behavior. The finite presence of mediating beauty yields a glimpse of the unseeable future, a strain of silent promise, a finite manifestation of the infinite beyond. The beauty of art in religion promises ineffable yet assured benefit. The faithful have seen the otherwise invisible path.

Notes

1 A rather different version of this chapter was published in *Religion: Material Religion*, edited by Diane Apostolos-Cappadona. Farmington Hills, MI: Macmillan Reference USA, 2016: 21–43.
2 It is also worthy of comment that such universal tendencies are in no way "atemporal" or "ahistorical." Although they may develop in the *longue durée* of evolutionary time, they are very much products of history.
3 The whole collection of most wanted and unwanted images can be seen at http://awp.diaart.org/km/painting.html, which states:

Fair use of copyrighted material includes the use of protected materials for noncommercial educational purposes, such as teaching, scholarship, research, criticism, commentary, and news reporting. Unless otherwise noted, users who wish to download or print text, audio, video, image and other files from Dia's website for such uses are welcome to do so without Dia's express permission. Users must cite the author and source of this material as they would material from any printed work; the citation should include the URL http://www.diaart.org and images must be accompanied by the credit line that accompanies the image.

4 Taves distinguishes between attributions and ascriptions, the former being "commonsense causal explanations… that people often supply consciously," and the latter often being "supplied implicitly below the threshold of awareness" (2009, 10 see also 89 n.1). I will follow Taves in using the term "ascription" to apply to a non-conscious apperception of a given attribute.
5 It must be recalled that in using the phrase "common ancestor" in this way I am now using biological descent as an analogy. Humanity, rather than religion or art, remains the evolving biological unit, and religion and art are "siblings of a common ancestor" in the sense of being members of a common genus, the differentiation of which chronologically preceded the contemporary distinction between religion and art.
6 The radical distinctions between the human and non-human, between the animate and inanimate, are products of the modern Western separation of categories that will be discussed further in Chapter 7 and are not simply natural sorts inherent in all human communities.

References

Bacon, Francis. *The New Organon*. Edited by Lisa Jardine and Michael Silverthorne. Cambridge Texts in the History of Philosophy. Cambridge, UK: Cambridge University Press, 2000.

Boyd, Brian. *On the Origin of Stories: Evolution, Cognition, and Fiction*. Cambridge, MA: Belknap Press of Harvard University Press, 2009.

Brennan, Marcia. *Curating Consciousness: Mysticism and the Modern Museum*. Cambridge, MA: MIT Press, 2010.

Bulbulia, Joseph, Richard Sosis, Erica Harris, et al., eds. *The Evolution of Religion: Studies, Theories, and Critiques*. Santa Margarita, CA: Collins Foundation Press, 2008.

Darwin, Charles. *The Descent of Man and Selection in Relation to Sex*. London: Murray, 1871.

Dissanayake, Ellen. *What Is Art For?* Seattle: University of Washington Press, 1988.

Dissanayake, Ellen. "The Arts After Darwin: Does Art Have an Origin and Adaptive Function?" In *World Art Studies: Exploring Concepts and Approaches*, edited by Kitty Zijlmans and Wilfried van Damme, 241–263. Amsterdam: Valiz, 2008.

Dixon, John W. Jr. "Painting as Theological Thought: The Issues in Tuscan Theology." In *Art, Creativity, and the Sacred: An Anthology in Religion and Art*, edited by Diane Apostolos-Cappadona, 277–296. New York: Crossroad, 1984.

Dutton, Denis. *The Art Instinct: Beauty, Pleasure, and Human Evolution*. New York: Bloomsbury, 2009.

Dutton, Denis. "A Darwinian Theory of Beauty," TED Talk, 2010. www.ted.com/talks/denis_dutton_a_darwinian_theory_of_beauty#t-395599.

Freed, Rita E. *Pharaohs of the Sun: Akhenaten, Nefertiti, Tutankhamen*. Boston, MA: Bulfinch Press/Little, Brown and Company, 1999.

Gell, Alfred. *Art and Agency: An Anthropological Theory*. Oxford, UK: Oxford University Press, 1998.

Girardot, Norman. *Envisioning Howard Finster: The Religion and Art of a Stranger from Another World*. Oakland: University of California Press, 2015.

Glassie, Henry. *The Spirit of Folk Art*. New York: Henry Abrams, 1989.

Huang, Siu-chi. "The Concept of Beauty in Contemporary Chinese Aesthetics." *Journal of Chinese Philosophy* 3 (1976): 413–431.

Kermani, Navid. *God Is Beautiful: The Aesthetic Experience of the Quran*. Cambridge, UK: Polity, 2015.

Kierkegaard, Søren. *Of the Difference between a Genius and an Apostle*. Translated by Alexander Dru. New York: Harper Torchbooks, 1940.

Kohn, Marek and Steven Mithen. "Handaxes: Products of Sexual Selection?" *Antiquity* 73 (1999): 518–526.

Liverani, Mario. *Uruk: The First City*. London: Equinox, 2006.

Mahoney, Andrew. "Theological Expression as Costly Signals of Religious Commitment." In *The Evolution of Religion*, edited by Joseph Bulbulia, Richard Sosis, Erica Harris, et al., 161–166. Santa Margarita, CA: Collins Foundation, 2008.

Martin, James Alfred. *Beauty and Holiness: The Dialogue between Aesthetics and Religion*. Princeton, NJ: Princeton University Press, 1990.

McGilchrist, Iain. *The Master and His Emissary: The Divided Brain and the Making of the Western World*. New Haven, CT: Yale University Press, 2009.

Mithen, Steven J. *The Singing Neanderthals: The Origins of Music, Language, Mind, and Body*. London: Weidenfeld and Nicholson, 2005.

Mothersill, Mary. *Beauty Restored*. Oxford, UK: Clarendon, 1984.

Otto, Rudolf. *The Idea of the Holy*. Translated by John W. Harvey. Oxford, UK: Oxford University Press, 1958.

Pashler, Harold. *The Psychology of Attention*. Boston, MA: MIT Press, 1999.

Plato. *The Symposium*. Translated by Christopher Gill. London: Penguin Books, 1999.

Pyysiäinen, Ilkka. "Ritual, Agency, and Sexual Selection." In *The Evolution of Religion*, edited by Joseph Bulbulia, Richard Sosis, Erica Harris, et al., 175–180. Santa Margarita, CA: Collins Foundation Press, 2008.

Qur'an Explorer. www.quranexplorer.com/Quran/.

Schelling, Friedrich Wilhelm Joseph von. *System of Transcendental Idealism*. Translated by Peter Heath. Charlottesville: University Press of Virginia, 1978.

Slone, D. Jason. "The Attraction of Religion: A Sexual Selectionist Account." In *The Evolution of Religion*, edited by Joseph Bulbulia, Richard Sosis, Erica Harris, et al., 181–187. Santa Margarita, CA: Collins Foundation, 2008.

Rilke, Rainer Maria. *Duino Elegies* (1923). Translated by Stephen Mitchell. Boston, MA: Shambhala, 1992.

Taves, Ann. *Religious Experience Reconsidered: A Building-Block Approach to the Study of Religion and other Special Things*. Princeton, NJ and Oxford, UK: Princeton University Press, 2009.

van der Leeuw, Gerardus. *Sacred and Profane Beauty: The Holy in Art*. New York: Oxford University Press, 2006.

Waley, Arthur, trans. *The Analects of Confucius*. New York: Vintage Books, 1989.

6 Art and the sacred

All of us, at all times, inhabit imagined worlds. An imagined world is an emotionally and aesthetically modulated vision of oneself and the world one inhabits. ... The imagined worlds we inhabit overlap with the imaginative virtual worlds created by artists or by collective cultural efforts extending over generations or centuries. Imaginative virtual worlds feed into our imagined worlds, profoundly influencing the way we imagine our own actual lives. For instance, the Biblical myth of the creation of the world is, for many people, part of the imagined actual world that they inhabit.

(Joseph Carroll, "Evolutionary Literary Study" from
the *Handbook of Evolutionary Psychology*, 1106)

Part one: experiencing the sacred in the profane

The Romanian/American historian of religions Mircea Eliade wrote a significant amount on art and religion. Although "the sacred" as employed by Eliade has often been assumed to be equivalent to "God" or some autonomous "transcendental" entity, it is more consistent with his writings to identify it as an ascription or attributed characteristic, like beauty in art. As such it is a viable candidate for a companion concept to "beauty" as defined as the categorical concept in art. When understood this way, Eliade's description of experiencing the sacred in the profane can be seen, not as anticipating, but as consistent with, the proposed ethological understanding of art and religion. Just as "beauty" identifies that which is special in terms of art, so too "the sacred" identifies that which is special in terms of religion. Just as beauty is experienced—by some and not others—as inhering in, but not a simple property of, some entities and not others, so too the sacred is differentially experienced for closely related (but not identical) reasons. It is fruitless to do nothing but pore over earlier scholars who did not themselves give an adequate account of the relation of art and religion. They were not in possession of the recent insights of cognitive science and ethology. However, if we are not to lose everything that is of value in earlier insights we must recognize what light earlier scholars can shed on the new information that we do have. The one scholar I have studied most

extensively is Eliade, and his analysis of the sacred can be of considerable utility now. Before that utility can be explored, however, more needs to be said concerning the workings of art to clarify the connection of the beautiful and the sacred.

As we have seen in preceding chapters, one of the chief identifying characteristics of art is the focus of attention on skilled performance and the production of artifacts, apprehended as beautiful, including an apparent perception of personality or character. Usually, it is a perception of the personality of the artist or performer that is assumed; however, where religion is concerned the perception must, almost by definition, be something other. As Claude Lévi-Strauss pointed out, myth always "is credited with a supernatural origin" (Lévi-Strauss 1969, 18). If this is to be seen as indicative of the consanguinity of art and religion, how is it to be explained? First, the art object—artifact or performance—must become a focus of attention. In *Art and Agency* Alfred Gell pointed out that "there is seamless continuity between modes of artistic action which involve 'performance' and those which are mediated via artefacts. The distinction has no theoretical significance" (1998, 67). This, he explains, is because finished artifacts are "congealed" performances (71). Furthermore, the reception of all art "occurs in the light of the *possibility* that the recipient could, technically, approach the same task of art-making, himself or herself" (69, emphasis original). The acute awareness of the audience of their own lack of skill in comparison with the performer/producer produces a kind of "captivation," which Gell considers to be "the primordial kind of artistic agency" (69). So he agrees that this captivation is primarily effected through the recognition of skill, although art objects exert this captivation in and of themselves, "rather than as an outcome of the prior agency of an artist" (72). Thus captivated by art, even without immediate access to the performance of a human agent, we abduct personality and agency through it. Gell explores art as "a domain in which 'objects' merge with 'people' by virtue of the existence of social relations between persons and things, and persons and persons *via* things" (12). He proposes that "art-like situations" can be recognized as those in which a material index (the artifact) enables a particular cognitive operation which he identifies as "*the abduction of agency*" (13). This abduction of agency occurs when any object is taken as an index of agency, as smoke is an index of fire. Pascal Boyer also considered abduction to be "an indispensable inference principle" in *The Naturalness of Religious Ideas* (1994, 147). A fundamental component of Gell's approach is that we have "access to 'another mind' in this way, a real mind or a depicted mind" (15). In saying this, Gell was specifically considering the abduction of agency involved in seeing a representation of a person. However, the sense of access to other minds, other "personalities," is far more widespread than in the representation of humans. We never, even with the immediate acquaintance of other people, directly perceive minds or personalities but always, necessarily, assume their presence. *Agency is attributed* (16), it is not something that we experience

objectively, but something that we *attribute*, like attributions of intentionality, of beauty, and of sacrality, and it is attributed to things other than humans. Agency can inhere in images and artifacts.

> People do attribute intentions and awareness to objects like cars and images of the gods. The idea of agency is a culturally prescribed framework for thinking about causation, when what happens is (in some vague sense) supposed to be intended in advance by some person-agent or thing-agent. Whenever an event is believed to happen because of an "intention" lodged in the person or thing which initiates the causal sequence, that is an instance of "agency" ... artefacts can quite well be treated as agents in a variety of ways.
>
> (Gell 1998, 17)

An agent can be understood as something that has the capacity to initiate causal events, which cannot be ascribed to the current state of the physical cosmos, but only to a special category of mental states, that is, intentions (19). However, once an attribution of agency is made the entity *is* an agent, *even if it lacks the mental states that are ascribed to it*. Its activity—even inaction—is interpreted as agency and causes results in the attributor. The attributor acts as a patient and thus *makes* the object an agent.

> We recognize agency, *ex post facto*, in the anomalous configuration of the causal milieu—but we cannot detect it in advance, that is, we cannot tell that someone is an agent before they *act as an agent*, before they disturb the causal milieu in such a way as can only be attributed to their agency. Because the attribution of agency rests on the detection of the effects of agency in the causal milieu, rather than an unmediated intuition, it is not paradoxical to understand agency as a factor of the ambience as a whole, a global characteristic of the world of people and things in which we live, rather than as an attribute of the human psyche, exclusively.
>
> (20)

Gell refers to this as "distributed personhood" (21) in which artifacts into which people have invested time, skill, and effort, become "components of their identities as human persons" (21). The concept of agency that Gell employs is relational and context dependent rather than being classificatory and context free (22), and it is particularly useful in pursuing the present analysis.

Although art, especially in the contemporary Western sense, is not necessarily representational, most Western art-theory is about representational art, even though much of ethnological or folk art is decorative rather than representative. Representational art has been with us since the cave art of almost 40,000 years ago, so I will consider representational art first. It seems that representation itself is a source of direct pleasure for human beings and we may

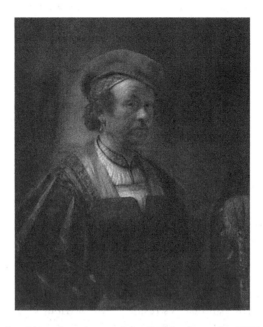

Figure 6.1 Portrait of Rembrandt *van Rijn* (1650), from the Widener Collection. National Gallery of Art Open Access Images—National Gallery of Art, Washington DC.

enjoy representation for at least two conscious reasons: that is, how well the representation is accomplished and the thing itself represented. Representation takes skill, the demonstration of which is attention grabbing and pleasing in its own right, but further, it allows us to contemplate freely and without exposure the thing represented. Humans have a natural (that is, an evolved and inherited) inclination to see without being seen. Invisibility—the ability to see without being seen—is a much-valued "superpower," which is in some way available every time we observe a skillfully wrought representation. Think of a general contemplating a detailed model of a forthcoming battle, for example. This is a source of direct pleasure. One of the greatest skills in artistic representation lies in making the representation as valuable or even *more* valuable than direct observation of the thing represented. For example, a Rembrandt painting can be more revealing than direct observation not only because we can contemplate it without interruption, but also because it allows access to the mind of the painter, the original, highly skilled, observer who is now the representing artist (Dutton 2009, 192). Yet the potential to express individual personality is more than just communication of the personality of the artist because of the nature of skill and virtuosity. Skill is by definition variable, differential, and hierarchical. There is a great potential to recognize the individual's skill *as* individual. In any process involved in mate selection, this is a crucial component—one has to recognize one's potential

mate *as an individual*—the expression of individuality becomes in many ways what it is all about! If skill is a fitness marker used in mate selection, then this is only to be understood. Even skills with no evident utility would be attractive simply because they identify individuals.

The general value of open-ended and apparently pointless skills might also be seen as adaptive for a species whose primary skills are intelligence, sociality, and language- and tool-use, who have devised ways to live in almost all available environments. That is, we are creatures for whom skill is valuable per se, without any immediate, self-evident utility, because of potential future utility. No wonder, then, that experience of works of art is highly emotional. Direct pleasure is itself an emotional response, and it is the particular tenor of the emotional response implied by the expressive individuality of the work that yields the particular and specific emotional tone of each art event *as well as* the sense of insight into the inner being of an originating agent. The skill of the agent becomes available—or at least identifiable, comprehensible, perceptible, cognizable, and potentially imitable—to the audience, as the mind of the human author is "made available" through the capacity for empathy, and the audience experiences a sensation in which it is as if they can utilize the acuity and skill of the author. Art may not, in any measurable and permanent sense, make its audience more intelligent or capable, but the subjective phenomenology of art yields the sensation that it does. According to the arguments of Dissanayake et al. concerning the improvement of cognition, it actually does (Dissanayake 2008, 7). The cluster of concepts operative in art and its appreciation can offer the experience of harnessing and enjoying the capabilities of the creative artist, and of thus being more intelligent, more capable, more sensitive, than one is alone. In terms of behavior, it motivates persistent attention to the artist and their art.

The cognition of skill and the ascription of agency are very close. Skill is necessarily an attribute of animate, intentional agents. It involves the accomplishment of a *desired* end. When we observe skill we are, for recognizable evolutionary and adaptive reasons as described, attracted to it. It seizes our attention because it promises reward for effort. Performances that demonstrate skill are real, empirical events. However, the skill itself, as a repeatable, imitable, and learnable ability that can bring future reward, is not immediately visible. It is an ascription, an abduction of agency. Because agency is an ascription in this way, it can be ascribed to non-intentional agents. The cognition of and response to skill in conspecifics or other animate agents, is immediately equivalent to the ascription of agency to the non-intentional environment. It must be borne in mind that the radical distinction of the human from the non-human, and of the animate from the inanimate, is a relatively recent cultural phenomenon and was not (as far as we can measure) operative in early history. When natural forces of the environment: floods, lightning, the seasons, the growth of crops, strike us with the same impact, if they get our attention, then the same adaptive process that attracts us to intentional skill is at work.[1] We attend to them because we can learn from them. The very act of

attending changes our behavior, and, assuming we survive, we will feel that it has done so for the better. While skill is not the same as agency, our response to the cognition of skill and to the ascription of agency is the same response. In ascribing agency—highly skilled agency—to natural forces, we are applying emotional intelligence, possibly theory of mind, to non-intentional forces (although theists disagree). To argue that this is teleological thinking and therefore inaccurate may or may not be technically correct. It is, however, fruitless. If such ascription changes behavior for the better (in evolutionary terms it promotes survival and reproduction), it is adaptive.

In overtly religious situations, the ability to apprehend the intervention and nature of the gods or the Dao—the invisible agencies that determine our environment—would have obvious impact on a mind, which, unaided, has no such capacity. Art may be considered "cooked experience." Just as we derive greater dietary nourishment from cooked than from raw food,[2] so too we derive greater cognitive and epistemological benefit from the skillfully worked experiences of art than we do from the "raw" experience that we know as the natural world. That art objects and performances are given significance by their place in the history and tradition of their art (Dutton 2009, 58) is not only part of the ongoing discussion that is criticism, appreciation, and continuous recreation. It is one of the means by which persistent attention is focused on art that produces an emergent apprehension of agents as "personalities" or "characters" greater and more skilled than any of the human personalities who produced the individual works; from the "superhuman" genius, to the Muses, to the One True God.

For Gell "style … is the harmonic principle which unites works of art into groups, into collectivities … style attributes enable individual artworks to be subsumed in the class of artworks which share these particular attributes" (153, 162). An artwork that is considered as exemplifying a style makes salient the intentions behind the artwork because we can draw connections between the particular work and others "of the same style."

> *The psychological saliency of artworks is a function of the stylistic relationship between any given artwork and other artworks in the same style.* Artworks do not do their cognitive work in isolation; they function because they cooperate synergistically with one another, and the basis of their synergic action is style.
>
> (163, emphasis original)

This relates especially to the religious artwork, which is necessarily located in a wider matrix of religious artifacts, including narratives, and, consistent with Ann Taves' (2009) observations, functions by virtue of *composite* ascriptions of specialness. "Each object, seen in the light of all the others in its corpus, appears as a microcosm of the corpus because our perception of it is informed by our knowledge of the macrocosm of which it is a fragment" (Gell 166). With the development of the monotheistic traditions, the apprehension of agency

becomes that of a singular "personality of reality," the Abrahamic God. I do not mean to imply that the monotheistic traditions are any "more evolved" or "better" than any other—just a particular and relatively recent manifestation of the same processes. The character of the real can just was well be apprehended in *impersonal* terms—as in the Dao or "the supreme"—*nirguṇa* Brahman. But it is effected through a concatenation of experiences of material culture.

Just as "theory of mind" assists us in predicting and coping with our conspecifics through a representation of their essentially inaccessible "inner world," so too, generalized through an extended matrix of stylistically related art (nowadays identified as a religious tradition), we are assisted in predicting and coping with the whole world of people and things in which we live through the apperception of, and emotional response to, its essentially inaccessible "nature," perceived as personality or character (plural or singular). It might be argued that this "assistance" could be other than beneficial if the perceived representation simply is not real, but it is the subjective assurance and the ensuing persistence that is the effective value of the process. The inherent, objective property of beauty as described in the previous chapter implies a certain objectivity, a reality, to this *composite* perception, which I now equate with "the sacred."

One of the concepts that indicates this bridge between art and religion is play. Johan Huizinga's important work, *Homo Ludens* (Huizinga 1949/1955), focused on play as a matter of cultural history rather than of religion. However, the sort of reconsideration of the nature of religion that is required here obviates that distinction to some extent. Huizinga suggested that play is primary to and necessary for the generation of culture, and Boyd's treatment of the concept indicates its importance to functions normally associated with religion. Boyd points out that most biologists agree that play "must be adaptive, since it is so widespread within and across species, since it consumes valuable energy, since it puts players at increased risk of predation or injury, yet remains eagerly anticipated, solicited, and maintained. But they do not often agree on its adaptive role" (2009, 179, with reference to Bekoff 2000; Bekoff and Allen 2002; Špinka et al. 2001). With further support from Colin Allen and Marc Bekoff (*Species of Mind: The Philosophy and Biology of Cognitive Ethology* 1997, 109) Boyd points out that play "constitutes the first decoupling of the real, detaching aggression or any other 'serious' behavior from its painful consequences so as to explore and master possibilities of attack and defense. ... In play we act as if within quotation marks" (2009, 180). This is characteristic of the process whereby fiction enhances creativity. "It offers us incentives for and practice in thinking beyond the here and now, so that we can use whole of possibility space to take new vantage points on actuality and on the ways in which it might be transformed" (197). This develops Dissanayake's observation that art improves cognition. It is, among other things,

> [b]ecause fiction extends our imaginative reach, we are not confined to our here and now or dominated by automatic responses. We can think

in terms of hidden causes, inspiring or admonitory examples from the past, fictional or real, utopian or dystopian models, of probable scenarios or consequences, or of counterfactuals whose very absurdity clarifies our thought.

(Boyd 2009, 198)

The response to "inspiring or admonitory examples," or paradigmatic exemplars, or "archetypes" as Eliade was wont to call them, has been one of the foremost characteristics of religious behavior in many analyses. Not only Eliade, but also Ian Barbour, Karl Jaspers, and Clifford Geertz saw religion as a source of behavioral exemplars. The very concept that "we are not confined to the here and now" sounds remarkably like a defining feature of religious behavior, but let me attempt further to fill out the details of these initially rather sketchy ideas.

Dissanayake insists that "art exercises and trains our perception of reality, it prepares us for the unfamiliar" (1988, 67). So neither art, nor religion, are simply "invented stories that people take as true" (Boyd 199), but inventions that somehow, if indirectly, improve our response to the true. If religion behavior is seen as an emergent form of an ancestral behavior that uses the persistent focus of attention, engaged by skilled performance, inducing an emotional apprehension of environmental agency, of the implicate order, of intangibles such as values and ethics, of imponderables such as the whole *gestalt* and *zusammenhang* of reality, of unknowables such as the beginning and the end of all things, of the "moral order" of the cosmos, and the scale of values implied thereby, so as to determine appropriate behavioral responses, then the evolutionary analysis of the arts as adaptive can be—must be—applied to religion, and without necessarily categorizing religion as error or delusion. The believers' unshakable faith that their tradition is true in the sense that it represents the real (instead of simplistically just *being* the real, that is, literal, historically accurate, chronicle) is, to this extent, justified, and the history of religions can be both more accurately represented and more equitably appreciated. Certainly, the assurance and persistence of religious behavior can be better explained. The actual degree of historical truth in any given tradition is beyond determination, and insistence upon it varies between different traditions. The major role of ritual traditions with their involvement of all the arts, can be seen as striving to communicate accurately, if figuratively, the really real, involving a differential scale of values attributed to acts, objects, and events—the scale of good and bad that provides answers to the huge question concerning "confusion and uncertainty in choices available for action" (Dutton 2009, 120). Its end is to produce emotionally assured, persistent, and sustainable behavior in response. It must here be remarked that any matrix of related representations and forms can achieve such behavior, as is evidenced by the fact that secular people, uncommitted to any specific religious tradition, do not lack an ethical sense and can also be assured and persistent in their behavior.

As we have seen, evolutionary critics consider religion to have commandeered the power of storytelling and the other arts. The process, however, must be recognized as considerably more ramified. Religious belief (as we have recently come to identify it in the modern West) may be closely associated with the political and institutional structures that we now identify as "religions," supported by the explanatory and cohesive powers of storytelling and all the accompanying arts, but religion can equally, arguably more appropriately, be characterized by the effective and adaptive application of artistic or creative behavior that (re)presents the hidden nature of reality (not of historical phenomena) so as to determine our response to it.[3] Rather than thinking of religion in terms of reality, truth, and belief, which are essentially verbal constructs, we might think in terms of behavior, of actions, of performance. This does not remove the category of faith. Faith would be the underlying emotional sense that some specific behavior—including associated linguistic behavior—is more appropriate, more emotionally *right*, than possible alternatives.

I do not mean to suggest that, in its overlap with religion behavior, art behavior simply and reliably reveals to us what is "really there," but that, just as our complex capacity of empathy or theory of mind enables us to experience an adequately accurate, working intuition of the inner state of the other, so the art of religion mediates an understanding, experienced as a perception, of the nature of the real beyond the empirical, an apprehension of the character of the cosmos, "the expression on the face of god," so to speak. It determines our emotional response to that perception. Ultimately, it persuades us of the most skillful way that we can behave in response to the nature of reality. Verbal explanations and justifications of that behavior—expressions of belief—are *ex post facto* creations that seek to reinforce and perpetuate the creative tradition that produced that perception.

Initially the idea can be simply expressed. Confronted with examples, even if only in the form of narratives that are confessedly fictional, of individuals who suffer after performing a certain behavior and are rewarded after another, we are emotionally inclined to imitate the rewarded behavior and avoid the behavior that entailed suffering. Yet it is obviously not that simple. We can and do distinguish between fact and fiction, and emulating Frodo Baggins or Harry Potter does not alone constitute religious behavior. Furthermore, we are all-too-often all-too-aware that the righteous perish in their righteousness and the wicked prosper in their wickedness (Ecclesiastes 7:15, Isaiah 57:1). However, to imply that we are dependent upon some kind of theoretical account to justify our behavior, that the associated verbal behavior *generates and explains* our persistence in other contingent behaviors, is simply unfounded. Such behavior, rather, is produced by experiences of beauty and the sacred, which induce an emotional response to the unseen processes behind observable reality.

In order to investigate the connection between such behavior, which could still be considered art or even play, and behavior that is more convincingly "religious," I return to my earlier analysis of religious behavior as described by Mircea Eliade.[4] I continue to follow the trails blazed by Dissanayake et al.

in the ethology of art and by those pursuing a cognitive science of religion, particularly Ann Taves (2009), in assuming that religious behavior, like art behavior, concerns things made and apprehended as special and that simple ascriptions of specialness aggregate and accrete until a composite ascription develops that might be properly regarded as "religious." In *Reconstructing Eliade: Making Sense of Religion*, I argued that Eliade's understanding of the sacred was as "*the intentional object* of human experience which is apprehended as the real" (Rennie 1996, 21, emphasis added). My argument was supported by both J. Z. Smith's and William Paden's recognition of the similarity of Eliade's understanding of the sacred with that of Émile Durkheim. Smith pointed out that Eliade may have substituted Rudolf Otto's language of the Holy (Otto 1958) for "Durkheim's more neutral and positional sacred while maintaining the dynamics of Durkheim's dualism" (J. Z. Smith 1978, 91), and Paden demonstrated in detail that the Eliadean category is "under some debt to the French school" of Émile Durkheim (Paden 1994, 199). Here the sacred is "an index of a system of behavior and representation which follows its own rules" rather than a name for some autonomous transcendent reality to which religious experience points.

This reading of Eliade remains defensible and closely related to the present analysis of religion and art but, for the sake of precision, some additional discussion is required in order to clarify the status of an "intentional object." In his *Logical Investigations*, philosopher Edmund Husserl (1859–1938) speaks of "intentional and true objects" (1970, Vol. 2 Intro. §5, 260). He also talks of "objectless ideas" (Vol. 2 Investigation II, Chapter two, §7, 352), which he differentiates from "ideal objects" such as the number 2, the quality of redness, or the principle of contradiction, and which exist independently as the "objects" of our ideas and are not "mere fictions." Speaking specifically of gods, Husserl says: "If, however, the intended object exists, nothing becomes phenomenologically different. It makes no essential difference to an object presented and given to consciousness whether it exists, or is fictitious, or is perhaps completely absurd" (Vol. 2, V, §11, 559).

In the same chapter, Husserl calls intentions that lack intended objects "merely intentional," and says further that, "we must distinguish between the object as it is intended and the object which is intended" (Vol. 2, V, §17, 578).

> If I represent God to myself, or an angel, or an intelligible thing-in-itself, or a physical thing or a round square etc., I mean the transcendent object named in each case, in other words my intentional object: it makes no difference whether this object exists or is imaginary or absurd. "The object is merely intentional" does not, of course, mean that it exists, but only in an intention, of which it is a real (*réelles*) part, or that some shadow of it exists. It means rather that the intention, the reference to an object so qualified, exists, but not that the object does. If the intentional object exists, the intention, the reference does not exist alone, but the thing referred to exists also.
>
> (Vol. 2, V, §21, 596)

So, if one is faithful to Husserl's original usage, it is incorrect to refer to God or the sacred as an intentional *object*. That would assume the very conclusion that I seek to avoid. Rather the *intention*, the *reference*, exists. I defer judgment as to the existence of its object. The Polish phenomenologist Roman Ingarden, Husserl's student, developed the vocabulary of the "*purely* intentional object," which is to say the intention that definitively lacks an intentional object, which Husserl would call "merely intentional," and the "*properly* intentional object," which correspond most precisely to Husserl's "intentional object." It was Ingarden's usage that I employed in speaking of the sacred as an intentional object, insisting that the question of its pure or proper intentionality be deferred (Rennie 1996, 21, 216).

We can, of course, question what aspects of *any* intention are "merely" intentional. No intention relates *perfectly* to its object, even one that does refer to a properly intentional object. It is unavoidable that there will always be some aspect of the intention that is peculiar to the intention rather than derived from its object. The relation of any intention to its object remains somewhat mysterious. Just as no intention can be entirely "proper," we must ask whether any intention can be entirely "merely or purely" intentional. Husserl uses the examples of the round square and the golden mountain: while these do not exist and therefore are not properly intentional objects, there *are* proper intentional objects for round, for square, for gold, and for mountains. All we do is (imaginatively and creatively) to relate them; to construct "counterintuitive objects" in Pascal Boyer's phrase (2001, 65–78) that are *purely* intentional by conflating two *properly* intentional objects.

Considering this minor but important digression, it is still both correct and relevant to consider the sacred as "intention," possibly a "purely intentional object." That is, as an intentional reference of the human mind, an ascription or attribution, leaving aside for the moment the question (properly addressed by metaphysics and theology) of the existence, nature, and status of its object. As Husserl says, "*this concept of consciousness can be seen in a purely phenomenological manner, i.e. a manner which cuts out all relation to empirically real existence*" (Vol. 2, V, §. 1, 537, emphasis original). In the terms that I have adduced above, the intention is of the nature, character, or "personality" of reality—that to which our emotional intelligence responds.

Most importantly for present purposes, and continuing to follow Eliade's analysis, my analysis of the sacred as the religious "special," can also be seen to leave aside the question of the putatively independent ontological status of the sacred as referent, equivalent to the accuracy of our representation of its character, in favor of a concentration upon observable human behavior, including claims (verbal behavior) that some sacred or divine presence is apprehended in the special objects or events venerated in religious traditions. As Eliade repeatedly states, "the sacred is an element in the structure of (human) consciousness" (1969, i, 1977, 313, 1978a, xiii). Understanding the sacred in this way implies an analysis of the equation of the sacred and the real such that "the real" is *also* interpreted as an intentional object of human apprehension,

a "structure of consciousness," that may also be "pure" or "proper." It might be argued that the sacred is not intersubjectively verifiable, and is therefore clearly *not* "real" (that is, not a properly intentional object). However, simply to identify the real with the intersubjectively available and empirically verifiable is an unacceptably narrow philosophical position that is not without problems, and, more to the point here, it was not the position to which Eliade's analysis of religious behavior led. While there are a great number of empirically available entities that the majority of human agents can be relied upon to identify as "real," there remains a vast area of disagreement and of categories of dubious ontological status whose very existence indicates that "reality" is also an intention that is attributed by human agents to some experiences and not to others.

Eliade's observation of religions led him to conclude that *sacrality* is a category that is apprehended by some people in some experiences while simultaneously remaining unrecognized by others in what is empirically the same experience. As he said,

> à savoir qu'un miracle n'est évident que pour ceux qui sont préparés, par leur propre expérience et leur propre culture religieuses, à le reconnaître comme tel. Pour tous les autres, le « miracle » n'est pas évident, il est donc inexistant; en effet il reste dissimulé dans les objets et dans les événements quotidiens. (Awareness of a miracle is only straightforward for those who are prepared by their personal experience and their religious background to recognize it as such. To others the "miracle" is not evident, thus it does not exist; in fact it remains concealed in mundane objects and events.)
>
> (1978b, 7)

And further,

> By manifesting the sacred, any object becomes *something else*, yet it continues to remain *itself*, for it continues to participate in its surrounding cosmic milieu. A sacred stone remains a *stone*; apparently (or, more precisely, from the profane point of view), nothing distinguishes it from all other stones. But for those to whom a stone reveals itself as sacred, its immediate reality is transmuted into a supernatural reality.
>
> (1959a, 12)

Thus "the sacred" is seen as a characteristic attribution of certain intentional states, specifically the characteristic of apprehending certain objects and events as revealing the reality, meaning, and truth of the unseen nature or character of the world, the personality of reality. One need not have any particular religious sentiment, nor agree with the apprehension, to recognize this, but simply an understanding of religion as involving, by definition, that intentional affect and the ascription of "specialness" to those items that are apprehended as "revelatory" in this way. While it is naïve to assume without

question the existence of the sacred as an independent agent, it is equally naïve to assume that Eliade's attribution of reality to the sacred was so unsophisticated. Equally naïve would be the *denial* of all reality to the sacred since it unquestionably exists as the intention of a definable area of human experience, which, like the attribution of beauty, can be argued to be a response to some objective characteristic.

This recapitulation of the nature of the sacred for Eliade is necessary to my main concern here, which is to consider the *perception* of the sacred in the profane as a compound effect of art-related behavior. Eliade understood that *homo religiosus*, the specifically religious subject, in some way perceives the presence of the sacred in objects of devotion. His description of the sacred as the perceived source of reality, being, meaning, and truth implies the identification of the sacred as the intention of a certain type of subjective experience. He says, "every rite, every myth, every belief or divine figure reflects the experience of the sacred and hence implies the notion of being, of meaning, and of truth" (1978a, xiii). From the early 1930s on, he made clear his understanding of all lived physical experience as not *inherently* meaningful. He perceived a human need to transform ordinary, run-of-the-mill experience into "authentic" experience, expressive of the "truly real," as common to both his Romanian intellectual friends and to the Indian yogis and the popular devotees whom he had encountered in India. "Normal, everyday experience is seen as illusory, unreal, profane ... Yet that same experience, *when apprehended in a specific way*, when *interpreted* in a certain manner, becomes authentic, real, sacred: it becomes an hierophany."[5]

A passage by Eliade on the veneration of the *liṅgam* (a symbol of the god Śiva, often identified as a phallus) by tribal peasant women (Eliade 1982, 55) has interesting implications. Mac Linscott Ricketts comments that Eliade, "seeing how the *liṅgam* ... could evoke religious sentiments on the part of women and girls in India, ... was able to understand the veneration of icons in Orthodox churches—something he had regarded previously as 'idolatry'" (Ricketts 1988, 362). Despite his support for Orthodox Christianity, until his visit to India Eliade had not sympathized with one of its most beloved and widely practiced rituals, the veneration of icons. It was Eliade's understanding of Hindu veneration that enabled his understanding of his own tradition. I suggest that this is an example of what I seek to explain about Eliade's understanding of religious symbolism: for Eliade his own "profane" or mundane experience of Orthodox worship, previously meaningless to him, is made meaningful by his experience of Indian devotion. Previously he did not know how to respond to it, what to make of it. Thereafter he did.

Both Eastern Orthodox and Hindu traditions provide examples of empirical experience as the source of a perceived access to the sacred. The icon and the *liṅgam* are, on one level, mundane empirical perceptions. That is, to the human subject outside of the tradition they are without transcendental referent or special significance—they lack sacred intentionality.[6] Nonetheless, they are observably the focus of communal behavior indicative of a

perceived revelation of the sacred to their worshipers, for whom they exist embedded in an extended matrix of stylistically related, skillful presentations and so possess a correspondingly greater emotional affect. This observation is foundational to Eliade's thought and, I argue, to an understanding of the relation of art and religion capable of integrating all of the recent observations and analyses so far discussed. This understanding implies that, isolated and *uninterpreted*, physical perception is without meaning—it is unreal, illusory, profane (banal). That is, it does not generate emotionally assured behavior in response. William James' association of behavior and meaning mentioned earlier is highly significant: any perceived event can be said to be meaningless if one lacks a sense of appropriate behavioral response to it, if it not "fitted to produce" any specific conduct (James 1902/1961, 427). Such "profane" perception is, nonetheless, the only possible source of our perceptions of the real, the true, the meaningful—the "sacred"—and the emotionally assured response. Hence the experience of the sacred has often been described as a simultaneous and paradoxical coincidence of opposite experiences: it can only be *both* sacred and profane.

Eliade came to this understanding relatively early in his life. As Romanian Orthodox, he had long been exposed to the Romanian church as a multi-media performative theater intent on inducing—via narrative, visual, and dramatic representations of elements of their tradition—transformative "sacramental" experiences. This had not changed his own fundamentally "modern" inability to perceive these representations as hierophanies. The journal of Eliade's Portuguese years, for example, "is replete with explicit comments and affirmations that show Eliade to have been a man of definite convictions on many religious points … [although he] did not engage in conventional religious practices" (Ricketts 2006, 27). In a fascinating attempt to derive Eliade's religious beliefs from his written statements Ricketts reveals that Eliade, in fact, considered himself a "pagan" unable to believe in Christianity, although Eliade considered this to be a "tragedy" (Ricketts 2006, 27). Nonetheless, the Eastern Church sensitized the young Romanian to the potential of religious representation as an experience that influences the behavior of its audience, including the production of presentations of an apprehension of the "real," "the sacred" in their empirical experience—that is, accounts of revelations. Both the orthodox icon and the Hindu *liṅgam* are evidently experienced by those who venerate them as something more than their experience gives to others—they are vehicles for the perception of the sacred. They may be described as being, at least to the properly prepared audience, hierophanies, agents determinative of future behavior.

Every effective and functioning religious symbol is a hierophany, that is, in terms of the current analysis, it may be utilized to account for the persistent behavior of those for whom it constitutes a "revelation of the sacred" or the really real. It is in his analysis of symbols that Eliade is most specific about his understanding of the apprehension of the sacred. (Although, of course, what holds true for symbols also holds true for myths and rituals, since they

are themselves systems of religious symbols in narrative or dramatic form.) Eliade's most precise exposition of symbolism occurred in an article of 1959, "Methodological Remarks on the Study of Religious Symbolism" (also in Eliade 1965, 201–211, and Rennie 2006, 132–140). Here he explains that

> A symbol is not a replica of objective reality. It reveals something deeper and more fundamental. ... Symbols are capable of revealing a modality of the real or a condition of the World which is not evident on the plane of immediate experience. ... let us take an example: the symbolism of the Waters, which is capable of revealing the pre-formal, the potential, the chaotic. This is not, of course, a matter of rational cognition, but of apprehension by the active consciousness prior to reflection. It is of such apprehensions that the World is made ... it is not a question of considered knowledge, but of an immediate comprehension of the "cipher" of the World. The World "speaks" through the medium of the [symbol], and its "word" is directly understood.
>
> <div align="right">(1959b, 97–98, 1965, 201–202; Rennie 2006, 133)</div>

Symbols, according to Eliade, allow people to become conscious of alternative modalities of the real, which I suggest to be homologous to personality traits or character insofar as our theory of mind or emotional intelligence responds to them. They "disclose to us a perspective from whence things appear different." They "make the immediate reality 'shine'" (Eliade 1986, 6). In an explanation of "The Structure and Morphology of the Sacred" from *Patterns in Comparative Religion*, Eliade argues that

> this paradoxical coming-together of sacred and profane, being and non-being, absolute and relative, the eternal and the becoming, is what every hierophany, even the most elementary, reveals. ... This coming-together of sacred and profane really produces a kind of breakthrough of the various levels of existence. It is implied in every hierophany whatever, for every hierophany shows, makes manifest, the coexistence of contradictory essences: sacred and profane, spirit and matter, eternal and non-eternal, and so on. ... the sacred may be seen under any sort of form, even the most alien.
>
> <div align="right">(1958, 29; Rennie 2006, 54)</div>

The apprehension of some physical perceptions, which are, as material perceptions, mundane and ordinary, as being authentically communicatory of a sacred reality that is simultaneously concealed and revealed within them is characteristic of Eliade's understanding of religion. We can now add to that the insights from the ethology of art. Symbols—which can be simple visual sigils, elaborate dramatic rituals, or special narratives of varying complexity, are initially made special by the processes of "artifying." They attract and retain our attention initially as beautiful in the sense proposed in the preceding

chapter, promising to repay that attention, and they continue to do so because of their location within an extended matrix of stylistically related forms that amplify and reinforce the effect of their attraction. The initial process may be regarded as secular and unconnected with religion, since it has not necessarily attained that "critical mass" of compound ascriptions that enable and empower religious institutions. However, when multiple symbols attain that critical mass they engage mental processes like "theory of mind" by which we cognize the personalities of our conspecifics so as to produce a behavioral response. Adherents will continue to pay attention to, to focus their ongoing behavior upon, and to behave in response to, these symbols, which, for them, contribute to the communication and revelation of the *nature* of the real—thus providing adherents with an assured sense of how best to behave in response to the collective total of their physical perceptions.

Part two: seeing the invisible

This experience of our environment as inducing experiences of differential significance can, with the help of insights from ethology and cognitive science, be both explained and understood and can also be seen as a now precisely meaningful example of "seeing the invisible." This provides a potential or partial explanation of the concept broached in my introduction as part of the "problem" of the relationship of art and religion: the variety of claims concerning the ability of art in connection with religion to enable "seeing the invisible," revealing the infinite in the finite, expressing the inexpressible, and so on. Such claims are often seen by secular scholars to be simple figures of speech denoting a special emotional response, or, by the more materialist and politically minded, as obfuscatory mystical mumbo-jumbo that seeks to gain an otherwise unwarranted privilege for a particular discourse. However, involving the understanding of "theory of mind" and of art as a window into the mind of others we can begin to make better sense of it.

This "perception of the imperceptible," as well as being connected to the theory of mind that enables an apparent perception of the inner state of the other, can also be seen as the epistemological equivalent of the optical effect of pattern recognition. When exposed to a confused or imprecise perception in which the "noise" overcomes the "signal," we may not initially perceive the information contained in the experience. No clear response to the perception will be suggested. However, once another stimulus is supplied in the form of some semantic input so that the signal overcomes the noise, the appropriate response will become clear. The meaning of the perception will be apprehended. This sort of conceptually determined or paradigm-determined perception is known as "apperception," that is, a physical perception whose affect or significance is determined by experience other than the perception itself, and is thus experienced differently by differently prepared subjects. Thomas Kuhn argued in his *Structure of Scientific Revolutions* that even in the hard sciences, "paradigms determine large areas of experience" (1962, 129).

Without appropriate prior conditioning experience, some subjects will continue to be unaware of implications of a given experience that are apparent to others. That is, in specifically religious terms, they will experience no apperception of the sacred *meaning* of otherwise mundane physical perceptions— they will have no clear idea of how to behave in response to it. As we have seen: "[a]wareness of a miracle is only straightforward for those who are prepared by their personal experience and their religious background to recognize it as such. To others the 'miracle' is not evident, it does not exist" (my translation from Eliade 1978b, 7). Looked at in this way religious myths, symbols, and rituals can be seen as deliberately manipulated and communicable experiences, the aim of which is to transform our normal, mundane perception of the world into a perception (or more properly an apperception) that stimulates an emotionally assured behavioral response.

Eliade explicitly recognizes that in such cases "the meaning is in the mind, as the phenomenologists would say," but he adds that, "it is not a *creation* of the mind" (1973, 103; Rennie 2006, 59, emphasis added). In order to explain further what I am suggesting here, let me refer to certain other optical effects, specifically these well-known Kanisza figures.

Here, the perception of the line is in the mind, but it is not solely a *creation* of the mind, it is strongly suggested by the data. These Kanisza objects demonstrate that it is often misleading to distinguish too strongly between experience and the interpretation of experience, between the perception and the implication of the perception. As far as I am aware, all sighted human subjects perceive the dividing line between the inner and outer areas of the implied shapes (which lines do not exist as an external physical stimulus or a properly intentional object). Likewise, the great majority will agree on the perception of a cow and a dog (and *only* a cow and a dog) in the earlier illustration. By contrast, the implication of the religious symbol, the apprehension

Figure 6.2 Visual Signal-to-Noise. Such images are usually not recognizable until the subject is told what they are. Then they become instantly and permanently meaningful. The left-hand image is a cow and the right, a Dalmatian dog sniffing among fallen leaves. The additional stimulus of the names is (usually) required to enable the perception.

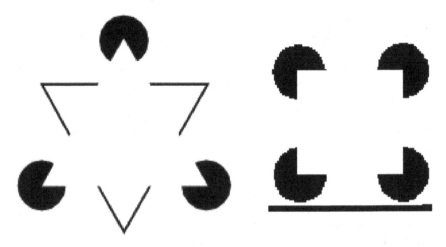

Figure 6.3 Left and right: Kanisza Figures in which the suggested shape is strongly perceived by the subject although not empirically present to the senses.

of the sacred, is *not* uniform or universal. Nor, of course, is it as simple as the optical effects that I have used to illustrate these ideas. The cow and the Dalmatian were deliberately and consciously formed into these challenging images and are "really" (that is, intersubjectively, verifiably) there. When it comes to religious symbols, which can only exist as part of a physically and temporally extended matrix of stylistically related items, there is no "God's-eye view" from which to determine what is "really" there. The operation of religious imagery is something more like a combination of these two effects, in which "personal experience and religious background" serves to condition the apperception of the sacred—so different people apprehend different things. Like the Kanisza figures, what we seem to perceive is genuinely suggested by actual perception, but not to everyone. Of course, the ultimate litmus test of the "reality" of one's cognitions is, in ethological terms, survival and reproduction and the concomitant persistence of behaviors determining and determined by that cognition.

Similarly, Eliade's analysis of symbols suggests that the apperception of the sacred is not simply arbitrary or delusory (even if fictional), because it is based on our communal experience of the world and what that experience reveals to us. For example (please pardon the dated, gender-exclusive language):

> Before the discovery of agriculture, man did not grasp the religious meaning of vegetation. But with the discovery, man identified his destiny with the destiny of a plant; he translated the meaning of human existence into vegetative terms. As is the case with a plant, I am born from a seed, I will die, I will be buried, and I will come to life again. This meaning is certainly in the mind, yet it could not have developed

before the discovery of agriculture. At the same time we cannot say that this religious intentionality of the vegetation is a creation of the mind; it was already there in the fact that vegetative life starts from seeds, goes into flower and then dies and comes again. The intention is there and that intention is grasped by the human spirit, but it is not invented or created by the human mind because the intention is in the agricultural process.

(1973, 103; Rennie 2006, 59)

This is emphasized in Eliade's article on the symbolism of the arrow, where he points out that "[n]o conquest of the material world was effected without a corresponding impact on human imagination and behavior" (1968, 465, 2006, 143). Similar to the discovery of agriculture, the discovery of the bow and arrow provided human cultures with images, effects, and relationships previously unthought-of. All new material technologies, like steam power and personal computing, make possible a range of symbolism that is not simply a creation of the mind but is (like the lines in the Kanisza illusion) suggested by the data of empirical experience and suggestive of the nature of the real. The *implicit meaning* of the experience is not simply the same thing as the physical perception of the experience, but recognition that some such meaning informs the experience.

Eliade also adds that,

an essential characteristic of religious symbolism is its multivalence, its capacity to express simultaneously several meanings the unity between which is not evident on the plane of immediate experience. The symbolism of the Moon, for example, reveals a connatural unity between the lunar rhythms, temporal becoming, the Waters, the growth of plants, women, death and resurrection

(1959b, 99; Rennie 2006, 133)

and "[e]very hierophany we look at is also an historical fact. Every manifestation of the sacred takes place in some historical situation. Even the most personal and transcendent mystical experiences are affected by the age in which they occur" (1958, 2; Rennie 2006, 43). Given this addition, it is necessary to add another layer of hopefully suggestive visual imagery to extend the explanation of this understanding of the perception of the sacred in the profane. Profane experience resembles an ambiguous (or, rather, polysemic, "multivalent") image—Wittgenstein's Duck/Rabbit image is a famous example, but there are plenty of other examples.

Not only is there an ambiguity between the sacred or meaningful apperception and the profane or meaningless empirical perception, but there is also a multitude of potential interpretations of our empirical perceptions, corresponding to a multitude of potential behavioral responses. The specific "apperception of the sacred" is a creative response, necessarily shaped and colored by the historical situation in which it occurs (it does not empirically

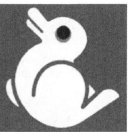

Figure 6.4 Left: *The General's Family* by Octavio Ocampo (1990 used with permission of Visions Fine Art: Publisher/Agent/Representative for Octavio Ocampo USA). Right: the Wittgensteinian "Duck/Rabbit." Like ambiguous or polysemic images, lived experience is multivalent, as is the religious symbol, and more than one meaning can authentically be seen in the "profane" or empirical experience.

differ from the historical situation in which it occurs), involving the production of further presentations utilizing the same stylistically related components. However, as creative, the apperception of the sacred is always *more* than that historical situation and remains cognizable to those who have experienced it. Once one has "seen" the sacred—or the cow—the prior perception of the image as meaningless is *different*, it has effectively become something else. For Eliade, the hierophany is always an *anamnesis*, an unforgetting, because one does not actually "see" anything "new" but rather "unforgets" or realizes the meaning of what was already there, as one recalls the duck/rabbit or the old man/peasant couple or realizes that the cow was there all along.

This is what the study of religion, as Eliade understood it, is about—the (ap)perception of experiences as meaningful—in the terms of this analysis, as

implying an appropriate behavioral response. This is, in part, why the religious cannot be reduced to the economic, the psychological, the political etc. The economic, psychological, and political are *specific strategies* of meaning-recognition, specific ways in which the empirical data of physical perception and lived experience can be rendered more-or-less meaningful by prior attentive focus upon specific, "cooked" experiences organized in a particular tradition. The *general category* of such recognition, what I am calling the apperception of the sacred in the profane, is the specifically religious activity, which (by definition for Eliade) centered upon the hierophany that provokes that apperception. To interpret Eliadean "non-reduction" as insisting on the ontological autonomy of the sacred merely perpetuates and compounds an overly simplistic and inaccurate reading of his understanding of the sacred and the real.

There is another way in which the study of religion might be seen as "irreducible." That is, it involves an unavoidably subjective component necessitating an aesthetic appreciation. The Oxford social anthropologist, Rodney Needham, recognized that anthropologists cannot describe anyone's "attitude to God, whether this was belief or anything else ... it was one thing to report the received ideas to which a people subscribed, but it was quite another matter to say what was their inner state (belief for instance) when they expressed or entertained such ideas" (1972, 1–2). According to philosopher and cognitive scientist, Daniel Dennett, this signals a "need for recasting anthropological theories as accounts of religious behavior, not religious belief" (2006, 239). Dennett also recognizes that "people need to see their lives as having meaning. The thirst for a quest, a goal, a meaning is unquenchable, and if we don't provide benign, or at least nonmalignant avenues, we will always face toxic religions" (2006, 334). So Dennett encourages both the focus on behavior and the importance of meaning. As an internal, individual, and non-intersubjective phenomenon, meaning is not fully accessible to purely scientific theorizing, even though it issues from empirical experience and in empirical behavior.

This understanding of the role of religion might be thought unavoidably to doom researchers in religion to inescapably fruitless speculation about the content of other people's minds (specifically their "*pisteuma*" as Raimon Panikkar has called it—the content of people's faith-based apprehensions, Panikkar 1989). Happily, this is not the case. Just as "behaviorists were meticulous about avoiding speculation about what was going on in *my* mind or *your* mind, or *his* or *her* or *its* mind" (Dennett 1991, 70), so the phenomenologist of religion can be likewise meticulous. Dennett explains that minds "are not among the data of science, but this does not mean that we cannot study them scientifically ... The challenge is to construct a theory of mental events, using the data that scientific method permits" (1991, 71). He calls this "heterophenomenology" and describes it as "a method of phenomenological description that can (in principle) do justice to the most private and ineffable subjective experiences, while never abandoning the methodological

scruples of science" (1991, 72; see Rennie 2012 for my own application of "heterophenomenology" to the study of religion). This method "makes no assumption about the actual consciousness of any apparently normal adult human beings" (Dennett 1991, 73). Dennett goes on to consider the role of verbal interactions in empirical psychological or neurological studies. In, for example, preparing a written transcript of some such experiment from an audio record, we are interested in the sounds "that are *apparently* amenable to a linguistic or semantic analysis" (74, emphasis original). In so doing, he points out, "we move ... from one world—the world of mere physical sounds—into another: the world of words and meanings" (74). I would argue that, in Eliade's terms, this is equivalent to a move from the profane to the sacred. This "yields a radical reconstrual of the data" (75) and Dennett asks, "[w]hat governs this reconstrual?" (75). Obviously, in Dennett's example, "it depends on assumptions about which language is being spoken" (75). It is based upon such assumptions that the raw data of physical sounds can be "purified" into formal expressions and we can "'make sense' of the sound stream in the process of turning it into words" (75). The history of religion is a process of making sense of the raw data of our observation of religious phenomena in the same way as I have attempted to "make sense" of the texts of Eliade, and religion itself is a comparable process of making sense of the world of our lived experience (Rennie 1996, 1–6). A large part of the process involved is, as Dennett insists, amenable to a linguistic or semantic analysis. However, I would argue that it cannot be *reduced* to this analysis *without remainder*. The unavoidable aesthetic and emotional components determine our behavioral responses in ways that are simply *not* amenable to a linguistic or semantic analysis.

Dennett recognizes that such "making sense" is not final; that is, it does not necessarily "proceed all the way to understanding" (76). The linguistic process might stop at word recognition with no understanding of the further implication of those words. However, even in that case "we must move beyond the text" (76) as a purely physical entity. Where Dennett is more precise that we must interpret the empirical text as "a record of speech acts" (76), Eliade spoke more vaguely of the *meaning* of the religious text. "We must treat," says Dennett, "the noise-emitter as an agent ... who harbors beliefs and desires and other mental states that exhibit *intentionality* ... and whose actions can be explained ... uttered noises are to be interpreted as things the subjects *wanted to say* ... meant to *assert*" (76). Similarly, we must treat our entire lived experience, the "noise-emitter" that finally "tells" us how to behave, as an agent (or collection of agents) apparently exhibiting intentionality—and the ancestral behavior of art and religion ensures that we do. No matter how detailed our clinical investigations of religion may become, there will always be a remainder that concerns this "meaning" and that involves the speculative (re)presentation of this inaccessible, subjective, intentional state, homologous to differential perceptions of an individual's character or personality, which remains irreducibly creative and variably skillful.

It would not be surprising to consider at this point some more complex version of Friedrich Max Müller's assertion that religion is a disease of language (see, for example, Sharpe 1975, 40–43). Since human agents are so accustomed and, indeed, neurologically "programmed," to make sense out of language, we are misled into assuming that non-linguistic aspects of our experience likewise "make sense" and "communicate" meaning to us. The arguments from the ethology of art, however, indicate that it is a more-or-less unavoidable concomitant of representational consciousness that has potentially beneficial consequences. This would certainly be consonant with Eliade's frequent assertions that religion is a human universal. As he says:

> If, in the history of religions, the idea of the sacred is related to the idea of being and meaning, the historian of religions—who is also a phenomenologist because of his concern with meaning—will eventually discover something which has not always been evident: that the sacred is an element in the structure of human consciousness. … man simply discovers himself in the world, that the structure of his consciousness is such that somewhere in his experience there is something absolutely real and meaningful, something that is a source of value for him. As far as I understand it, the structure of human consciousness is such that man cannot live without looking for being and meaning. If the sacred means being, the real, and the meaningful, as I hold it does, then the sacred is a part of the structure of human consciousness.
>
> (1973, 101; Rennie 2006, 58)

Again, Eliade can be seen to agree with Dennett's approach to the extent that both insist that "people need to see their lives as having meaning" (Dennett 2006, 334) and both attempt to "get at what these people are experiencing" (Dennett 1991, 78). Of course, Dennett continues (and I agree) that "[w]e can't be sure that the speech acts we observe express real beliefs about actual experiences; perhaps they express only *apparent* beliefs about *nonexistent* experiences" (78). However, certitude in that respect is not required—we can observe the retention and protention of, and behavioral responses to, creative presentations. The phenomenal fact that people behave in specific ways and make specific claims is more important than any hypothesized intentional state "behind" that fact. As Dennett says, "[w]e can compare the heterophenomenologist's task of interpreting the subject's behavior to the reader's task of interpreting a work of fiction" (79). Similarly, Eliade held that "it is regrettable that historians of religion have not yet sufficiently profited from the experience of their colleagues who are historians of literature or literary critics" (1969, 4). They are both conscious of the similarity of the analyses of literature and of religion. Works of fiction only weakly imply the ontological independence of their characters whereas the autonomy of their characters is strongly asserted by religious texts and their adherents—especially in the monotheist West. That is characteristic of the difference between the special

in art and in religion, between beauty and the sacred. A focus on the human origins and literary nature of the religious text is assumed to reduce its ability to work its persistent effect. This does not change the role of the heterophenomenologist whose task is to interpret both the human origins and the sacred effect. The heterophenomenologist "lets the subject's text constitute that subject's heterophenomenological world, a world determined by fiat by the text ... The subject's heterophenomenological world will be a stable, intersubjectively confirmable theoretical posit" (Dennett 1991, 81). The "text" for the historian (and philosopher) of religions is not only the sacred symbol, ritual, or scripture that inspires the believer (although it involves that), but is the record of the believers' behavior as expressive of their subjective experiences.

Dennett considers the hypothetical case of certain "anthropologists who were to discover a tribe that believed in a hitherto-unheard-of god of the forest called Feenoman. ... Feenoman is being treated as merely an 'intentional object,' a mere fiction so far as the infidels are concerned" (1991, 82). However, the "heterophenomenological method neither challenges nor accepts as entirely true the assertions of subjects, but rather maintains a constructive and sympathetic neutrality, in the hopes of compiling a definitive description of the world according to the subjects" (83). Of course, the subjects may insist that, not only do the objects of their assertions really exist as autonomous entities, but also this is a point of crucial importance. Again, that may contribute to, but does not fundamentally change the heterophenomenological undertaking to describe the subjective world of the subject and to thus access its meaning—what conduct does this produce?

The point of this digression into the thought of Daniel Dennett here is that, despite the criticism of Eliade's insistence that religion is a meaningful, irreducible, *sui generis* phenomenon, none of Eliade's consideration of the sacred as definitive of religion fundamentally contradicts the observations of more recent reductionist theorizing in the academy. Dennett's 2006 volume, *Breaking the Spell*, concentrates entirely on the cognitive study of religion.[7] Its principal thesis is that empirical and clinical observations and experimentations can be performed to evaluate whether or not religious behavior is genuinely adaptive, that is, contributory to human reproduction and survival. This assertion raises a series of questions: first, can effective empirical experimentation be done to determine whether some behavior *was* adaptive in the past, even though it might have become maladaptive now? Second, is the understanding and implicit definition of religion which Dennett (et al.) applies accurate, or is it a manifestation of the profoundly misrepresentative modern Western conception? Third, is human reproduction and survival, as assisted by actual adaptations, exhaustive of value? Finally, nothing is achieved by denying the existence of the sacred if it is seen as the implicate order of natural, physical (profane) reality, as apperceived in various ways by various traditions as an agent to which we have no choice but to respond and to which we might respond better or worse.

There is little doubt that Eliade considered religion in general to be a positive good, even though Ricketts (2006) has shown that he had no personal commitment to Christian metaphysics. Eliade's analysis, as I have interpreted it, would allow that, while specific religious traditions might be non-adaptive "byproducts," religious behavior in its most general sense is adaptive—emotionally assured and persistent behavioral responses have proven very effective in ensuring human survival and reproduction in the past. It was in this most general sense that William James defined religion as, "the belief that there is an unseen order and that our supreme good lies in harmoniously adjusting ourselves thereto" (1902, 69). In this most general sense, the apperception of the sacred would be the apprehension of some "order," specifically some order to which we can "harmoniously adjust" our behavior to our own ultimate benefit, and this may be seen as self-evidently adaptive. The religious symbols (myths and rituals etc.) of specific traditions can be seen as attempts to present experiences conducive to apperceptions of that order. This undoubtedly leads to byproducts specific to local cultures that may be, as Dennett describes them, mutualist, commensal, or parasitic (2006, 84); that is beneficial, neutral, or harmful. However, the general apperception of an orderly whole to which we can respond coherently and consistently, makes a strong claim to being adaptive, since it permits a confident, consistent, coherent, and at least partially predictable response. It harnesses our ability to cognize the character of other people, and it is homologous to our ability to perceive meaning in the orderly, rule-governed nature of human language. Both of these are kinds of apperception since they require a considerable amount of preparatory experience to occur. Both of them are forms of "seeing the invisible."

It is conceivable that clinical tests and empirical studies could be designed to investigate the adaptability of a function of the human mind that seeks consistent order and emotional affect in experience. Such a function would, no doubt, be closely connected to the "causal reasoning" and "theory of mind" functions already mentioned. It might, indeed, be more or less identical to them. It is interesting to note that Eliade commented in his journals on the "exile returning to Ithaca" who represents all of humanity in our "search for the center." It is better, he said, to recognize meanings and see signs *even if they are not there* (1977, 85—Eliade expounds on this theme further in his short story, "Incognito la Buchenwald" (written in 1974), in which his characters are forced to "interpret" meaningless water stains on a wall. Although this raised the ire of, for example, Ivan Strenski (1982, 392ff.) as an example of the apparent willful proliferation of non-entities, perhaps, if it is read as an existential need to (ap)perceive some *zusammenhang* to our experience that reveals clues as to how we might confidently respond, rather than leaving us clueless and aimless, it becomes more comprehensible and acceptable.

It is not my claim that Eliade somehow anticipated cognitive theories of religion. I simply seek to show that an understanding of the sacred as definitive of religion is not undermined by cognitive theory. It is, on the contrary, *complementary* to it. Cognitive theory indeed provides evidence of the

coherence of this position on art and religion. In this way, religious symbols, myths, and rituals may not themselves be historically accurate or physically veridical and so they might appear to be inaccurate misunderstandings and misrepresentations of the world and acting as if they were not would appear maladaptive. However, as Eliade said, "a symbol is not a replica of objective reality [but] reveals something deeper and more fundamental" (1959b, 97, 1965, 201; Rennie 2006, 133). Symbols, myths, and rituals are physical, perceptible items that "fine tune" our apperception of the world enabling the cognition of a consistency and coherent character to which our behavior can conform. The image of "tuning" is taken from Wassily Kandinsky's *Über das Geistige in der Kunst* where he says that

> die "Stimmung" des Werkes kann die Stimmung des Zuschauers noch vertiefen—und verklären. Jedenfalls halten solche Werke die Seele von der Vergröberung ab. Sie erhalten sie auf einer gewissen Höhe, wie der Stimmschlüssel die Saiten eines Instrumentes. (The mood [literally the "voice"—the way it *speaks* to one] of the work [of art] can deepen—and clarify—the mood of its audience. At least such works of art stop the soul from coarsening. They tune it to a certain pitch, as the tuning-key does the strings of an instrument.)
>
> (1911, 5)

Religious symbols can be seen as catalytic "seminal experiences" that cumulatively enable the recognition of a *meaning* in experience, just as the words "cow" and "Dalmatian" enabled our recognition of the content of the confused images above, or as Eliade's experience of Hindu devotees "fertilized" his understanding of Eastern Orthodox devotions. This also constitutes a significant contribution to our understanding of the relationship of religion and art. Religious art particularly and explicitly uses traditional forms—elements embedded in an extended matrix of stylistically related and skillfully wrought presentations—to enable and encourage the apperception of a specific "sacred" in mundane experience as something to which we can confidently respond.

It does not require a great deal of imagination to understand the evolutionary contribution of perceiving (or apperceiving) human experience as having some meaning as opposed to none, as soliciting some coherent and consistent response to the human situation as opposed to none, and as suggesting some potential resolution to the human dilemma. Eliade's understanding of religious symbolism goes some way toward suggesting how such imaginary, or imaginal, responses to our environment might be "true" in the sense of workable adaptations to the human condition, even if their historical accuracy or physical factuality is unverifiable or even obviously false. He consistently stresses the imaginary as effective. As we have already seen, he insists that "no conquest of the material world was effected without a corresponding impact on human imagination and behavior," and he adds

to that, "I am inclined to add that the reflections of the objective conquests upon such imaginary Universes are perhaps even more important for an understanding of man" (1968, 465, 2006, 143). In *The Quest* he points out that initiatory motifs and symbols "partake of an *imaginary* universe, and this universe is no less important for human existence than the world of everyday life" (1969, 121, emphasis original); and in *Images and Symbols*: "that essential and indescribable part of man that is called *imagination* dwells in realms of symbolism and still lives upon archaic myths and theologies" (1961, 19, emphasis original). On a slightly different note, which serves further to explain his meaning and to support the consanguinity of religion and art, he states that "the novel must tell something, because narrative (that is, literary invention) enriches the world no more and no less than history, although on another level" (1977, 205).

That imagination is not only of great importance to art but also an integral part of religious life is indicated by Eliade's statement that "One can pass through a Symplegades[8] in so far as one behaves 'as a spirit,' that is to say shows imagination and intelligence and so proves oneself capable of detaching oneself from immediate reality" (1959b, 101; Rennie 2006, 135). This identifies "spiritual" existence with imagination and, specifically, with the ability to "detach oneself from immediate reality" (cf. Boyd 2009, 53, 180). For Eliade, "spiritual" existence is constituted by the specific human imaginative ability to become detached from immediately experienced reality, *Erlebnis*, or "history." This is his "escape from history," nothing more (or less) mystical than the ability to learn from that which one has not oneself experienced and, via "spiritual" discipline, to avoid the purely physical effects of causal determination and to see the world as something other, something more, than merely the sum of physical perceptions. At one extreme, this might possibly enable astonishing feats, like sitting naked on a glacier for days, at the other it is simply not allowing the quotidian pressures of life to "get you down" (which may, in the end, be no less astonishing a feat given human neuropsychology). One "escapes from history" every time one smiles in the face of adversity or performs any act that is not directly determined by historical/empirical preconditions (such as making any sacrifice). This can most effectively be accomplished with reference to the object of religious belief—the sacred—as apperceived in and through the mundane world as transformed by religious myth, symbol, or ritual. When one actually experiences the world as infused with meaning, possessed of a compelling causal narrative, having a consistent character, one can react to it with more confidence, control, and consistency, and assurance that one is "doing the right thing."

Our ability to "escape history" in this way is directly dependent on our relationship to imaginative narrative. One illustration that I have already employed to explain this was taken from Martin Seligman's 1975 book, *Helplessness* (Rennie 1996, 223–224). "Helplessness" is the condition in which an experimental subject acquiesces and no longer makes any attempt to avoid "powerful negative stimuli" (suffering). This condition is induced relatively

easily in subjects that have no way to control the suffering. Given some meas-
ure of control, subjects are considerably more resistant to such "helplessness"
(this applies to a large range of animals as well as to people) but continue to
strive for an improvement of their condition, no matter how elusive con-
trol may be. In an empirically controlled experiment Seligman reported that
"merely telling a human subject about controllability duplicates the effects of
actual controllability" (48). In other words, a story which one is told *can have
the same effect as if it were a part of the world of real experience* (and Seligman was
clear that it does not have to be "true" in the sense that it does not have to be
factual or historically accurate). Stories, *as stories*, are in fact part of the world
of experience. By dint of imagination and the apperception of the sacred in
the profane the human spirit can be seen to "escape history," to be "detached
from the immediate reality," to be "autonomous" in that it is not wholly de-
termined by its physical environment but contributes, through the creative
generation of skilled behavior, to the construction of its own determining
environment. Imaginative creations become a component part of the condi-
tioning factors in human experience, and one which history reveals to be of
the greatest significance.

Even as concepts, an imaginative fiction in the sense indicated here, an in-
tention, religious concepts, such as "God," the Dao, karma, are infinitely
creative entities, agents of unbounded imaginative fertility, capable of sup-
porting a wealth of imaginary universes and providing powerful exemplary
models. Once the idea of God has been conceived, it is eminently possible
to conceive the idea of heaven, paradise, etc., that is to say a mode of being
in which humanity is not entirely conditioned or limited by our actual, his-
torical, and physical state. It can quite credibly be suggested that if one *cannot*
imagine an eternal and perfect state of human existence then one cannot
have really imagined, or imaginatively realized, the idea of God, one has not
cognized the character of reality.

To those who, conditioned by their own experience of specific alternate
skillfully-wrought representations that invoke a different apperception of the
real, insist on the self-evident nature of the empirical and the perceptible
as the ultimately real, Eliade's equation of the sacred and the real appears
simply wrong, as does his insistence that the religious cannot be reduced to
any other area of human analysis. From that perspective, the creative herme-
neutics of Eliade's history of religions may remain an unwarranted prolifer-
ation of imaginary non-entities. The meaninglessness of "religion" *from that
perspective*, however, clearly does not render religion meaningless from oth-
ers. The characterization of religion as the mere proliferation of imaginary
non-entities corresponds to a deliberate restriction of imagination, a denial
of meaning, a refusal of creativity and little else—a sort of cultural autism. If
it be accepted that the creative imagination and the various skills of cogni-
tion, representation, and reception have an effective role in inducing specific
apperceptions, then symbols, as creative, meaningful, pre-reflective devices,
are not *just* symbols but effective tools for directing and tuning perception

and thence behavior. If one recognizes that imaginary ideas have real effects then the restriction of an idea capable of significant effects to the imaginary is finally no restriction at all.

Studies have indicated that, for example, religious kibbutzim behaved more co-operatively than their secular counterparts, and that the distinction was greatest with those who attended synagogue daily (Sosis and Ruffle 2003a, 2003b). The authors of that study suggest that it is the public display of devotion that effects this distinction. The understanding of art and religion proposed here suggests that those who attend to religious ritual more frequently and more closely will be more effectively conditioned by that ritual to (ap) perceive their world as being possessed of a nature or character that will (naturally) respond most favorably to co-operative, obedient, self-sacrificing, and "righteous" behavior, and they behave accordingly. Their experience of the world, conditioned by religious myths, symbols, and rituals, is an apperception of the profane as suffused by the sacred and possessed of a predictable and reliable nature. Religious traditions can (please note that I am not saying that they all *do*) stimulate their audience to apprehend the world in which they live as a meaningful event to which the appropriate response is co-operation and altruism. In this way, in Eliade's words, it can "make the immediate reality 'shine'" (1986, 6).

If such an understanding of art and religion be adopted, what implications might this have for their study? No doubt the study will go on much as before with ethnography and philology leading the way, although ethology and neuroscience now have more to contribute. For methodologists and theorists (and philosophers of religion in the broad sense) there may be some fruitful implications. I agree with Dennett that empirical and clinical studies can and should be performed to distinguish the "mutualist" from the "parasitic" elements of religious traditions. As Dissanayake indicated, if "we see patterns of behavior that were adaptive in the original environment in which they evolved, and realize that they are maladaptive in present-day circumstances, we can set about trying consciously to change them (by cultural means)" (1988, 32)—but it is also implied that there is a complementary component to the study of religion that will remain for the foreseeable future irreducibly subjective or aesthetic, more akin to literary and artistic criticism, and indeed to literature and to art, than to any clinical procedure. In these ways, adding the insights of the ethology and anthropology of art to the cognitive science of religion and to an understanding of religion involving the Eliadean sacred could have considerable benefits.

Notes

1 The vegetative example is an intriguing challenge to facile distinctions between intentional and non-intentional skill. Is wheat "skilled" at producing food? Yeast may be an even greater challenge.
2 See Richard Wrangham's (2010) *How Cooking Made us Human*.

3 "(Re)presentation" may be a rather clumsy device. However, I will use it occasionally to maintain attention on the fact that what is (re)presented is not literally "presented again," since it may never have existed prior to and independent of its presentation. I occasionally use the term "presentation" to mean any art object or event.

4 Much of the following is derived from material originally published in Rennie (2007 and 2011).

5 Rennie (1996, 10, 11)—for a detailed consideration of the route by which Eliade came to this conclusion and of the idea of the hierophany as an appearance of the holy, see chapter one of that volume; it is also worthy of comment that "profane" is better understood as simply "banal" or "mundane," not as actively sacrilegious.

6 I will not say that they lack "specialness," since they might well provoke the *simple* ascription of specialness of the art object, but they lack the *compound* ascription of specialness that equates to the "perception of the sacred," the apprehension of a sense of the "personality of reality" that provokes a behavioral response.

7 Barbara Herrnstein Smith's *Natural Reflections* (2009) includes a wonderfully informative and insightful critique of Dennett's book as well as of other, overly materialistic, cognitive approaches to religion. I am in complete agreement with her that

> an adequate understanding of the religions of the world requires the sorts of historical, comparative, and interpretive approaches associated with the humanities as distinct from but not to the exclusion of, the experimental, quantitative, explanatory approaches associated with the natural sciences.
>
> (141)

8 According to Greek mythology, a pair of rocks at the mouth of the Bosphorus that Jason and the Argonauts negotiated safely, although they clashed together, threatening to crush any who would pass through. They have thus become a trope for any perilous undertaking.

References

Allen, Colin and Marc Bekoff. *Species of Mind: The Philosophy and Biology of Cognitive Ethology*. Cambridge, MA: Bradford/MIT Press, 1997.

Bekoff, Marc. *The Smile of a Dolphin: Remarkable Accounts of Animal Emotions*. New York: Discovery Books, 2000.

Bekoff, Marc and Colin Allen. "The Evolution of Social Play: Interdisciplinary Analyses of Cognitive Processes." In *The Cognitive Animal: Empirical and Theoretical Perspectives on Animal Cognition*, edited by Marc Bekoff, Colin Allen, and Gordon Burghardt, 432–434. Cambridge, MA: MIT Press, 2002.

Boyd, Brian. *On the Origin of Stories: Evolution, Cognition, and Fiction*. Cambridge, MA: Belknap Press of Harvard University Press, 2009.

Boyer, Pascal. *The Naturalness of Religious Ideas: A Cognitive Theory of Religion*. Berkley: University of California Press, 1994.

Boyer, Pascal. *Religion Explained: The Evolutionary Origins of Religious Thought*. New York: Basic Books, 2001.

Carroll, Joseph. "Evolutionary Literary Study." In *The Handbook of Evolutionary Psychology*, edited by David M. Buss, 2nd ed., 1103–1121. Hoboken, NJ: Wiley, 2016.

Dennett, Daniel. *Consciousness Explained*. London & Boston, MA: Little, Brown, and Company, 1991.

Dennett, Daniel. *Breaking the Spell*. New York: Viking, 2006.

Dissanayake, Ellen. *What Is Art For?* Seattle: University of Washington Press, 1988.

Dissanayake, Ellen. "The Arts after Darwin: Does Art Have an Origin and Adaptive Function?" In *World Art Studies: Exploring Concepts and Approaches*, edited by Kitty Zijlmans and Wilfried van Damme, 241–263. Amsterdam: Valiz, 2008.

Dutton, Denis. *The Art Instinct: Beauty, Pleasure, and Human Evolution.* New York, Berlin, and London: Bloomsbury Press, 2009.

Eliade, Mircea. *Patterns in Comparative Religion.* London: Sheed and Ward, 1958.

Eliade, Mircea. *The Sacred and the Profane: The Nature of Religion.* London: Harcourt Brace Jovanovich, 1959a.

Eliade, Mircea. "Some Methodological Remarks on the Study of Religious Symbolism." In *History of Religions: Problems of Methodology*, edited by Mircea Eliade and Joseph Kitagawa. Chicago, IL: Chicago University Press, 1959b.

Eliade, Mircea. *Images and Symbols: Studies in Religious Symbolism.* London: Harvill Press, 1961.

Eliade, Mircea. *The Two and the One.* Chicago, IL: University of Chicago Press, 1965.

Eliade, Mircea. "Notes on the Symbolism of the Arrow." In *Religions in Antiquity*, edited by Jacob Neusner, 463–475. Leiden: E. J. Brill, 1968.

Eliade, Mircea. *The Quest: History and Meaning in Religion.* London: University of Chicago Press, 1969.

Eliade, Mircea. "The Sacred in the Secular World." *Cultural Hermeneutics* 1 (1973): 101–113.

Eliade, Mircea. *Incognito at Buchenwald.* Unpublished Translation by Mac Linscott Ricketts, 1974.

Eliade, Mircea. *Journal II, 1957–1969.* Chicago: University of Chicago Press, 1989. First Published in English as *No Souvenirs: Journal, 1957–1969.* New York: Harper and Row, 1977.

Eliade, Mircea. *A History of Religious Ideas*, vol. I, *From the Stone Age to the Eleusinian Mysteries.* Chicago: University of Chicago Press, 1978a.

Eliade, Mircea. *Mademoiselle Christina.* Paris: L'Herne, 1978b.

Eliade, Mircea. *Ordeal by Labyrinth: Conversations with Claude-Henri Rocquet.* Chicago, IL: Chicago University Press, 1982.

Eliade, Mircea. *Symbolism, the Sacred, and the Arts.* Edited by Diane Apostolos-Cappadona. New York: Crossroad, 1986.

Gell, Alfred. *Art and Agency: An Anthropological Theory.* Oxford: Oxford University Press, 1998.

Huizinga, Johan. *Homo Ludens: A Study of the Play-Element in Culture.* London: Routledge & Kegan Paul, 1949.

Husserl, Edmund. *Logical Investigations.* New York: Humanities Press, 1970.

James, William. *Varieties of Religious Experience.* New York: Collier, 1902 (1961).

Kandinsky, Wassily. *Über das Geistige in der Kunst.* Munich: R. Piper and Co., 1911.

Kuhn, Thomas. *The Structure of Scientific Revolutions.* Chicago, IL: Chicago University Press, 1962.

Lévi-Strauss, Claude. *The Raw and the Cooked.* New York: Harper & Row, 1969.

Needham, Rodney. *Belief, Language, and Experience.* Chicago, IL: University of Chicago Press, 1972.

Otto, Rudolf. *The Idea of the Holy.* Translated by John W. Harvey. Oxford: Oxford University Press, 1958.

Paden, William. "Before 'The Sacred' Became Theological: Rereading The Durkheimian Legacy." In *Religion and Reductionism: Essays on Eliade, Segal, and the*

Challenge of the Social Sciences for the Study of Religion, edited by Thomas A. Idinopulos and Edward Yonan, 198–210. Leiden: E. J. Brill, 1994 [Reprinted in Rennie, 2006, 68–80].

Panikkar, Raimon. Personal Conversation Following Panikkar's Gifford Lectures, Edinburgh, 1989. See http://raimon-panikkar.org/english/gloss-pisteuma.html.

Rennie, Bryan. *Reconstructing Eliade: Making Sense of Religion*. New York: State University of New York Press, 1996.

Rennie, Bryan. *Mircea Eliade: A Critical Reader*. London: Equinox Publishing, 2006.

Rennie, Bryan. "Mircea Eliade: The Perception of the Sacred in the Profane, Intention, Reduction, and Cognitive Theory." *Temenos: Nordic Journal of Comparative Religion* 43, no. 1 (2007): 73–98.

Rennie, Bryan. "Fact and Interpretation: *Sui Generis* Religion, Experience, Ascription, and Art." *Archaeus: Studies in the History of Religions* 15 (2011): 51–74.

Rennie, Bryan. "Heterophenomenology as Self-Knowledge." *Bulletin for the Study of Religions* 41, no. 3 (2012): 6–11.

Ricketts, Mac Linscott. *Mircea Eliade: The Romanian Roots*. Vols. I & II. New York: Columbia University Press, 1988.

Ricketts, Mac Linscott. "Eliade's Religious Beliefs as Shown in the Portuguese Journal." Unpublished Paper Read at the 6th EASR and IAHR Special Conference, Bucharest, September 20–23, 2006.

Seligman, Martin E. P. *Helplessness*. San Francisco, CA: Freeman and Co., 1975.

Sharpe, Eric J. *Comparative Religion: A History*. La Salle, IL: Open Court, 1975.

Smith, Barbara Herrnstein. *Natural Reflections: Human Cognition at the Nexus of Science and Religion*. New Haven, CT and London: Yale University Press, 2009.

Smith, Jonathan Z. *Map Is Not Territory*. Leiden: E. J. Brill, 1978.

Sosis, Richard and Bradley Ruffle. "Religious Ritual and Cooperation: Testing for a Relationship on Israeli Religious and Secular Kibbutzim." *Current Anthropology* 44 (2003a): 713–722.

Sosis, Richard and Bradley Ruffle. "Does It Pay To Pray? Evaluating the Economic Return to Religious Ritual." *The B. E. Journal of Economic Analysis and Policy* 7 (2003b): 1–35. [Also available at http://ideas.repec.org/p/wpa/wuwpex/0309002.html.]

Špinka, Marek, Ruth Newberry, and Marc Bekoff. "Mammalian Play: Training for the Unexpected." *Quarterly Journal of Biology* 76, no. 2 (2001): 141–168.

Strenski, Ivan. "Love and Anarchy in Romania." *Religion* 12, no. 4 (1982): 391–404.

Taves, Ann. *Religious Experience Reconsidered: A Building-Block Approach to the Study of Religion and Other Special Things*. Princeton, NJ and Oxford, UK: Princeton University Press, 2009.

Wrangham, Richard. *Catching Fire: How Cooking Made Us Human*. New York: Basic Books, 2010.

7 Wisdom and the personality of reality

> Ancient wisdom must be made responsive to contemporary concerns, ancient folly must be challenged in its modern forms, and, as one may also discover from such forays, it's a good idea to pause from time to time to be sure one knows which is which.
>
> (Barbara Herrnstein Smith, *Natural Reflections*, xv)

In the ethology of art, the question of the evolutionary adaptive nature of art behavior is largely settled (I will give a more detailed précis of the argument in the next chapter). That it is an adaptation is initially indicated by its universality. However, no such conclusion has been forthcoming in the analysis of religion, despite its comparable universality. Nor has the widespread recognition that the modern Western concept of religion is even more of "a mess" than our concept of art, and for similar reasons, led to a similar reconceptualization. Steven Mithen, who has made a significant contribution to applying ethology to both art and religion, agrees with Boyd that it is an important ability of the human mind to think "of things which are not 'out there', in the world. Things which *could not* be out there in the world" (1996, 34). It is Mithen's hypothesis that, as the mind/brain of anatomically modern humans developed, specific functions of intelligence that were originally isolated and autonomous became integrated by the development of "cognitive fluidity" at around the time of the first flowering of art and culture. These specific intelligences are "content rich," which is to say that they

> not only provide sets of rules for solving problems, but they provide much of the information that one needs to do so. This knowledge reflects the structure of the real world—or at least that of the Pleistocene in which the mind evolved.
>
> (43)

Mithen's reasoning here is based on what Noam Chomsky referred to as "the poverty of the stimulus" (Chomsky 1980). That is, in developing their language skills children cannot possibly infer the complex rules of grammar from

the limited amount of speech they hear from adults around them. Rather we are born with an adaptation for language that enables its acquisition. Similarly, Mithen argues (or rather he adopts the argument of John Tooby and Leda Cosmides, 1992, with whom he clearly agrees—Mithen 1996, 55) that we cannot develop our complex native understanding of physics, natural history, social behavior, personal psychology, and so forth simply from observing the world around us. These areas also suffer from a "poverty of the stimulus." This may be a rather weak analogy since, in this case, the stimulus may well be too rich, rather than too poor. In either case, however, lived experience alone does not simply provoke assured, persistent, and sustainable behavior. Once again, much of the understanding that moderates behavior must come from *within* our minds rather than from without. Although Mithen's position on Chomsky's argument changed considerably later (see Mithen 2005, 256), the basic point remains that a great deal more than simple induction is at work in these functions. "It is simply impossible that people could generalize from the limited evidence available to them during development to the complex taxonomies universally adopted, unless they possessed a 'blueprint' for the structures of the living world hardwired into their minds" (Mithen 1996, 55).

Iain McGilchrist argues along the same lines that what exists comes into being for each of us through its relationship with our brains and minds, so it is not feasible to think that we could have knowledge of reality that was not also an expression of ourselves, "dependent on what we brought to the relationship" (2009, 37). Whether "what we bring to the relationship" is genetic or cultural is not immediately important. What is most important is that we today, and certainly our Pleistocene ancestors, lack adequate unambiguous information to make fully informed, rational decisions about our behavior and so must engage our emotional intelligence and non-conscious functions of the mind. The purely physical stimuli of the empirical environment cannot simply prompt in us the complex responses that we require to negotiate that environment with any real confidence. We must instead behave "as if" we had access to the unseen rules (analogous here to the rules of grammar) of the causal structure that determines the environment and so provide some predictability and thus allow us to divine the best course of action. But what do we assume to be "the best bet" to act as if it were true? This is not (in the vast majority of cases) determined by any conscious rational decision but by the complex prompting of our cultural environment with its constant (re)presentation of the real, interacting with genetically determined predispositions. We are exposed to the material products of behavior, to the beautiful and the sacred, and to others responding to them, behaving as if this or that were real and true. The perceived skill of that behavior and its products assures us of the wisdom of certain behaviors, which prompts us in turn to adopt related behaviors, as if this or that were *known* to be an accurate (re)presentation of the real.

As has been mentioned earlier, Tooby and Cosmides recognize adaptive mental "modules" for facial recognition, spatial relations, the mechanics of rigid objects, tool use, fear, social exchange, emotion-perception, kin-oriented

motivation, effort allocation and re-calibration, childcare, social inference, friendship, semantic inference, grammar acquisition, communication pragmatics, and theory of mind (Mithen 1996, 45 with reference to Tooby and Cosmides 1992, 113). Art, or more accurately, the behavior ancestral to what we now call art and religion, can be considered as a means of overcoming the "poverty" of the immediate stimulus by rendering specific objects and events "important" or "special" by "artifying" them—that is, investing human skill into them thus engaging attention, enhancing their apparent value and status, and encouraging specific behaviors in response to them, thus communicating the prior perceptions of others and broadening the experiential basis of behavioral responses to the environment from individual to communal determinations. As Mithen points out,

> it is very difficult to draw any division between what is a piece of "art" and what is "tool", and such artifacts epitomize the absence of any boundaries between different domains of activity. Many of the art objects can indeed be thought of as a brand-new type of tool: a tool for storing information and for helping to retrieve information stored in the mind.
>
> (1996, 195)

So Mithen agrees with Dissanayake both about the inaccuracy of our contemporary understanding of art and about art as functional. Also, and crucially for the integration of these insights about art with the study of religion, he tends to the conclusion that conceiving of art as a distinct domain is a modern development.

As has been seen, a very significant contribution to any attempt to integrate recent cognitive and evolutionary theory of art with an understanding of religion is provided by the anthropology of art, through Alfred Gell's *Art and Agency* (1998). This work has been described as perhaps "the most radical rethinking of the anthropology of art since the field of enquiry emerged" (Thomas 1998, vii). In an earlier paper,

> Gell provocatively claimed that the anthropology of art had got virtually nowhere thus far, because it had failed to dissociate itself from projects of aesthetic appreciation, that are to art as theology is to religion. ... [progress] required disowning the "art cult" to which anthropologists, as cultured middle-class intellectuals, generally subscribe.
>
> (Thomas 1998, viii with reference to Gell 1992)

Gell insists on looking at art objects as devices "for securing the acquiescence of individuals in the network of intentionalities in which they are enmeshed" (Gell 1992, 43). In common with Dissanayake et al., he insists that art cannot be understood in its Modern Western sense, and, rather than being a matter of meaning and communication, it is about *doing* or *agency* and it directly influences behavior. His "anthropology of art is constructed as a theory of

agency, or of the mediation of agency by indexes, understood simply as material entities which motivate inferences, responses or interpretations" (Thomas 1998, ix). Gell goes so far as to insist that "art objects are the equivalent of persons, or more precisely, social agents" (Gell 1998, 7). McGilchrist also argues

> that the work of art is more like a living being than a thing. That our encounter with that being matters and means something depends on the fact that any living being is in itself whole and coherent, and forms part of a larger context in which we too are involved and engaged.
>
> (McGilchrist 2009, 410)

Mithen agrees, specifically in terms of music, that "we treat music as a virtual person and attribute to it an emotional state and sometimes a personality and intention" (2005, 275). This appears to be a common feature of art behavior.

The particular cognitive operation which Gell identifies as "*the abduction of agency*" (1998, 13) occurs when an art object, or indeed any object, is taken as an index of the presence of agency and we feel ourselves to have access to another mind in this way (Gell 1998, 15). Agency is attributable and we can and do attribute it to non-intentional entities (Gell 1998, 16). "Whoever allows his or her attention to be attracted to an index, and submits to its power, appeal, fascination, is a patient, responding to the agency inherent in the index" (Gell 1998, 31). As index of agency, art is an agent by virtue of the fact that the perceiver abducts agency from it (Gell 1998, 51). So, an

> idol may not be biologically a "living thing" but, if it has "intentional psychology" attributed to it, then it has something like a spirit, a soul, an ego, lodged within it. ... This is certainly true, ethnographically and psychologically, because of the innateness of the "theory-of-mind module" which attributes intentionality to persons (and things as well, under certain circumstances).
>
> (Gell 1998, 129)

Gell thinks of a body of related artworks as kind as a spatio-temporally dispersed "population," an agency distributed in time and space, which comes into being by historical accretion and deletion through a network of social relations among artists and patrons, spectators, insiders and outsiders, collectors, scholars, etc. (Gell 1998, 221). For example, there is a ritualized exchange of valuables known as "Kula" in Melanesia. These valuables consist of arm-shells, necklaces, and similar items, which are precisely art as understood by Dissanayake, Dutton, Gell, et al. The "Kula operator"

> must possess superior capacity to engage in strategic action, which necessitates a comprehensive *internal model* of the external field within which Kula valuables move about ... The operator must be able to comprehend

the manifold and inordinately complex field of exchanges, must be able to remember innumerable past histories of exchanges, and evaluate their outcomes. He must construct "what if" scenarios that anticipate the future with precision, guiding strategic intervention. His mind, in other words, must work as a simulation device—and this indeed is what all minds do, more or less—presenting a synoptic view of the totality of Kula transactions, past, present, and to come.

(Gell 1998, 231)

Such observations imply a potentially coherent theory of art and religion in which attention and meaning are closely related—the meaning of an item is the "conduct it is fitted to produce"—as William James noted of meaning in general (1902/1961, 427). The "attention" that we pay to the work *is* the behavior that we exhibit in response to it. It is crucial to recognize in all of this the obsessive tendency of the Modern West toward the separation of categories. Most evolutionary theorists, and many others, agree. According to Ernst Gellner the "single strandedness, the neat and logical division of labour, the separation of functions" is a principal characteristic of Modern Western society. Indeed, "the conflation and confusion of functions, aims and criteria is the normal and original condition of mankind" (Gellner 1988, 45 quoted in Mithen 1996, 50). Tim Ingold agrees, suggesting that, for example, the cognitive separation between nature, society, and technology is a product of Western thought (Ingold 1993, cited in Mithen 1996, 268 n. 34). One promising explanation of this appears to be McGilchrist's description of the gradual dominance of the left hemisphere of the brain in contemporary Western culture (McGilchrist 2009), and Mithen lends support to that theory when he says that "we can see that there has been an oscillation between specialized and generalized ways of thinking" (Mithen 1996, 223). This agrees precisely with McGilchrist, who explains this oscillation as the varying dominance of left and right hemisphere, respectively. Whatever the reason—"art" as we tend to think of it in the Modern West did not become a "functionally differentiated system," until relatively recently. As Luhmann has it,

[t]he stratified societies of the Old World were far from realizing a fully differentiated art system. Art had to please, and whom it should please was no matter of indifference. Not until modernity—we can date its beginning in the Renaissance—did the art system begin to set its own standards for recruiting observers, and the heyday of the arts in the Middle Ages most likely facilitated this change. For an artist who worked in the service of God, it was only a small step to present himself as directly inspired by God. ... This gave rise to the trend (which did not yield results until the mid-eighteenth century) of subsuming all the arts under a unified concept.

(Luhmann 2000, 80, 81)

This lends further support to the argument that art and religion are only recently separated and distinguished. In their pre-modern condition, religion and art were practically (but not entirely) indistinguishable. Dissanayake considers ritual "in many respects hardly to be distinguished from art" because there is a close evolutionary connection between them (1988, 99, 189). Boyd speaks of "art's once intimate alliance with religion" (2009, 113), and Dutton holds "that so much of the finest art of history has religious meaning … Very many religious believers who are art lovers feel that art is essentially religious" (Dutton 2009, 230), yet he goes on to say that "[r]eligion, though often intermingled with art, need not be confused with it" (Dutton 2009, 71). Barbara DeConcini has pointed out that "art criticism and religion tended, in their efforts to articulate the consonance, to collapse art into religion … or religion into art" (1991, 323). I do not claim that "religion is art" or that "art is religion" but that in considering the pre-modern and the non-Western history of either, we are dealing with the common ancestor of both, which was, at least originally, adaptive. Just because we do distinguish them now—often poorly and confusedly—does not mean that we should project and retroject that dubious distinction into all contexts. Taves' distinction between "simple ascriptions" and "compound ascriptions" (2009, 9–10, 12–14) suggests one means of maintaining the distinction—art can remain relatively simple where religion is unavoidably compound. But even understood in their modern, Western mode, art and religion are closely related categories deriving from the same ancestral behavior, even if, in that contemporary Western sense, we can maintain their distinction. Our immediate problem is to identify and describe those behaviors as products of evolution.

Mithen identifies a form of communication that he calls "Hmmmmm" (holistic, manipulative, multi-modal, musical, and mimetic) as the common ancestor of music and spoken language (2005, 172, 267). It is tempting to identify the "common ancestor" of both art and religion as *play* (on play see Huizinga 1955, Boyd 2009, and Bellah 2011, *inter alia*). However, that word has certain disadvantages and it seems better to think of "inspired performance," skilled, creative, behavior, which fascinates and compels cultivation and imitation and contributes to specific fitness. While it is problematic, for example, to think of the builders of the monumental mysteries of Göbekli Tepe in the tenth millennium BCE as "playing," it seems quite reasonable to think of them as indulging in a behavior that attracted attention and fascinated, compelled encouragement and imitation, reinforcing, perpetuating, and propagating that behavior—a very serious mode of "inspired performance." Boyd's important observation about spare time should be recalled here:

> We did not solve the "problem" of spare time, as did other top predators, lions, tigers, or bears, by sleeping the extra hours away to conserve energy. Even at rest our large brains consume a high proportion of our energy, and since they offer us most of our advantages against other species

and other individuals, we benefit not from resting them as much as possible but from developing them in times of security and leisure.

(Boyd 2009, 406)

A surplus of imaginative activity would naturally give rise to this kind of inspired and inspirational performance. But is it art or is it religion? In his study Gell has "to explain why a book ostensibly about 'art' has to devote so many pages to a topic which appears to belong to the study of religion rather than aesthetics" (1998, 97), and he goes on to explain that he

> cannot tell between religious and aesthetic exaltation; art-lovers, it seems to me, actually do worship images in most of the relevant senses and explain away their *de facto* idolatry by rationalizing it as aesthetic awe. Thus, to write about art at all is, in fact, to write about either religion, or the substitute for religion which those who have abandoned the outward forms of received religions content themselves with. ... We have neutralized our idols by reclassifying them as art; but we perform obeisances before them every bit as deep as those of the most committed idolater before his wooden God ... we have to recognize that the "aesthetic attitude" is a specific historical product of the religious crisis of the enlightenment and the rise of Western science, and that it has no applicability to civilizations which have not internalized the enlightenment as we have. In India ... idolatry flourishes as a form of religiosity, and nobody in their right minds would try to drive a wedge between the beautiful form and religious function of venerated idols. In India aesthetics, as in the ancient world, is so subsumed under the philosophy of religion, that is, moral philosophy, as a matter of course. Consequently, it is only from a very parochial (blinkered) Western post-Enlightenment point of view that the separation between the beautiful and the holy, between religious experience and aesthetic experience, arises. Since this is so, the anthropologist writing about art inevitably contributes to the anthropology of religion, because the religious is—in some contexts, though not all—prior to the artistic.

(Gell 1998, 97)[1]

I would disagree only with Gell's final statement from the point of view that what is prior to the artistic is also prior to the religious. That is, "the religious attitude" as we now think of it is every bit as much a specific historical product of the cultural crises of the enlightenment as the "aesthetic attitude." Both art and religion, *as we now identify them*, arose in the modern period as descendants of a common ancestor, which originally subsumed them both—and that common ancestor can itself be seen as *a form of cognition*. Gell claims that "the Kula system as a whole is a *form of cognition*, which takes place outside the body, which is diffused in space and time, and which is carried on through the medium of physical indexes and transactions

involving them" (Gell 1998, 232). This itself is profoundly reminiscent of Eliade's analysis of "Folklore as an Instrument of Knowledge" (reprinted in Rennie 2006: 25–40), and it can be seen to be a form of the concept of distributed cognition or "extended mind" popularized by Andy Clark and David Chalmers (1998).

The scenario that results is one in which we are evolutionarily programmed to pay close attention to displays of skill and their associated products and to experiences of the environment that trigger ascriptions of agency, because art and agency are an indication of what humanity may accomplish (McGilchrist 2009, 444). According to Dutton, "our admiration of skill and virtuosity itself is an adaptation derived from sexual selection off the back of natural selection" (Dutton 2009, 175). Objects and events in which other people have invested a considerable degree of time and effort attract our attention. That we are instinctively driven to employ our abilities creatively seems to be borne out by the activities of "outsider artists," such as Henry Darger or "visionary artists," such as Howard Finster, or the majority of the artists collected in the American Visionary Art Museum in Baltimore (see http://www.avam.org/). As already mentioned, they compulsively produce art with no inducement and no reward and no connection to the worlds of the gallery or museum. "The demonstration of skill is one of the most deeply moving and pleasurable aspects of art" (Dutton 2009, 53). Objects and events invested with skilled performance in this way become the focus of attention and what Gell calls "secondary agents," that is, indexes of distributed agency. One obvious factor increasing the salience and therefore the effective agency of any singular demonstration of skill is its integration in an extended matrix of pre-existing presentations, thus harnessing what Taves identified as "compound ascriptions" of specialness (Taves 2009, 9–10). That is, the salience of the experience is hugely enhanced by its association with pre-existing, skillfully wrought items, including narratives. As we saw earlier, Gell insists that art functions not in isolation but through the cooperation of stylistically related pieces (style being precisely what unites works of art into groups according to Gell 1998, 163, 153). The specifically *religious* artwork is always deliberately located in a wider matrix of artifacts, including narratives. Only with the secular modern understanding of art did we even begin to conceive of an art piece as an independent entity. A religious tradition, at the other extreme, can only be seen as a collectivity of distributed art objects and events. Our focus upon such objects and events generate the abduction of an agency other than human, which acts in a very real social medium, bringing about changes and influencing behavior.

This crucially involves our capacity for empathy and "theory of mind." As we have seen, Dutton and McGilchrist also argued that works of art are specifically "windows into the mind of another being." Art performance ineluctably communicates the character and personality of an agent or agents. Religious behavior communicates the character and personality of superhuman (not necessarily "supernatural") agents. Mimesis is of crucial importance

in this modality of religion-and-art behavior. Human beings tend to observe and to be enchanted by displays of skill and we irresistibly seek to imitate acts of skill by emulating the apprehended agent: "skill ... is acquired by each of us through imitation, by the emotional identification and intuitive harmonisation of the bodily states of the one who learns with the one from whom it is learnt" (McGilchrist 2009, 122). Such mimesis is a behavior that is itself adaptive, selected for, and closely related to "theory of mind," and, as Gell says of religious art,

> [t]he great monuments that we have erected to God, the great basilicas and cathedrals, are indexes from which we abduct God's agency over the world ... God is not really powerful at all unless his power is apparent in this-worldly indexes (behavioural ones, or, in the present case, material ones).
>
> (1998, 114)

The gods, then, are ascriptions of agency with the greatest imaginable degree of skill and creativity. Our fundamental, naturally evolved, and effective, drive is to imitate them, to become like them, to elevate ourselves and increase our skill-in-being to the highest possible degree. Such behavior, we can be assured, is beneficial and sustainable. In keeping with Gell's "action centered" approach to art—a theory of art as involving the mediation of agency by indexes—this extends beyond the production of artifacts and involves the skillful manipulation of the apperceived agency and the effect of those artifacts. (It must always be borne in mind that these artifacts include narratives, texts, and rituals, not just representations and relics.) Given this understanding we can claim that there is a constant testing of the veridicality of (re)presentation insofar as its application succeeds in effectively improving human life. This can best be represented as a process of divinization, an *imitatio dei* leading toward *theosis*. McGilchrist suggests that the defining quality of the artistic process is its implacable opposition to the inauthentic (2009, 374). Furthermore,

> [w]e can, through our ability to imitate, make our own choices about the direction we take, mold our thinking and behaviour, and therefore our human future, according to our own values, rather than waiting to be driven by the blind process of genetic competition, which knows only one value, that of utility. We can choose to imitate forms of thinking or behaving; and by so doing both speed up our evolution by many orders of magnitude, and shift away from the blind forces of chance and necessity, in a direction or directions of our own choosing.
>
> (McGilchrist 2009, 124, see also 253–256)

It cannot be quite so simple. How do we select which forms to imitate? Art behavior enables the abduction of the agency, not only of human individuals, but of collectivities and of cultural (re)presentations of the character of

the real. In religious behavior, it seems crucial that the apprehended agent is greater than human. Hence Lévi-Strauss's observation that myth always "is credited with a supernatural origin" (1969, 18). Originally the Christian Gospels were credited to no author. In Western Religious art, where the agency of the artist, say, Michelangelo or the apostle Paul, *is* recognized, the historical accuracy of the representation is also assumed—ensuring that the ultimate origin of the (re)presentation is the God who creates history—Michelangelo may sculpt an astonishing Pietá, but God Himself arranged the conditions of the Crucifixion. Paul may be a great poet, but God gave him his material. Muhammad may have recited the Qur'an, but Allah created it. Each religious art piece is apprehended as an index of an extended agency of the sacred— and, in the case of the Western traditions, the monotheistic god becomes the perceived personality of reality. This encourages the development of the skill of a (hopefully) coherent, consistent, and satisfying response to the whole of reality, just as "theory of mind" and empathy for the individual permits a coherent response to the other.

Imitation seems to be at the heart of this response, as Merlin Donald has long argued (1993, 2001, 2006). This may be the *imitatio dei*—"you shall be holy, for I, the LORD your God, am holy" (Lev. 19:2), or the emulation of the wise and venerable sage. All human creativity adds to and thus changes reality, but considering the adaptive, evolutionary nature of this process, the ultimate skill of creativity is to *change reality for the better in terms of human success* (in the process constantly redefining and recreating what "better" is). The skill involved is much more than manual skills of performance or presentation, or cognitive skills of cognition and reception, but ultimately the skill of a life well-lived. That is, wisdom or *sophia*. *Philosophia* is the fondness for wisdom, "wisdom" rendering the Greek *sophia*. Etymologically *wissen*, means to know, and ~*dom*, is an abstract suffix of state, such as in freedom, the state of being free. So, etymologically, wisdom is the state of knowing. Yet wisdom is consistently differentiated from knowledge. Philosophical and religious traditions both emphasize the quest for a wisdom that is more than knowledge, and we can learn much from exploring and exploiting this commonality.

While the details of how to attain such wisdom are varied and culturally specific, the end-state of wisdom appears to be consistent in all traditions, religious and philosophical. As is well known, Socrates (or his biographer, Plato) was in pursuit of the good life and how to live it—and he was thought to be wise despite denying his own knowledge. The *Analects of Confucius* or *Lun Yu*, the *Daodejing*, and the *Dhammapada* have in common with Socrates this claim that the *denial* of knowledge is the beginning of wisdom. The *Daodejing* states that "to know yet to think that one does not know is best; not to know yet to think that one knows will lead to difficulty" (71—D. C. Lau, trans. 1963 and see *Lun Yu* 2:17). *Dhammapada* 5:62 agrees: "A fool with a sense of his foolishness is—at least to that extent—wise. But a fool who thinks himself wise really deserves to be called a fool" (translation by Ṭhānissaro Bhikkhu from Dhammatalks.org). This can be compared to the

Biblical tradition: "Do you see persons wise in their own eyes? There is more hope for fools than for them" (Proverbs 26:12).

So wisdom is distinct from, and better than, simple knowledge. But what, then, *is* wisdom? What does it accomplish? The Chinese and Greek traditions agree that the employment of wisdom is the means to the good, but this is an area fraught with dangerous circularities and self-fulfilling authentication. Wise people are good and good people wise, and the criteria by which the good or the wise are recognized are defined by their recognition. That is, they are defined ostensively: examples that are assumed to be self-evidently good or wise are used to demonstrate the nature of goodness and wisdom, without inspecting the principle by which the examples were initially identified. The Greek tradition of *philosophia* distinguishes itself from other wisdom traditions precisely in that it sought to inspect the principles behind such claims; the *logos* given to justify examples. Other traditions simply accept the wise as wise based on the authoritative source of their wisdom and the self-evident nature of their goodness. The philosophical work of interrogating the foundations of wisdom can be promoted if examples of wisdom can be identified to reveal common characteristics, which would permit an intensional definition—one that determines the meaning of the word so that alleged examples can be accepted or rejected.

Chinese wisdom (*zhi*— 智, *wisdom, from zhi*— 知, *to know*) is often seen as the adherence to the "three treasures" of charity, simplicity, and humility. The *Lun Yu* has it that Kongzi (Confucius) said,

> without goodness a man cannot for long endure adversity, cannot for long enjoy prosperity. The good man rests content with goodness; he that is merely wise pursues goodness in the belief that it pays to do so.
>
> (4.2—quotations of the *Lun Yu* are from Arthur Waley's 1989 translation)

and also that

> the ways of the true gentlemen are three. I myself have met with success in none of them. For he that is really good is never unhappy, he that is really wise is never perplexed, he that is really brave is never afraid.
>
> (14.30)

The "true gentleman" (*junzi*) here is the Confucian characterization of the wise and good person.[2] The *junzi* "can endure adversity" where a lesser man cannot (*Lun Yu 15.1*). A later Confucian text, *The Doctrine of the Mean* (*Zhong Yong*, a chapter of the *Liji*, or *Book of Rites*) states, "the *junzi* does what is proper to his position and does not want to go beyond this. ... He can find himself in no situation in which he is not at ease with himself" (*Doctrine of the Mean*, 14:1–2, in Chan 1963, 101). The history of religions is replete with narratives of the wise whose composure is barely disturbed by the most

grotesque suffering. San Lorenzo (Saint Lawrence) famously quipped to the torturers roasting him to death that they should turn him over because he was done on one side. Rabbi Akiva had to explain to the Roman soldiers combing the flesh from his bones that he was smiling simply because he had realized a new interpretation of the Shema. As is so often the case, the historical accuracy of these narratives is less important than their symbolism and their popularity. The wise are believed to endure easily in the face of all adversity.

The closest term to wisdom in Buddhism and Hinduism would be *prajñā*, again etymologically a compound of knowledge (*jñana*) and a prefix (*pra~*) indicating something higher or greater than knowledge, often rendered discernment. Ananda Coomaraswamy specifically used *sophia* to translate *prajñā* (1964, 240). In Buddhism, according to the *Dhammapada*, "as solid rock is not shaken by the wind, so wise men [in this case *paṇḍita*] are not moved amidst blame and praise. ... The wise do not show variation ... whether touched by happiness or else by sorrow" (6:6, 8—Radhakrishnan's 1950 translation). In the *Aṣṭasāhasrikā Prajñāpāramita* the personification of Perfect Wisdom (*Prajñāpāramita*)

> spreads her radiance, ... and is worthy of worship. Spotless, the whole world cannot stain her ... In her we may find refuge; ... she brings us to safety under the sheltering wings of enlightenment. She brings light to the blind, that all fears and calamities may be dispelled, ... She leads those who have gone astray to the right path.
>
> (7:170–71—Edward Conze 1955, 61)

In the Islamic tradition wisdom, *Hikmah*, is one of the primary attributes of Allah. For people it is crucial to the attainment of peace and obedience to Allah. Rejecting Islam is rejecting wisdom (Q 2:171). The Qur'an, rather than describing wisdom, simply speaks of it as a self-evident good. Sufism, as well as having its own concept of wisdom, is a major source of the idea of the *philosophia perennis*, the enduring love of wisdom, which is thought by some to be at the heart of all of the world's religions. The 14th-century Islamic jurist and theologian, Ibn Qayyim al Jawziyya (1292–1350 CE) emphasized that

> the basis of the *Sharī'ah* is wisdom and the welfare of the people in this world as well as the Hereafter. This welfare lies in complete justice, mercy, welfare and wisdom; anything that departs from justice to oppression, from mercy to harshness, from welfare to misery, and from wisdom to folly has nothing to do with the *Sharī'ah*'.
>
> (*I'lām al Muwaqqi'in*, quoted in Kurshid 1975, 176)

In the Hebrew Bible we find that, since wisdom (*chokma*) is taken to be a self-evident good, it is seldom described, but one may infer its nature from what it is not.

The ostrich's wings flap wildly,
 though its pinions lack plumage.
For it leaves its eggs to the earth,
 and lets them be warmed on the ground,
forgetting that a foot may crush them,
 and that a wild animal may trample them.
It deals cruelly with its young, as if they were not its own;
 though its labor should be in vain, yet it has no fear;
because God has made it forget wisdom.

<div align="right">(Job 39:13–17)</div>

Similarly in Psalms, where the wise and the good are contrasted with the wicked and the wrongdoers:

Do not fret because of the wicked;
 do not be envious of wrongdoers,
for they will soon fade like the grass,
 and wither like the green herb.
Trust in the Lord, and do good;
 so you will live in the land, and enjoy security. ...
Depart from evil, and do good;
 so you shall abide for ever. ...
The mouths of the righteous utter wisdom,
 ... their steps do not slip.

<div align="right">(Ps 37: 1–31)</div>

In the Christian New Testament, Matthew tells us that "wisdom is vindicated by her deeds" (Mtt 11:19) and Luke agrees that "wisdom is vindicated by all her children" (Lk 11:31). By the time of the New Testament it seems that "wisdom" (now *sophia*), under the influence of the Greek sophists had largely come to seem a human and petty thing compared to the divine revelation of *chokma* and Paul is particularly scathing about worldly wisdom (*sophia de on ton aionos*) in *Corinthians* (1 Cor 1 & 2). Apparently, the sophists had not produced evidence adequate to convince early Christians of the authenticity of their wisdom. Nonetheless, Paul can say that "we have not ceased praying for you and asking that you may be filled with the knowledge of God's will in all spiritual wisdom [*sophia ... pneumatike*] and understanding, so that you may lead lives worthy of the Lord" (Col 1:9–10). Once again, the pragmatic effect of "spiritual wisdom" is asserted despite Paul's skepticism concerning worldly or human wisdom. The practical benefits of wisdom are universally agreed upon.

In all of these traditions, "wisdom" is a necessary but not sufficient step on the way to the good, as knowledge is a step on the way to wisdom. Basic knowledge is of what is best for oneself and one's progeny, but the ability to *endure* is the fruit of wisdom. The common trait of wisdom is to enable a

lifestyle that is secure and sustainable in the long term. Nor is it just that the lifestyle is secure and sustainable, it is also assured and confident, contented and satisfying. The Chinese quotations made that eminently clear, "without goodness a man cannot for long endure adversity, cannot for long enjoy prosperity. The good man rests content with goodness," and the Hebrew tradition seems to concur: "But God will ransom my soul from the power of Sheol" (Ps 49: 15). This is not a reference to resurrection or post-mortem continuation—such an interpretation would be anachronistic, reading a later and foreign doctrine back into a text where it shows no sign of belonging—but a claim that the certain knowledge of death has no power over the wise: "When we look at the wise, they die; fool and dolt perish together and leave their wealth to others. Their graves are their homes forever" (Ps 49: 10–11). That is, they all die and remain dead, but that fact has no power to disturb the equanimity of the wise.[3] Wisdom personified can say, "those who listen to me will be secure and will live at ease, without dread of disaster" (Prov 1: 33). They do not avoid disaster, no-one can, but they are free of the *dread* of disaster. It has no power over them. "Do not be afraid of sudden panic, or of the storm that strikes the wicked; for the Lord will be your confidence" (Prov 3: 25–26). Proverbs emphasize that the wise follow the right path, and are content: "Happy are those who keep my ways" (8:32), and it makes the point clear with the trope of the "loose woman" as the rival of true wisdom, which counsels us to

> Rejoice in the wife of your youth,
> a lovely deer, a graceful doe.
> May her breasts satisfy you at all times;
> may you be intoxicated always by her love.
> Why should you be intoxicated, my son, by another woman
> and embrace the bosom of an adulteress?
>
> (Prov 5:18–20)

This trope is also used in chapters four and seven of *Proverbs*, and is a metaphor for attraction to the true wisdom that provides enduring assurance and sustainable persistence, in which one might have confidence, as opposed to short-term gratification of the "loose woman" (a point perhaps more easily grasped later in life than in one's 20s). The wise, those who have found the good life, are untroubled. They are assured that they are doing the right thing and "following the true path." They are content and they remain, and ultimately they die, content without having to change their perspective or position. They attain psychobiological homeostasis.[4]

If such homeostasis is seen as the ultimately desirable end then assumptions that enable one to attain that end can be said to be true to that degree. As Charles Sanders Peirce (1839–1914) argued, the end of all methods of inquiry is "the fixation of belief." What he termed "the scientific method" of rational philosophy is that procedure which has the best possibility of revealing error

and thus preventing the fixation of belief upon untruths, which are unlikely to remain fixed.[5] Now we can propose an intensional definition of wisdom that is not viciously circular (as are most lexical definitions[6]) and is pragmatically true: wisdom yields the ability to remain assured and confident, and to behave sustainably in the face of both prosperity and adversity. This definition can be exposed to a critical (Socratic) examination and would allow interrogation of all putative claims to wisdom, as well as a means of organizing the content of the religious traditions. Does the experience of the Eucharist, daily *salah*, *darśan* of the devas, yoga sadhana, vipassana meditation, or the observance of *li* (Confucian ritual) yield such ability? If so, how?

So far, this has been a classical example of a philological approach focused on literary texts and to that extent on the intellectual elite. This is often the easiest approach to take since it yields the most obvious, easily available, and portable examples. Yet such an approach tends to logocentrism and must be deepened and widened. As well as scriptural traditions, one must also consider Indigenous cultures with all of their oral traditions, as well as dramatic rituals, buildings, and artifacts that might contribute to assurance and persistence (or homeostasis). This is what Gell called the protention and retention of forms, that is, the retention and transmission of religious *topoi*, the common motifs of each tradition.[7] Instead of focusing on the retention and transmission of religious *ideas*, we must consider the common elements of material culture that contribute to settled, viable, homeostatic lifestyles. How did any given tradition flourish and persist as a cultural fashion? How did it "catch on?" Not "why" but "how," that is, where and when and in what forms did its *topoi* emerge? How were they retained, transmitted, and propagated?—in all their forms. This must necessarily be a more complex matter than the "minimally counter-intuitive concepts" that are often proposed as explaining religious retention and transmission (Boyer 2001, 65–75; Whitehouse 2004, 31), and it remains closer to art history and criticism than to science (and closer to philosophy than to any of these).

Such an approach inextricably connects wisdom to the skill of divination, primarily the attempt to answer the perennial question: "What should I do? What must be done?" (rather than "what is going to happen next?")—which involves a creative synopsis of the totality of the causal factors of the lived environment, expressed in the monotheistic traditions as an insight into "the mind of God." With creative input from our own minds, particularly narration and emplotment, theory-of-mind functions, and the ascription of agency, we come to recognize and respond to "the expression on the face of God," the unique character of the cosmos, the personality of reality, the perceived emotional disposition of the principal agency or agencies of the world, including non-intentional agencies such as the Dao, or karma, or the *logos*.

The culminating skill of all skills is the negotiation of life. Not just brute survival and reproduction but the creation of a life worth living. This may be seen as the end of the religion-and-art behavior that I propose to be the common ancestor of the modern categories of religion and art. As Gell says, all

minds, more or less, have internalized the causal texture of lived experience as part of being as a person and as an independent agent and "not to put too fine a point on it—something like godhead is achievable" (Gell 1998, 231) when this is done with sufficient skill.

> This (relative) divinization through the fusing together of an expanded, objectified agency, and the myriad causal texture of the real world seems to me [Gell] to be the ultimate objective of Kula. It suggests, to me [Gell] at any rate, pathways towards transcendence which are as accessible to us, secular souls and die-hard materialists, as to the inhabitants of the Melanesian islands which participate in Kula transactions.
>
> (Gell 1998, 231–232)

From the perspective of an historian of religions, of course, one must add: as accessible to Hindus who seek *mokṣa*, Buddhists who seek *nirvāṇa*, Daoists who seek to become immortal sages, and Eastern Orthodox Christians who seek *theosis*. "The Son of God became man so that we might become God" (Athanasius, *Contra Gentes: De Incarnatione* §54). This may appear to court the blasphemous to a Protestant Christian imagination, for which the separation between Creator and creature is irreducible. However, such separation appears to be a product of the insatiable Modern Western appetite for separation and distinction. It is a betrayal of the majority of religious traditions, including the Christian, which *do* seek the "divinization" of the individual, and of the fundamental, evolved attitude and tendency to utilize our own faculties of mimesis, cognition of agency, and skill development. It is a failure to pursue the *imitatio dei* and a by-product of the modern, Western, misconception of religion.

The application of such skills allow us to "*expand our understanding of the humanly possible*" (Dutton 2009, 100, emphasis added), to further comprehend and to develop that of which we can become capable. Just as anthropomorphizing animals assist in prediction and comprehension, so populating reality with nonphysical intentional agents apprehended as superhumanly creative and skilled allows an otherwise impossible integration of responses with the incalculable stimuli of lived experience and the development of highly effective behaviors. We could not, until very recently, even think about "the whole of reality" effectively in any other way. It is questionable that we can now. The perception of reality as possessed of a cognizable "personality," a nature or character to which we may have a distinct emotional response can engender a sense of confidence in behavior, of doing the right thing, of following the will of God, going with the flow of the Dao, or "knowing the decrees of Heaven" (*Lun Yu* 2:4). Given the massive range of behavioral options among which we must choose, the encouragement of confident and consistent, assured and persistent behavior alone would be a valuable adaptation. In the end, all that is required to form a religious tradition is that this behavior should persist.[8]

An extended matrix of stylistically related, skillfully wrought presentations to which a significant number of members of any given culture attend in the fashion described would engender that emotional response, and is equivalent to what we in the modern West have come to call a religious tradition, which unavoidably contains much that we would call art. McGilchrist points out that, unfortunately (and quite probably because machines appear to be the most "skilled," or at least most capable, entities in our currently perceived environment) the contemporary Western world has become dominated by a machine model of reality and we seem to have begun to imitate machines instead of gods. Our *techne* has become technology. This accompanies the cerebral left hemisphere dominance that McGilchrist describes. Not only is the attention of the left hemisphere particularly attracted to the linearity and predictability of machines, the fact that the machines are *products* of the left hemisphere, internal to its own created world, renders them objects of irresistible fascination.

In the light of this theoretical construct, the end of skilled behavior (maintaining focus on ethology) is not worship in the sense of self-abasement before an almighty power, but has the goal of producing a life worth living—a state of assurance and contentment—through *theosis* or the *imitatio*,[9] both in the sense of obedient cooperation with, and mimetic approach to, the divine ideal of skillful means manifest in indices of environmental agency. This involves, not predicting the future precisely, but responding best to the present—which inevitably involves some anticipation—as Gell pointed out in terms of the Kula operator. Not only does imagination allow the weighing of indirect evidence (Dutton 2009, 105), it also gives us the ability to react to stimuli that are not present, or, via creative (re)presentation, to react to stimuli that are present only as (re)presentations. By responding emotionally to our environment as possessed of a cognizable agency, we produce behaviors that are confident and consistent, assured and persistent. We thus endure as persistent cultural entities.

Dutton argues that such a capacity for strategic, prudential, conditional thinking, gave to bands of early humans who behaved this way a vast adaptive advantage over groups that did not, "imagination gave human beings one of their greatest cognitive assets" (2009, 106), and Boyd points out that "[m]inds exist to predict what will happen next. They mine the present for clues ... to anticipate the immediate future and guide action" and calls this "rough-and-ready heuristics" (2009, 134, with reference to Gigerenzer et al. 1999, 5, 21, 128; see also Sperber and Wilson 1988, 45; Boyer 2001, 162). I agree with these descriptions except where they imply a response that is deliberate and rational in the sense of being consciously elaborated. Emotional intelligence produces responses that are far more rapid and compelling and more suited to the rough-and-ready, fast and frugal heuristics that are implied here. Human responses to the rigors of life are anticipatory and hence unavoidably creative, emergent, and probably impossible to predict. It might be argued that the more rigorous the life the more creative we must become. In the process we

create the extended matrices of stylistically related creative expressions that we now identify as religious traditions—and it can be seen that, even from an entirely secular perspective, these are not vacuous and illusory fictions, false stories mistakenly assumed to be true. They are potentially invaluably skilled expressions of the human situation in general that conjure emotional responses and encourage potential avenues of human improvement. They enable the (re)presentation of the character of the world in which we live in emotionally cognizable terms, with which our natural faculties can empathize and engage, and to which we can coherently and confidently respond. The same processes unavoidably entail the threat of idolatry—of taking the representation to be the thing represented, the index to be the agent, and therefore the only "correct" form of representation.

There is a long way to go in terms of human history from the earliest recorded emergence of "art behavior" in the Upper Pleistocene to the contemporary world, or even to the Biblical prophets of the neo-Babylonian period. It will eventually become necessary to retrace that path in the light of this suggested understanding but first it will be productive to consider more closely what this ancestral behavior does and how it does it, and why it is neither art nor religion but the common antecedent of both.

Notes

1 Compare André Malraux: "The gestures we make when handling pictures we admire (not only masterpieces) are those befitting precious objects: but also, let us not forget, objects claiming veneration" (Malraux, *The Voices of Silence*, 600).
2 Literally, it means "son of a Lord," but as the English "noble" changed from indicating social rank to indicating moral value, so did *junzi*.
3 "'Where, O death, is your victory? Where, O death, is your sting?' The sting of death is sin, and the power of sin is the law. But thanks be to God, who gives us the victory through our Lord Jesus Christ. Therefore, my beloved, be steadfast, immovable, always excelling in the work of the Lord, because you know that in the Lord your labor is not in vain" (1 Cor 15:55–58). In the later, Christian texts, the promise of resurrection and eternal life encourage behavior as if such steadfast equanimity were simply assured.
4 As I say, this phrase comes from Dissanayake (2008, 22), which also has a great deal to say on the function of both ceremonies and the arts in combatting existential uncertainty and anxiety.
5 There remain many areas of belief that cannot be "fixed" by rational means, which thus require more aesthetic or "spiritual" means to attain the fixation required to remove "the irritation of doubt" so as to "establish in our nature some habit which will determine our actions" (Peirce, 1877).
6 For example, **Wisdom**: *noun* (1) Capacity of judging rightly in matters relating to life and conduct; soundness of judgment in the choice of means and ends; sometimes, less strictly, sound sense, esp. in practical affairs. (2) Knowledge (esp. of a high or abstruse kind); enlightenment, learning, erudition; in early use often = philosophy or science. Also practical knowledge or expertness in an art. (3) Wise discourse or teaching (*Compact Oxford English Dictionary*, second edition, Oxford: Clarendon Press, 1991).
7 Gell (1998, xii, 235, 239, 250). *Topoi* is the plural of *topos*: Greek, from [*koinos*] *topos*, a [common]place: indicating a traditional theme or motif; a literary or cultural convention, a "meme."

8 The basic behavior is frequently identified as "love" (or Xiao, or Bhakti). It is the ability to love or adore images, statues, rituals, etc., which leads to behavioral modifications that have been adaptive. Most creatures can only relate to immediate kin this way. Its inherent danger is mistaking the artifacts of material culture actually to *be* the abducted agent of which they are necessarily only indices.
9 In specifically Christian, specifically Orthodox, theological terms: "our Saviour opened to us anew the way to Deification" (Lossky 1978, 137). This is an "ascent towards God and our own perfect state fully realized" (Staniloae 2000, 211). "The culminating state of the spiritual life is a union of the soul with God ... Deification is realized through the believer's participation in the divine powers, by flooding him with boundless divine things" (Stanilaoe 2002, 22). Similarly, Confucian beliefs "focus on the possibility of nurturing human nature so as to achieve moral perfection" (Swain 2017, 1).

References

Bellah, Robert N. *Religion in Human Evolution: From the Paleolithic to the Axial Age*. Cambridge, MA: Belknap Press of Harvard University Press, 2011.

Boyd, Brian. *On the Origin of Stories: Evolution, Cognition, and Fiction*. Cambridge, MA: Belknap Press of Harvard University Press, 2009.

Boyer, Pascal. *Religion Explained: The Evolutionary Origins of Religious Thought*. New York: Basic Books, 2001.

Chan, Wing-Tsit. *A Sourcebook in Chinese Philosophy*. Princeton, NJ: Princeton University Press, 1963.

Chomsky, Noam. *Rules and Representations*. Oxford, UK: Basil Blackwell, 1980.

Clark, Andy and David J. Chalmers. "The Extended Mind." *Analysis* 58 no. 1 (1998): 7–19. Reprinted as "Chapter 2: The Extended Mind." In *The Extended Mind* edited by Richard Menary, 27–42. Cambridge, MA: MIT Press, 2010.

Conze, Edward. *Selected Sayings from the Perfection of Wisdom*. London: The Buddhist Society, 1955.

Coomaraswamy, Ananda. *Buddha and the Gospel of Buddhism*. New York: University Books Incorporated, 1964.

DeConcini. Barbara. "The Crisis of Meaning in Religion and Art." *The Christian Century* 108, no. 10 March 20–27 (1991): 223–326.

Dissanayake, Ellen. *What Is Art For?* Seattle: University of Washington Press, 1988.

Dissanayake, Ellen. "The Arts After Darwin: Does Art Have an Origin and Adaptive Function?" In *World Art Studies: Exploring Concepts and Approaches*, edited by Kitty Zijlmans and Wilfried van Damme, 241–263. Amsterdam: Valiz, 2008.

Donald, Merlin. *Origins of the Modern Mind: Three Stages in the Evolution of Culture and Cognition*. Cambridge, MA: Harvard University Press, 1993.

Donald, Merlin. *A Mind So Rare: The Evolution of Human Consciousness*. New York: W. W. Norton and Co, 2001.

Donald, Merlin. "Art and Cognitive Evolution." In *The Artful Mind*, edited by Mark Turner, 3–20. Oxford, UK and New York: Oxford University Press, 2006.

Dutton, Denis. *The Art Instinct: Beauty, Pleasure, and Human Evolution*. New York, Berlin, and London: Bloomsbury Press, 2009.

Eliade, Mircea. "Folklore as an Instrument of Knowledge." In *Mircea Eliade: A Critical Reader*, edited by Bryan Rennie, 25–40. London: Equinox Publishing, 2006. (Originally "Folklorul ca instrument de cunoaştere," *Revista fundaţiilor regale* 4 no. 4 (1937): 137–152.)

Gell, Alfred. "The Technology of Enchantment and the Enchantment of Technology." In *Anthropology, Art and Aesthetics*, edited by Jeremy Coote and Anthony Shelton, 40–63. Oxford, UK: Oxford University Press, 1992.

Gell, Alfred. *Art and Agency: An Anthropological Theory*. Oxford, UK: Oxford University Press, 1998.

Gellner, Ernest. *Plough, Sword and Book: The Structure of Human History*. London: Collins Harvill, 1988.

Gigerenzer, Gerd, Peter Todd, and the ABC Research Group, eds., *Simple Heuristics that Make Us Smart*. New York: Oxford University Press, 1999.

Huizinga, Johann. *Homo Ludens: A Study of the Play Element in Culture*. Boston, MA: Beacon Press, 1938/1955.

Ingold, Tim. "Tool Use, Sociality and Intelligence." In *Tools, Language and Cognition in Human Evolution*, edited by Kathleen R. Gibson and Tim Ingold, 429–445. Cambridge, UK: Cambridge University Press, 1993.

James, William. *Varieties of Religious Experience*. New York: Collier 1902/1961.

Kurshid, Ahmad. *Islam: Its Meaning and Message*. Leicester, UK: The Islamic Foundation, 1975.

Lau, D. C. *Lao Tzu: Tao Te Ching*. Middlesex, UK: Penguin Books, 1963.

Lévi-Strauss, Claude. *The Raw and the Cooked*. Translated by John and Doreen Weightman. New York: Harper Torchbooks, 1969.

Lossky, Vladimir. *Orthodox Theology: An Introduction*. Crestwood, NY: St. Vladimir's Seminary Press, 1978.

Luhmann, Niklas. *Art as a Social System*. Stanford, CA: Stanford University Press, 2000.

McGilchrist, Iain. *The Master and His Emissary: The Divided Brain and the Making of the Western World*. New Haven, CT and London: Yale University Press, 2009.

Mithen, Steven J. *The Prehistory of the Mind: A Search for the Origins of Art, Religion and Science*. London: Thames and Hudson, 1996.

Mithen, Steven J. *The Singing Neanderthals: The Origins of Music, Language, Mind, and Body*. London: Weidenfeld and Nicholson, 2005.

Peirce, Charles Sanders. "The Fixation of Belief." *Popular Science Monthly* 12 (November 1877): 1–15.

Radhakrishnan, Sarvapelli. *The Dhammapada*. Oxford, UK: Oxford University Press, 1958.

Rennie, Bryan. *Mircea Eliade: A Critical Reader*. London: Equinox Publishing, 2006.

Smith, Barbara Herrnstein. *Natural Reflections: Human Cognition at the Nexus of Science and Religion*. New Haven, CT and London: Yale University Press, 2009.

Sperber, Dan and Deirdre Wilson. *Relevance: Communication and Cognition*. Oxford, UK: Blackwell, 1988.

Staniloae, Dumitru. *The Experience of God: Orthodox Dogmatic Theology, Vol. 2: The World: Creation and Deification*. Brookline, MA: Holy Cross Orthodox Press, 2000.

Staniloae, Dumitru. *Orthodox Spirituality: A Practical Guide for the Faithful and a Definitive Manual for the Scholar*; translated from the original Romanian by Archimandrite Jerome (Newville) and Otilia Kloos; foreword by Alexander Golubov. South Canaan, PA: St. Tikhon's Seminary Press, 2002.

Swain, Tony. *Confucianism in China*. London and New York: Bloomsbury, 2017.

Taves, Ann. *Religious Experience Reconsidered: A Building-Block Approach to the Study of Religion and Other Special Things*. Princeton, NJ and Oxford, UK: Princeton University Press, 2009.

Thomas, Nicholas. "Foreword." In *Art and Agency: An Anthropological Theory*, edited by Alfred Gell, vii–xiii. Oxford, UK: Oxford University Press, 1998.

Tooby, John and Leda Cosmides. "The Psychological Foundations of Culture." In *The Adapted Mind: Evolutionary Psychology and the Generation of Culture*, edited by Jerome Barkow, Leda Cosmides, and John Tooby, 19–136. Oxford, UK: Oxford University Press, 1992.

Waley, Arthur. *The Analects of Confucius.* New York: Vintage Books, 1989.

Whitehouse, Harvey. *Modes of Religiosity: A Cognitive Theory of Religious Transmission.* Walnut Creek, CA: Altamira Press, 2004.

8 What is art (and religion) for? What do they do?

> Where is the Life we have lost in living?
> Where is the wisdom we have lost in knowledge?
> Where is the knowledge we have lost in information?
> (T. S. Eliot, *Choruses from the Rock*)

This chapter constitutes a summary of what I take to be the potential benefits of combining the ethology of art with the cognitive science of religion. By giving the genealogy of my perspective, so to speak, I hope to clarify it and to draw out some of its further implications in anticipation of the ensuing argument. The first specific contribution is Ellen Dissanayake's observations that art *does* something—something that must have had evolutionary survival value (1988, 61, 151). Second, that there is a need to reconceive art if it is to be understood in the global context. Art is something distinct from the contemporary Western notion of aesthetics. It is, in fact, a universal human behavior (5), which must be understood as a general human endowment or propensity, common to all human societies (*x*) and including not only visual objects but also music, dance, poetry, drama, and so on (4), and including more personal and individual acts of "making special," taking into account the representatives of this category created by all people, everywhere, through all time (5) and encompassing the very ordinary activities that an ethological view such as the present one includes as instances of a behavior of art (167). These observations are indispensable to the "ethology of art" and, I suggest, should be paralleled in the study of religion.

In a similar vein both Denis Dutton and Brian Boyd considered the cognitive and evolutionary analysis of art—art in general in Dutton's case and the literary arts in Boyd's. Dutton agrees with Dissanayake on the ubiquity of art behavior (2009, 29–30) and reminds readers of the importance of sexual selection in its evolution (5, 136–152), which can account for the flamboyance of the arts despite the fact that natural selection is normally economical and abstemious (136). He also inclines toward the idea that group selection is as significant as individual selection (45) and asks the important question: *"are the arts in their various forms adaptations in their own right, or are they better understood as modern by-products of adaptations?"* (86, emphasis original). Although I cannot do his full

argument justice in this context, he concludes that the arts *are* adaptations (93), with support from Joseph Carroll (1995, 2004), Michelle Scalise-Sugiyama (2001a, 2001b, 2004, 2005), John Tooby and Leda Cosmides (1992), and E. O. Wilson (1975)—although he wisely seeks to avoid a "hyper-adaptationism" that uses genes to explain every feature of life (94), but he emphasizes that the distinction between adaptations and by-products "cannot make sense of the ancient origins and present reality of aesthetic and artistic experience" (102). Art behavior is assumed by all these scholars to have been beneficial for survival and reproduction in the ancestral environment (Dutton 95, 109–110).

Boyd agrees that art is adaptive (2009, 35, 38, 205, 381, 388) and his analysis gives more specific insight into at least part of the adaptive advantage of the arts:

> By developing our ability to think beyond the here and now, storytelling helps us not to override the given, but to be less restricted by it, to cope with it more flexibly and on something more like our own terms.
>
> (50)

He identifies this as the ability "to detach thought from the immediate" (53). Through the arts, our behavior is determined by something other than the immediate, empirical, here-and-now. It is determined by our response to skillfully wrought (re)presentations of reality. By means of such (re)presentation we become capable of "suppressing immediate natural responses for the sake of long-term strategic advantage" (267) gained through the skillful, if fictive, (re)presentation of the real.

Are you paying attention?

Boyd emphasizes the importance of *attention* (391–393) and the possibility of art to "reconfigure minds" (94) via the focus of attention. There is a tendency to think of attention as some inner subjective state of deliberate focus, but, in keeping with the present ethological initiative, let us consider it, rather, as behavior in response to some experience. When we pay attention to something our experience of that something can change both our perception and our behavior. Iain McGilchrist insists that

> [a]ttention is a moral act: it creates, brings aspects of things into being, but in doing so makes others recede. ... we neither discover an objective reality nor invent a subjective reality, but ... there is a process of responsive evocation, the world "calling forth" something in me that in turn "calls forth" something in the world.
>
> (2009, 133)

On what grounds might we transfer these observations about art as a behavior to religion as a behavior? Many of those who analyze cognition,

evolution, and art hazard *some* comment on the relevance of this approach to the understanding of religion and a few brave souls have made an attempt to combine all three variables—the cognitive/evolutionary approach, art, *and* religion. Notable among these is Steven Mithen (1996). However, considering the promise of the topic—especially given the moral component that McGilchrist invoked—there has been relatively little attempt to integrate the three and one might ask why this is so. From the perspective of the quite extensive cognitive and evolutionary analysis of religion there is little specific focus on art. As has been mentioned, of the 50 contributions to the anthology, *The Evolution of Religion* (Bulbulia et al. 2008), 12 of them make some reference to art behavior, but only one makes any reference to the ethology of art.

I have suggested that cognitive theorists of religion wish to practice a particularly scientific analysis of religion and so have little interest in something as irreducibly unscientific as art. Furthermore, they appear understandably reluctant to grant adaptive status to what they see as simply "false belief." Most of them conclude that religion is at best a "spandrel." From the side of the ethologists of art, we have seen that Dutton is representative in assuming that the "biocritical" approach is not applied to religion because "explaining religion in terms of an evolutionary source attacks religion at its core" (2009, 9–10). In *The Evolution of Religion*, Michael Murray identifies "a belief that scientific explanations of religious belief serve in some way to undermine the justification for those beliefs" (2008, 365). He considers four arguments in support of this claim and rejects the common forms of all four. Considering the claims of Dissanayake, Dutton, and Boyd that creative fictions can *improve* cognition (Dissanayake 1988, 67, 2008, 6–9; Boyd 2009, 86, 209, 378, 381; Dutton 2009, 102, 192), the probability exists that religious behavior is equally adaptive, rather than unreliable, although, in precisely what way it might be "reliable" must be considered very carefully. As Murray says (in agreement with D. S. Wilson 2007), "false beliefs can be as adaptive as true beliefs *as long as they are paired with affective systems that, together with the false beliefs, give rise to adaptive behaviors*" (370, emphasis original). Steven Mithen has provided an example:

> Even though a deer or a horse may not think about his foraging and mobility patterns in the same way as Modern Humans, imagining that it does can act as an excellent predictor for where the animal feeds and the direction in which it may move.
>
> (1996, 192)

It is worthy of note that Murray's argument involves shifting focus in his conclusion from *belief* to *behavior*. As well as being consistent with the ethological initiative, this calls attention to the fact that arguing about the justification of *belief* is unavoidably to argue about the truth or falsity of a given proposition and such argumentation is itself a form of verbal or literary religious behavior

which assumes the superiority of one's own (re)presentation of the real—and one's own understanding of "truth."

Instead, we should consider whether the specific *behavior* of religious agents can be justified. If religious agents claim that their behavior is self-justifying—as people claim about art behavior—and that behavior causes no appreciable harm and could be sustained, then it is not "unjustified." That is, it is not an acceptable assumption that any "inaccurate belief" is inescapably harmful or "wrong"—especially where no "accurate belief" is available in its stead. There is increasing consensus from the ethology of art that a fictitious representation—an "inaccurate belief"—can promote greater fitness than the lack of representation. Given all of the foregoing, there is considerable reason to believe that the two areas of the ethological (cognitive/evolutionary) study of art and of religion can be integrated, that the reconception of art as a universal behavior with adaptive origins can be made, *mutatis mutandis*, for religion, and that the integration of the ethology of art and religion can produce a critical study of religion that is not inherently inimical to religion despite Dutton's misgivings. It will doubtless conflict with particular modes of religion—notably fundamentalism, literalism, and fanaticism—and also with the artificial restriction of "religion" to a modern, Western understanding as being centrally concerned with (unwarranted) belief and (inaccurate) historical truth-claims. These are all products precisely of the modern, Western notion of religion that is so badly in need of reconceptualization. An ethology of art and religion could initiate a critical analysis that is significant to both the understanding and the practice of religious traditions.

According to the ethology of art, when we ask "what is art for?" we are asking a very specific question. We are trying to identify a behavior that benefitted the species in some way so as to be selected for and become "*a specific human ability or tendency that genes could transmit and environments could act upon*" (Dissanayake 1988, 60, emphasis original). Dissanayake's notion of art as a behavioral trait whose evolution can be hypothetically reconstructed rests on the recognition of a fundamental behavioral tendency that, she claims,

> lies behind the arts in all their diverse and dissimilar manifestations from their remotest beginnings to the present day. It can result in artifacts and activities in people without expressed "aesthetic" motivations as well as the most highly self-conscious creations of contemporary art.
>
> (92)

For Dissanayake and like-minded scholars, art can be described as a behavior by describing what people do when they make art—when they "artify" (Dissanayake 2008, 14). Throughout her publications (1988, 1992, 1995, 2008), she has suggested a common denominator for art behavior that she identified simply as *making special*. She claims that in all instances of this behavior, in all times and places, "ordinary experience (e.g., ordinary objects, movements, sounds, utterances, surroundings) is transformed, is made extraordinary"

(2008, 14), and she claims that this is as distinguishing and universal in humankind as is speech or the skillful manufacture and use of tools (1998, 92).[1] She proposed that "making special," which she uses interchangeably with "artifying," is "the ancestral activity or behavior that gave rise to and continues to characterize or imbue all instances of what today are called the arts" (2008, 15). There is by no means universal agreement among ethologists of art that this is "the ancestral activity" but the claim has very particular relevance concerning the study of religion.

The core of Dissanayake's thesis is that art as making special "seeks to shape and embellish reality (or experience) so that it appears otherwise additionally or alternatively real ... and we will probably respond emotionally with stronger feelings than we would to 'nonspecial' reality" (2008, 95). As well as this heightened response to things "made special," Dissanayake considers what has been called a "cognitive imperative" by Eugene D'Aquili et al. (1979), which is a behavioral tendency to fit our perceptions "into some kind of an overarching socially shared explanatory scheme which then produces 'aesthetic' satisfaction" (Dissanayake 2008, 95). Here is an area in which art behavior blends into and becomes indistinguishable from religious behavior. When "making special" is accomplished by associating acts, objects, and events with a pre-established narrative (which is itself an artifact) in an extended matrix of other "stylistically" related artifacts (Gell 1998, 153, 162–163), which includes cosmogonic and cosmological narratives, this is more than Dissanayake's art behavior as "making special" requires. It has crossed the line into specifically religious behavior. This also descends from the activity that is ancestral to *both* art and religion: making special in this way, now expressed in composite ascriptions of specialness that invoke an overarching explanatory theme, is indistinguishable from the ascription of sacrality.[2] Evidence indicates, however, that the verbal expression of that scheme, which we now identify as faith and belief, is itself a behavior subsequent to an emotional satisfaction or assurance that one is paying attention to the right things.

In *Religious Experience Reconsidered* (2009), Ann Taves, without reference to or awareness of the work of Ellen Dissanayake, used the concept of "specialness" as fundamental to her analysis of religious experience. Following Emile Durkheim's well-known definition of a religion as "a unified system of beliefs and practices relative to sacred things, that is, things set apart and forbidden" (1912/1995, 44) Taves sought to clarify Durkheim's reference to "sacred things ... things set apart and forbidden" by using "specialness as a generic ascription" (Taves 2009, 26), and recommending that we

> refer simply to things that are more or less special, things understood to be singular, and things that people set apart and protect with prohibitions ... we can use the idea of "specialness" to identify a set of things that includes much of what people have in mind when they refer to things as "sacred," "magical," "mystical," "superstitious," "spiritual," and/or "religious."

(27)

One of the things that this "specialness" involves is the recognition of "where value is or ought to be placed in relation to concrete objects, relationships, and abstractions" (29) and Taves considers specialness as a function of value, although that is not the only way to think about specialness (35). She goes on,

> special things of one sort or another are the building blocks of what we think of as religions or spiritualities. Religions and spiritualities are composite formations ... Focusing our attention on "special things" takes our attention away from "religion" in the abstract and refocuses it on the component parts or building blocks that can be assembled in various ways to create more complex socio-cultural formations, some of which people characterize as "religions" ... A building block approach to religions, grounded in the concept of specialness and processes of singularization, strikes me as a more promising way forward in the study of religion than continuing to wrestle with defining the abstract concept of "religion."
>
> (162)

But neglecting the abstract concept, the intensional definition, leaves unanswered the questions, what does it mean to be "special"—what makes things "special" in this way? Taves points out that "the basic tendency to singularize is rooted in the special relationships that humans and perhaps some other animals need to survive. If that is the case, we may be biologically primed to see something as special" (48). Thus she joins Dissanayake and the ethologists of art in considering the biological, evolutionary origins of the ascription of "specialness" and recognizes that this kind of specialness is not something inherent in any act, object, or event, but something *ascribed* to it through human action and cognition. She says:

> If we want to understand how anything at all, including experience, *becomes* religious, we need to turn our attention to the processes whereby people sometimes ascribe the special characteristics to things that we (as scholars) associate with terms such as "religious," "magical," "mystical," "spiritual," etcetera.
>
> (8, emphasis original)

This process of ascription, attribution, or deeming is crucial to the analysis at hand. Ascription is "the assignment of a quality or characteristic to something" (181). Taves points out that attribution theory had been applied to religious experience in the 1970s (Proudfoot and Shaver 1975; Proudfoot 1985) and to religion in general in the 1980s (Spilka et al. 1985; Taves 2009, 10) and I have argued that, although he did not use those terms, Mircea Eliade's concept of "the Sacred," as *the intentional object of human experience which is apprehended as the real*" (Rennie 1996, 21, emphasis original, and see Rennie 2011, 2017, 669) is an example of attribution theory that avoids the implication that the ascription is in any way deliberate or conscious. Taves also distinguishes between attributions and ascriptions. The former being

"commonsense causal explanations… that people often supply consciously," and the latter often being "supplied implicitly below the threshold of awareness" (2009, 10 see also 89 n.1). She recommends a way of studying religion that allows us to understand how humans have used simple ascriptions as building blocks to create the composite ascriptions we typically refer to as religions (9).

These consonances between Dissanayake's analysis of art and Taves' analysis of religion indicate not only a close correspondence between religion and art but also a specific area of that correspondence. Dissanayake's ethology of art includes a quite precise explanation of how things become "special"—that is, how we produce the blocks with which we build religions according to Taves. To progress and to further resolve the continuity between art and religion, we need to consider more closely how and why "specialness" is ascribed and something is deemed to be special, and more importantly, to consider what specific adaptive value such ascriptions might have, especially when those things do not appear to possess inherent survival value.

Dissanayake recognizes that

> both ritual and play, like art, "make special." Both, like art, are concerned with metarealities, and we have seen how they are in many respects hardly to be distinguished from art. … The close evolutionary connection between ritual and art and between art and play … should reinforce our hope that we are on the right track ethologically speaking. … Although the notion of making special, then, must not be considered to be synonymous with the behavior of art, it is certainly a major ingredient of any specific instance of it, and "art" can be called an instance of "making special."
>
> (1988, 98–99)

So "making special" is the genre to which art belongs as a species, the ancestor from which art descends. With such an understanding, it is equally unsurprising that, in some areas, religion is hardly to be distinguished from art, since religion is ineluctably connected with ritual and, as Taves has indicated, is produced by composite ascriptions of "specialness." It is another species of the same genre, another descendant of the same ancestor. But how and why do we "ascribe specialness," and why would such behavior have been selected for in our evolutionary past?

One of the reasons given by Dissanayake for making something special is that "it will be responded to by others for its aesthetic quality" (102). This is unhelpfully circular: art is making special, and people respond to special things for their aesthetic qualities. Things are made special, and people respond to them for their specialness. This does not make it immediately apparent *why* it should be the case that,

> [a]s an essential feature of the behavior of art, as well as characterizing ritual and play, the tendency to make special would be an inherited

predisposition, selected for according to Darwinian principles. Although traits as complex as human behavior are influenced by many genes, each of which shares only a small fraction of the total control of the expression of the behavior, natural selection can still affect whether or not a certain predisposition is retained and often for the ways in which it is manifested. What is inherited is a capacity or a tendency to behave one way rather than another. The genetic predispositions and the constraints of the environment together guide the developing behavior; if it confers greater selective fitness, it will in the long run be retained. We could postulate that societies whose members tended to make things special or recognize specialness survived better than those who did not.

(103)

We could, but why should we? Why would such behavior confer greater selective fitness? Dissanayake's answer, in her original analysis of 1988 was that

[a]ctivities that are suffused with bodily, sensual pleasure are likely to be repeated, and investing necessary but routine acts with pleasure would increase the likelihood of their being performed. ... Making socially important activities gratifying, physically and emotionally—this I would claim is what art was for.

(152)

This is a very significant elaboration of Dissanayake's thesis. It is not simply that art is a matter of making special. It is a matter of making "socially important activities" special and so ensuring their performance and their persistence. "What this behavior of art was 'for' in human evolution was to facilitate or sugarcoat socially important behavior, especially ceremonies, in which group values often of a sacred or spiritual nature were expressed and transmitted" (167). At that point in time (1988) Dissanayake focused on this single function of art and neglected, for example, the effect of sexual selection (which Dutton utilized to great effect in *The Art Instinct* 2009, 137–163). Since 1988 (in 2008—"The Arts After Darwin: Does Art Have an Origin and Adaptive Function?" which is an excellent update and short summary of her position, although it lacks the richness and detail of the earlier work), Dissanayake has both refined and clarified her argument that certain observations suggest that art behavior is adaptive. She suggests a series of general adaptive functions that art can be said to serve in human evolution. What continues to suggest to Dissanayake and like-minded theorists that art behaviors are adaptive is that

A. They are observable cross-culturally in members of all known societies regardless of their degree of economic or technological development ...
B. Their traces are evident in our ancestral past, as we find from at least 100,000 years ago with the use of red ochre (Watts 1999) and subsequent

material artifacts ... C. Their rudiments are detectable and easily fostered in the behavior of young children, as when babies and toddlers spontaneously move to music, sing along or alone, make marks, decorate their bodies and possessions, play with words, find pleasure in rhythm and rhyme, or enjoy make believe ... D. They are generally attractants and sources of pleasure, like other adaptive behaviors such as mating, parenting, resting, or being with familiars in warm and safe surroundings. E. They occur under appropriate and adaptive conditions or circumstances—that is, they are typically "about" important life concerns, as in ceremonies that mark stages of life or that concern prosperity, safety, and subsistence ... F. They are costly: large amounts of time, physical and psychological effort, thought, and material resources are devoted to the arts as to other biologically-important activities such as sex, finding, preparing, and consuming food, socializing and gaining social acceptance, helping close kin, talking with friends, and acquiring useful information. Especially in small-scale or subsistence societies, art behavior consumes resources far beyond what one would expect for an unimportant activity. A trait, activity, or behavior meeting these requirements is a candidate for being considered adaptive.

(3–4)

These six observations establishing the probable adaptive value of art further imply that it could have adaptive functionality in four areas. That is, what it seems to be *for*, according to Dissanayake, is

1 Improving Cognition: *the arts contribute to problem solving and making better adaptive choices* ... fiction safely presents vicarious experience of adaptive information to cognitive systems that are involved with foresight, planning, and empathy, thereby providing risk-free practice for later life when similar circumstances might arise (7, 8, emphasis original, with reference to Tooby and Cosmides, 2001).
2 Propaganda: *the arts are used to manipulate, deceive, indoctrinate, or control other people* (8, emphasis original).
3 Sexual display: *the arts promote mating opportunity through display of desirable qualities (e.g., physical beauty, intelligence, creativity, prestige) which denote fitness.* At present [2008] the most popular and influential evolutionary explanation of the adaptive value of art is the *sexual selection hypothesis*, derived from Darwin's speculations about the extravagant plumage or elaborate songs of some male birds (Darwin 1871) ... The ornamental character of plumes, crests, tails, and songs provides an obvious analogy with human arts, which are claimed also to be honest, costly signals since the strength, vitality, intelligence, skill, and creativity required for their display cannot be faked by those who are less well-endowed (see Miller 1999, 2000a, 2001; Voland 2003) (9, emphases original).
4 Reinforcing sociality: *The arts enhance cooperation and contribute to social cohesion and continuity* (9).

This last was Dissanayake's original focus, but its association with these other adaptive functions now enhances and elaborates it. Her thesis of the adaptive value of art and her identification of art as making special are both well-argued, and they have implications beyond the value of art behavior as "making special" simply to sugarcoat socially important behavior.

I repeat Dissanayake's argument at such length in order to demonstrate what will be apparent to any scholar of religion: this applies to religious behavior as much, if not more, than to art behavior—undeniably so if religion is built out of compound ascriptions of "specialness" and art is an instance of making special.

Both propaganda value and the reinforcement of sociality are functions commonly associated with religion. The sexual selection hypothesis is applied to the production of material artifacts (specifically stone hand axes) by Kohn and Mithen (1999), and to music, aesthetics, and moral virtue by Geoffrey Miller (2000b, 2001, 2007), and to religion by Andrew Mahoney, Ilkka Pyysiäinen, and Jason Slone (in Bulbulia 2008, 161–166, 175–180, 181–187). However, the implications of this further consanguinity between art and religion are not pursued in any of these contexts. This leaves only the "improvement of cognition" as a novel function, here attributed to art alone. Just as Dutton, to whom Dissanayake refers in her later work (2008, 13, 15), emphasized the notion of sexual selection, so Brian Boyd (especially 2009 but also elsewhere) contributed another refinement to the theory, that of attention. It is helpful to conceive of the process (in both art and religion) as "directing attention" rather than "making special." "Specialness" remains a rather abstract and debatable characteristic, supposedly inherent in the object, whereas directing one's attention is an observable behavior that requires both object and subject. As we saw in the earlier consideration of beauty, both subjective response and objective qualities are needed to fully comprehend this process.

Attention to the artifact is what artist and audience have in common. We invest attention in some object, act, or event by focusing behavior upon it, which, in turn, can make that item attractive of the attention of others. Dissanayake points out that many humanist scholars oppose the idea of any single, "essential" characteristic of art, such as beauty or skill (2008, 12–13). No doubt both "making special" and "directing attention" may be seen as such singular, putatively "essential" features and will therefore meet with opposition as an essential defining feature of art (or religion). I would argue, however, that "attention," because of its ineluctably dual nature, requiring both subject and object in a fashion reminiscent of reader response theory and affect theory, avoids the worst problems of essentializing. While paying attention is not a sufficient condition for either art or religion, it does appear to be a necessary condition for both. "Directing attention" is more descriptive of what transpires when something is regarded as "special" (beautiful or sacred). That is, it explains what "special" *means*: someone is paying or has paid a lot of attention to this, and others find that it seizes their attention also,

because it simultaneously reveals itself as a focus of attention and some novel potential in the arena of human skill, and the abduction of agency. Where "making special" lends itself particularly to the fourth functional hypothesis (reinforcing sociality, Dissanayake's original focus) "attracting attention" lends itself more readily to the first three (improving cognition, social control, and sexual display). D'Aquili et al. (1979) and Joseph Carroll (2004, 159) suggested that the creation of cognitive order is an "elemental, universal motive" and Dissanayake suggests "that the operations of making special ... not only help to create cognitive order (meaningfulness) but give it added emotional salience" (2008, 15, n.10).

I would argue that the increase of salience, the attraction of attention, so as to influence subsequent behavior, is the process that requires explanation here. Certainly, that which has been ordered required focused attention to become ordered and it also (as Dissanayake notes) gains attention thereby. By paying close attention to an apparently disordered complex one is more likely to detect some order that is there, even if it is not immediately evident, as opposed to simply imposing an arbitrary order. Composite ascriptions of specialness in an extended matrix of indices of agency will attract repeated and prolonged attention. Significantly, as we have seen in Chapter 5, one pays attention to natural beauty or spectacle. However, attention to natural phenomena is not gained by the initial investment of human attention. Dissanayake says, rather than ask why people have art, why we "create fictions, make music, or paint landscapes, the more fundamental evolutionary, adaptive question is to consider why our ancestors intentionally began, and continued—as we continue today—to make things special or extraordinary" (2008, 16). In this light, it may be even more fundamentally rephrased as "why our ancestors initially began, and continued, *to pay close and sustained attention* to certain things, and attempted to persuade others to do likewise?" An answer may be suggested: because skillful performance promises reward for attention. Certain natural phenomena also fascinate by their latent promise of benefit. The same aura of fascination is apprehended for similar reasons. Those who became fascinated by the right things survived.

Of course art attracts attention. This has long been known and may even appear unhelpfully self-evident. Boyd quotes Sir Philip Sidney from *A Defense of Poetry* (1595): "the poet ... cometh unto you, with a tale which holdeth children from play and old men from the chimney corner" (Boyd 2009, 213). Aristotle's dramatic unity of action "matters because it focuses our attention and promises an overall pattern" into which ensuing events fit purposefully (Boyd, 224). It may seem all-too-obvious that "works of art need to attract and arouse audiences before they 'mean.' Every detail of a work will affect the moment-by-moment attention it receives, but not necessarily a meaning abstracted from the story" (Boyd, 232, with reference to Levin 1971, 1979, 2003 and Bordwell 1989). He argues that, although an evolutionary perspective on storytelling will not make us ignore meaning, "we will not rush to

reduce complex strategies for holding attention and evoking emotion, and the rich psychological intuition and invention they require, to portable, take-home meanings" (Boyd, 254).[3] Boyd's evolutionary theory of art, including especially narrative fiction, thus stresses attention more than reference and he gives several reasons for his emphasis.

1 *Attention is important to all art, literature, and story …*
2 *Art's effects on human minds depend on its power to compel attention.*
3 *Attention capture can explain the* design *features of stories,* as other explanations cannot (392, emphasis original).

Attention itself is "a *sine qua non* of all art" (215): "To explain art we need to attend to attention. Art dies without attention, as people since Aristotle have noted" (99–100). His observation seems irrefutable: "From infancy humans seek to command the attention of others, to shape it more finely, and to share it more fully, than do any other species" (96), and his conclusion follows inexorably:

> Art begins in infants' predisposition to engross themselves in patterned cognitive play. But the unique pull of human *shared* attention also compels parents to engage infants in protoconversation, which directs their children's predilection for pattern toward the rudiments of song, music, and dance.
>
> (100)

This relies upon

> our species' singular capacity to share attention … the father engages his son's attention to change his mood. He thereby affects the mood of others, whose appreciation in turn alters his own mood. The feedback of action, attention, reaction, and the refinement of action to shape further attention and reaction provide an exclusively human basis of art.
>
> (7)

On this basis, Boyd suggests "that we can view art as a kind of cognitive *play*, the set of activities designed to engage human *attention* through their appeal to our preference for inferentially rich and therefore *patterned* information" (85, emphasis original). Thus, for example, we see the art of the Chauvet cave from some 30,000 years ago as "not required for immediate survival, or even for practicing survival skills, [but] it seems designed especially to appeal to the eyes and minds of the artist and others" (8), that is, to focus attention.

Furthermore, "the unique human capacity for narrative emerges from animal capacities for representing events but adds specifically human

capacities for joint attention, imitation, and language" (16). This, Boyd explains, occurs

> [s]ince humans benefit from collaboration far more complex and on a far larger scale than that of dolphins or chimpanzees, we have a much greater need to motivate cooperation and master coordination. We achieve much of our advanced cooperation through language, but even language emerges from the increasingly flexible and finely-tuned attention to others evolved among highly social mammals.
>
> (103, with reference to Tomasello et al., 2005; D. S. Wilson, 2007)

This elaborates upon the mechanisms of making special that bring about Dissanayake's reinforcement of socially important activities, etc., and it also begins to explain the importance of art behavior in sexual selection. Anything to which others pay attention becomes highly compelling of our own attention. Boyd points out that primatologist Michael Chance "defined dominance in terms of being the *focus of attention* of subordinates, and proposed that the social organization of attention has been a crucial factor in human evolution" (110, emphasis original, with reference to Chance and Larsen 1976). He elaborates: "the capacity to command attention in social animals correlates highly with status ... Status in social animals also correlates with survival and reproductive success. We therefore seek attention as a good in itself and compete to tell stories" (168). This has numerous important entailments:

> Since we pay close attention to others, art can earn interest and esteem and hence offers an incentive to override the stopping routines in other goal-directed activities. ... if you know that your work can impress an audience you keep honing your Acheulean hand-ax or your sonnet and seeing new possibilities as you do so ... Attention provides the selective mechanism of art. If a work of art fails to earn attention, it dies. If it succeeds, it can last even for millennia.
>
> (121)

In art "we work at forms especially elaborated to hold attention in ways that appeal enough to override the criterion of relevance" (111). That is, our attention is attracted to certain things, including things into which others have invested considerable attention, even when they have no apparent relevance. One outcome of this is that

> because we pay such close attention to one kind of agent, our own species, we have evolved an understanding of false belief—a capacity to see that others, or we ourselves, may conceive a situation differently from the way it really is.
>
> (115, with reference to Dennett 1978)

We also "listen eagerly to those with strategic information they think we will value" (164). There is a primitive urge to attend to those who seek to attract our attention, even when their behavior has no apparent relevance, although we eventually become irritated with those who demand our attention for no return. Initially, at least, skillfully wrought performances and artifacts—especially stories—"are presumed worth their audience's attention either for the interest of the events themselves or for their implications" (369) and we will pay persistent attention to them, even when that worth is not immediately identifiable. Persistence itself—the overriding of stopping routines—is a profoundly conditioned and potentially immensely valuable behavior. The persistence required to perfect the knapping of stone hand tools, or the persistence required to woo a desirable mate, no less than the persistence required to run down an antelope by endurance hunting. It has been argued that "endurance running"—a rather extreme example of persistent behavior—"may have been far more important for the evolution of human anatomy than walking" (Mithen 2005, 153 with reference to Bramble and Lieberman 2004). Persistence itself may be an adaptive behavior. It is experienced as self-gratifying even when productive of obvious ill-effects, as persistent addictive behavior indicates—which raises the question: how do we decide in what behavior to persist?

One advantage of considering art behavior as directing attention rather than just "making special" is that it implies a more ramified explanation of not only why we do it, but also how it affects us. For Boyd, art not only attracts and holds, but also "shapes" the audience's attention. Art "affects minds over time because it so compulsively engages attention" (215). It "alters our minds because it engages and re-engages our attention" (99–100). It "can reshape minds piecemeal because its high doses of pattern engage us compulsively" (329). It "reconfigures minds" (94). Thus art can alter our relation to our world. "By focusing our attention away from the given to a world of shared, humanly created possibility, art makes all the difference" (125)—and at some time in the past, if this behavior is adaptive and selected for as the ethologists argue, the difference that it made must have been beneficial to our survival.

Boyd's understanding of the role of attention as formative in our construction of the world that we perceive to exist is echoed in the work of Iain McGilchrist, who states that "[t]hings change according to the stance we adopt towards them, the type of attention we pay to them, the disposition we hold in relation to them" (2009, 4). In a section on "The Nature of Attention" (2009, 28–29), McGilchrist argues that

> [a]ttention is not just another "function" alongside other cognitive functions. Its ontological status is of something prior to functions and even to things. The kind of attention we bring to bear on the world changes the nature of the world we attend to, the very nature of the world in which

those "functions" would be carried out, and in which those "things" would exist. Attention changes *what kind of* a thing comes into being for us: in that way it changes the world.

(28, emphasis original)

Here we see the causal *effects* of attention. A central theme of McGilchrist's book

is the importance of our disposition towards the world and one another, as being fundamental in grounding what it is that we come to have a relationship with, rather than the other way round. *The kind of attention we pay actually alters the world: we are, literally, partners in creation.*

(5, emphasis added)

Once again, we can "see the world better" (again reminiscent of Eliade, who insisted that *homo religiosus* participates in the cosmogony—1958, 404–407). Human creativity is no "mere" matter, although we have, with the separation of art and religion, come to see human creativity as of an order of magnitude lesser than independent creativity, both "natural" and "divine."

Boyd suggests that

[c]reativity matters to us as humans, but may seem difficult to account for in terms of hard biological costs and benefits. Yet like sex, wasteful in that we lose half of our variable genes in each offspring ... creativity ultimately benefits us in producing a wide array of behavioral options, some of which will survive better than others under unpredictable selection pressures.

(2009, 382, emphasis original)

We may not *consciously* appreciate creativity as benefitting us in terms of survival—ascriptions of specialness are "below the threshold of awareness." Like sex, it engages our attention and is apprehended as self-rewarding, its value appears self-evident.

One must proceed cautiously in the area of attention. Patricia Churchland pointed out that "the nature and function of attention is ... poorly understood" (1986, 232) and Harold Pashler, an experimental psychologist and cognitive scientist who has focused on the psychology of attention, went so far as to say that "no one knows what attention is, and there may even not be an 'it' there to be known about (although of course there might be) ... there may or may not be anything called attention" (1999, 1, 7). According to casual usage, the word "attention" implies that "the mind is continually assigning priority to some sensory information over others, and this selection process makes a profound difference for both conscious experience and behavior" (Pashler 1999, 2). Pashler and his colleagues discuss attention within the framework of the contemporary, information-processing

approach and their goal is to produce an account of how the mind processes information, "to analyze the mind in terms of different subsystems that form, retain, and transmit representations of the world" (6, 7). As "representations of the world" or worldviews, this obviously has significant relevance to our understanding of religion. My earlier analysis of Mircea Eliade (in *Reconstructing Eliade* and above, Chapter 6) is closely concerned with his understanding of religion as a process of "valorizing," that is, ascribing value—"assigning priority to some sensory information over others"—and concludes that the specifically religious form of consciousness is the hierophany, the apprehension of the sacred in profane existence. That is, the tendency to valorize, and to evaluate some certain phenomena as "of ultimate concern," that upon which we are "absolutely dependent," that which constitutes the conditioning antecedents and controlling factors of our current situation, which is the source of significance and value in all other phenomena. That which is most worthy of our attention. Thus understood, "the study of religion would become the study of the cognition of value" (1996, 243). I attempted to define religion in those terms:

> Religion is the total structure of values held, traditionally transmitted through a cultural matrix of symbol, oral and written narrative, scripture, and ritual, and reinforced by mythical rather than by rational means. This structure is dependent upon self-authenticating intuitions of the real, hierophanies or revelations apprehended in individual experience, on human cognitive interaction with our environment.
>
> (109)

The English word "worship" is from *weorthscipe*, Old English for worth or worthiness, and its original sense seems to have been to valorize or hold something in high esteem (217). In traditional cultures that worth was "reinforced by mythical rather than by rational means," that is, the ascription of value was made apparent and self-evident through the process of acculturation, through "appeals to our species preferences and our intuitions, often as they have been modified by local culture" (Boyd 2009, 411), as much as by any appeal to rational deduction or induction from empirical observation. Ascriptions of specialness, being below the threshold of awareness, would not be experienced as actions but as perceptions. It is not we who actively pay attention but the beautiful and the sacred to which we ascribe the agency that fascinates us and demands our attention. Ascriptions of specialness that involve the abduction of agency are functionally indistinguishable from Eliade's "hierophanies."

This again emphasizes, and to some extent explains, the importance of creativity. Of traditional ("religious") cultures Eliade insists

> their mind was neither "pre-logical" nor paralyzed by a *participation mystique*. It was a fully human mind. ... every significant act was validated and valorized both on the level of empirical experience and in a Universe

of images, symbols and myths. No conquest of the material world was effected without a corresponding impact on human imagination and behavior.

(1968, 465; in Rennie 2006, 143)

The emphasis on this contingent ascription of value is closely allied to, and may be further clarified by the emphasis on fascination and attention. What is it to "valorize" something but to be fascinated by it, to pay close and sustained attention to it, to concern oneself with it, to cultivate it, to direct others to pay attention to it, to learn from it and to look to it for meaning, to *respond* to it? (Ultimately, to exchange goods of intrinsic practical value for it—the social capital invested in religious behavior often has a pay-off in material capital.) One is fascinated, not only when one directs one's cognitive faculties toward something, but also when one bases one's behavior upon the object of fascination, when one defers to its influence ("pay attention to your father, honey").

Attention "brings into being a world and, with it, depending on its nature, a set of values" (McGilchrist 29). This implies that a complete and consistent world is—can only be—brought into being concurrently with a set of values. The two are mutually necessary conditions. We need to have a "complete and consistent" world in order to have a set of values, and having a complete and consistent world implies a necessary set of values. That is, a world becomes complete and consistent and coherent when it is a world of values, when the individual acquires a sense of moral behavior in its environment. This idea demands further attention and we will return to it. It is further supported by McGilchrist's agreement

with Max Scheler, and for that matter with Wittgenstein, that moral value is a form of experience irreducible to any other kind, or accountable for any other terms; and I believe this perception underlies Kant's derivation of God from the existence of moral values, rather than moral values from the existence of God. Such values are linked to the capacity of empathy, not reasoning; and moral judgements are not deliberative, but unconscious and intuitive, deeply bound up with our emotional sensitivity to others. Empathy is intrinsic to morality.

(86)

Boyd's analysis of art emphasizes attention in the same way as Eliade's analysis of religion emphasizes the ascription of value, and McGilchrist provides a bridge between the two. Boyd points out that initially, "[c]hildhood play and storytelling for all ages engages our attention so compulsively through our interest in event comprehension and social monitoring that over time their concentrated information patterns develop our facility for complex situational thought" (49, citing Tooby and Cosmides 2001). Furthermore, "fiction specifically improves our social cognition and our thinking beyond the here and now. Both invite and hold our attention strongly enough to engage

and reengage our minds, altering synaptic strengths a little at a time, over many encounters" (209). By attending to special (re)presentations of the real given skilled artistic form the worlds that we inhabit are conjured and their values established.

... to art and religion

One question has constantly been involved in the academic study of both art and religion—why are we fascinated by, why do we hold in high esteem, objects and activities that have no inherent, intrinsic, or evident practical worth? The answer now suggests itself that there are inherited, complex, cognitive, and neurological processes that determine our tendency to apprehend differential values, which, modified by local culture, result in our specific ascriptions of specialness to—equivalent to our fascination with—apparently valueless activities and objects. In both art and religion, what most frequently commands our attention are the products of skilled human behavior. This fascination is neither voluntary nor conscious but is genetically determined, although culturally modified, and apprehended as a simple self-evident perceptual experience—a "self-authenticating intuition of the real"—the experience of insight into an agency that fascinates us and to which our behavior is a response.

Boyd, with influences from Dissanayake, Robert Root-Bernstein, John Tooby and Lisa Cosmides, has elaborated an understanding of art in which the connection to religion and Eliade's "escape from history," whereby religion somehow allows people to "escape" from the "terror of history" (Eliade 1954, 139–162, and Rennie 1996, 91–96), becomes inescapable (and please note that one escapes from the *terror* of history, not from history itself). Art, understood in this way, has been the means by which religious traditions managed to enhance and tune experience in existentially valuable ways and to avoid, or at least to cope with, the negative effects of our own historical consciousness.

> Fiction enormously enhances creativity. It offers us incentives for and practice in thinking beyond the here and now, so that we can use the whole of possibility space to take new vantage points on actuality and on the ways in which it might be transformed.
>
> (Boyd 2009, 197)

Our myths are the fictions, the narrative artifacts, that we live by and these inspiring or admonitory examples are the exemplary models mentioned earlier as the hallmark of religious apprehension in the Eliadean understanding (as well as Jaspers' and Geertz's, *inter alia*).

Social psychologists, Max Weisbuch and Nalini Ambady make a strong case for "non-verbal behavior" as a source of social influence and "the shared consciousness that characterizes culture" (2008, 160). "If we consider only the prevalence of exposure to potentially influential acts, then the capacity for influence is larger for nonverbal than verbal communication" (164).

Although by "non-verbal behavior" Weisbuch and Ambady specifically mean "facial expressions, body language and prosodic vocalization (e.g. tone, pitch, rhythm)" (163), it must be borne in mind that if these relatively subtle human expressions have such significant effect, then the effect of the not-so-subtle expressions of art—statuary, elaborately decorated objects, music, ritual performance, drama, architecture, etc.—must have even greater influence in generating "the shared consciousness that characterizes culture." Unquestionably, the fine grain of this effect must be recognized in that neighbors of even a very stable and homogenous culture demonstrate considerable differences, but its effect cannot be ignored. Its specific manifestations are culturally variable phenotypes, but its general existence is a biologically universal genotype.

We are only gradually becoming aware of the processes that generate "the consciousness that characterizes culture" and that awareness changes the dynamic and has had significant effect in the development of modernity, postmodernity, science, and the arts (that is, of contemporary culture). These newer insights of ethology, cognitive studies, and cultural neuroscience can be integrated with the older, "Eliadean" understanding of the history of religions without losing the valuable insights of earlier theoreticians (and, perhaps, allowing us to distinguish long-term values from short-term gains). This integration can alloy the best of both cultural neuroscience and the non-reductive phenomenological approach to religion.

The mechanisms of these processes are evolutionary and cognitive: our propensity to be fascinated by artifacts demonstrative of skilled agency is repeated in our experiences of elements of the natural world to which we ascribe agency. Both have latent promise of reward, both attract and retain our attention and influence the way that we apprehend and respond to our experience, in a meaningful, adaptive way. The potential is there to change synaptic strengths and neural activity so as to make certain behaviors self-rewarding. An entirely natural and empirically assessable understanding of religion can thus be effected without any necessary conflict between the truth values of religious traditions except that those truths must be seen as skilled, creative, artistic, evolving, suggestive, and productive representations rather than simply historically accurate or ontologically verifiable realities.[4] It is always a mistake to assume our representations of the sacred to be *the* sacred (although they might be sacred—just as beautiful objects *are* beautiful but cannot be *the* beautiful or beauty itself). Those of us who have been culturally conditioned to apprehend historical accuracy and independent ontology as self-evidently more valuable than human creativity and play (to valorize the literal over the metaphorical, so to speak) may be resistant to such an understanding. However, with a growing understanding of the functional importance of the arts and skilled creative *poesis*, this historicist and logocentric vision is not the only game in town.

Not only must any proper understanding refrain from compartmentalizing the verbal and visual arts, or folk and fine art, but art and religion should not be artificially compartmentalized, either. They may be distinct, but they

are species of the same genre. The logocentric tendency to identify religious traditions with scriptures and doctrinal propositions must be resisted, as must the tendency to consider religious literary and verbal constructs as something other than examples of art. According to Weisbuch and Ambady,

> empirical research on social influence has largely been research on verbal social influence ... It is our argument that the methodological focus on verbal influence has unnecessarily limited the scope of what might be theorized and concluded with regard to social influence and shared beliefs. Specifically, as a channel of influence, nonverbal communication may be equally prevalent, more influential, and based in a more primitive and spontaneous psychological system than verbal communication. If so, cumulative knowledge of the psychological processes responsible for shared beliefs—and hence culture—may require considerable revision.
>
> (2008, 163)

We can never accurately analyze any religion or art form removed from the elaborate context to which it properly belongs: as Eliade often insisted, we must always interpret religious behaviors *in their own terms* (1973, xvii). In this way, we could attain an understanding of religion as the use of creativity to fine-tune our perception to facilitate not only assured, but also persistent and sustainable, interaction with our environment. This requires a close connection between the ethological approach, cognitive science, and earlier phenomenological and non-reductive approaches to religion.

The (artfully manipulated) attention that we pay to skillfully wrought and skillfully associated objects and events alters our interpretation and even our perception of what is and what is not real in a way that is self-gratifying (and thus self-perpetuating), and which also allows for an elaborated and enhanced cognitive apprehension of the order or organization of the real that has (at least in our evolutionary past) produced behavior that enhanced survival and reproduction. The reason why human skill so powerfully attracts attention is evident: humans are not born with a specific set of pre-determined abilities but with the potential to develop a wide range of variable skills. We are required to attend to available examples of skill so that we might emulate it and thus develop our own personal skill-set. Attention and emulation require empathy and "theory of mind." That to which we attend—that which fascinates us—shapes our perception of reality. It is not so much how we see that world that matters as how we behave in response to our perception. This is convenient for scholars, as I have suggested, since behavior is observable while the content of perception is not. It is also potentially valuable in our attempt to understand and define religion. It provides a parameter whereby the "improvement of cognition" can be recognized. One's cognition of the environment is improved when one's behavior in response to it becomes persistent and contributory to survival and reproduction. If the ability to respond effectively to the apprehended environment be seen as a hallmark of "truth,"

as the pragmatic theory of truth proposes (see, for example, Hare 1995), then these apprehensions must, to that extent, be seen as "true." Classifying and ordering the world of one's experience in such a way as to determine a sustainable behavioral response to its implicate order is itself a highly developed and highly valuable skill. The entire world of even one individual's personal experience is too complex, even chaotic, for a fully considered and rational response. It is our emotional intelligence that we must engage here. Increasingly it has been recognized that "emotion lies at the root of intelligent action in the world" (Mithen 2005, 86). In our constant need to choose among courses of possible action, it is our emotional response that guides us in open-ended situations of imperfect knowledge. The ability to respond emotionally to the external world as if it were determined by knowable intentional agency engages that highly adaptive ability (on emotional intelligence as crucial to the effective determination of behavior, see Evans 2001).

A central function of religion—what religion is *for*—is the determination of behavior. If true, we would expect to find a history of individuals and groups appealing to specifically religious behavior in order to determine their own future course of action. Indeed we do: it is generally called divination, which is from the same root as the word divine. Both terms are usually traced back to the Indo-European root √DIV (द्वि) usually interpreted as meaning "shine." McDonnell's Sanskrit dictionary (1974) points out that DIV has the primary sense of "cast, throw," and only the secondary meaning of "radiate, shine" (119). This appears to be derived from the metaphorical "throwing or casting light upon" (although it also has the sense of "throw *dice*" or gamble, 119, emphasis original). The implication is that divine things have an aura that casts light upon other things, and it seems that what they ultimately cast light upon is the behavior in which we should persist.

The thesis proposed to explain the relation of art and religion, then, is this: there is a human universal behavioral tendency that is ancestral to both art and religion. That is, to make things special and to make special things (which is the proposed ethological understanding of art). "Special" in this case means fascinating and salient because of the promise of beneficial return on the investment of attention. This is *"a specific human ability or tendency that genes could transmit and environments could act upon"* (Dissanayake 1988, 60, emphasis original). It has proven adaptive because it initially ensures our fascination with and attention both to acts and products of human skill that can be cultivated, perpetuated, and communicated and to natural phenomena that might repay attention. Paying close and prolonged attention to anything changes our perception. It involves cognitive functions evolved primarily to assist in interactions with conspecifics and which involve the ascription of "internal states" to agencies with which we interact. Similar ascriptions are made to both human and non-human agents. The external behavioral response of persistent attention correlates with an internal sensation of assurance that one is "doing the right thing," that is, seeing the situation aright, and responding to agency in the most appropriate fashion. Cognition of skill

necessarily involves the ascription of agency and when "special" agency is ascribed to the extra-human environment we have the opportunity, not only to improve our understanding of what effective agency is, but to apply emotional intelligence to the challenge of identifying normative behavior.

The evolutionary benefits, although building on the recognition, retention, and transmission of useful skills, is more generally the ability to pay selective attention in order to improve our situation. Although the initial benefit may be in the development of new, environmentally manipulative skills, a further benefit lies in the induction of inner assurance. Persistence in behavior allows the achievement of more complex aims, and contentment in attitude allows cooperation, altruism, and constancy, recognized in religious traditions as "wisdom." The initial process of making and paying attention to special things encourages novel behavioral responses to the environment. When a significant number of related special things form a gestalt the patterns of behavior produced tend to be highly conservative and profoundly persistent. Perceiving reality as a place that includes intelligible agencies can make it a better world when it is a world in which we are assured and confident and have a clear understanding of how to behave. Rather than "telling the future," divination in this respect concerns the identification of the appropriate behavior in response to the principal determining agencies of the environment and the history of divination merits careful consideration as being the possible evolutionary *point* of religion.

Notes

1 This seems to imply that this behavior is both a necessary and a sufficient condition for being human, which it cannot be. Bower birds make their bowers special. It may be necessary but it's not sufficient. It may be universal, but it's not distinguishing.
2 Although, once again, I find an "overarching explanatory theme" to be somewhat too intentional. In keeping with an ethological approach, a better benchmark would be behavior *as if* such a scheme were known.
3 This resonates with Frits Staal's observation that rituals are not necessarily required to have any referential meaning at all (Staal 1989).
4 This is precisely what the application of conceptual linguistics to the evolution of religion implies, as Robert Masson, using the concept of cognitive blending, argued at the second Evolution of Religion conference in 2017.

References

Bordwell, David. *Making Meaning: Inference and Rhetoric in the Interpretation of Cinema.* Cambridge, MA: Harvard University Press, 1989.
Boyd, Brian. *On the Origin of Stories: Evolution, Cognition, and Fiction.* Cambridge, MA: Belknap Press of Harvard University Press, 2009.
Bramble, Dennis M. and Lieberman, Daniel E. "Endurance Running and the Evolution of *Homo*." *Nature* 432, no. 7015 (2004): 345–352.
Bulbulia, Joseph, Richard Sosis, Erica Harris, Russell Genet, Cheryl Genet, and Karen Wyman, eds. *The Evolution of Religion: Studies, Theories, and Critiques.* Santa Margarita, CA: Collins Foundation Press, 2008.

Carroll, Joseph. *Evolution and Literary Theory.* Columbia: University of Missouri Press, 1995.

Carroll, Joseph. *Literary Darwinism: Evolution, Human Nature, and Literature.* New York: Routledge, 2004.

Chance, Michael and Ray Larsen. *The Social Structure of Attention.* London: Wiley, 1976.

Churchland, Patricia. *Neurophilosophy: Toward a Unified Science of the Mind/Brain.* Cambridge, MA and London: MIT Press, 1986.

D'Aquili, Eugene G. and Charles D. Laughlin, Jr. "The Neurobiology of Myth and Ritual." In *The Spectrum of Ritual,* edited by Eugene D'Aquili, Charles D. Laughlin, Jr, and John McManus, 152–182. New York: Columbia University Press, 1979.

Darwin, Charles. *The Descent of Man and Selection in Relation to Sex.* London: Murray, 1871.

Dissanayake, Ellen. *What Is Art For?* Seattle: University of Washington Press, 1988.

Dissanayake, Ellen. *Homo Aestheticus: Where Art Comes from and Why.* New York: Free Press, 1992.

Dissanayake, Ellen. "Chimera, Spandrel, or Adaptation: Conceptualizing Art in Human Evolution." *Human Nature* 6, no. 2 (1995): 99–117.

Dissanayake, Ellen. "The Arts After Darwin: Does Art Have an Origin and Adaptive Function?" In *World Art Studies: Exploring Concepts and Approaches,* edited by Kitty Zijlmansand Wilfried van Damme, 241–263. Amsterdam: Valiz, 2008.

Durkheim, Emile. *The Elementary Forms of Religious Life.* Translated by Karen Fields. New York: Free Press, 1912/1995.

Dutton, Denis. *The Art Instinct: Beauty, Pleasure, and Human Evolution.* New York, Berlin, and London: Bloomsbury Press, 2009.

Eliade, Mircea. *Cosmos and History: The Myth of the Eternal Return.* Princeton, NJ: Princeton University Press, 1954.

Eliade, Mircea. *Patterns in Comparative Religion.* London: Sheed and Ward, 1958.

Eliade, Mircea. "Notes on the Symbolism of the Arrow." In *Religions in Antiquity,* edited by Jacob Neusner, 463–475. Leiden: E. J. Brill, 1968.

Eliade, Mircea. *Australian Religion.* London: Cornell University Press, 1973.

Evans, Dylan. *Emotions: The Science of Sentiment.* Oxford, UK: Oxford University Press, 2001.

Gell, Alfred. *Art and Agency: An Anthropological Theory.* Oxford, UK: Oxford University Press, 1998.

Hare, Peter. "The Pragmatic Theory of Truth." In *The Oxford Companion to Philosophy,* edited by Ted Honderich, 707–710. Oxford, UK and New York: Oxford University Press, 1995.

Kohn, Marek and Steven Mithen. "Handaxes: Products of Sexual Selection?" *Antiquity* 73 (1999): 518–526.

Levin, Richard. *The Multiple Plot in English Renaissance Drama.* Chicago, IL: University of Chicago Press, 1971.

Levin, Richard. *New Readings vs. Old Plays: Recent Trends in the Reinterpretation of English Renaissance Drama.* Chicago, IL: University of Chicago Press, 1979.

Levin, Richard. *Looking for an Argument: Critical, Encounters with the New Approaches to the Criticism of Shakespeare and His Contemporaries.* Madison, NJ: Fairleigh Dickinson University Press, 2003.

Mahoney, Andrew. "Theological Expression as Costly Signals of Religious Commitment." In *The Evolution of Religion*, edited by Joseph Bulbulia, et al., 161–166. Santa Margarita, CA: Collins Foundation Press, 2008.

Masson, Robert. Unpublished paper, "What Cognitive Linguistics Brings to an Understanding of the Evolution of Religion and Religious Expression." Plenary address to the Evolution of Religion II conference, Tamaya Hyatt Regency Resort, Santa Ana Pueblo, New Mexico. Monday November 13th, 2017.

McDonnell, Arthur, A. *A Practical Sanskrit Dictionary*. Glasgow, UK and New York: Oxford University Press, 1974.

McGilchrist, Iain. *The Master and His Emissary: The Divided Brain and the Making of the Western World*. New Haven, CT and London: Yale University Press, 2009.

Miller, Geoffrey. "Sexual Selection for Cultural Displays." In *The Evolution of Culture: An Interdisciplinary View*, edited by Robin Dunbar, Chris Knight, and Camilla Power, 71–91. Edinburgh, UK: Edinburgh University Press, 1999.

Miller, Geoffrey. "Evolution of Human Music through Sexual Selection." In *The Origins of Music*, edited by Nils L. Wallin, Björn Merker, and Steven Brown, 329–360. Cambridge, MA: MIT Press, 2000a.

Miller, Geoffrey. *The Mating Mind: How Sexual Choice Shaped the Evolution of Human Nature*. New York: Doubleday, 2000b.

Miller, Geoffrey. "Aesthetic Fitness: How Sexual Selection Shaped Artistic Virtuosity as a Fitness Indicator and Aesthetic Preferences as Mate Choice Criteria." *Bulletin of Psychology and the Arts* 2, no. 1 (2001): 20–25.

Miller, Geoffrey. "Sexual Selection for Moral Virtues." *Quarterly Review of Biology* 82, no. 2 (2007): 97–125.

Mithen, Steven J. *The Prehistory of the Mind: A Search for the Origins of Art, Religion and Science*. London: Thames and Hudson, 1996.

Mithen, Steven J. *The Singing Neanderthals: The Origins of Music, Language, Mind, and Body*. London: Weidenfeld and Nicholson, 2005.

Murray, Michael. "Four Arguments that the Cognitive Psychology of Religion Undermines the Justification of Religious Belief." In *The Evolution of Religion: Studies, Theories, and Critiques*, edited by Joseph Bulbulia, Richard Sosis, Erica Harris, Russell Genet, Cheryl Genet, and Karen Wyman, 365–370. Santa Margarita, CA: Collins Foundation Press, 2008.

Pashler, Harold. *The Psychology of Attention*. Boston, MA: MIT Press, 1999.

Proudfoot, Wayne. *Religious Experience*. Berkeley: University of California Press, 1985.

Proudfoot, Wayne and Phillip Shaver. "Attribution Theory and the Psychology of Religion." *Journal for the Scientific Study of Religion* 14, no. 4 (1975): 317–330.

Pyysiäinen, Ilkka. "Ritual, Agency, and Sexual Selection." In *The Evolution of Religion*, edited by Joseph Bulbulia, et al., 175–180. Santa Margarita, CA: Collins Foundation Press, 2008.

Rennie, Bryan. *Reconstructing Eliade: Making Sense of Religion*. New York: State University of New York Press, 1996.

Rennie, Bryan, ed. *Mircea Eliade: A Critical Reader*. London: Equinox Publishing, 2006.

Rennie, Bryan. "Fact and Interpretation: *Sui Generis* Religion, Experience, Ascription, and Art." *Archaeus: Studies in the History of Religions* 15 (2011): 51–74.

Rennie, Bryan. "The Sacred and Sacrality: from Eliade to Evolutionary Ethology." *Religion* 47, no. 4 (2017): 663–687.

Root-Bernstein, Robert. "The Sciences and Arts Share a Common Creative Aesthetic." In *The Elusive Synthesis: Aesthetics and Science*, edited by Alfred I. Tauber, 49–82. Dordrecht: Kluwer, 1996.

Root-Bernstein, Robert. "Art Advances Science." *Nature* 407, no. 6801 (2000): 134.

Scalise-Sugiyama, Michelle. "Food, Foragers, and Folklore: The Role of Narrative in Human Subsistence. *Evolution and Human Behavior* 22, no. 4 (2001a): 221–240.

Scalise-Sugiyama, Michelle. "Narrative Theory and Function: Why Evolution Matters." *Philosophy and Literature* 25, no. 2 (2001b): 233–250.

Scalise-Sugiyama, Michelle. "Predation, Narration and Adaptation: 'Little Red Ridinghood Revisited.'" *Interdisciplinary Literary Studies* 5 (2004): 108–127.

Scalise-Sugiyama, Michelle. "Reverse Engineering Narrative: Evidence of Special Design." In *The Literary Animal: Evolution and the Nature of Narrative (Rethinking Theory)*, edited by Jonathan Gottschall and David Sloan Wilson, 177–196. Chicago, IL: Northwestern University Press, 2005.

Slone, D. Jason. "The Attraction of Religion: A Sexual Selectionist Account." In *The Evolution of Religion*, edited by Joseph Bulbulia, Richard Sosis, Erica Harris, et al., 181–187. Santa Margarita, CA: Collins Foundation, 2008.

Spilka, Bernard, Phillip Shaver, and Lee Kirkpatrick. "A General Attribution Theory for the Psychology of Religion." *Journal for the Scientific Study of Religion* 24, no. 1 (1985): 1–20.

Staal, Frits. *Rules without Meaning: Rituals, Mantras, and the Human Sciences*. Toronto Studies in Religion. New York: Peter Lang Publishing, 1989.

Taves, Ann. *Religious Experience Reconsidered: A Building-Block Approach to the Study of Religion and Other Special Things*. Princeton, NJ and Oxford, UK: Princeton University Press, 2009.

Tomasello, Michael, Malinda Carpenter, Josep Call, Tanya Behne, and Henrike Moll. "Understanding and Sharing Intentions: The Origins of Cultural Cognition." *Behavioral and Brain Sciences* 28 (2005): 675–735.

Tooby, John and Leda Cosmides. "The Psychological Foundations of Culture." In *The Adapted Mind: Evolutionary Psychology and the Generation of Culture*, edited by Jerome H. Barkow, Leda Cosmides, and John Tooby, 19–136. Oxford, UK: Oxford University Press, 1992.

Tooby, John and Leda Cosmides. "Does Beauty Build Adapted Minds? Towards an Evolutionary Theory of Aesthetics, Fiction and the Arts." *SubStance* 30, nos. 1 and 2 (2001): 6–27.

Voland, Eckhart. "Aesthetic Preferences in the World of Artifacts—Adaptations for the Evaluation of 'Honest Signals'"? In *Evolutionary Aesthetics*, edited by Eckhart Voland and Karl Grammer, 239–260. Berlin: Springer, 2003.

Watts, Ian. "The Origin of Symbolic Culture." In *The Evolution of Culture: An Interdisciplinary View*, edited by Robin Dunbar, Chris Knight, and Camilla Power, 113–146. Edinburgh, UK: Edinburgh University Press, 1999.

Weisbuch, Max and Nalini Ambady. "Non-Conscious Routes to Building Culture: Nonverbal Components of Socialization." *Journal of Consciousness Studies* 15: 159–183. Reprinted in *The Origins of Consciousness in the Social World*, edited by Charles Whitehead, 159–183. Exeter, UK: Imprint, 2008.

Wilson, David Sloan. *Evolution for Everyone: How Darwin's Theory Can Change the Way We Think about Our Lives*. New York: Delacorte, 2007.

Wilson, Edward O. *Sociobiology: The New Synthesis*. Cambridge, MA: Belknap, 1975.

Part II

Applying the theory

9 Divination

The vanishing point of religion

The things that we may or must know without applying any procedures are of many kinds, and they include all the things that deserve to be called the foundations or ultimate grounds of all the rest of our knowledge. ... Wherever there are procedures there are things that can be known without procedures, and whose knowledge is necessary for the devising and validation of the procedures.

(Renford Bambrough, "Intuition and the Inexpressible," 202–203)

This is an appropriate juncture to begin to alloy the theoretical with a more historical consideration of the topic. The concept of a "common ancestor" of the modern conceptions of art and religion, as adaptive behavior that is attentive to both skilled products of agency and ascriptions of agency to natural phenomena as similarly indicative of potential future benefit, must be of benefit in analyzing observed religious behavior to be of any value. In divination we find religion to be quite evidently associated with conscious attempts to determine behavior. Approaching unseen agencies as a means of determining subsequent actions is usually seen as a primary characteristic of religious behavior. Divination—seeking guidance for one's future behavior from some physical clue in the environment—is a practice ubiquitous in human history and culture and may be seen to be the place where religion and art most closely meet and serve a practical function. According to the mathematician, psychologist, and cognitive neuroscientist Stanislas Dehaene, "a range of brain circuits, defined by our genes, provides 'pre-representations' or hypotheses that our brain can entertain about future developments in its environment" (Dehaene, 7). Recent analysis by Andy Clark, professor of logic and metaphysics at the University of Edinburgh and expert in artificial intelligence and embodied cognition, suggests that "predictive processing" is the very nature of our intelligence. Divination may be native to certain specialized functions of the brain (Clark, 2016).

To look in an older, and more obviously traditional "religious," setting to establish the relation of religion and divination, the Hastings *Encyclopedia of Religion and Ethics* (Vol. IV, 1912) has 56 pages on divination including entries

for American, Assyro-Babylonian, Buddhist, Burmese, Celtic, Christian, Egyptian, Greek, Indian, Japanese, Jewish, Litu-Slavic, Muslim, Persian, Roman, Teutonic, and Vedic divination. This indicates both the universality of the practice and the attention paid in the early 20th century to divination as an aspect of religion. The absence of Chinese divination here is notable since the *Yijing* (*I Ching*) has become probably the most venerable, widely used, and carefully studied object of divination in the world (see, for example, Richard Smith 2008, 2012). However, the *Yijing* does not have an entry in the Hastings *Encyclopedia*. It is mentioned (as the *Yih-King*) in the entry on Japanese divination where it is called an "obscure book" although it is recognized to be "the basis of the system of divination in use at present" in Japan and treated with marked respect and unusual credulity by the author (Michel Revon, 804). It also appears (as the *I King*) in the entry on China (Walshe, vol. iii, 551) but is poorly understood by the standards of contemporary scholarship and one has to turn to more recent work for a better understanding of its use.

Divination takes a great many forms other than the use of literary texts like the *Yijing*. Augury is a general term for all forms of interpreting supposedly objective messages from the unseen world of the "spirits" via natural phenomena. They may appear as signs in the weather (sometimes called aeromancy and more specifically brontologia—reading thunder), or the behavior of animals (zoömancy). Decoding natural phenomena is a very wide general source of the divinatory reading of portents in the environment and can be seen in the forms of palmistry (or cheiromancy), or astrology. Geomancy, reading the lie of the land for portents, is best known in its Chinese form as *feng shui*, but in the Hasting *Encyclopedia* is called one of the two most characteristically Muslim forms of divination (Margoliouth, 817). Ornithomancy, interpreting the flight of birds, is a particularly common and worldwide form of the interpretation of ordinary natural phenomena, whereas the interpretation of extraordinary "prodigies" has been called teratoscopy. Divining from simply random events or haphazard encounters such as the chance words of passers-by—cledonomancy—was not uncommon. A particularly well-known instance is that of St. Augustine, who reports in chapter XII of his *Confessions* that it was his chance over-hearing of the phrase "take up and read," that was instrumental in his conversion to Christianity.

Divination has employed glossolalia or "talking in tongues" and the interpretation of dreams (oneiromancy), which dreamers may deliberately induce by sleeping in specific places (a practice known as "dream incubation"). "That a dream may be in some way prophetic is a view held by all races at all times," according to the Hastings entry by Herbert Jennings Rose (776). The same author also provides the entry on Classical Greek divination. One may use general presentiments and hunches as a simple form of divination, or involuntary body actions (sneezes, twinges, twitches, hiccups, etc.). Painful trials and ordeals may also be used and this includes specifically "wager by battle" (Rose, 777), which warrants the inclusion of the martial arts as among those skills that reveal the unseen—this was clearly a means of recognizing

the will of the Hebrew God in the period of the Judges. However, a more common and obvious form of divination is mediumistic possession, which, according to Evan Zuesse in the entry on Divination in the more recent (1987) Macmillan *Encyclopedia of Religion,*

> may be of several theoretical forms: prophetic inspiration, shamanistic ecstasy, mystical illuminations and visions, and mediumistic or oracular trance. They differ according to the degree of ego awareness and lucidity, awareness of the ordinary world, and the theoretical recipient of the divinatory message.
>
> (Zuesse 2370)

It is worthy of note that the Macmillan Encyclopedia entry, originally from the 1987 edition and retained unchanged and unelaborated in the 2nd edition of 2005, is only seven (similarly sized) pages compared to the Hasting's 56 pages. General consideration of the role of divination in the history of religions has waned significantly—a fact connected to the increasing hegemony of the modern Western logocentric conception of religion and its concomitant separation from conceptions of art behavior. In Jeffrey Kripal's (2014) *Comparing Religions* a brief consideration of the functions and purposes of religion (111–141) does not identify divination as a significant function of religious behavior, although it considers divination as a comparativist category that "established ritual practices that attempt to intuit, predict, or fathom the future, usually to some practical end or decision" (130). On the other hand, in the 1980s and 1990s at the University of Chicago, Ioan Culianu, Eliade's Romanian protégé, taught a course on divination, which was "wildly ambitious."[1] He apparently believed strongly in the significance of the phenomenon. Scholarship continues to produce specific and detailed studies of particular instances of divination, for example (Florida 1995; Savage-Smith 2004; Richard Smith 2008; Annus 2010). The Wikipedia page on divination lists just short of 400 named forms of divination.

The importance of divinatory behavior for the history of religions cannot be over-emphasized. Consulting the dead (necromancy) is a well-documented attempt to divine the best course of actions, to which is connected consulting the entrails (extispicy or haruspicy), or liver (hepatoscopy) of a sacrificial victim, which was the principal method employed by the Sumerians and also used by the Greeks, Etruscans, and Romans. The victims' last movements before death could be "read" for guidance. One may also "read" the random manipulation of small objects such as dice, drawing long or short stalks from a bundle, and so on. This is generally called sortilege, although the specific use of rods or sticks is called rhabdomancy, of which belomancy, the even more specific act of reading arrows pulled from a quiver, is a sub-set. A form particularly popular in Victorian England was reading tea-leaves (tasseomancy). Using playing cards (cartomancy) is best known in the more specific form of Tarot card-reading. One might also stare into a mirror or a crystal ball

(scrying), which is closely related to trance-like staring into any medium such as water (hydromancy) or oil (lecanomancy). When the liquid in question is contained in a cup of some sort, it is known as cylicomancy. Gazing into a burning fire or lamp (lychnonomancy) seems to be a form of self-induced hypnotic divination, a.k.a. "prophecy by hypnotism" (Spence in Hastings 1912, 782), although, like libanomancy (also known as livanomancy and knissomancy)—divination from the movement of incense smoke—it may involve more deliberate interpretation. Pyromancy is sometimes applied to divination by staring into a fire (for example, Barns 1912, 789), but that term (or empyromancy) is more properly used for reading the way that things burn or react when heated. This latter was the preferred form of early Chinese divination, most popular amongst which were the reading of the heated shoulder-blades of oxen (scapulimancy or omoplatoscopy) and of tortoise shells (plastromancy). These were inscribed with specific questions, then heated until they cracked, providing readable answers and are often called "dragon bones." Many forms of divination use devices akin to the modern *planchette* and Ouija board and there is a notable form of divining by a sieve held suspended and communicating its information by turning, known as coscinomancy.

The purpose of this potentially tedious listing of the forms of divination is simply to demonstrate the extent and variety of its use. The fact that in Uruk in Mesopotamia, one of the world's oldest cities, divination was of great importance, demonstrates its antiquity. Only slightly later than Uruk,

> in the reign of Urukagina, king of Lagash (c. 2800 BC), we have evidence of the wide-spread practice of divination by oil. From augural texts of a later period (c. 2000 BC), we know that in this particular form of divination the procedure consisted in pouring out oil upon the surface of water, the different forms taken by the oil on striking the water indicating the course which events would take. A professional diviner was naturally required to carry out the accompanying ritual and to interpret correctly the message of the oil.
>
> (King 783–784)

Leonard King in the Hastings Encyclopedia specifically argues that the Babylonians "inherited many of their augural beliefs and practices from the earlier Sumerian inhabitants of Babylonia, whom they eventually conquered and absorbed" (King, 783), and

> [t]he practice of divination entered very largely into the religious life of the Babylonians and Assyrians. Not only was it carried on by unofficial augurs and seers, whose services could be secured for a comparatively small fee by anyone desirous of reading the future or of learning the interpretation of some portent which had been vouchsafed to him, but it also formed one of the most important departments of the national religion.
>
> (King, 783)

A considerable portion of the literary and religious texts in the library of Ashurbanipal (668–626 BCE) in Nineveh were works on divination in its various forms (King, 783). Thus the process of divination was already a specialized, skilled, and politically significant profession in the earliest urban civilizations. The majority of the 1912 authors on divination refer to it as an "Art" (Rose, 775, 777; Spence, 781, 783; Waddell, 786; Dottin, 787; Jacobi, 800; Revon, 802, 804, Gaster, 809–812, Gray, 819, Wissowa, 823, 826, Bolling, 827), as did the Latins before them (see Barns, 789–792). My immediate point, however, is not just that divination is an art. It is that the practical function of such art responds to an obviously universal demand for such divination and the guidance of behavior. This is art that can be seen to be becoming religious in the way I have suggested. It is skillful and salient behavior that is part of an extended matrix of stylistically related objects and acts that cumulatively engage "theory of mind," communicate a perception of the "personality" of reality, and inspire an assured behavioral response to the agency ascribed to the environment. In earlier times, divination was even regarded as fairly lowly among the arts:

> The μάντις [mantis, or seer] is not, as a rule, an inspired prophet, but rather a craftsman ... classed with leeches and carpenters in a famous verse of the *Odyssey* (xvii. 384, μάντις, ἡ ἰητῆρα κακῶν ἢ τέκτωνα δούρον).[2] He practises seer-craft, μαντοσύνη, then later μαντικὴ (τέκνη), as a doctor practices physic, and by the favour of the gods he has more skill in it than ordinary men. But anyone can interpret an omen on occasion.
>
> (Rose, 1912b, 796)

Before we can draw any conclusions from this, we need to consider carefully what "divination" actually is. According to Rose:

> By "divination" is meant the endeavour to obtain information about things *future or otherwise removed from ordinary perception*, by consulting informants other than human. While mostly directed to foretelling coming events, it is not confined to this, but may seek to find out, e.g., what is going on at home while the inquirer is abroad.
>
> (Rose, 1912a, 775, emphasis added)

Although we might think of it as a very distinct category, that which is removed from ordinary perception by *time* (that is, the past or future) is not fundamentally distinct from that which is so removed by distance, obstacles, imperceptibility, or any other limitation of ordinary perception. According to Zuesse, the interrogation of future events is of *less* importance to the practice of divination than those otherwise removed from perception. Thus, divination "is the art or practice of discovering the personal, human significance of future or, *more commonly, present or past events.* A preoccupation with the import of events and specific methods to discover it are found in almost all

cultures" (Zuesse, 2369, emphasis added). So, most accurately, divination is the attempt to "see the unseen," to elicit information about partitions of the real that are simply not available to direct sense perception but whose disposition or nature may be implied by, or abducted from, things in the available world. Such information will determine ensuing behavior, which, as "behavior as if ...," may be interpreted as indicating the presence of certain beliefs. However, since those beliefs are underdetermined by the material evidence, conflicting statements of belief could be found in a single community, even one exhibiting highly consistent behavior.

Zuesse continues: "Divination involves communication with personally binding realities and seeks to discover the 'ought' addressed specifically to the personal self or to a group" (2369). He recognizes three general types of divination: "those based on the immediate context when interpreted by the spiritual insight of the diviner (intuitive divination); those based on spirit manipulation (possession divination); and those reflecting the operation of impersonal laws within a coherent divine order (wisdom divination)" (2370). In his *Introduction to the Prophets* (2007), Thomas Leclerc refers to the Platonic distinction between inductive or instrumental divination, which requires an obvious application of human skill, and intuitive or mediated divination, in which the diviner simply receives an irresistible message in a dream or vision, sometimes in an altered state of consciousness or ecstasy. Biblical prophecy, according to Leclerc, is most akin to the latter (27–29), and this will be more closely considered in a later chapter. In the era of Biblical prophecy we see an increase of "historical divination," that is, consulting textual chronicles to determine present behavior. This might be considered a mix of the best of both voluntary and involuntary forms of divination. While the *events* of history certainly force themselves upon us, the specific *texts* recording those events are voluntarily worked and sought out as sources of information. While the stark event of history in the raw, so to speak, may defeat our attempts at interrogation, the skillful and creative (all expression and representation being ultimately creative) *chronicling* of those events is highly likely to yield a fertile field for interpretation for those who follow. After all, "[a]nything can be used to divine the meaning of events. It is very common to assign spontaneous and arbitrary meaning to signs or omens when one is deeply anxious about the outcome of a personal situation" (Zuesse, 2369).

King recognizes this same distinction between "voluntary" and "involuntary" divination. "Under the former the diviner deliberately sought out some means of foretelling the future; under the latter he merely interpreted the meaning of portents, signs, or phenomena which, without being sought out, forced themselves on his notice" (King, 784). Rose points out that "divination should be treated as a branch of sympathetic magic, and regarded as a deduction or series of deductions from a vaguely conceived principle of *something like the uniformity of Nature*" (Rose, 1912a, 776, emphasis added). "Something like the uniformity of nature" must be assumed in order to motivate an assured response to it and it is our emotional intelligence, through something

like "theory of mind," that is best adapted to intuit this "uniformity." According to Iain McGilchrist, it is predominantly the right hemisphere of the brain that exercises both emotional intelligence and imitation and "the ability to extract a face or other meaningful form from highly degraded information" (McGilchrist, 205 n.23, and 58–64).[3] Such perceived "uniformity" or invariance cannot be inductively inferred (in the logical sense of induction as reasoning to probable, but never to certain, conclusions) from that which is "directly observed," especially when one recalls that even that which is "directly observed" unavoidably reflects the nature of the observing self. It can, at best, only be abducted. That is, we can make an inference to a possible explanation and identify what we consider the best candidate explanation, but multiple such "best explanations" will be forthcoming, underdetermined by the available material evidence, and thus finally determined largely by the cultural context working on genetic predispositions. In the end, it is the assurance with which the response is undertaken, rather than the factual accuracy of the representation of uniformity, that is the value of the behavior.

Things that attract and retain attention will be more likely to be used this way, and skillfully wrought items and skillfully performed activities are enormously salient. Artistically constructed objects or performed activities are thus much more likely to be the focus of divinatory activities, and skilled writing concerning actual events will be both salient and informative. Human skill *is*, at its most generalized, the ability to coordinate "inner thoughts" accurately and appropriately with the "outer world"—this is the basis of all forms of skill from warfare to clairvoyance. All skill is at base a certain indication of "clarity of sight," being able to cognize both situation and response. Skill as the ability to succeed in one's endeavors is of the greatest possible survival value and so would unquestionably be selected for and imitated. Whether it is throwing a projectile at a specific target so as to hit it with the greatest possible force (Calvin 1983), or rendering an accurate representation of a thing that is not present, or producing particularly compelling sounds to which others are drawn to listen, all skill brings into present reality an entity or event that was previously removed from perception—by time, distance, or imperceptibility. The ability to make, or to make happen, externally, perceptibly, physically, that which was previously only internal—imaginary—and to make the external represent the internal as closely as possible, may be seen as the very definition of skill. Skilled performances will thus unavoidably become a perceived source of reliable divination, of the ability to get things right, and to see so clearly that one's vision is communicable. Clairvoyance has thus been seen as inextricably linked to artistic ability—or, to be more accurate, it is only recently that we have begun to see them as distinct, which is why it is still to this day sometimes unreflectively supposed that skill goes hand-in-hand with clarity of cognition—as the continued consultation of actors and musicians on topics of politics and ecology attests.

The success or failure of the skillfully wrought items and events used in this way can ultimately only be measured by the extent to which they are

retained and repeated or discarded and abandoned. As Rose points out, we are more influenced by the recollection of a single successful prediction than we are by the forgetting of a thousand unsuccessful ones (Rose, 775). A good example is the motivations of astronomers during the Renaissance. "Astronomers, even those who regarded physical objects as desirable for theoretical astronomy, continued to regard prognostication as their primary objective" (Westman 684).[4] Despite a burgeoning scientific objectivity, astronomers remained entrenched in the practice of divination. Astrology's predictions have (then as now) a very low success rate. Yet astrology (astromancy) was often held in higher esteem than astronomy, and it offered a more lucrative salary (Brackenridge and Rossi, 85). Astrology's undeserved credibility resulted not only from both straightforward predictions of the physical movements of heavenly bodies and occasional lucky prognostications concerning the rich and powerful, but also from other skills with which astrologers performed their art.

In 1528, a Carmelite monk in Prato by the name of Giuliano Ristori foretold the death of Duke Alessandro de' Medici (1510–1537), in line to become the future ruler of the Florentine Republic. Nine years later, the Duke was found strangled to death in his bed (Westman, 255). Forecasting the early death of Duke Alessandro significantly enhanced the perceived reliability of astrology and Ristori's astrological reputation was established, just as many other astrologers' credibility would be after making a single such accurate prediction (Westman, 255). In 1601, Johannes Kepler wrote in his *On the More Certain Fundamentals of Astrology* that mathematicians were obliged to publish annual prognostications, as their demand was increasing, partially because of Ristori's success (Brackenridge and Rossi, 91).

> In those pamphlets some matters will be foretold which the event will make credible; but many more will be foretold which time and experience will refute as false and worthless. The latter will be written on the winds, the former very deeply inscribed in the memory, as is the way of the world.
>
> (Kepler, quoted in Brackenridge and Rossi, 91)

Unsuccessful prognostications were simply overlooked. "One success betokened the probability of more; and in the wildly unregulated world of astrological forecasting, there were different ways to blur, rectify, or simply ignore false predictions" (Westman, 257). Despite its fallibility, astrology—and divination in general—was deeply influential in the Church. Finally, what is important in assuring the retention of divinatory items is not their success or failure in accurately predicting the future or even in recommending appropriate behavior, but their production of confidence and assurance in the adherents who use them. The *Yijing* may today be the most obvious example of this, but the Biblical text and all other sacred scriptures, are also examples of the same dynamic.

Despite the huge range of types of divination, and the ease with which they are understood as a form of "reading," types of divination that specifically involve the reading of prepared texts, what one must call "graphomancy" or "bibliomancy," are not particularly well-represented in the literature. Searching online for references to these terms led only to obscure and exoteric sites such as "darktarot.com" and role-playing sites that inform us that graphomancers have a rank of 5, with 9 or more mana and an ability to absorb a "document" spell. Once again, our present logocentric perspective persuades us to think of writing almost exclusively as concerned with the assured, accurate, and reliable communication of pre-existent data, rather than as concerned with the chancy business of "revealing the unseen order," and inducing an emotional response to current affairs. However, that writing has been and continues to be used as a form of divination is indubitable. As mentioned previously the *Yijing* is the most striking example of graphomancy, but it is a recognized fact that books have been used in this way also in the West. For example:

> To the class of divination by mechanical means we must add, among peoples who possess sacred writings, or books for any reason esteemed to contain great wisdom (such as was attributed to the works of Vergil in the Middle Ages), a form of *sortilegium* which consists in opening such a book at random and taking an omen from the first passage met with. The prestige won for the Bible by the establishment of Christianity in Europe has resulted in the *sortes Biblicæ*, still used, we believe, among uneducated people.
>
> (Rose, 1912a, 780)

Christianity supposedly discouraged all forms of divination except for the immediate prompting of the Holy Spirit, and St. Paul particularly emphasized self-control, discouraging mediumistic or oracular trance: "The spirits of the prophets are subject to the prophets," he insists (1 Cor 14:32). Yet some mechanical forms of divination continued to claim Apostolic authority, such as divination by lot, for example, Acts 1:26, in which Matthias is added to the apostles by lot. Most divinatory practices were prohibited with a frequency and vigor throughout the history of Christianity as to indicate that they continued to be *practiced* with equal frequency. The Emperor Gratian (359–383) collaborated with another former Emperor, Valentinian II (371–392), and the current Emperor Theodosius I (347–395), to produce the *Edict of Thessalonica* declaring Christianity the official religion of Rome in 380. In his *Decretum Gratiani* he declared that "[Even] if it is demonstrated that there is nothing evil in [the use of] divination, nevertheless it is forbidden to the faithful, lest under the guise of divination, [the faithful] return to the ancient practices of idolatry" (Barns, 788).[5] Yet not all were entirely prohibited. Barns provides numerous examples of early Christian authorities who practiced forms of graphomancy or bibliomancy. The election of St. Martin

(316–397) to the Bishopric of Tours was decided by such a use of the Psalter. The open practice of such modes of divination in the Church is again illustrated on the occasion of the visit of Chramnus to Dijon (c. 556). The clergy determined to tell his fortune from random opening of each of the three Lections of the Gallican Mass. In fact, the practice of learning by such means the character and administrative ability of a newly elected Bishop became in early times an established Church custom known as the *Prognosticon*. The *sortes Sanctorum* is recorded with approval in a *Life of St. Hubert of Liege* (c. 714 CE). Here two books were placed on the altar—a Book of the Gospels and a Sacramentary—and they were simply opened at random to provide direction. It can easily be argued that, rather than simply prohibiting all such divination in principle, the Church sought to subject divination to its own authority.

A similar "*sortes Koranicae* … is said to go back to very early times" in Islam (Margoliouth, 818). In fact, all such practice of determining behavior by consulting ancient scripture can be seen to fall on a scale from, at one end, the clearly magical/mechanical bibliomancy of such methods as "divination by Bible and key," in which a Bible is suspended by a key tied with its wards between the leaves and the key supported on two persons' forefingers, by which the whole may turn and, in answer to questions posed of it, provide direction (described by E. B. Tylor (1878) in the *Encyclopedia Britannica*, 9th edition, sub "Divination"). In such a case "we doubt if the people who use this method could say definitely whether they suppose the answer to be sent by God or to come from some quasi-magical power inherent in the book itself" (Rose, 776). What might be called spiritual/interpretative graphomancy, in which the reader seeks guidance from a more careful reading of the text, is simply at the other end of the same spectrum.

It is hardly surprising that the Western tradition of scholarship, descended as it is from devout religious scholarship, has been reluctant to recognize this—such a understanding of the use of the text (and of its evolution through time) is liable to render the Biblical text as ultimately impossible to decipher indubitably as is the text of the *Yijing* (v. Richard Smith 2008, 3, 14–15, 23, 29). For example, take JoAnn Scurlock's (2010) attempt to identify the "real" referent of the name of Sennacherib in Isaiah 37. She concludes that the referent must, in fact, be Nebuchadnezzar—"Despite the specific references to Sennacherib and kings of Assyria, the religious policy expressed again marks the actual referent clearly as Nebuchadnezzar" (Scurlock 2010, 292). If this "divinatory" understanding of the use and development of the text is correct, the "actual referent" of the text could be any element of any situation that led any supplicant to approach the text for guidance—the text itself being formed, constructed, and reconstructed under the pressures of such usage—as was the *Yijing*. "Sennacherib" could refer to any oppressive power. It might mean anything, although it unquestionably contains *some* reference to historical actualities (as does the *Yijing*), certain portions have been so conditioned by such use as to become inherently indecipherable as historiography. I am

not suggesting that the attempt should be abandoned, as I said in the introduction, impossible tasks remain worthwhile, but it does call for a certain humility in the attempt. Also we need to recognize that

> much of science itself has evolved from forms of divination and may be said to continue certain aspects of it. Astronomy, for example, is deeply indebted to ancient Near Eastern and Hellenistic astrological researches; mathematics and physics were advanced by Indian, Pythagorean, and Arabic divinatory cosmological speculations; and several leading Renaissance scientists were inspired by the divinatory schemes of Qabbalah and hermetism in their search for the moral harmonies and direction of the universe.
>
> (Zuesse, 2369)

The fact that, even in scriptural/interpretive graphomancy, we read the nature of the invisible from marks that we have made ourselves seems to be the very model of the art of divination—what I have called epistemological echolocation. We read the nature of the invisible from things that we have ourselves created out of the raw materials of the physical world, and the reaction of the physical world—especially other people—to them. We are driven to create in order to have something adequately nuanced to interpret. The more that specific forms and sources of interpretation persist, the more they are consulted. When we exercise our skill and create something that did not previously exist, we express personality most intensively.[6] Our perception of the real world is structured by our consciousness, so in becoming acutely aware of the nature and structure of our consciousness we can in some ways become more acutely aware of the nature and structure of the real world that is perceived through it, and vice versa. This is how altered states of consciousness, such as in shamanism, could provide information that is useful and effective in the real world. The more such sources are consulted with any degree of satisfaction, the more widespread their consultation and utilization becomes. Again, the satisfaction of the client is the real end product of the process, no matter what else the outcome. That clients can be, and continue to be, satisfied in this way is attested by the remarkable success of "self-help" books, among other, more explicitly religious behavior.

This is not, of course, an entirely conscious process. Su Shih (1037–1101 CE) was one of the major Chinese poets of all time, an important official (when not in political exile) who was leader of the conservative faction in Sung Dynasty (960–1279) politics, and an amateur painter. His paintings were apparently created spontaneously after attaining an alcoholic trance, according to Jordan Paper (1985, 14). Su Shih said of his friend:

> When Yü-k'e paints bamboo
> He sees bamboo, not himself
> (quoted by Paper, 14)

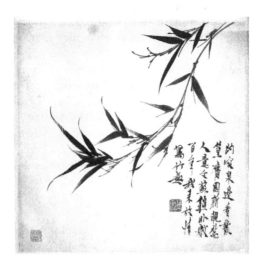

Figure 9.1 Yü-k'e [Wen Tong 1018–1079] paints bamboo.

This is an example of the process of becoming aware of one's own consciousness so that one can reduce its effects on one's perception (as was Emerson's infamous "transparent eyeball")—an ultimately impossible task, but at least Su Shih was aware of the entry of the self into the act of perception and representation. Similarly, Paleolithic visitors to the caves of France and Spain sought insight into the "invisible order" suggested by flickering light on the contours of the cave walls, yielding evidence of the nature of the invisible order (the "spirit world" according to David Lewis-Williams, 2002) via the nature of their consciousness. This can be seen as the earliest recorded instance of using skills of representation as a means of divination—art and religion seamlessly combined in a practical attempt to produce effective behavior—itself a behavior that would be selected for if it were successful and which would spread culturally by imitation.

As graphomancy has gradually become the most popular form of divination, especially in the Modern West, we may have begun to transgress the second commandment in the sense suggested earlier, and confused our representations of reality *with* reality. Such may be seen in Paul Tillich's contribution to Apostolos-Cappadona's anthology (1984). Here Tillich claims that "[u]ltimate reality underlies every reality, and it characterizes the whole appearing world as non-ultimate, preliminary, transitory and finite" (219). Thus "the deceptive character of the surface of everything … drives one to discover what is below the surface … the truly real which cannot deceive us" (220). So far, so good. Given the understanding of neurological processing of cognition, I would agree with this. However, Tillich goes on to talk of "the arts in which ultimate reality is expressed in artistic forms" (220). This general claim that art expresses the ultimate/infinite in and through the contingent/finite is repeated several times throughout Apostolos-Cappadona's volume as we have

seen (for example, 9, 26, 138, 189, 205, 206, 208–210, 288) and, as we have also seen, it constitutes one of the unexplained mysteries of the relationship of art and religion (which I hope the present work is beginning to unravel). The problem, of course, is that what may "express" ultimate reality cannot itself *be* ultimately real, and thus it necessarily both reveals and conceals.[7] Despite his admirable ability for systematic thought, Tillich (1886–1965)—who might be seen as in this way typical of the German Protestant theologians so influential in the establishment of the early academic study of religion—exhibits some confusion in his attempt to classify expressions of this ultimate reality. There are, he says, "three ways in which humanity is able to experience and express ultimate reality," philosophy, art, and religion (221). Philosophy expresses it indirectly by expressing "encountered reality" in "cognitive concepts," art does the same in "esthetic images," but in religion "ultimate reality becomes manifest through ecstatic experiences of a concrete-revelatory character and is expressed in symbols and myths" (221–222), and thus "ultimate reality" is expressed "directly."

But what are symbols and myths but "esthetic images"—visual and verbal respectively? And how does one have any "ecstatic experience" without having first encountered these aesthetic images in the expressions of one's own religious tradition? In fact, for Tillich here "religion" is evidently synonymous with what he calls "sacramental and mystical experience" (223). More commonly the word is used to denote the very symbols and myths that are said to "express" this experience, and it can easily be argued that the "sacramental and mystical experience" is a *product* of the experience of prior expression in symbol and myth, located within and determined by the matrix of stylistically related expressions, rather than any "direct" experience of anything that, unaffected by historical context, gives rise to subsequent expression of that thing.[8]

A large part of this problem, which has become endemic in the Modern Western understanding of religion and art, can be seen in Tillich's fundamentally incoherent concept of "the sacred, namely, the direct symbols of ultimate reality" (222). If a symbol expresses ultimate reality, and if, as he says, the expression is not the thing expressed (221) and there is a necessary divide between the two, then what sense does it make to identify such a thing as a "direct symbol" that can "express in a direct way the fundamental relation of humanity to ultimate reality" (223)? What could this even mean? Tillich is simply asserting the privileged status of those symbols that he apprehends as most effectively communicating "sacrality" to him.

It is particularly revealing that this same questionable assumption of some kind of "direct mediation" is at work when Tillich assumes that philosophy, the first of his "indirect expressions of ultimate reality" (221), expresses itself in "cognitive concepts." Cognition and concepts are what happens in the subjective consciousness mediated by communication. In fact, philosophy expresses itself in *words*, which are abstract audible/visual signs in response to which we may (or may not) *form* concepts. Similarly, art expresses itself in

aesthetic images, which may or may not provoke "concepts" in the audience. "Concepts" are not necessarily verbal, as Thomas Franklin O'Meara, John Dixon, and Leo Steinberg go to considerable length to establish in the same anthology.

A great deal of religion does express itself in words, especially since the Protestant Reformation and the academic study of religion (see, for example, John Hinnells' salutary consideration of this problem, Hinnells 2005, 509). Written words are both visual symbols and coded, conventional representations of audible words, which are themselves coded representations of both sensory experiences and associated abstract concepts (see Dehaene, 187). Philosophy is thus equally distant from "cognitive concepts" as is "art" (and it should now be clear that Tillich almost exclusively means "the visual arts" when he says "art," separating as he does, words *from* art). Tillich's classification here is both typical of the Modern West and profoundly dubious. He ranks expression hierarchically: religion is direct experience, philosophy is the indirect expression of concepts, and "art" is the expression of aesthetic images. But all three rely upon the expression of aesthetic (that is, sensory, perceptible, whether audible or visible) prompts—which, as expressions, cannot possibly be "ultimate reality," nor can they express it "directly," although they can communicate, by association or resemblance, some appropriate behavioral response to that reality. In all cases, they communicate through the medium of perceptible experience and never "immediately," never "directly." For Tillich "religion" is equivalent to some assumed subjective but nonetheless "direct" experience of the "really real." What we normally call religion, however, he relegates to "the expression in myth and symbol" of that presumed experience. One has to ask: how can experience be "expressed" in symbols? This is a little like asking, how can I be happy unless the word "happy" exists?—which may, at first, seem like a foolish question. It is not. There may be "natural sorts": I am 5′ 10″ tall, and my actual height remains unchanged whether or not the rather weird Imperial system of feet and inches exists to express it or not. I'm also getting a little short of hair, whether or not the word "bald" exists. But there are other than natural sorts: I am also "married." Can I actually *be* that without some associated word and the social convention to which it refers? I am also "British" and a "resident alien." There are some categories that are *created* by the very words used to describe them, created by the very symbols used to "express" them and it is a significant argument that cannot be ignored that any specific "sacramental and mystical experience" may be of that sort. However, that is not my primary concern here. What is of importance to my argument is that words have become increasingly apprehended as something quite other than an artistic medium and far removed from any process of divination. This is logocentrism..

Religious traditions try to make people "aware of" a reality beyond appearances, a truth that is not visible, and they do so by means of all possible art media, including words. All language tries to communicate more than is physically present in the medium employed, and all art likewise seeks to

make one apprehend more than is actually, physically present in the piece—
be it an object, an event, or an emotion. The thing that the ancestor of art
and religion has long been called upon to reveal is something that is more
significant than the physically visible world (hence Tillich's naming it "ulti-
mate reality"), and that is, considering the present evidence, the best way to
respond to that world. Of course, neither art nor religion can simply induce a
"direct experience" of "ultimate reality" or "the infinite" nor can they reveal
any indubitable divination of the best behavior. They both suggest it with
conventional symbols, empowered by their location in an extended matrix
of stylistically related media just as the flickering light in the Paleolithic cave
may once have suggested "the spirit world," and we respond as best we can
and keep, assuming our survival, coming back for more. The biggest ques-
tion of all is precisely "what do I do now? ... What *should* I do? ... What is
the right thing to do?" and divination seeks to answer that. By "reading" the
implications, initially of skillful observations of nature but increasingly of fas-
cinating, skillfully wrought objects and actions that arrest our attention, and
seeking to emulate the skill that they manifest—either skills of presentation
or of discernment—we seek to answer those questions and to select the wisest
course of action. This process can be seen to have been at work in the whole
history of what has now become religion (and art).

The emphasis of the Post-Reformation Western Church has been on the-
ology composed of categorical propositions: "Words have dominated con-
temporary theology," as O'Meara said (1984, 206) and it was *written* words
that came to dominate. One Orthodox theologian, Dumitru Staniloae, goes
even further, saying that "Protestant theologians consider the word as the
only means of divine revelation" (2002, 34). Yet, while "the propositional
language of traditional theology is a great imaginative achievement" it can-
not represent "the whole of human experience," according to Dixon (1984,
277). As we have seen, O'Meara also points out that non-verbal creative
art "suggests a mode of subjectivity that not only rejects the technocracy of
words but which unleashes, bestows, and discloses the more of Presence"
(1984, 206), and so the other arts have not been entirely supplanted. They,
too, can give an "aesthetic intuition of ineffable presence ... the aesthetic
illustrates human theological interpretation of divine revelation ... [and] can
describe religion, revelation, faith, and thinking-about-faith with a strength
and clarity equal to the categorical style" (O'Meara 1984, 205). But words
themselves *are* "aesthetic images." In his masterful analysis of comic art Scott
McCloud points out that written words are the most abstract of visual images
(1993, 47), so O'Meara, by juxtaposing words to "the aesthetic" illustrates
the same malaise. There cannot finally be a clear distinction between the
"categorical style" and the aesthetic. This is the false dichotomy that we often
impose between words and images. As Derridean deconstruction correctly
points out, in the binary couplet of words and images, as in all such binaries,
we assume one—in this case words—to be superior. However, verbal sym-
bols are almost entirely conventional and arbitrary. We could have chosen

any shape to indicate the sound that is now conventionally represented by the shapes "a" or "A" (or अ, א etc.). Visual symbols, like blue for heavenly or a circle for completion, may have at least some reference to common experiences, even so, their meaning is set more by convention than by resemblance. With traditional icons meaning is determined more by their conformity to the *narratives* of the stylistic matrix that they inhabit than to any actual resemblance to an historical saint or religious figure, so the transition from Eastern Orthodox Icons to post-Reformation verbal/propositional theology is not as radical as often thought. It came about by way of the Italian Renaissance and Tuscan visual theology and we can trace at least some small part of that complex trajectory.

The neurology of reading and writing in part explains both its extreme salience and its potentially deleterious effect. It involves intensely the three areas of skill that I identified earlier—the skills of (re)presentation, of cognition, and of reception—which makes graphomancy a dramatically salient art and a form of relatively easily achievable self-hypnotic divination. It also induces a powerful impression of an ever-closer approach of representation to the represented. As any serious reader knows, reading can conjure up worlds of astonishing conviction, compulsion, and enchantment. In the art of divination there is necessarily a creative element—it is not supposed to be an exact representation or the operative element of divination, the moral response, the answer to "how *ought* I to respond?" is lost. Graphomancy, like other forms of divination, co-opts remarkably sensitive skills and abilities that have allowed humans to achieve a sensitivity to our environment and that have permitted us to recognize, from vanishingly small clues, too small, too fast, and too subtle to process consciously, what our best behavior is most likely to be—what we ought to do. As Dehaene, says, the "visual word recognition process, from retinal processing to the highest level of abstraction and invariance, … unfolds automatically, in less than one-fifth of a second, without any conscious examination" (Dehaene, 93). That is remarkable sensitivity, and it must have *preceded* our ability to develop and use writing (Dehaene, 4). Employing such sensitivity humanity had flourished and spread into almost every environmental niche of the globe well before the development of written scripts. Our instinctive creativity leads us to enhance and highlight clues provided by our environment that suggest to us the disposition of the environment and hence our most appropriate response to it, employing the same (or very closely related) neurological processes that enable "theory of mind." Those enhancements and highlights led to our representation of the invisible order of reality.

It is not just metaphorical to suggest that we respond emotionally to our physical environment in a fashion fundamentally similar to that by which we respond to our social environment. It does seem to be the case that our most sensitive, subtle, fast and frugal response systems have evolved in the context of that social environment. The enhancement of the clues and suggestions of the physical environment permits the representation of an invisible reality functionally equivalent to the "personality" of reality, the "emotional

disposition of the gods," the communication of which enables a coordinated social, rather than simply individual, response to the promptings of the environment. In a competing market of perception, enchantment, insight, enhancement, and expression, those representations that will effectively seize the attention and compel imitation are reproduced and flourish. The behavior that they induce flourishes likewise. In any community that continues to survive and reproduce, that behavior will be perpetuated. However, the process is unavoidably creative, bringing into the environment something which, while *suggested* by an environment (which increasingly comes to consist of items of our own creation), did not actually exist previously. This is neither necessarily problematic nor entirely misleading, since such creativity permits heightened sensitivity to our own cognitive processes, to the structural overlay that our own neurology imposes upon our perception of reality, and thus permits, at least potentially, a clearer and more sensitive response to the reality that is independent of our perception. Our representations, while creative and ahistorical, can thus be seen as true in a pragmatic sense.

If we fail to *recognize* our creative input into this process, however, if we fail to see our creativity *as* creative, if we begin to confuse our representations with that which they represent, then it seems unavoidable that this process will become problematic and misleading. It may be the case that we have, on some level, been aware of this potential pitfall—hence (among other things) the injunction of the Biblical second commandment, the Muslim attempt to avoid figural representation, and René Magritte's *La Trahison des Images*. However, unfortunately, the monotheistic traditions are closely connected with a profound fascination with graphomancy. In the attempt to sidestep the temptations of visual and figural representation, we seem to have fallen headlong into a pit of our own creation. The graphical representation of language in visual form exercises such compelling conviction that the reality it represents is nothing other than reality itself, independent of our creativity, that, in far too many cases, it is taken to be precisely that. The written word is taken "literally." This not only leads, in its most obvious manifestation, to bibliolatry and scriptural literalism—a conceit into which even some Hindu traditions now appear to be drawn—but may also dramatically impair our ability to take an effective emotional "reading" of the environment independent of our perception. While secular scientific representations of the environment empower a truly astonishing ability to manipulate that environment mechanically for our own ends, we suffer from a simultaneous cultural blindness that has disabled us from responding appropriately to the promptings of the environment that might restrain such activity to more sustainable levels. Instead, we forge on with industrial exploitation despite clear evidence that it is unsustainable. We seem no longer to be capable of apprehending the clues and suggestions of the environment as "the wrath of God" or some such emotional condition to which we feel constrained to respond. This may well be connected to the fact that the neurological processes most intimately connected with reading are "strongly lateralized in the left hemisphere" of

the brain (Dehaene, 78) and that hemisphere is primarily devoted to analytic functions which do not attend to the unique and the new, while it is the right hemisphere that identifies emotional expression and enables creative mimesis (McGilchrist, 59, 248).

If we fail to distinguish between the invisible order and what our consciousness brings to it in our *representation* of the invisible order, we cannot "see the world better." If we believe that we simply see it as it is—even if we do become increasingly enabled to manipulate it—we cannot divine how best to behave in response to it. If the right hemisphere is dominant in our ability creatively to *imitate* and thus make present what is not present, then a reliance on graphomancy could significantly weaken the *imitatio dei* that is the crucial adaptive feature of the art/religion complex—left-hemisphere dominated, writing-driven divination can only encourage an ability to copy *mechanically*, which may have elevated us to the status of mechanically creative beings while neglecting the compassionate and emotional aspects of our traditions. This might portend that modern secular culture will be even more hidebound and blindly conservative than its traditional forebears. But how did we get here? How did a function that appears to have been genetically selected for as an adaptation that increased our effective ability to interpret and respond persistently and sustainably to our environment, come to develop behavior that seems an unsustainable threat to that environment? A chronological consideration of the workings of ancient art and religion may begin to answer that question.

Notes

1 Gregory Spinner, when he was visiting assistant professor of religion at Skidmore College, remembered his experience as a PhD student studying with Culianu at the University of Chicago. Culianu was, according to Spinner, a warm, supportive, and unconventional teacher.

> The reading course on divination was a wildly ambitious attempt to chart the vast continent of the occult sciences. This topic deserves a longer hearing, so let me just simply assert that Mike and I were not only expected to read about divination techniques. We were asked to perform them. Seriously—I would be graded on how well I performed divination.

http://chicagomaroon.com/2016/05/13/25-years-later-assassinated-professor-remembered/

2 " ... some universal art: *a seer, or physician, or architect,* or perhaps a divine minstrel ..." note that the minstrel is seen as more divine than the seer (mantis). (From Poetry in Translation.)

3 I repeat the footnote from Chapter 2 for those who may have missed it: I am aware of the significant volume of wildly speculative theories that have arisen from the basic fact of brain hemisphere asymmetry—to the extent that I am reluctant to refer to it. However, McGilchrist is a very significant scholar and psychiatrist whose opinions are well supported by considerable evidence and experience.

4 I must thank a former student, Troy Holden, for bringing this material to my attention.

5 Although the text of the *Decretum Gratiani* can be dated to the 12th century, at least some of the imperial decrees compiled within it appear to be authentic to the 4th century. My thanks to Prof. A. Dwight Castro for his invaluable assistance with both the Latin and the history of the text.

6 No-one else would perform a skilled task quite exactly alike and we are most fully ourselves—this is me, this is mine, and nothing and no one can stop it from being me and being mine—when we exercise creative skill, hence the importance of art and creativity to the oppressed and downtrodden (see, for example, Kirk-Duggan 2014 and De Gruchy 2014).

7 Although this dichotomy has been recently employed by Jan Assmann (see Assmann 2008, 70–72; Kripal 2014, 15), it is one of the most characteristic features of the entire oeuvre—both theoretical and fictional—of Mircea Eliade (Eliade 1936, Introduction, 6–7, 1978, xvi; see Idel, 2010, and Rennie 2013).

8 "The jury is still out" on this controversy and neither those who insist that the experience is a product, sometimes called constructivists or contextualists, nor those who insist that the experience pre-dates and determines its expression rather than vice versa, have been able to convince their opposite numbers. See particularly the work of Steven Katz.

References

Annus, Amar, ed. *Divination and Interpretation of Signs in the Ancient World*. Chicago, IL: Oriental Institute of the University of Chicago, 2010.

Apostolos-Cappadona, Diane, ed. *Art, Creativity, and the Sacred: An Anthology in Religion and Art*. New York: Continuum, 1984.

Assmann, Jan. *Of God and Gods: Egypt, Israel, and the Rise of Monotheism*. Madison: University of Wisconsin Press, 2008.

Bambrough, Renford. "Intuition and the Inexpressible." In *Mysticism and Philosophical Analysis*, edited by Steven T. Katz, 200–213. London: Sheldon Press, 1978.

Barns, Thomas. "Divination (Christian)." In the *Encyclopedia of Religion and Ethics*, edited by James Hastings, 788–792. Edinburgh, UK: T & T Clark, vol. IV 1912.

Bolling, George. "Divination (Vedic)." In the *Encyclopedia of Religion and Ethics*, edited by James Hastings, 827–830. Edinburgh, UK: T & T Clark, vol. IV 1912.

Brackenridge, Bruce and Mary Ann Rossi. "Johannes Kepler's *On the More Certain Fundamentals of Astrology* Prague 1601." *Proceedings of the American Philosophical Society* 123, no. 2 (1979): 85–116.

Calvin, W. H. "A Stone's Throw and its Launch Window: Timing, Precision and Its Implications for Language and Hominid Brains." *Journal of Theoretical Biology* 104 (1983): 102–135.

Clark, Andy. *Surfing Uncertainty: Prediction, Action, and the Embodied Mind*. Oxford, UK and New York: Oxford University Press, 2016.

De Gruchy, John W. "Art, Morality and Justice." In *The Oxford Handbook of Religion and the Arts*, edited by Frank Burch Brown, 418–432. Oxford, UK and New York: Oxford University Press, 2014.

Dehaene, Stanislas. *Reading in the Brain: The Science and Evolution of a Human Invention*. New York: Viking, 2009.

Dixon, John W. "Painting as Theological Thought: The Issues in Tuscan Theology." In *Art, Creativity, and the Sacred*, edited by Diane Apostolos-Cappadona, 277–296. New York: Continuum, 1984.

Dottin, Georges. "Divination (Celtic)." In the *Encyclopedia of Religion and Ethics*, edited by James Hastings, 787–788. Edinburgh, UK: T & T Clark, vol. IV 1912.

Eliade, Mircea. *Domnișoara Christina*. Bucharest: Editura Cultura Națională, 1936.

Eliade, Mircea. *A History of Religious Ideas, vol. 1: From the Stone Age to the Eleusinian Mysteries*. Chicago, IL: University of Chicago Press, 1978.

Florida, Nancy. *Writing the Past, Inscribing the Future: History as Prophecy in Colonial Java*. Durham, SC and London: Duke University Press, 1995.

Gaster, Moses. "Divination (Jewish)." In the *Encyclopedia of Religion and Ethics*, edited by James Hastings, 806–814. Edinburgh, UK: T & T Clark, vol. IV 1912.

Gray, Louis H. "Divination (Persian)." In the *Encyclopedia of Religion and Ethics*, edited by James Hastings, 818–820. Edinburgh, UK: T & T Clark, vol. IV 1912.

Hinnells, John R. "Religion and the Arts." In *The Routledge Companion to the Study of Religion*, edited by John Hinnells, 509–525. London and New York: Routledge, 2005.

Idel, Moshe. "The Camouflaged Sacred in Mircea Eliade's Self-Perception, Literature, and Scholarship." In *Hermeneutics, Politics, and the History of Religions: The Contested Legacies of Joachim Wach and Mircea Eliade*, edited by Christian K. Wedemeyer and Wendy Doniger. Oxford University Press, 2010.

Jacobi, Hermann. "Divination (Indian)." In the *Encyclopedia of Religion and Ethics*, edited by James Hastings, 799–800. Edinburgh, UK: T & T Clark, vol. IV 1912.

King, Leonard W. "Divination (Assyro-Babylonian)." In the *Encyclopedia of Religion and Ethics*, edited by James Hastings, 783–786. Edinburgh, UK: T & T Clark, vol. IV 1912.

Kirk-Duggan, Cheryl A. "Sacred and Secular in African American Music." In *The Oxford Handbook of Religion and the Arts*, edited by Frank Burch Brown, 498–521. Oxford, UK and New York: Oxford University Press, 2014.

Kripal, Jeffery. *Comparing Religions*. Chichester, UK: Wiley Blackwell, 2014.

Leclerc, Thomas L. *Introduction to the Prophets: Their Stories, Sayings, and Scrolls*. New York: Paulist Press, 2007.

Lewis-Williams, D. *The Mind in the Cave: Consciousness and the Origins of Art*. London: Thames and Hudson, 2002.

Margoliouth, David Samuel. "Divination (Muslim)." In the *Encyclopedia of Religion and Ethics*, edited by James Hastings, 816–818. Edinburgh, UK: T & T Clark, vol. IV 1912.

McCloud, Scott. *Understanding Comics: The Invisible Art*. Northampton, MA: Kitchen Sink Press, 1993.

McGilchrist, Iain. *The Master and His Emissary: The Divided Brain and the Making of the Western World*. New Haven, CT and London: Yale University Press, 2009.

O'Meara, Thomas F. "The Aesthetic Dimension in Theology." In *Art, Creativity, and the Sacred*, edited by Diane Apostolos-Cappadona, 205–218. New York: Continuum, 1984.

Paper, Jordan. "'Riding on a White Cloud': Aesthetics as Religion in China." *Religion* 15, no. 1 (1985): 3–27.

Rennie, Bryan. "Mircea Eliade's Understanding of Religion and Eastern Christian Thought." *Russian History* 40 (2013): 268–280.

Revon, Michel. "Divination (Japanese)." In the *Encyclopedia of Religion and Ethics*, edited by James Hastings, 801–806. Edinburgh, UK: T & T Clark, vol. IV 1912.

Rose, Herbert J. "Divination (Introductory and Primitive)." In the *Encyclopedia of Religion and Ethics*, edited by James Hastings, 775–780. Edinburgh, UK: T & T Clark, vol. IV 1912a.

Rose, Herbert J. "Divination (Greek)." In the *Encyclopedia of Religion and Ethics*, edited by James Hastings, 796–799. Edinburgh, UK: T & T Clark, vol. IV 1912b.

Savage-Smith, Emilie, ed. *Magic and Divination in Early Islam*. Burlington, VT: Ashgate Variorum, 2004.

Scurlock, JoAnn. "Prophecy as a Form of Divination; Divination as a Form of Prophecy." In *Divination and Interpretation of Signs in the Ancient World*, edited by Amar Annus, 277–316. Chicago, IL: Oriental Institute of the University of Chicago, 2010.

Smith, Richard. *Fathoming the Cosmos and Ordering the World: The* Yijing *(I-Ching, or Classic of Changes) and Its Evolution in China*. Charlottesville and London: University of Virginia Press, 2008.

Smith, Richard. *The "I-Ching": A Biography (Lives of Great Religious Books)*. Princeton, NJ: Princeton University Press, 2012.

Spence, Lewis. "Divination (American)." In the *Encyclopedia of Religion and Ethics*, edited by James Hastings, 780–783. Edinburgh, UK: T & T Clark, vol. IV 1912.

Staniloae, Dumitru. *Orthodox Spirituality: A Practical Guide to the Faithful a Definitive Manual for the Scholar*. Translated by Archimandrite Jerome (Newville) with a foreword by Otilia Kloos. South Canaan, PA: St. Tikhon's Seminary Press, 2002.

Steinberg, Leo. "The Seven Functions of the Hands of Christ." In *Art, Creativity, and the Sacred*, edited by Diane Apostolos-Cappadona, 37–63. New York: Continuum, 1984.

Tillich, Paul. "Art and Ultimate Reality." In *Art, Creativity, and the Sacred*, edited by Diane Apostolos-Cappadona, 219–235. New York: Continuum, 1984.

Tylor, Edward Burnett, "Divination." In the *Encyclopedia Britannica*, 9th edition, edited by Thomas Spencer Baynes, 293–294. New York: Charles Scribner's Sons, vol. VII 1878.

Waddell, L. Austine. "Divination (Buddhist)." In the *Encyclopedia of Religion and Ethics*, edited by James Hastings, 786–787. Edinburgh, UK: T & T Clark, vol. IV 1912.

Walshe, W. Gilbert. "China" In *The Encyclopedia of Religion and Ethics*, edited by James Hastings, 549–560. Edinburgh, UK: T & T Clark, vol. III, 1911.

Westman, Robert. *The Copernican Question. Prognostication, Skepticism, and Celestial Order*. Berkeley: University of California Press, 2011.

Wissowa, Georg. "Divination (Roman)." In the *Encyclopedia of Religion and Ethics*, edited by James Hastings, 820–827. Edinburgh, UK: T & T Clark, vol. IV 1912.

Zuesse, Evan M. "Divination: An Overview." In the *Macmillan Encyclopedia of Religion*, 2nd edition, edited by Lindsay Jones, 2369–2375. London and New York: Macmillan, 2005 (also in the 1st edition of 1987).

10 From caves to cities

Religion and the earliest art

Where there is devotion there is materiality and it is of an aesthetic nature. ...
Devotional art is meant to be touched, kissed, paraded around, put in pockets
displayed in kitchens, dressed up, buried, and a thousand other things.

(Alejandro Garcia-Rivera, "Postscript: On
Devotion at Çatalhöyük," 359–360)

Time line

Paleolithic (old stone age) begins c. 3.3 million years ago. Dinosaurs went
extinct c. 66 million years ago.

The Early or Lower Pleistocene spans the time between roughly 2.5 and
0.75 million years ago.

The Late or Upper Pleistocene spans from roughly 125,000 years ago to
9,600 BCE. Humanity (*homo sapiens*) spread to every continent except for
Antarctica during the Late Pleistocene.

Homo habilis existed 2.3 to 1.44 million years ago.

Homo sapiens first enters the fossil record about 195,000 years ago.

Homo erectus became extinct about 143,000 years ago.

Blombos Cave, South Africa contained an incised slab of ochre dating
from c. 75,000 years ago that has been argued to be one of the earliest indi-
cations of artistic and even symbolic behavior.

Aurignacian culture is an archeological culture of the Upper Paleolithic
extending from Europe to southwest Asia and lasting roughly from ca.
45,000 to 35,000 years ago. The Aurignacian technocomplex included many
identifiable stone tools.

Homo neanderthalensis became extinct (or entirely assimilated into the *homo
sapiens* population) about 30,000 years ago.

Pleistocene cave art:

Blombos (South Africa—c. 75,000 BCE)
Chauvet (France—oldest examples c. 30,000 BCE)
Cosquer (France—c. 25,000 BCE)

Pech Merle (France—c. 25,000 BCE)
Altamira (Spain—c. 16,500 BCE)
Lascaux (France—c. 15,500 BCE)
Volp (France—Les Trois Frères—c, 13,000 BCE)
Niaux (France—c. 11,500 BCE)

The Neolithic (new stone age) is a cultural period beginning about 10,200 BCE in some parts of the Middle East, and later in other parts of the world and ending between 4,500 and 2,000 BCE.

The (current) Holocene geological epoch begins c. 9,600 BCE.

Göbekli Tepe dates from c. 9,500 BCE.

Çatalhöyük, the largest, best preserved of the Neolithic sites, lasted from c. 7,250 to 5,700 BCE.

The Ubaid period in Mesopotamia dates from c. 6,500 to 3,800 BCE.

Late Neolithic Cultures in China include:

Yangshao (5,000–3,000 BCE)
Hongshan (4,700–2,900 BCE)
Dawenkou (4,100–2,600 BCE)
Liangzhu (3,400–2,250 BCE)

Uruk, an ancient city of the Sumerian culture from 3,500 to 2,900 BCE, has been called "The First City" (Liverani 2006).

Cuneiform writing, some of the earliest known written script emerged in the Uruk IV period, c. 3,300–3,100 BCE. Egyptian proto-hieroglyphs emerged at about the same time but did not become workable script until c. 2,900 BCE.

Indus Valley Civilization began c. 3,300 BCE. It produced cities of c. 200,000 people from c. 2,900 to 1,900 BCE. It also produced a written script that has yet to be deciphered.

Knossos, Crete had its first settlements c. 7,000 BCE; its Palace dates from c. 1,900 BCE.

Egypt: Ancient Pharaonic Egypt, c. 3,300–525 BCE, when the Persians took over.

Development of alphabetic script c. 1,800–1,700 BCE. Appearance of proto-Canaanite script.

The Amarna or 18th dynasty Period in Egypt: 1,353–1,292 BCE.

Biblical Hebrew traditions, c. 1,250 BCE–90 CE.

Development of demotic Egyptian script, c. 650 BCE.

Persia: Achaemenid Persia (550–330 BCE); Seleucid Persia (312–63 BCE); Parthian Persia (247 BCE–224 CE); Sasanian Persia (224–651 CE).

Greece: Mycenaean civilization (c. 1,600–1,100 BCE); Greek Dark Ages (c. 1,100–700 BCE); Classical Period (c. 500–300 BCE).

Xianyang, China (c. 200 BCE) source of the "Terracotta Army."

Roman Empire (27 BCE–476 CE).

Unearthing prehistoric religion—listening for the music of the stone age

It is a commonplace in archeology that the study of ancient religion poses almost insuperable difficulties. Only the most durable evidence survives but "religion, by definition, involves a system of beliefs which offers answers to profound existential questions … a coherent view of the nature of the present world, of the origins of the world and of future human destiny," according to archeologist Colin Renfrew (1994, 48). Such a system of beliefs, such answers, such views, yield little or no durable evidence from prehistory, but giving priority to "beliefs," subjective mental states that manifest as verbal (and much later, literate) behaviors is problematic. We must, instead, consider religion primarily in the sense suggested of an associated matrix of skillful performances and artifacts that fascinate and *promote persistent behavior.* Then an evidentiary trail may be followed. We cannot be primarily concerned with *belief* but with evidence of persistent behavior. That behavior may be taken as behavior *as if* … that is, as an index of possible beliefs that may, secondarily, be abducted from the behavior, but such inference will usually be underdetermined and inconclusive. Plural potential beliefs might promote the same behavior. Also, when one asks whether the earliest art was religious or not, or what the earliest interactions of art and religion were, the response depends almost entirely upon one's pre-existing interpretation or definition of the two terms. If, as I suggest, they are behaviors descended from a common ancestral trait, such questions are seriously misleading. There is no earliest time at which they interacted, but only an earliest time at which we can distinguish the one from the other. Prior to that "they" composed a single class of behavior.

This behavior may be best exemplified by something that most people may not recognize as either art or religion—the knapping of stone to produce sharp points and edges and other usable tools. The production of stone tools, and the various technocomplexes that it produced, is certainly one of the most persistent human behaviors that we have ever recorded, lasting some 3.4 million years. Cracking two rocks together to produce sharp flakes and so on may not seem like art. It certainly may not seem like religion. But if we consider it as ancestral to both it makes more sense. I am very much persuaded by Mithen's arguments (Mithen 2005) that music is, to say the least, strongly present in the earliest art. It is not, he argues, a later elaboration of language but, like language, is descended from an ancestral behavior that Mithen simply calls "Hmmmmm" (Mithen 2005, 27, 172).[1] Mithen also warns that "to separate rhythmic and melodic sound from rhythmic and melodic movement—song from dance—is quite artificial" (2005, 15). Further, Alfred Gell observes that

> [i]t is surely useful to consider the act of drawing as akin to dancing, and the design as a kind of frozen residue left by this manual ballet …

a painting by Rembrandt is a performance by Rembrandt, and is to be understood only as such, just as if it were a performance by one of today's dancers or musicians, alive and on-stage.

(1998, 95)

In this light we can only recognize the serious limitations and flaws of applying modern distinctions among the arts to Stone Age behaviors, and we must accept that what applies to one art form, unless it is very specifically constrained by the physical nature of the medium, applies to others. As we have seen, we are well-advised to broaden our classification of what counts as art. Archeologist Ian Hodder, in agreement with Dissanayake, says: "'art' is not 'art' in the sense of something simply to be contemplated with aesthetic sensibilities. The art at [the Neolithic settlement of Çatalhöyük] does something …" (Hodder 2006, 195). All *forms* of art contribute to what is done and the remaining products of that process bear witness to the performances that produced them, and there is increasing evidence that such performances were genetically influenced (Corbey et al. 2016).

The song and dance of early humanity have left little in the way of hard evidence, but the production of Paleolithic stone tools (documented from as early as 700,000 years ago) was almost certainly accompanied by rhythmic and melodic sound and movement and has left much more durable traces. Early hominids invested a great deal of time, skill, and attention into the production of such items, some of which "have a very high degree of symmetry that has been deliberately imposed by skillful and often delicate chipping of the stone … [and] have been called the first aesthetic artefacts" (Mithen 2005, 164, 188). Although these items were used for practical purposes such as butchery, cooking, and carpentry, they were produced in a much more elaborate form and to a much more numerous extent than was practically useful. Many have been found that show no signs of wear or use: "often several hundred [were] discarded together in pristine condition" (Mithen 2005, 191). Mithen's conclusion is that their manufacture was an indication of the genetic fitness of the manufacturer and thus became a component of mate-selection—they were "sexy hand-axes" (Kohn and Mithen 1999)—demonstrating the knowledge, ability, and skill of their makers and thus attracting attention to them. Simple possession of such an item would be inadequate to that end—it could have been stolen—so constant, practically superfluous, manufacture would be necessary—performance over product.

Such manufacture would be accompanied by both song and a form of dance. "Work songs" accompanied much of even early modern labor before the advent of recorded music (see Gioia 2006). Scots Waulking songs, to give but one example, were traditionally sung in Gaelic while fulling cloth in the 19th century. These, too, would function as attractor, indicating promising mates (Mithen 2005, 188–191). Singing and swaying while knapping a hand axe is, most accurately, *ancestral* to what we now call art, so questioning whether this is "really art" simply imposes modern definitions on the

prehistoric. Such activity conforms to the special behaviors that Dissanayake et al. would have us recognize as art and would have produced the subjective apprehension of beauty such as was described earlier and so contributed to persistence.

Such prehistoric evidence is always difficult to assess and conclusions drawn from it are always contentious. There are researchers who believe that the abundance, wide distribution, proximity to source, consistent shape, and lack of actual use of these "hand axes" are better explained by the assumption that they are in fact the left-over cores of flint nodules after useful flakes have been removed.[2] Nonetheless, in the production of early stone tools we have a scenario in which what are defensibly early forms of "artistic" activity specifically function to express and communicate the latent, otherwise inaccessible, inner nature of agents, engendering an emotional and behavioral response. They encourage imitation and persistence, and both responses conform to the proposed description of a behavior ancestral to art and religion. Finally, the production of such pieces communicates something general about the nature of reality—symmetry is good, making symmetrical things is desirable, there are hidden values in apparently useless embellishments to useful activity, and so on.

From caves (and elsewhere)

The pre-religious and pre-artistic, nature of stone-knapping may remain speculative, but art and religion have occurred closely together since humanity left graphic images on the walls of deep caves some 30,000 years ago—or so runs one widespread interpretation of parietal (cave) art. This is also a contentious interpretation and not without its critics as we will see. If such activities may accurately be seen as the common ancestor of art and religion, how else may it be seen in the records of the Paleolithic era?[3] One of the most frequently cited scholars of parietal art is David Lewis-Williams, who argues that the behavior of upper Paleolithic *homo sapiens* "presupposes a kind of human consciousness ... that permits conceptions of an 'alternative reality'" (2002, 101). In his analysis of Paleolithic parietal art as found in the caves of Chauvet, Alta Mira, and Lascaux he argues that Paleolithic artists had no intention to represent real—that is physical, empirical—items but specifically to represent "spirit beings" (194). For their makers, "the paintings and engravings *were* visions, not representations of visions—as indeed was the case for the southern African San and the North American shamans" (194). He identifies the artists as "Shamans [who] learn to increase the vividness of their mental imagery and to control its content" (134) by engaging and manipulating the visionary experiences and employing "guided imagination," which is "a form of imagination that goes beyond what we normally understand by the word ... it consists in 'setting aside the critical faculty and allowing emotions, fantasies and images to surface into awareness'" (135 with reference to Siikala 1992, 105–106). Lewis-Williams and those who agree with him thus see this art as irreducibly religious, pointing both to a universal human need

to make sense of a shifting spectrum of consciousness and to conceptions of alternate realities (132, 101).

Not everyone agrees that the art was religious or that the artists were shamans. R. Dale Guthrie's *The Nature of Paleolithic Art* (2005) is a marvelously detailed and well-reasoned work, which anyone who wishes to know more about Paleolithic art would do well to consult. Guthrie identifies a "magico-religious paradigm" in contemporary analysis of Paleolithic art, which is so well entrenched and pervasive "that it is often uncritically evoked for any prehistoric art" (9) and simply assumed to be the most appropriate explanation. This paradigm tends to assume that when art first arose it was such a mysterious process that it was "incorporated totally into the religious part of human behavior. [However,] There is absolutely no evidence whatsoever for this assumption" (10). Guthrie deems this paradigm to have generated increasing error and confusion, impatience with which has caused many researchers to concentrate on entirely nonreligious dimensions of Paleolithic art and some even to "question whether any of the art can be explained by invoking religious motives" (11).[4] It is a fact that

> Paleolithic mythograms (images that are regarded and used as containing mythic meaning, like a Star of David or those of the Northwest Coast Indian totems) have not emerged. Attempts to associate some kind of symbolism with the dominant animals, bison and horses, have not been very credible.
>
> (10)

And there is evidence that contradicts this "magico-religious focus" (8). Guthrie invokes what he calls "Sieveking's Law" (36), which holds that the deep caves were very seldom used and only preserve so much art because of their conditions.

> The discovery of so much Paleolithic art back in deep caves contributed to interpretations of magic or religious function. If indeed all the rock art was located back in these inhospitable, virtually inaccessible recesses, one could only conclude that the artists must have a special reason to make this considerable effort just to draw and that cave art was deliberately hidden. But such conclusions can be drawn only by ignoring three features: (1) wall paintings made in cave environments are more likely to survive than such art exposed to the elements, (2) there is strong evidence that all the deep caves were barely used, and (3) many abri and open-air sites contain abundant Paleolithic art—despite the greater vulnerability to the elements.
>
> Failing to understand these points unavoidably leads one to imagine ideas such as shamans making seasonal ceremonial trips into cave recesses for ritual purposes.
>
> (39–40)

So "the image of a shaman taking the initiates into deep caves for secret rites, generation after generation, is bogus" (36). Contributory to the problem is that early scholars of Paleolithic art developed ideas about the function of that art by analogy to existing subsistence cultures, whose art is often immersed in myth and magic. "The art of living illiterate tribal peoples carried deep symbolic meaning that could not be easily deciphered by an outsider" (7). However, it has become increasingly clear that modern tribal peoples are not always appropriate analogs to Paleolithic peoples (8). Unfortunately, that did not become clear before this observation encouraged an

> idea that all prehistoric art was created by illiterate peoples communicating mystical beliefs: sympathetic magic of hunting and fertility, totems, demons, gods, and the dream world. Academic studies of prehistoric art became preoccupied with symbolic interpretation—assuming every image also has an inner mystical meaning ... some scholars continue to propose that cave art was the result of regular vision quests.
>
> (8, 36)

Guthrie specifically refers to Lewis-Williams, who began his studies with contemporary subsistence tribalists and moved from there to the Paleolithic. I agree with Guthrie's caution here, but not with his rather harsh judgment of Lewis-Williams. The latter is well-aware that the analogy between contemporary subsistence people and the makers of Paleolithic art cannot be precise and himself warns of the dangers of such an approach (2002, 46). His understanding of Paleolithic shamanism is not naïve and he recognizes that "[a]bout half the men in any San camp are shamans and about a third of the women" (2002, 139), so even when "shamanism" is involved, this is not the work of a small number of especially gifted people. More than 40% of the population are involved.

For my purposes it is enough to observe that the visual (re)presentations of Paleolithic parietal art, defined as shamanistic or not, may be one way in which we have made sense of the spectrum of human consciousness, but it certainly established our understanding of the nature of the unseen order with which we treat (recalling that this is not "supernatural" but simply the natural, causal, and temporal realms to which we do not have direct access) by making items that are not empirically available present to immediate perception. "Alternative modes of consciousness" are deemed to yield insight into otherwise inaccessible areas, and thus into the nature of the reality we inhabit. In this light, artists are often deemed to have the same role as such "shamans."

Guthrie allows that

> it is not that the many rock art researchers who see art as magic and mystical are totally wrong; it is rather that they had taken good observations on mystical components of Paleolithic art (and most prehistoric art, for that

matter) and extended them universally to the entire art. I aim, not to deny the existence of the supernatural themes, but only to lift their tyranny.

(10)

I again agree. It is not that this art has no religious significance whatsoever, rather that such categories as shaman, initiate, secret rites, and symbols are associated with our modern conception of religion and thus are anachronistic to the period. They cannot be simply retrojected into the distant past. I propose a scenario of skilled behavior, ancestral to both art and religion, which is both self-gratifying and attractive of attention as an evolutionary adaptation yielding insight into unseen partitions of the world, leading to a sense of assurance and thus propagating that behavior, and I believe this to accommodate both Guthrie's and Lewis-Williams' observations.

There is wide agreement, including from Guthrie, that "one is struck by the number of Paleolithic images in caves that were obviously suggested by natural rock forms" (Guthrie 2005, 35). There is a common observation that "the decoration of the cave seems to conform to a pattern that invariably takes advantage of the natural relief" as the basis for its images (Lewis-Williams 2002, 66) and Lewis-Williams speaks of "the use that image-makers made the features of the rock surfaces on which they placed their images. Almost every cave contains instances"; for example, "a natural rock at Comarque seems to have suggested a remarkably realistic horse's head, complete with nostrils and mouth ... An engraver merely completed and added details to the form" (211). The point is that these early shaman/artists were not simply setting down images of natural objects from memory upon a canvas of their own choosing, but were looking carefully to see what *present* entities suggested realities that were not present. How can this present and visible rock be used to suggest an absent and invisible horse? How can we humans learn to employ our remarkable ability to associate any one thing with any another thing? What can we learn about the unseen from the seen?

Lewis-Williams insists,

> to speak of Upper Paleolithic shamanism is to make a statement about cosmology, not just about religious belief and ritual, as if such matters were epiphenomena and therefore of no great importance to our understanding of Upper Paleolithic life. All life, economic, social and religious, takes place within and interacts reciprocally with a specific conception of the universe. It cannot be otherwise.

(209)

From such a perspective, we can see that, as early as 30,000 BCE, if not before, the object of emotional and mimetic response was more than just the skills of the human agents who create artifacts. The earliest art is representative of hidden partitions of the natural world. As soon as the artist begins to look for a non-present reality that is suggested by or revealed in present

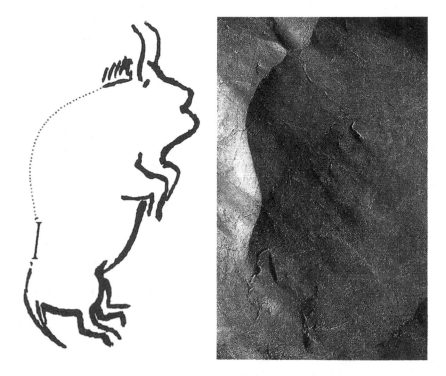

Figure 10.1 Here the light on a natural rock formation suggests the line of a bison's shoulder from the Salon Noir, Niaux, France. Left: drawing by Abbé Henri Breuil, c. 1906. Right: photograph by Jean Clottes, used by permission of Jean Clottes.

physical reality—initially, perhaps, just a rock that suggests a horse—people are seeking the way in which the seen shows the unseen.[5] There is immediate adaptive value in such behavior. Not only is it fundamental to human communication, but from it we learn skills of pattern recognition and abstraction, of reading the subtle "messages" of the seen environment and solving the "puzzles" with which imperfect perception presents us. But there is also more distal value. Believing that the puzzle of perception has a solution is immediately equivalent to greater persistence in seeking the solution, and the sheer pleasure of applying pre-existing skills of production in making parietal art, and skills of cognition and reception in viewing it, ensure the persistence of the associated behavior.

One may argue about whether this "specific conception of the universe," this "alternative reality," this "unseen order" is best characterized as multiple or as single, as person-like, or as an impersonal force, as a God or gods, as the "laws" of physics, or as the Dao—but *however* we characterize it, we have to respond to it somehow and we will, by definition, persist in those responses in which we feel most assured. None of this directly confirms

my suggestion that the generalized operation of theory of mind, engaged by and operating on an extended matrix of skilled presentations, enables and empowers a (virtual) perception of the "personality of reality," thereby engaging a coherent and assured emotional response to the environment. That remains an abducted theory underdetermined by the available material evidence. However, none of the evidence is *inconsistent* with such a theory. Given Lewis-Williams' claim that both Upper Paleolithic parietal art and the contemporary art of southern African San tribespeople portray "images of another world" (143–156) and the discussion of the function of art in preceding chapters, it seems highly likely that the portrayal of the invisible order conveyed in such media would be charged with an emotional affect that can, entirely consistently, be conceived of as closely analogous to the "personality" of the unseen agency that determines the incalculable outcomes of human behavior in the world, involving mimesis of the apperceived agency.[6] For an intelligence such as ours, constantly seeking information about the outer circles of reality beyond our immediate apprehension (I repeat—this refers to the absent, including the chronologically distant, rather than the "supernatural") novel states of consciousness promise a valuable source of creative, imaginative (re)presentations of reality—especially when one considers that those (re)presentations are seldom entirely novel. Like most art forms, the most influential are those that retain much from the preceding "tradition" and contribute most to what follows. This tension between the novel and the persistent relates to later distinctions between art and religion, as we will see. According to Lewis-Williams,

> [p]eople tend to hallucinate what they expect to hallucinate. There was, therefore, probably a recursivity between rock art images and visions: visions were painted on the rock walls, and then these paintings prompted people to see similar visions. As a result, rock art probably exercised a conservative, stabilizing effect on the range of mental imagery that shamans experienced.
>
> (158)

We cannot dispute that this behavior is *art*—certainly not in the understanding proposed by the ethology of art and art as things made special—but any determination of its *religious* status will depend on the understanding of religion involved. To consider other prehistoric situations in which behavior may be religious is illuminating.

... to Göbekli Tepe

Dating from around 9,500 BCE. Göbekli Tepe is an archeological site in southeast Anatolia in Turkey, not far from the Syrian border. Under excavation under the leadership of Klaus Schmidt of the German Archeological Institute since 1996, it is the site of some of the oldest known ruins of human stone construction and is most often characterized as a series of "sanctuaries"

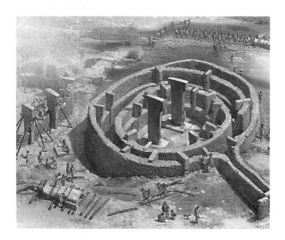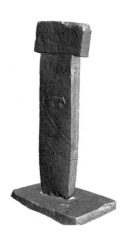

Figure 10.2 Left: Göbekli Tepe: an artist's impression by Fernando Baptista for *National Geographic Magazine.* Used with permission. Right: one of the anthropomorphic pillars of Göbekli Tepe (Pillar 18 in Building D) from *The Tepe Telegrams*, news and notes of the Göbekli Tepe research staff (https://tepetelegrams.wordpress.com/). The image was generated from a 3D laserscan conducted by Tilmann Müller (HS Karlsruhe) for the German Archaeological Institute (DAI). Used with permission of DAI.

for "ritual use" and as the world's oldest religious site or "Temple" (Schmidt 2006; Curry 2008; Scham 2008). Its "religious" nature is seldom doubted. So far as is currently known (only about 5% of the site had been excavated as I write), it consists of more than 200 T-shaped pillars of up to 20 tons arranged in about 20 circles. The pillars, which appear to represent human figures, and the surrounding enclosures, are decorated with relief carvings of animal, known and unknown.

From the perspective from which I write, such a site could equally be described as "the world's first installation art" as the world's "first temple," as Schmidt and others style it—called into being by humanity's instinctive need to shape and to create, to encourage and to imitate such creation, and thus to seek emotional endorsement of persistent behavior, rather than by any need to worship in the sense understood in contemporary Western "religion."[7] "It may also have been the Neolithic version of Disneyland" (Mann 2011). Seeing the ruins of Göbekli Tepe as "temples" certainly invokes the "magico-religious paradigm" of which Dale Guthrie warned us, but could it be more accurate to see them as "installation art"? The weight of opinion that this site is religious is so overwhelming as to make its contradiction seem perilous, if not blasphemous (see Schmidt, 2006; Hodder 2010; Luckert 2013; Collins 2014). But how well-founded are these assumptions of the specifically religious nature of the ruins?

What seems to lead commentators to describe these ruins in religious terms, and their function as "ritual," seems to be based primarily on the

inability to attribute any more practical function to them.[8] Although there is evidence of many centuries, possibly a millennium and a half, of activity at the site, the ruins show no sign of being habitations, or useable for storage or any other practical purpose. Nor were they burial sites. They are miles distant from a water source. Their builders and their users appear to have been supported by others who brought food and water to them as they worked ("building" or "performing"?). The earliest phase of the complex has yielded four circular enclosures ranging from 10 to 30 meters in diameter. These contain stone T-shaped pillars set evenly into circular interior walls of rough stone with two taller pillars standing inside the circle.

> The T-shaped pillars forming the major and most prominent feature of Göbekli Tepe's architecture need to play a crucial role in our observations here. While large and highly abstracted, they also clearly own human characteristics: some of these pillars show arms on their sides and hands brought together above the abdomen. There are elements of clothing depicted in relief as well: stola-like garments draped around pillars' shoulders and fox-skin loincloths depicted dangling from belts. This emphasizes quite impressively that the T-pillars apparently have to be understood as monumental anthropomorphic sculptures.
>
> (Göbekli Tepe Research Staff 2019)

Most of the pillars are decorated with highly skilled carved animal reliefs and some rather enigmatic pictograms and a few human shapes. The centrality of the anthropomorphic figures to this site supports the contention that in this case, the dynamic of fascinated attention focuses on our fellow humans, and spreads from them to artifacts, and thence to the natural world. The earlier structures were filled in as later ones were constructed (again emphasizing performance over product) and the whole site was abandoned sometime after 8,000 BCE. No sign of any domesticated animals or plants have been found, confirming the identification of the site's builders and users as hunter-gatherers, that is, people prior to the development of agriculture and the concomitant habitation of permanent settlements.

It is not my purpose to argue that this site is *not* religious but *instead* artistic. Rather that, as with Paleolithic cave art, it is something of an anachronistic and misleading misnomer to classify it as either. It exhibits attributes of both categories. The classification of the site as religious leads to the attribution to its builders and users of specific organized and conscious "representations" and "beliefs," or even "belief-systems," considered essential to religion as we now conceive of it. This is anachronistic and unnecessary, belonging to later developments of "religion" and "religions" that came about after greater institutionalization and (as I will argue) the development of written texts. It is better to keep in mind the equally, or ancestrally, *artistic* nature of the edifice. That is, it is a product of the instinctive expression of distinct and practiced human skills, the application of which attracts and focuses intense attention,

leading directly to encouragement and imitation of the initiating agents and, indirectly, to an apperception of the nature or character of the agency of the extended environment, producing, in turn, an emotionally assured, therefore persistent, pattern of behavior among those involved. The British archeologist Ian Hodder suggests that "communities first came together around large-scale and intense rituals before they intensified their subsistence economies to such an extent that genetic change occurred in crops and flocks" (Hodder, 2010, 338). Major monuments of this area such as the "temples" of Göbekli Tepe (9,000–7,400 BCE), the towers of Jericho (c. 8,000 BCE) and of Tel Qaramel (roughly contemporary with Göbekli Tepe), the large circular buildings at Jerf el Ahmar (c. 9,200 to 8,700 BCE), and the Skull building of Çayönü (c. 7,200 to 6,600 BCE) indicate collective rituals (Hodder 2014, 21). These places and dates indicate that monumental, collective, non-domestic rituals predated settlement in permanent communal housing collectives. The persistent behavior induced by the monumental art/religion of Göbekli Tepe required increasingly permanent habitations and reliable sources of food, possibly precipitating the so-called "Neolithic Revolution," the transition of semi-nomadic hunter/gatherer communities to permanent settlements with domesticated crops and livestock.

… to Çatalhöyük

That this assured and persistent pattern of behavior contributed to a very distinct change in human culture is suggested by the slightly later developments at Çatalhöyük. First excavated by James Mellaart (1925–2012) in 1958, Çatalhöyük is about 600 kilometers west of Göbekli Tepe. It was an occupied settlement from perhaps 500 years after Göbekli Tepe was finally filled in. Flourishing around 7,000 BCE it continued to be occupied until around 5,700 BCE. Estimates of its population suggest a maximum of perhaps 10,000

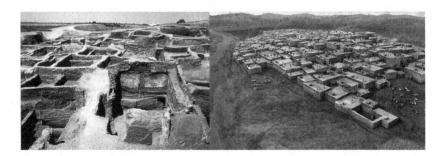

Figure 10.3 Çatalhöyük. Left: Mellaart's excavation in the 1960s by Omar Hoftun (https://commons.wikimedia.org/w/index.php?curid=26650324) and an artist's impression of the settlement during its occupation (courtesy of Google Images).

people, although it seems to have averaged about 6,000. Çatalhöyük consists entirely of mudbrick domestic habitations with no apparent public buildings or monuments. Conventional art such as murals—often showing extended groups of small human figures attacking or baiting wild animals depicted as huge—reliefs, and anthropomorphic statuettes or figurines are common. Most common are bucrania, the mounted heads of wild bulls. Bull and human heads were both removed and treated similarly in that they were separated from their bodies and displayed, sometimes plastered over to "reflesh" the bones.

The John Templeton Foundation sponsored a project at Çatalhöyük from 2006 to 2008 (and continued thereafter) which resulted in the publication of *Religion in the Emergence of Civilization: Çatalhöyük as a Case Study*, edited by Hodder in 2010. There is much of interest to Hodder's edited volume and to its sequel *Religion at Work in a Neolithic Society: Vital Matters* (2014). Hodder's project, "involving natural scientists, archaeologists, anthropologists, philosophers, and theologians in a novel, field-based context" (Hodder 2010, 1), tasked the interdisciplinary team to confront four major questions:

1 How can archeologists recognize the spiritual, religious, and transcendent in early time periods?
2 Are changes in spiritual life and religious ritual a necessary prelude to the social and economic changes that lead to "civilization"?
3 Do human forms take on a central role in the spirit world in the early Holocene, and, if so, does this centrality lead to new conceptions of human agency that themselves provide the possibility for the domestication of plants and animals?
4 Do violence and death act as the foci of transcendent religious experience during the transition of the early Holocene in the Middle East, and are such themes central to the creation of social life in the first large agglomerations of people? (14–23 and passim).

The published results, combining theoretical sophistication with a detailed empirical knowledge of the site, make fascinating reading. The first three of these questions are central to my own investigations. In answer to the first, Hodder concludes that "it is undoubtedly possible for archaeologists to identify religion" (348) at Çatalhöyük. This was not, however, entirely uncontested. Anthropologist Peter Pels (with reference to Talal Asad 1993) argues that "the category of 'religion' as such is based on [a] 19th-century comparativist and secularizing consciousness" (232) and concludes that definitions of religion "always arose and will still have to be understood in opposition to something called 'the secular,' so that the 'religious' denotes a separate realm of social life" (232). Pels—in agreement with several of the contributors to this volume—insists that religion does *not* belong to any such separate realm, and he warns his readers of "the fallacy of 'religion'" (232–236), which is that

the word "makes us look for a distinct practice, with institutional and doctrinal unity or coherence, and based on propositions about entities that have no worldly or secular (and therefore usually material) presence" (233). Another anthropologist, Maurice Bloch, went even further, being

> confident that there was no religion at Çatalhöyük ... Looking for religion is a misleading wild goose chase. The English word 'religion' inevitably refers to what English speakers have known, and no amount of redefinition or manipulation of the term can escape the associations that a particular history has created.
>
> (161)

Despite my admiration for Bloch and my appreciation of his otherwise extremely helpful chapter, I have to argue that this is simply wrong. It fails to recognize the indubitable fact that words frequently have multiple significations (the "nested homonyms" to which I referred earlier). Words *do* change their associations (gay, republican, Aryan), and a redefinition that proves useful and repeatable can oust a previous, more contentious understanding, no matter how well-established. The inappropriate use of the modern, English, post-Reformation sense of the word "religion" has unquestionably led to misunderstandings. It will, almost certainly, continue to be misused in popular parlance. This does not, however, necessitate that such misunderstanding must continue without exception, or that the term could not come to refer to the operations of the "transcendental," which Bloch uses freely. The Latin term *religio* was in circulation long before the 19th century and had some other definition then. No doubt the most popular and widespread current definitions are based on the 19th-century misapprehension, but to assume that this is simply incurable is without foundation. As with "art," a new understanding must be established. Such misunderstanding cannot establish that the behavior of the inhabitants of Çatalhöyük can never be identified as religious.

Hodder recognizes that, while several of the contributors were wary of the term "religion," they were nonetheless committed to developing an account of behavior that might well be called "religious" (334). "There was agreement that a more applicable approach focused on marking or dealing with 'the beyond'—defined as absence, ultimate boundaries or the transcendental" (338). Comparable to Mary Mothersill's (1991) argument in respect of beauty in Chapter 5, whatever term one might employ (Bloch's "transcendent social," or "the beyond") functions as a synonym for religion, a term that is functionally equivalent to it because it finally signifies the same characteristics.

Whatever term one employs to refer to these characteristics, Hodder is confident that "changes in spiritual life and religion are inextricably linked to settled agglomerated life and agriculture" (348). "Religion was thoroughly involved in the creation of new social forms during this period" (353–354).

The answer to the second question is thus a very positive, "yes," with the proviso that that religion was not a distinct "sphere" (Hodder 2010, 15–16, 338) but an "emergent property of other human capacities, instantiated in particular times and places" (338), where "emergence" is defined as

> the view that new and unpredictable phenomena are naturally produced by interactions in nature; that these new structures, organisms, and ideas are not reducible to the sub-systems on which they depend; and that the newly evolved realities in turn exercise a causal influence on the parts out of which they arose.'
>
> (Shults 2010, 75 with reference to Clayton 2004, vi)

According to contributing philosophical theologian, LeRon Shults, "the religious" is "that emergent sphere of human life in which social groups tend to their fascination with and fear of ultimate boundedness, which shape and are shaped by all of the other dynamic modes of social (and material) binding and being-bound" (77).

Webb Keane, a third contributing anthropologist in Hodder's earlier volume, is described by Hodder as arguing "that what looks to us like religion emerges from convergences between different kinds of practice that are not necessarily 'religious' in their own right, but become so when they are combined" (335). I would agree but with further specification: those practices involve art; they are combined in such a way as to produce assured and persistent behavior; and they do so by the invocation of and response to some form of agency. This addresses the third question:

> Do human forms take on a central role in the spirit world in the early Holocene, and, if so, does this centrality lead to new conceptions of human agency that themselves provide the possibility for the domestication of plants and animals?

The concept of agency features strongly in Hodder's (2006) monograph on Çatalhöyük, *The Leopard's Tale: Revealing the Mysteries of Çatalhöyük* (particularly chapter eight, "Materiality, 'Art' and Agency," 185–206). Although Hodder mentions Alfred Gell only once in that context (54), the ideas from Gell's *Art and Agency* (1998) are influential and Hodder states that "objects act as material agents or as delegates for humans" (189). Shults quotes Hodder as saying

> people became more invested in a web of material relations so that their social relations were 'objectified.' ... the social world became more malleable and susceptible to transformation ... humans came to see themselves more clearly as agents able to transform social lives by transforming material objects, artifacts, monuments and environments.
>
> (Hodder 2006, 205–206; quoted in Shults 2010, 78)

Shults adds that

> "civilization" evolved slowly as a result of small changes in the way persons were increasingly bound to material objects and as their relation to one another became increasingly mediated through such objects ... phenomena like sedentism and domestication can be interpreted as the unintended by-product of a growing entanglement with material objects [and] the apparent increase in awareness of the power of human agency, which is displayed in the art and (arguably) the figurines [found at Çatalhöyük].
>
> (78–79)

Concentration upon the agency of artified or special objects and the agents, visible and invisible, that they implied revealed more about our own agency and, reciprocally, the agency of the natural world, and "the increased sense of awareness of human agency is suggested by the prevalence of human forms in the art of the early Neolithic, contrasting significantly with the Paleolithic" (Shults 2010, 80). The anthropomorphic T-pillars of Göbekli Tepe are early examples of the use of human forms but they are always accompanied by various theriomorphic representations. "Theory of mind" may have developed originally to help with interactions among human beings, but before we had any clear understanding of human agency we were already applying this function to the non-human and the inanimate.

Hodder's understanding of "material entanglement," described in chapters 2 and 8 of his earlier monograph, is that, for example,

> plastering a wall or floor entangled people in all sorts of social and material dependencies, and ... burying the dead beneath floors had all sorts of material and social implications. ... this point can be generalized to all the detail and change in the material life of the house. The movement of the oven changes the place of the stair and the entrance which affects movement patterns on the roof. The burial of someone beneath a platform means that special white plaster has to be obtained and used, implicating social relationships, dependencies, alliances and exchange. ... The great density of material engagement in the house entails an enormously complex entanglement between people, society and things."
>
> (2006, 139–140)

In this way people entered into increasingly complex "social" relationship with material things. Several of the contributors to this volume recognize the agency of the "artified" object: "a thing marked is a thing to which people have attributed agency" (Pels 2010, 234). Pels also speaks of "things acting on people" (243). "Material things too seemed to have agency," says cognitive archeologist Paul Wason, another contributor to the 2010 volume (292). There is thus a general agreement that agency is an attributed characteristic

rather than being entirely objective, and that, even in the Neolithic, it is commonly attributed to things, especially to "artified" objects and representations. Keane insists that in practice the recognition of agency is mediated by what he calls "semiotic ideologies," that is, "notions about what might count as an intentional sign or as evidence of a purposeful agent" (214). In the 2014 volume the sociologist and architect Anke Kamerman refers to Ernst Gombrich (1960) and Alfred Gell (1998), both of whom argue that art, especially in "primitive" societies, should not be interpreted "aesthetically," but as a means of persuasion and action. Art "can be understood as persuasion devices in daily life. The possibilities for persuasion by an image or artifact inhere in the ways its patterning and spatial organization can direct the attention of producers and observers" (305). Gombrich shows "how positioning can achieve the focusing of attention" (307), and he, along with Gell and art historian Rudolph Arnheim "were conscious of the possible function of artifacts as practical instruments, tools to achieve certain goals" (321). Kamerman develops the idea of artworks, including the Çatalhöyük leopards and bucrania, as persuasive/persuasion devices (305–319). For the moment, it suffices to observe the continuing attribution of agency to inanimate, "artified" objects, requiring the direction of human social intelligence toward material things, which, in return, exercise an influence over human behavior. As Mithen puts it, "from the Upper Paleolithic onwards, the nonsocial world is explored and exploited partly using thought processes which evolved for social interaction" (Mithen 1994, 35), and as Wason says explicitly, "the 'theory of mind' employed at Çatalhöyük may have extended to inanimate things" (293).[9]

Agency was primarily attributed to powerful forces of the environment, both animate and inanimate. This focus on greater agency is maintained in the art of Çatalhöyük where wild bulls, bears, and leopards almost eclipse domestic animals and crops, the former being free agents and the latter domesticated patients. The increasing understanding of persons as agents—expressed, embodied, and externalized in creative performance—gave rise to, and was further enhanced by, both the monumental art of Göbekli Tepe and the domestic art of Çatalhöyük. Both must have contributed to a powerful sense of what might be termed the aggregate agency of the environment, apprehended as something analogous to a personality (or community of personalities). Having a clear sense of that personality, people could respond with greater assurance, confidence, and thus persistence. So the third question regarding conceptions of agency is also answered affirmatively. There is little doubt that all of these agents, human and non-human, were used in connection with divination in the sense of determining and governing behavior. As early as 1912, Moses Gaster was aware that divination by means of mummified human bodies or separated heads was an archaic practice still known among the early Hebrews (Gaster explicitly identifies this practice with the *teraphim* of the Biblical text, 1912, 811).

The fourth question, on violence and death, addressed by Hodder's first interdisciplinary team is of less interest for my immediate purposes, although

questions of violence do concern effective agency and death is a powerful and fascinating event that convincingly demonstrates the existence of some irresistible agency other than our own. Hodder concludes that, although "the very term 'violence' might be unhelpful ... through violent imagery and practice the person was drawn into a social world in which long-term transcendental social institutions were increasingly prevalent" (342, 349). Here the conflation of the objective reality (violence) with its representation (violent imagery), and its issue in "long-term transcendental social institutions" should be noted. The representation, in certain ways, accomplishes as much as that which it represents, and what is accomplished is persistent.

... through paradoxically persistent change

There is, however, a paradox here. I argue that the evolutionary adaptation at work here is the encouragement of persistence in pursuit of "psychobiological homeostasis," yet, as Hodder plainly states:

> It is clear that the materialization of the social structures at Çatalhöyük did not lead to fixity and lack of change. Indeed the rate of cultural change seems to increase through the sequence and the rate of house rebuilding also increases ... One can argue, in fact, that material entanglement produced a representation in the object world of the social structure such that it could be contested and changed. There is much emphasis on constructing continuities through time, and links to the ancestors ... But at the same time, there were moves to transform traditional modes of life ... There is a continual tension between continuity and change, with the latter beginning to get the upper hand in the upper [that is, later, more recent] levels of the site.
>
> (2006, 204–205)

How might this continual tension be resolved or explained? Why did the prolonged and stable human situation of the Paleolithic change to the Neolithic around 12,000 years ago? The Neolithic coincides with the massive increase in artifactual production and, as Hodder says, an increasing rate of change. Improvement is itself change, and if one improves a situation, even in order to make it more permanent, one changes it. Once the mutually enhancing elements of artifactual production, material entanglement, and the application of human social intelligence to the environment were active, barriers against rapid change collapsed. In that situation, change becomes our default state, so that inducements for change are no longer necessary but inducements for stability become advantageous. Earlier, Lewis-Williams suggested that "rock art probably exercised a conservative, stabilizing effect" (2002, 158). The behavior that was ancestral to both art and religion may have exerted a stabilizing effect, but here we begin to see the manifestation of the later distinction between art and religion. What we now call art reveals

possibilities for improvement and therefore change. Religion, as we now see it, involves set patterns of art, which encourage homeostasis, moderating the impetus for change and preventing it from being overly rapid and damaging. Unsuccessful, short-lived, patterns of behavior would manifest as temporary "sub-cultures" or "counter-cultures," driven largely by artistic expressions and materializations. These provide a challenge to the stability of dominant culture that must either die out, separate from, or transform the original culture.

... to the earliest cities

Allowing that art and religion, so understood, do indeed comingle in parietal art, at Göbekli Tepe, and in Çatalhöyük, what does it tell us about ourselves, about our history, and about how art and religion relate to one another in the past, in the present, and perhaps in the future? The growing consensus among archeologists and paleoanthropologists, not only those from the Templeton Çatalhöyük project, is that religious behavior contributed significantly, if not decisively, to the development of more complex culture as *homo sapiens* became more "civilized" (by which I mean no value judgment, simply populations that are more commonly found in the large agglomerations we call cities—Latin *civitates*).

I do not imply that a specific transition from Göbekli Tepe to Çatalhöyük is "the" singular event that marks and precipitates the "Neolithic Revolution"—nor even that it is the earliest such transition, nor even that "it" is an event at all—simply that the two cultures are excellent example of modes of religiosity and art that demonstrate the workings and the utility of the art/religion complex that I am attempting to elucidate.[10] The monumental art/religion behavior of Göbekli Tepe was enormously successful both in the sense that it persisted for about 1,700 years and in the sense that it contributed significantly if indirectly to the very possibility of the domestic art/religion lifestyle of Çatalhöyük. The general trend from something like Göbekli Tepe to something like Çatalhöyük serves as an exemplar. Göbekli Tepe itself, or the kind of culture that it represents, was superseded by cultures such as that of Çatalhöyük, which certainly superseded other cultures around it. As Wason says, "the period of occupation of Çatalhöyük is associated with a disappearance of sites from the alluvial fan on which the site is located. People were drawn into (and perhaps also repulsed from) this special place" (Wason 2010, 289). He specifically compares Göbekli Tepe to Çatalhöyük, which "differed, of course, in being at heart a settlement rather than a ceremonial center" (288), but neither he nor any of the contributors consider what they had in common *specifically as centers of art*—especially as understood ethologically. It is notable that neither the 2010 nor the 2014 volumes include contributions from any ethologist of art, practicing artist, or art historian.[11] Where other strategies of explanation fall short, the ethology of art could contribute significantly.

In either typical or atypical circumstances, in persistent peace or in rapidly changing turmoil, the determination of human cultural creativity is complex, even chaotic. It is subtle, emergent, and impossible to predict. To put it bluntly (but metaphorically), we need all the help that we can get to understand such a process. While the monumental behavior of Göbekli Tepe may have given rise to agriculture and permanent settlements and ceded its place to smaller-scale domestic art in Çatalhöyük, it certainly did not go away. It continued through the Ubaid period of c. 6,500 to 3,800 BCE, whose culture combined unwalled settlements of rectangular mud-brick domiciles like those of Çatalhöyük with temples that housed monumental, extra-domestic complexes of art and religion, and it was to re-emerge, or to re-establish its effectiveness, in the early cities that superseded places like Çatalhöyük as the largest agglomerations of human habitation. From the early 5th millennium the first known cities emerged. Among these, the Sumerian city of Uruk, near the Euphrates in what is now southern Iraq, combined the domestic and the monumental to great effect as a city of as many as 50–80,000 inhabitants that persisted over more than 5,000 years. At its height, around 3,000 BCE, Uruk was 7.5 times the size of Çatalhöyük with more than ten times the population. The Eanna precinct of Uruk was an area of monumental and ritual art that we know, from later texts to have been a religious center, home of the Goddess Inanna. Through the paradox of persistent change, we have moved from Paleolithic nomadic hunter/gatherers to the type of cultural context in which prophecy in the Biblical sense was to emerge.

Notes

1 Mithen describes this as a form of human vocalization in which words as we know them were absent but nonetheless sounds that were "Holistic, manipulative, multi-modal, musical, and mimetic" (2005, 172) contributed to communication.
2 See the discussion at http://en.wikipedia.org/wiki/Acheulean#Hand-axe_as_a_ left_over_core, which gives further bibliographic references.
3 The Paleolithic ("Old Stone Age") is a prehistoric period distinguished by the development of the most primitive stone tools. It extends from the earliest known use of such tools, probably by hominins such as australopithecines over 3.3 million years ago, to the end of the Pleistocene around 10,000 BCE.
4 An excellent example is Guthrie's disagreement over the interpretation of the Hohlenstein-Stadel "lion-man." Numerous interpretations have argued that the ability to imagine a hybrid figure, with features of both *homo* and *leo*, is inherently religious. Guthrie counters that the figure could easily be a standing bear (446).
5 This seems to be equivalent to what Harvey Whitehouse calls "spontaneous exegetical reflection" (see Whitehouse 2004, 190). It occurs more markedly when we are forced by circumstance to abduct to theoretical causes from intense experience, and it may be the basis of all "revelation."
6 Such mimesis may be relatively indirect, consisting of the attempt to employ the same sort of abstract skills and abilities as apperceived in the agent—to *be* like it is ("be holy as I am holy," Lev. 19:2)—rather than direct imitation of specific acts.
7 Although even "the need to worship"—understood as the need to perform acts of self-abasement before, and praise of, a more potent being—can be seen to be a specific sub-set of a broader need to enact behaviors that are emotionally

appropriate toward, and solicit approval from, the abducted agency or agencies to which determination of reality is ascribed. More fundamentally, "worship" identifies a tendency to attribute value, other than immediately self-evident practical value, to material objects, especially the fascinating productions of human creation. Most fundamentally it is a form of the fascination/obsession/love/adoration/devotion to external phenomena of which we *homo sapiens* are capable and from which we once benefitted.

8 In an anthology to which I will refer below Webb Keane provides an excellent summary of the situation in which

> the relationship between art and religion is virtually predetermined by the way in which the writers have defined them. The main diagnostic for identifying material remains as art or evidence of religion is their supposed lack of utility ... in the absence of apparent utility, the assumption runs, we must be in the presence of the symbolic. ... According to a venerable tradition in British social anthropology, lack of utility virtually defines something as religious. ... in Harvey Whitehouse's opinion. 'What both ritual and art have in common is their incorporation of elements that are superfluous to any practical aim and, thus, are irreducible to technical motivations' (2004, 3). Similarly Steven Mithen writes, 'Artefacts which relate directly to religious ideas lack any utilitarian explanation' (1996, 98).
>
> (Keane 2010, 189–190)

The ultimate utility of certain items, actions, and persons may remain entirely unknown to those who value them—especially of values determined by evolutionary adaptation. Does a bird know the utility of the nest it builds? Does a hungry student consider the nutritional utility of fried potato? The kind of utility that ensures the persistence and continuity of social behaviors would, most likely, be entirely unknown to those who participate. They would simply be following an emotional prompt, akin to sexual attraction or appetite, to focus on and to cultivate actions within the extended matrix of mutually reinforcing material prompts.

9 Applying social intelligence to the non-social environment is part of what Mithen calls "cognitive fluidity" (1996, 109). He sees the mind as composed of "modules" or a variety of specialized tools (with reference to Tooby and Cosmides, see Chapter 3) and to Howard Gardner's concept of seven separate intelligences: the "linguistic, musical, logical-mathematical, spatial, orderly-kinaesthetic and two forms of personal intelligence, one for looking in at one's own mind, and one for looking outward towards others" (Mithen 1996, 40 with reference to Gardner 1983). It is Mithen's hypothesis that, as the mind/brain of anatomically modern humans developed, intelligences that were originally isolated and mutually inaccessible became integrated.

10 Using the phrase, "modes of religiosity" unavoidably conjures Harvey Whitehouse's (2004) book of that name. The monumental and domestic modes of religiosity that I apply here obviously have some similarity to the "imagistic and doctrinal" modes, respectively, that he develops in that work and elsewhere. They are not the same by any means. For the moment, suffice it to say that they are simply alternative means of classifying the same data.

11 With the exceptions of passing references to the visual artist Eva Bosch who contributed an article to the *Çatalhöyük Archive Report* (Bosch 2008) and "revealed that during the day the rectangle of light from the entry hole moves across the southern part of the main room" (Hodder 2010, 354; Wason 2010, 286). Anke Kamerman in the 2014 volume is an architect specializing the relation between behavior patterns and spatial organization (Kamerman 2014) but can certainly be seen as an artist.

References

Asad, Talal. *Genealogies of Religion*. Baltimore, MD: Johns Hopkins University Press, 1993.

Bloch, Maurice. "Is there Religion at Çatalhöyük ... Or Are There Just Houses?" In *Religion in the Emergence of Civilization*, edited by Ian Hodder, 146–162. Cambridge, UK: Cambridge University Press, 2010.

Bosch, Eva. "The Sun Clock and Light and Shadow inside the Replica House." *Çatalhöyük Archive Report* (2008): 282–283.

Clayton, Philip. *Mind and Emergence*. Oxford, UK: Oxford University Press, 2004.

Collins, Andrew. *Gobekli Tepe: Genesis of the Gods: The Temple of the Watchers and the Discovery of Eden*. Rochester, VT: Bear & Company, 2014.

Corbey, Raymond, Adam Jagich, Krist Vaesen, and Mark Collard. "The Acheulean Handaxe: More like a Bird's Song than a Beatles' Tune?" *Evolutionary Anthropology* 25, no. 1 (2016): 6–19.

Curry, Andrew. "Gobekli Tepe: The World's First Temple?" *Smithsonian* 39, no. 8 (2008): 54–60.

Garcia-Rivera, Alejandro. "Postscript: On Devotion at Çatalhöyük." In *Religion at Work in a Neolithic Society*, edited by Ian Hodder, 357–363. Cambridge, UK: Cambridge University Press, 2014.

Gardner, Howard. *Frames of Mind: The Theory of Multiple Intelligences*. New York: Basic Books, 1983.

Gaster, Moses. "Divination (Jewish)." In *The Encyclopedia of Religion and Ethics*, edited by James Hastings, 806–814. Edinburgh, UK: T & T Clark, vol. IV 1912.

Gell, Alfred. *Art and Agency: An Anthropological Theory*. Oxford, UK: Oxford University Press, 1998.

Gioia, Ted. *Work Songs*. Durham, NC: Duke University Press, 2006.

Gombrich, Ernst Hans. *Art and Illusion: A Study in the Psychology of Pictorial Representation*. New York: Pantheon Books, 1960.

Guthrie, R. Dale. *The Nature of Paleolithic Art*. Chicago, IL: University Of Chicago Press, 2005.

Hodder, Ian. *The Leopard's Tale: Revealing the Mysteries of Çatalhöyük*. London: Thames and Hudson, 2006.

Hodder, Ian, ed. *Religion in the Emergence of Civilization*. Cambridge, UK: Cambridge University Press, 2010.

Hodder, Ian, ed. *Religion at Work in a Neolithic Society: Vital Matters*. Cambridge, UK: Cambridge University Press, 2014.

Kamerman, Anke. "The Use of Material Order in Çatalhöyük Material Culture." In *Religion at Work in a Neolithic Society: Vital Matters*, edited by Ian Hodder, 304–336. Cambridge, UK: Cambridge University Press, 2014.

Keane, Webb. "Marked, Absent, Habitual: Approaches to Neolithic Religion at Çatalhöyük." In *Religion in the Emergence of Civilization*, edited by Ian Hodder, 187–219. Cambridge, UK: Cambridge University Press, 2010.

Kohn, Marek and Steven Mithen. "Handaxes: Products of Sexual Selection?" *Antiquity* 73 (1999): 518–526.

Lewis-Williams, D. *The Mind in the Cave: Consciousness and the Origins of Art*. London: Thames and Hudson, 2002.

Liverani, Mario. *Uruk: The First City*. London: Equinox Publishing, 2006.

Luckert, Karl W. *Stone Age Religion at Göbekli Tepe* with a Foreword by Klaus Schmidt. Portland, OR: Triplehood, 2013.

Mann, Charles. "Birth of Religion: The World's First Temple." *National Geographic* 219, no. 6 (2011): 34–59.

Mithen, Steven J. "From Domain Specific to Generalized Intelligence: A Cognitive Interpretation of the Middle/Upper Paleolithic Transition." In *The Ancient Mind: Elements of Cognitive Archaeology*, edited by Colin Renfrew and Ezra B. W. Zubrow, 30–39. Cambridge, UK: Cambridge University Press, 1994.

Mithen, Steven J. *The Prehistory of the Mind: A Search for the Origins of Art, Religion and Science*. London: Thames and Hudson, 1996.

Mithen, Steven J. *The Singing Neanderthals: The Origins of Music, Language, Mind, and Body*. London: Weidenfeld and Nicholson, 2005.

Mothersill, Mary. *Beauty Restored*. Oxford, UK: Clarendon Press, 1984. Reprinted New York: Adams, Bannister, Cox, 1991.

Pels, Peter. "Temporalities of 'Religion' at Çatalhöyük." In *Religion in the Emergence of Civilization*, edited by Ian Hodder, 220–267. Cambridge, UK: Cambridge University Press, 2010.

Renfrew, Colin. "The Archaeology of Religion." In *The Ancient Mind: Elements of Cognitive Archaeology*, edited by Colin Renfrew and Ezra Zubrow, 47–54. Cambridge, UK: Cambridge University Press, 1994.

Scham, Sandra. "The World's First Temple." *Archaeology* 61, no. 6 (2008): 22–27.

Schmidt, Klaus. *Sie bauten die ersten Tempel*. Munich: Beck, 2006.

Shults, LeRon. "Spiritual Entanglement: Transforming Religious Symbols at Çatalhöyük." In *Religion in the Emergence of Civilization*, edited by Ian Hodder, 73–98. Cambridge, UK: Cambridge University Press, 2010.

Siikala Anna-Leena. "Shamanistic Knowledge and Mythical Images." In *Studies on Shamanism*, edited by Anna-Leena Siikala and Mihalyi Hoppal, 87–113. Budapest: Akadémia Kiadó, 1992.

Wason, Paul. "The Neolithic Cosmos of Çatalhöyük." In *Religion in the Emergence of Civilization*, edited by Ian Hodder, 268–299. Cambridge, UK: Cambridge University Press, 2010.

Whitehouse, Harvey. *Modes of Religiosity: A Cognitive Theory of Religious Transmission*. Walnut Creek, CA: Altamira Press, 2004.

11 The art of Biblical prophecy
The technocracy of the text[1]

> A primary assertion of this study is that the work of prophecy continued in textualized prophets, whose influence can be seen in the growing significance of literature.
>
> (Mark McEntire, *A Chorus of Prophetic Voices*, 16)

The prophets

Perhaps it would be true to say that prophecy had always been present in the religion of the Hebrews as a form of shamanism, since charismatic religious leadership with visionary and performative elements was typical of leaders as early as Moses. The figures of early Israel such as Joshua and other personalities are called "Judges." The Hebrew *shâphat* comes from a verb meaning to pronounce sentence for or against, to vindicate or punish, by extension to govern, indicating their influence over the behavior of the people. Predominantly ancient military heroes, these "Judges" seem to have practiced the art of war, rather than any more irenic art. However, unhappily perhaps, martial art reflects both the skill that I propose to be its salient feature and an emotional intensity communicative of the response to a perceived powerful agency. In what appears to be one of the oldest portions of the Bible, Judges 5, the stars themselves as well as the Wadi Kishon fight on behalf of the Israelites in a precise example of the attribution of agency to inanimate entities—and a sure sign of the approval of a controlling agent. It was by no means only the Hebrew Judges whose skill extended to the arts of war: the heroes of the Hindu Epics, the Rāmāyaṇa and the Mahābhārata, were renowned for their martial prowess, as was the Prophet Muhammad—a very effective military leader—and Chinese and Japanese tradition has no qualms about the combination of religion and the martial arts with the likes of Bodhidharma (5th or 6th century CE), founder of the Shaolin Temple tradition, and Miyamoto Musashi (c. 1584 –1645) with his *Book of Five Rings*. As Musashi can say, secure in his position in a highly literate culture, "the warrior's is the twofold way of pen and sword" (Musashi 1974, 37). In the case of both the Muslim Prophet and the Hebrew Judges their rhetorical skills—seen, of course, as

divinely inspired[2]—were important components of their military effectiveness, indicative of their inspiration. Muhammad was a consummate poet and the Judges, likewise, are portrayed as highly effective speakers as well as warriors.

The highly structured form of the Judges' narratives as we now know them from the Biblical book of that name has been imposed on them by a later, Deuteronomistic, historian. That is to say, a later compiler and editor of the earlier texts, whose understanding of Israel's history was based on the concept of a covenant between Yahweh and Israel (as laid out in the book of Deuteronomy). Specifically a writer who is certain that the national prosperity of Israel depends entirely on adherence to that covenant—on a precisely regulated relationship with the unseen agent. It is often asserted that such Deuteronomistic history was composed between the fall of the northern kingdom of Israel to the Assyrians and the fall of the southern kingdom of Judah to the Babylonians, that is, between 722 and 587 BCE. The activity of the historical Judges and the roots of Biblical Prophecy would be considerably older than the Deuteronomist's revisions. Recently, and increasingly, the importance is asserted of the post-Exilic restoration period of the 6th to the 4th centuries BCE when it is undeniable that the texts were edited into their final form.

It is almost exclusively from those edited texts that we derive our understanding of events. Samuel, Nathan, and Gad, characters contemporary with the United Kingdom of c. 1020–920 BCE, are called "seers": "Formerly in Israel, anyone who went to inquire of God would say, 'Come, let us go to the seer'; for the one who is now called a prophet was formerly called a seer" (1 Samuel 9:9). The English "seer" is a rendition of the Hebrew, *râ'âh*, from a verb meaning to see. Saul, the first king of the United Kingdom of Israel (and another successful military leader), followed directly from Samuel, a self-styled seer (1 Sam 9:19), although he is also called a prophet (1 Sam 3:20), and Saul was installed and anointed by him (1 Sam 10:1). Saul was also known for his shamanic ecstasies, "the spirit of God coming upon him" such that he was inspired to strip off his clothes in an apparent trance-state and he seems to have temporarily joined a band of prophets in their ecstatic dancing (1 Sam 19:23–24, 10: 5–13).

After Saul's time, such charismatic leaders are consistently called "Prophets" (Hebrew *nâbîy'*, plural, *nevi'im*—etymologically, to speak, call, or sing). The earlier prophetic books, or Former Prophets, the first half of the "Nevi'im" in the Hebrew Bible, are grouped as "historical" books in the Christian Old Testament (that is, Joshua, Judges, Samuel, and Kings). The Hebrew Prophets began as the more-or-less typical ecstatic or shamanic religious leaders that were familiar all over the Middle East at that time. They came to be seen (emphatically in the Deuteronomistic strand of the text) as those people who could most accurately claim to know the will of their God. That is, they could most reliably advise the people—and especially the Kings—how to observe the Covenant central to Deuteronomistic

understanding. The factors usually seen as contributing to the rise of Hebrew prophecy (and later to prophetic literature) were the threats posed to the worship of Yahweh, especially the emphasis on the worship of Baal under king Ahab (869–850 BCE) and his queen, Jezebel, who actively oppressed Yahwism (1 Kings 18:4); economic and social developments in the kingdoms of Israel and Judah which produced an oppressed lower class— the theology of the prophets insisted that all were equal insofar as they followed the Mosaic Law; the political instability caused by the Assyrians' return to international dominance; and the division of the Jewish nation into two kingdoms after the death of Solomon around 920 BCE. All of these threatened the stability and persistence of the culture. With the division of Israel and development of these imperial foreign powers, military prowess— martial art—was no longer a realistic option for the demonstration of the inspired skill of their leaders. Under these circumstances, the need to comprehend the disposition of unseen agency so as to base one's behavior upon it had to be accomplished by other means. Initially, this would have been accomplished by the Temple in Jerusalem. However, the latter prophets were masters of many media. They were ecstatics and visionaries in the typical shamanic sense, procuring knowledge through altered states of consciousness. Zechariah saw a 20-cubit long flying scroll and women with wings like the wings of a stork (Zech 5); Ezekiel's visions are no less intense (Ezek 1: 5–28), nor Isaiah's (Isa 6). The texts use the imagery of these visions to great rhetorical effect, speaking to their audience in the symbolic language that is one of the hallmarks of poetic skill:

> So I went down to the potter's house, and there he was working at his wheel. The vessel he was making of clay was spoiled in the potter's hand, and he reworked it into another vessel, as seemed good to him. Then the word of the LORD came to me: Can I not do with you, O house of Israel, just as this potter has done? says the LORD. Just like the clay in the potter's hand, so are you in my hand, O house of Israel.
>
> (Jer 18:3–6)

> ...
>
> The LORD said to me again, 'Go, love a woman who has a lover and is an adulteress, just as the LORD loves the people of Israel, though they turn to other gods and love raisin cakes.' So I bought her for fifteen shekels of silver and a homer of barley and a measure of wine. And I said to her, 'You must remain as mine for many days; you shall not play the whore, you shall not have intercourse with a man, nor I with you.' For the Israelites shall remain many days without king or prince, without sacrifice or pillar, without ephod or teraphim. Afterwards the Israelites shall return and seek the LORD their God, and David their king; they shall come in awe to the LORD and to his goodness in the latter days.
>
> (Hosea 3:1–5)

Prophecy as performance

These poetic visionary and symbolic references were not originally restricted to subjective states and verbal behavior, but made manifest in the physical acts of the prophets. There is widespread agreement that such passages do not represent merely linguistic activity, either spoken or written, but the actual performance by the prophets of deeds of powerful theatrical expression:

> In the beginning of the reign of King Zedekiah son of Josiah of Judah, this word came to Jeremiah from the LORD. Thus the LORD said to me: Make yourself a yoke of straps and bars, and put them on your neck. Send word to the king of Edom, the king of Moab, the king of the Ammonites, the king of Tyre, and the king of Sidon by the hand of the envoys who have come to Jerusalem to King Zedekiah of Judah. Give them this charge for their masters: Thus says the LORD of hosts, the God of Israel: This is what you shall say to your masters: It is I who by my great power and my outstretched arm have made the earth, with the people and animals that are on the earth, and I give it to whomsoever I please. Now I have given all these lands into the hand of King Nebuchadnezzar of Babylon, my servant, and I have given him even the wild animals of the field to serve him. All the nations shall serve him and his son and his grandson, until the time of his own land comes; then many nations and great kings shall make him their slave.
>
> (Jer 27: 1–7)

Later, the prophet Hananiah took the yoke from the neck of the prophet Jeremiah, and broke it, saying that this is how their God will break the yoke of King Nebuchadnezzar of Babylon from the neck of the nations. Ezekiel, under divine inspiration, of course, took a brick and used it to portray the city of Jerusalem, putting siege-works against it, and building a siege-wall around it, complete with battering-rams all around (Eze 4: 1–8). He shaved his hair and beard with a sword, dividing the hair into thirds, burning one third, striking another with the sword and scattering the remainder to the wind (Eze 5: 1–4). Isaiah was inspired to "loose the sackcloth from your loins and take your sandals off your feet" and did so, walking naked and barefoot for three years

> as a sign and a portent against Egypt and Ethiopia, so shall the king of Assyria lead away the Egyptians as captives and the Ethiopians as exiles, both the young and the old, naked and barefoot, with buttocks uncovered, to the shame of Egypt.
>
> (Isa 20: 1–4)

Current understanding is that at least some of these acts were performed in a sacred theater of the inspired, their performance expressing the understanding

of the shaman/prophets and communicating it to the people in such a way as to enchant the attention of the audience, communicate the understanding of the performers, and influence the behavior of the audience. This would be entirely consistent with the sort of religious ritual that is suggested by the Covenant enactments indicated in the Book of Genesis (15: 7–16). Such ritual enactments conform precisely to Ellen Dissanayake's idea of art as ritual drama functioning to "facilitate or sugarcoat socially important behavior" (Dissanayake 1988, 167). Although "sugarcoating" here seems more than a little euphemistic, such behavior nonetheless made "socially important activities" special, it directed attention to them, and ensured their performance and persistence.

Bernard Lang and Joseph Blenkinsopp emphasize "that Ezekiel was a poet and literary artist in a more self-conscious way than any of the other prophets" (Blenkinsopp 1983, 200, quoted by Lang 1986, 297). Lang takes the verse Ezekiel 33: 32—"To them you are like a singer of love songs, one who has a beautiful voice and plays well on an instrument"—

> to imply that the prophet is not only *compared* to a public performer but actually did sing songs and did play on an instrument in order to attract and present his message to a crowd. As a performer the prophet was no different from other ancient bards, storytellers, and street musicians.
>
> (Lang 1986, 297. n.3)

Not only that, but Lang seeks to "demonstrate that the prophet was creatively receptive to foreign ideas" (Lang 1986, 298), specifically in this case, to "the Zoroastrian background to the resurrection passage of chapter 37" (Lang 1986, 298). Although

> [i]n the nineteenth century biblical scholars tended to consider most of the symbolic acts not as actual performances, but as parables ... Twentieth century authors ... are convinced of the actual performance of these acts, emphasizing the realistic, dramatic nature of the accounts.
>
> (Lang 1986, 298, 299)

Twenty-first century authors continue to do so. The Book of Ezekiel tells us that Ezekiel performed at least another ten acts in the same category, and Lang argues "that the so-called symbolic acts, especially those of Ezekiel, should be understood as public, street-theatre like performances" (Lang 1986, 299, 300). Lang and Blenkinsopp were not the first to read the prophets this way. In the late 19th century Ernest Renan (1823–1892) saw the prophet as "a journalist who works in the open air, who reads out his article in person and accompanies it with mime, indeed often converting it into a sign language" (Renan 1953, 574, quoted by Lang 1986, 300 n.14). Wolfram von Soden, in 1955, likewise suggested that "mimical productions played a far greater role in worship as well as in politics and popular entertainment than ancient literature allows us

to discern" (von Soden 1955, 156, quoted by Lang 301). Although such symbolic acts were primarily geared to engaging the attention of the audience and thereby modifying their behavior, according to Lang, "the symbolic act does not exclusively serve as a medium of instruction. The act pre-imitates the future, that is, it influences and shapes future events simply by being performed" (Lang 1986, 303). This is precisely the complex that I suggest. The Hebrew Prophets were "inspired performance artists" who used all the arts, including initially martial arts, later restricted to poetry and the verbal arts as well as music and dramatic performance in order to accomplish their role as diviners, commending and influencing specific behavior by artfully expressing their own emotional reaction to the unseen agency in the environment. It would be equally true that the priests of the neo-Babylonian Empire were performance artists, but the emotional impact of their performances relied upon their massive sanctuaries and monumental statuary, whereas the street theater of the colonized population under the influence of the Prophets, initially in competition with that mode of Temple ritual, depended perforce upon more portable, spontaneous, and flexible media. Bereft of the first Temple (usually thought destroyed in the Babylonian assaults of 587 or 586 BCE) the Hebrew culture would be increasingly dependent upon and shaped by such performative prophecy.

The art of the text

Obviously, a hugely important development in religious behavior occurred around the era of Biblical prophecy. Karl Jaspers' trope of the "axial age" has been repeated with varying degrees of approval and disapproval since he coined it in his 1949 *Vom Ursprung und Ziel der Geschichte* (*The Origin and Goal of History*, 1953). It is not necessary for my thesis that any general, simultaneous, or interconnected global shift in human behavior had to occur, but considering the interaction of art behavior and religion behavior in the manner suggested sheds light on specific shifts in specific cultures. Local variants of universal propensities produced unique but related manifestations of art and religion in every continent.

In the Middle East, the combination of monumental and domestic art, architecture, and ritual in a walled city was not the only thing to emerge in Uruk. Writing emerged there too, in a system that was at first pictographic and logographic, that is, a single sign was visibly recognizable as an object and represented a whole word. After this, the cuneiform script evolved in a development that has been well documented (Liverani 2006, 12). Writing is an art by any estimation and it has, of course, been crucial in the development of religion as we know it. Gradually, prophetic performance became increasingly textually oriented.

It is a primary assertion of Mark McEntire's (2015) study of the Prophets that "the work of prophecy continued in textualized prophets, whose influence can be seen in the growing significance of literature" (16). On

three occasions, the Prophet Jeremiah is specifically told by God to write, as is Ezekiel (Jer 30:2; 36:2; 36:28, Eze 43:11; McEntire 164, 185). This is an indication of the developing importance of the relatively new technology of phonetic script in connection with prophecy and prophetic literature. The unusual command for Jeremiah to write down his prophetic message grants that message a life beyond his own physical presence (McEntire 170). When Ezekiel eats the scroll he has written, it is evident that the prophetic word is identified with the written word, according to Thomas Leclerc (283), and the "essential message" of Isaiah 40:7–8 is that God's word, now in written form, endures forever (309). All the post-exilic prophets agree that the Torah contains God's words in written form (337). Even now, Jewish, Catholic, and Protestant Lectionaries all continue to follow the lead of Second Isaiah in that they take ancient texts and traditions and apply them to new settings (Leclerc 332). That is, they practice graphomancy: using writing as a means of divination and specifically employ the idea that messages from the gods come through written texts (Leclerc 31). Leclerc is not unusual in recognizing that this is divination and, although he sees this as the method of discovering the will of the gods (Leclerc 27), this is a more specific formulation of the more general method of ascertaining the correct behavior. Obviously, the will of the gods is what we should do. As we saw in Chapter 9, divination can be variously classified. Leclerc groups it into two broad categories: Inductive or Instrumental Divination and Intuitive or Mediated Divination (27–29). The first, also known as *artificiosa divinatio*, requires some specific skill (27). The second, *naturalis divinatio*, is most akin to the phenomenon of Biblical prophecy. It is mediated through possessed or ecstatic intermediaries (29). This, however, is also a skill.

The texts, generated by and based upon the activities of the Prophets, were absorbed into the ritual of the local cult, and would become their portable focus in the ensuing Exile. Text proved just as capable of *(re)presenting* the prophets as performers without the need for their live performance, perpetuating the abduction of the agency that inspired the prophets to their impressive performances, and so continuing to be effective in determining the behavior of their audience, even after the death of the historical prophets. Textual (re)presentation allowed the prophets to operate over periods of several hundred years and to "perform" physically impossible or highly unlikely acts, such as Jeremiah's burying of his loincloth by the banks of the Euphrates when he was not in Mesopotamia (Jer. 13), or the cauterization of Isaiah mouth with hot coal (Isa. 6), or even Ezekiel's ingestion of a written scroll (Eze. 3).

Considering the Prophets as diviners and the Biblical text as literary art is hardly a new approach, although all-too-often its implications are underestimated. In contemporary criticism such consideration has led, among other things, to the recognition of a similarity between Biblical Prophetic Literature and Post-Colonial Literature. There is considerable existing research on the relation of the Prophets to Post-Colonial literature—after all the Hebrew Prophets came from a people who had been invaded, conquered, colonized,

and oppressed. They, too, were an example of how "*The Empire Writes Back*" (Ashcroft, Griffiths, and Tiffin 1989). Although this is a relatively recent development in scholarship on the prophets, McEntire judges the examination of prophetic literature through the lenses of disaster, trauma, and survival now to merit inclusion in an introductory textbook (22). McEntire and Kathleen O'Connor agree that reading—and forming—the text of the Book of Jeremiah was an act of survival (96). Some of this research anticipates quite clearly the value of integrating our understanding of the literary arts and the history of religions. "An Exile's Baggage: Toward a Postcolonial Reading of Ezekiel," by Jean-Pierre Ruiz points out that

> [w]hile it makes little sense simply to set Queen Victoria's British Empire side-by-side with Nebuchadrezzar's neo-Babylonian Empire, postcolonial biblical critics argue that quite a bit can be learned by using the critical tools crafted to investigate texts that emerged under the influence of the former to re-examine texts that emerged under the influence of the latter.
>
> (2007, 124)

The Book of Ezekiel clearly contains "an unmistakable expression of resistance against the neo-Babylonian imperial ideology" (Ruiz 2007, 131). Such "resistance" is a very deliberately adopted course of action. The proposed ethology of art and religion suggests a particular reading of these events. There is an inescapably religious component to Biblical Prophecy that seems superfluous, if not foreign, to contemporary Post-Colonial Literature but here is where we need to consider the role of divination. As I have indicated, the "divination" empowered by the behavior ancestral to both religion and art does not so much entail "telling the future," but attempting to identify and implement the best course of action in the present. Although prophecy does involve oracles, the role of the prophet was more to call people to a life well-lived than to foretell the future. Moses Gaster's entry on Jewish Divination in the Hastings' Encyclopedia tells us that the establishment of the sanctuary in Jerusalem by David (c. 1,000 BCE) marks a turning point in history of the Jewish practice of divination. According to the Biblical text, the "Urim and Thummim" (Gaster points out that rabbinical writers identify these as stones in a breastplate which either lit up or did not, thus providing answers to questions) were no longer effective as a means of divination.

> After the disappearance of the Urim and Thummim another inspired oracle took its place—the *Bible oracle* (the oral recitation of biblical verses). Infants were asked to tell a verse to a man who met them quite unexpectedly, and from the verse which the child repeated innocently the questioner drew his own conclusions, for he saw in it the miraculous answer to this query.
>
> (813)

This, according to Gaster,

> is the origin of the Bible oracle (stichomancy) by means of written and later on a printed book. It consists in opening the book and looking at the first verse that meets the eye as a means of divination, or putting in a pointer, and the passage where the pointer rests is taken as full of significance and prognostication.
>
> (813)

While it seems likely that the text itself has retrojected the transition to graphomancy from more performative methods some 500 years back in time, the transition itself remains clear.

Israel's neighbors and conquerors continued "serving wood and stone" (Eze 20:32), that is, continuing to rely upon massive monumental arts as the source of their primary emotional understanding of the real, the focus of their divination, and the determination of their behavior. In a unique cultural situation the Hebrews, emphatically but not uniquely, developed skills in a different direction. Eventually they came to rely on the exegesis of texts for their divination, which is to say for the determination of their actions. The discovery of "the book of the law in the house of the Lord" and the prophet Huldah's commission to interpret it (2 Kings 22:8–14) is the archetypal textual example. In our present theoretical terms, the text came to prove a more compelling index of the agency of divinity than other material representations.

Not only are the Biblical Prophets a particularly clear example of the skilled and creative determination of behavior by the artistic (re)presentation of an immensely powerful determining agent, they are also, and possibly even more informatively, examples of a transition from the focus of such creative skill, then most widely focused in the standard temple complex, transitioning through a variety of visual and performing arts, and surviving through the intense and interactive skills of textuality, moving from rituals involving the massive plastic arts to rituals involving the literary arts. In person, the Hebrew prophets can be seen as artists: religious street-theater performers who communicated "the will of the divine," interpreted here as visionary artists whose performances express a perception of the intentional state of the unseen agency that determines the outcomes of human behavior and thus empower that agency. As literary characters, they perform the same function, with all the added advantages of graphomancy. The skills of music and song, dance and drama are, in a transformation rendered necessary by the historical pressure of the colonial environment, replaced by the skills of *textual* presentation, discernment, and reception. The production of the text itself was a massively skilled performance, combining calligraphy and composition with all of the arts of storytelling, character and plot development and the poetic parallelisms, eponyms, and tropes typical of the Biblical text. As religious behavior, graphomancy would require a greater involvement of the audience's

skills of cognition and reception as much as of the original composers and editors and performers, encouraging a mode of religious (and art) behavior that was more participatory and certainly more effective in a domestic environment lacking a central temple and its priesthood.

Perception of the unseen agency of the environment, as has been suggested, is attained not only by the "reading" of the "signs" and suggestions of the natural world, but also the interpretation of the prior output of other performers in the same tradition (what Alfred Gell called "protention and retention" 1998, *xii*, 235–239, 250). The Hebrew Prophets represent a very significant transition to an emphasis on a particular use of text in that process. As long as it has existed, text has always been important in deciphering "the will of the Gods." Egyptian hieroglyphs, "sacred inscriptions," are not lightly so-called—the Greek, "hieroglyph," is a close rendition of the Egyptian *mdw·w-ntr* (*medu-netjer*)—god's words. The script of the sacred language of Sanskrit is similarly called the script (of the city) of the Gods, *devanāgarī*. In the latter case, the appellation is relatively recent and interaction with the material text is not central to Hindu temple ritual. In the former case the use of its complex script, including phonetic, logographic, and determinative elements, was tightly restricted to the professional religious and could have little immediate effect on the wider populace except as an element dependent upon the whole complex of the material temple culture of the tradition. In the case of Biblical prophecy that dependency was about to change.

The process by which this came about has left clear traces in the early texts. It indicates that the Prophets as visionary artists initially of lesser importance than the Priesthood found increasing success when they became the earliest interpreters of the written Torah. The priesthood—performers in the arena of Temple architecture and familiar dramatic ceremonial—would have become all but powerless in the context of the Babylonian Exile, deprived of all of the necessary accoutrements of their trade. The Prophets, with their spontaneity and improvisation, could work with whatever they had to hand—increasingly with text. As noted, the prophet Huldah in 2 Kings is a clear example:

> The high priest Hilkiah said to Shaphan the secretary, "I have found the book of the law in the house of the LORD." When Hilkiah gave the book to Shaphan, he read it. Then Shaphan the secretary came to the king, and reported to the king, "Your servants have emptied out the money that was found in the house, and have delivered it into the hand of the workers who have oversight of the house of the LORD." Shaphan the secretary informed the king, "The priest Hilkiah has given me a book." Shaphan then read it aloud to the king.
>
> When the king heard the words of the book of the law, he tore his clothes. Then the king commanded the priest Hilkiah, Ahikam son of Shaphan, Achbor son of Micaiah, Shaphan the secretary, and the king's servant Asaiah, saying, 'Go, inquire of the LORD for me, for the people, and for all Judah, concerning the words of this book that has been found;

for great is the wrath of the LORD that is kindled against us, because our ancestors did not obey the words of this book, to do according to all that is written concerning us.'

So the priest Hilkiah, Ahikam, Achbor, Shaphan, and Asaiah went to the prophetess Huldah the wife of Shallum son of Tikvah, son of Harhas, keeper of the wardrobe; she resided in Jerusalem in the Second Quarter, where they consulted her. She declared to them, 'Thus says the LORD, the God of Israel ...

(2 Kings 22: 3–20)

While Shaphan the "secretary" (or "scribe"—Hebrew, *çâphar*, a professional writer) can read the text perfectly well and the High Priest is with him, it is the prophet, standing in line of descent from the shamanistic *nevi'im* and the seers, who is called upon to determine its true sense and ultimate import. (In this context and in keeping with the ethological thrust of the present work I understand the "import" of the text to be the appropriate *response* to it, that is, the behavior that it is supposed to elicit.) In this passage, worked by the later editors, the Deuteronomic theology of reward and retribution based on the observance of the Covenant is emphasized at the same time as the importance of the text compiled by the Deuteronomic editors is emphasized as a source of knowledge of that Covenant. The powerful constellation of ideas expressed in this literature became understandably influential in the very survival of Hebrew culture through the Babylonian and Persian periods. The combination of votive religion with communal cultural identity and the corresponding elevation of the stature of the local deity, now seen as responsible for both prosperity and impoverishment, would be further enhanced by its expression in written form and the dependence upon that form for interpretation—the deep involvement of graphomancy in the religious behavior of the culture.

Huldah's interpretation of the book of the law appears to be set in about 620 BCE, some 25 years before the first deportation of the Hebrew ruling classes into Exile in Babylon. Even in Exile, the Hebrews were recognized as talented performers as Psalm 137 famously attests:

By the rivers of Babylon—
there we sat down and there we wept
when we remembered Zion.
On the willows there
we hung up our harps.
For there our captors
asked us for songs,
and our tormentors asked for mirth, saying,
"Sing us one of the songs of Zion!"

They are still live performers—but chief among their talents, from our perspective almost two and a half millennia later, is the art of rendering their

materials—dramatic performance, oral tradition, song, and religious ritual—
into written text, and of deriving from that text guidance for behavior. One
might ask how the Hebrews became such masters of the text, and the answer—
an answer that is entirely consistent with the present evolutionary and etholog-
ical approach—seems readily forthcoming: the necessity of surviving potential
cultural extinction, aided by text rather than temple. Although a century and
a quarter had passed since the destruction of the Northern Kingdom of Israel
by the Assyrians, the memory of the ten lost tribes of Israel could only remain
strong with the remaining tribes of Judah and Benjamin, and the fear—and
the very real possibility—of sharing their fate would be all too keen.

Scholarship indicates that the portrait of the persecution of the exiles in
Babylon painted by the Book of Daniel in the 2nd century BCE is exagger-
ated. The Hebrews were certainly an oppressed, minority, immigrant com-
munity, threatened by cultural assimilation. But they were relatively secure
in their immigrant community by the banks of the River Chebar. Forced
from their homeland, they were bereft of their cities, and especially of their
temple and all of the ritual trappings that went with it. Exiled with only what
they could carry they would be forced to rely more heavily than any commu-
nity had previously done on the one thing they *could* bring with them—their
narratives and the relatively new skill of rendering them into text.

Exigencies of space and time do not allow a detailed digression into the
complexities of the development of writing systems. Egyptian hieroglyph-
ics had developed as early as 3,000 BCE alongside a cursive form known
as hieratic, although this was still difficult and unwieldy. Sometime in the
mid-7th century BCE the more flexible and easily learned demotic system
had appeared. Similarly, the cuneiform script widely used in Mesopotamian
regions had gradually become increasingly flexible and could transcribe any
sound in their language. Although earlier forms of the script were intensely
pictographic and hence required a great number of signs (more than 1,500
have been identified by modern scholars), as early as the 14th century BCE in
the city of Ugarit an "alphabetic" cuneiform script had been developed that
employed only slightly more than 20 consonant signs. Nonetheless, although

> [t]he Egyptians and the Sumerians thus came very close to the alphabetic
> principle, … neither managed to extract this gem from their overblown
> writing systems. The rebus strategy would have allowed them to write a
> word or sentence with a compact set of phonetic signs, but they contin-
> ued to supplement them with a vast array of pictograms. This unfortu-
> nate mixture of two systems, one primarily based on sound, the other on
> the meaning, created considerable ambiguity … the scribes could have
> simplified their system vastly by choosing to stick to speech sounds alone.
> Unfortunately, cultural evolution suffers from inertia and does not make
> rational decisions. Consequently, both the Egyptians and the Sumerians
> simply followed the natural slope of increasing complexity.
>
> (Dehaene 188)

However, even earlier, as early as the 18th century BCE, the proto-Sinaitic or proto-Canaanite alphabet had appeared in the Sinai Peninsula (Dehaene 186; Goldwasser 2010). Thus, it seems certain that the Hebrews in exile in Babylon were familiar with a fairly simple phonetic script.

> Egyptian hieroglyphic and Mesopotamian cuneiform with its curious wedge-shaped characters, each required a knowledge of hundreds of signs. To write or even to read a hieroglyphic or cuneiform text required familiarity with these signs and the complex rules that governed their use. By contrast, an alphabetic writing system uses fewer than 30 signs, and people need only a few relatively simple reading rules that associate these signs with sounds.
>
> (Goldwasser 2010, 40)

The simplicity of the alphabetic script allows a greater proportion of the population to make use of it. However, even more significant is the intensity of the dependence upon it and the skills required for both its production and reception. While, for the more powerful, large-scale cultures that surrounded them, writing operated as one inseparable part of the whole complex of the material culture of the tradition, for the Hebrews in Exile, not only had that specific medium attained primary position in their cultural autopoiesis, but the persistence of their very existence depended upon it. Furthermore, as a culture relatively recently transformed from semi-nomadic pastoralism to the urban environment, they were still masters of the primary artform of the nomad—storytelling.

One wonders if, even with the help of the written texts, the Hebrews in Exile could have withstood the perfectly natural pressures to assimilate for much longer than they did. As we know, those who returned to Israel with Ezra in the late 5th or early 4th century BCE no longer spoke Hebrew as a natural language and required the sacred text to be translated into Aramaic (at least, this is the standard interpretation of Nehemiah 8:8: "they read from the book, from the law of God, with interpretation. They gave the sense, so that the people understood the reading"). However, with the conquest of the Babylonian Empire by Cyrus the Great of Persia in 539 BCE their status had changed. After at most 58 years of enforced exile (perhaps just 48 or 43 years for some), a limited autonomy was restored to the Hebrew people with at least the option of their return to Judah and the pressure to assimilate proportionally reduced. It can be argued that this pressure had been rather dramatically replaced by an opposite need to emphasize their cultural autonomy if they were to take advantage of that option. This was clearly no straightforward restoration of the *status quo ante* and the reconstruction of the Jerusalem Temple and its cult was to take hundreds of years, during which time the newfound art of graphomancy could flourish. Dependence on the text for the identification and maintenance of the culture thus became and remained more or less total in this situation.[3]

As has been said, the point of such behavior is not worship in the sense of self-abasement before an almighty power, but has the goal of imbuing the audience with assured, persistent, and sustainable behavior through *theosis* or the *imitatio dei*, in the sense of obedient cooperation and a mimetic relationship with the divine ideal of skillful creativity manifest in religious art as an index of divine agency. By responding emotionally to the environment as if possessed of a comprehensible agency, confident and consistent, assured and persistent, sustainable behavior was produced. This is how human cultures survive as recognizable entities.

Such a developing relationship with the increasing effectiveness of the text is a widespread phenomenon and is clearly involved with our relationship to history and historiography. It is not, I believe, particularly unique nor restricted to the creative genius of post-Exilic Judaism but is a cumulative process endemic in the modern world. It is simply the case that its early trajectory is particularly clear in Biblical Prophetic literature. The most effective urban rituals involving the priesthood, temple complex, and monumental artforms had long been both complemented and contested by the more individual and spontaneous performances of inspired shamanistic practitioners that preceded them. Denied the former, the Hebrew culture of the Babylonian and Persian periods became increasingly focused on the latter, which, under the pressure of the Exile and with the help of increasingly effective phonetic writing, rapidly morphed into the mainly graphomantic mode of the post-Exilic period. Nor was this increasing dependence on the text a liability. It brought with it certain strengths and freedoms. As mentioned earlier, protention and retention "adverts to the ways artworks at once anticipate future works and hark back to others" (Gell 1998, *xii*) and it is evident that any work that has durable form has a greater potential for such protention than any temporally fleeting performance, which must rely on memory to work its influence. The plastic arts have such durable form but, in the main, lack portability or, before the advent (or rediscovery) of proper perspective as recently as the 15th century CE, lack complexity and depth. Writing, on the other hand, is durable, accessible, and capable of all the complexity and depth of the narrative arts of poetry, chronicle, and storytelling. Not only can it communicate the complex conceptual structure of the Deuteronomic covenant theology with all of the power of visionary poetic language, but it remains available to be recited as the central act of ritual, and pored over, analyzed, interpreted and reinterpreted, and continuously mined for further inspiration (divination). The intense fashion in which the texts of the Christian tradition exploit the texts of the Hebrew is clearly demonstrative of that power. The reading of the Old Testament as explicitly predictive of the events in the New Testament is a precise example of such graphomancy. Unfortunately, perhaps, the text is almost too effective, capable of transmitting the sensation that the representation simply is the thing represented, as if the text were a perfectly transparent window through which the events of the past and the other unseen partitions of reality could be directly viewed. Graphomancy is powerfully conducive to bibliolatry and logocentrism.

The written records of early Hebrew oral traditions, descriptions of the deeds of judges and kings, chronicles of warfare and political intrigue were the raw materials out of which the Deuteronomic historians were able to fashion their own texts. The texts suggested and thus "revealed"—in the same way that the shapes and shadows of Paleolithic caves suggested and revealed the shape of the spirit world to Stone Age seekers—the structure of the covenant theology. Once it had been suggested that their favored deity could be responsible for both their rise, via the Davidic monarchy, and their fall, now seen as a provisional, contingent, temporary punishment, reversible on their return to the proper observance of the law, the pressures to assimilate to the culture of their conquerors, to abandon the worship of their own deity in favor the worship of Marduk or Ahura Mazda, could be resisted. (The implication here is that any reasoned and rational explanation of that resistance is more a symptom than a cause of the persistence inspired by the text.)

The inspired performances by means of which the former prophets glorified their God and encouraged their fellows became the poetic images and tropes that the literary prophets faithfully recorded in writing. As texts, these remained, and still remain, available for reinterpretation, further suggestion, deeper revelations. Not only is their God the LORD "who created you, O Jacob, and formed you, O Israel" (Isa 43:1); not only is there no savior but the LORD for the remnant of the once proud Israel; not only must they *have* no other God but him; but now, in a veritable paroxysm of creative hyperbole, "there is no other, there is no God besides me" (Isa 45:5, 6, 18, 21, 22). Out of the wild creativity of the prophetic tradition, out of the visionary *poetike techne* that expresses the personality of reality among this small group, comes arguably the one line with the greatest protention of human history to date, which will be retained into their far future, to the current day, and doubtless well beyond. Step-by-step by the elaboration of earlier tropes (such as Isa 37:18–19, " ... the kings of Assyria have laid waste all the nations and their lands, and have hurled their gods into the fire, though they were no gods, but the work of human hands—wood and stone—and so they were destroyed") the textual tradition elaborated itself and provided guidance for an increasingly high proportion of the human race as monotheists.

Notes

1 Published in part as "Religion and Art Behavior—A Theory and an Example: The Biblical Prophets as Postcolonial Street Theater." *Journal for the Study of Religion, Nature and Culture* 9, no. 3 (October 2015): 312–334.
2 Inspiration is divine almost by definition—whence else can the creative come? The unseen agents that determine our situation and our fortune also provide us with access to the new and the creative. They are the exemplars of creativity.
3 The utilization of the text was taking a very different direction in the Hellenistic world at much the same time as the pre-Socratic philosophers developed their systems of reasoning based on the internal authority of the discourse rather than on external revelation. Such dependence on discourse requires the availability of an accurate record of the discourse—the text. Of course, the rational,

logical discourse of the philosophers was to remain a minority practice, soon to be swamped by the vastly more popular, visceral, and poetic discourse of early Christianity, thoroughly dependent on the idea of text as revelation. (For the characterization of philosophy as internally authoritative discourse, see Rennie, 2010, 127–129.) Still, both modes are representatives of the determination of behavior by textual skills—the technocracy of the text.

References

Ashcroft, Bill, Gareth Griffiths, and Helen Tiffin. *The Empire Writes Back: Theory and Practice in Post-Colonial Literatures*. London and New York: Routledge, 1989.

Blenkinsopp, Joseph. *A History of Prophecy in Israel*. Philadelphia, PA: Westminster Press, 1983.

Dehaene, Stanislas. *Reading in the Brain: The Science and Evolution of Human Invention*. New York: Viking. 2009.

Dissanayake, Ellen. *What is Art For?* Seattle: University of Washington Press, 1988.

Gaster, Moses. "Divination (Jewish)." In *The Encyclopedia of Religion and Ethics*, edited by James Hastings, 806–814. Edinburgh, UK: T & T Clark, vol. IV 1912.

Gell, Alfred. *Art and Agency: An Anthropological Theory*. Oxford, UK: Oxford University Press, 1998.

Goldwasser, Orly. "How the Alphabet was Born from Hieroglyphs." *Biblical Archaeology Review* 36, no. 2 (2010): 36–74.

Jaspers, Karl. *The Origin and Goal of History*. New Haven, CT: Yale University Press, 1953.

Lang, Bernhard. "Street Theatre, Raising the Dead, and the Zoroastrian Connection in Ezekiel's Prophecy." In *Ezekiel and His Book: Textual and Literary Criticism and their Interrelation*, edited by Johan Lust, 297–316. Leuven: Leuven University Press, 1986.

Leclerc, Thomas L. *Introduction to the Prophets: Their Stories, Sayings, and Scrolls*. New York: Paulist Press, 2007.

Liverani, Mario. *Uruk: The First City*. London: Equinox Publishing, 2006.

McEntire, Mark. *A Chorus of Prophetic Voices: Introducing the Prophetic Literature of Ancient Israel*. Louisville, KY: Westminster John Knox Press, 2015.

Musashi, Miyamoto. *A Book of Five Rings: A Guide to Strategy*. Woodstock, NY: The Overlook Press, 1974.

O'Connor, Kathleen M. *Jeremiah: Pain and Promise*. Minneapolis, MN: Fortress Press, 2011.

Renan, Ernest. *Oeuvres Completes*, volume IV, edited by Henriette Psichari. Paris: Calman-Lévy, 1953.

Rennie, Bryan. "After this Strange Starting: Method and Theory and the Philosophy of Religion(s)." *Method and Theory in the Study of Religion* 22, nos. 2–3 (2010): 116–135.

Ruiz, Jean-Pierre. "An Exile's Baggage: Toward a Postcolonial Reading of Ezekiel." In *Approaching Yehud*, edited by Jon L. Berquist, 117–135. Atlanta, GA: Society of Biblical Literature, 2007.

Soden, Wolfram von. "Gibt es ein Zeugnis dafür, daß die Babylonier an die Wiederauferstehung Marduks geglaubt haben?" *Zeitschrift für Assyriologie* 51 (1955): 130–166.

12 Where is the art we have lost in religion?

> [T]here are arts other than the art of speech through which we can express
> and communicate thoughts and feelings. [Rudolf Otto] writes persuasively
> of architecture, of what is conveyed and recorded by Chinese temples, or the
> Pyramids of Egypt. He tells us of what is conveyed by sculpture, by statues of
> the Buddha and the Sphinx, that could not be conveyed by words.
> (Renford Bambrough, "Intuition and the Inexpressible," 209)

The monotheistic graphomancy of the Abrahamic traditions is only one
example of the operation of art in religion. The power and sophistication
of that particular mode of religious behavior—dramatically enhanced since
the Protestant Reformation in Western Europe—has very significantly con-
tributed to logocentrism with a concomitant difficulty to remain conscious
of the operations of art in religion. These operations can be more clearly
seen in other arts and other traditions. Using the example of Michelangelo's
Pietá I have already pointed out how religious art benefits from an enhanced
impact that goes beyond the power exerted by the sheer skill of its produc-
tion. Location in an extended matrix of stylistically related, multi-media,
art forms, mutually enhances the affective power of religious art to inspire
ascriptions of the sacred. Any piece becomes more potent when it is associ-
ated with mythology—narrative art—which combines with and contributes
to the plastic arts to amplify their emotional affect. Such amplification by
association is true of most art, but particularly so of all religious art, which
is *necessarily* located in an extended matrix of stylistically related media—the
religious tradition.

An instructive example may be drawn from the Hindu tradition, Hanumān,
the eleventh avatar or incarnation of Śiva. He is a central character in the
Indian epic poem, the *Rāmāyaṇa*. Hanumān is a "vānara," that is, one who
lives in the forest, usually identified as "monkeys," but more accurately quasi-
mythic "forest-people." (This, by the way, is the source of Rudyard Kipling's
"Bandar-log" in the *Jungle Book* stories, from the Hindi, *bandar* plus *–log*, peo-
ple.) Hanumān is the son of Vāyu, an older Hindu deity, mentioned in texts
as early as the Ṛg Veda (c. 1,200 BCE) as god of the winds (and sometimes
of breath). Hanumān is thus doubly wayward, being both wind-born and

simian—the perfect incarnation of the "monkey-mind" or inner agitation and lack of mental self-control against which Hindu and Buddhist meditation techniques warn us. Yet as an incarnation of Lord Śiva, one of the greatest of Hindu devas, and the ultimate ascetic meditator, Hanumān becomes the paradigm of focused and controlled immobility. How does one still such agitation and go from monkey mind to divine homeostasis? Hanumān distinguished himself in Rāma's war against the demon king, Rāvaṇa. The Divine King, Rāma, the contemporary form of whose name, Rām, is often used as a simple synonym for God, is another major Hindu deva. The primary plot of the *Rāmāyaṇa*—frequently retold in oral and dramatic performances—is the kidnapping of the Divine King's wife, Sītā, the ensuing war, and Hanumān's role as the principal agent who reunited Rāma and his wife. In a famous passage of the *Rāmāyaṇa* the Monkey General proves that he is a genuine emissary of Rāma by showing Rāma's ring to Sītā in her captivity among the asuras or "demons." The episode has been enshrined in song by, among others, Krishna Das, the American *kirtan* performer.[1] So the visual image, the written narrative, dramatic, oral, and musical performances all mutually enhance one another.

Hanumān also exhibits several other highly significant aspects of the operation of art and religion. The archetypal devotee of Rāma and Sītā, he is often shown with Rāma and Sītā located in his heart. It is by thus interiorizing

Figure 12.1 Images of Interiority. Hanuman shows Rama and Sita inside his chest; An embroidery of the Sacred Heart of Jesus (Saint Nicholas' Church, Ghent, Belgium); *If Jesus Lived inside my Heart*, by Jill Roman Lord and Amy Wummer (WorthyKids; Board Book edition, 2014 used with permission from Hachette Books).

the divine, making his own interiority divine, that even the undomesticated Hanumān, son of the wind itself, can become the essential meditator, focused and certain, utterly devoted, controlled, and confident. Alfred Gell (1998, 136) makes good use of this concept of interiority, although my use of the concept differs from Gell's. As has been mentioned above, Gell argued that "idols" and other (re)presentations of divine beings may not be biologically living things but, if "intentional psychology" is attributed to them, then they effectively have "something like a spirit, a soul, an ego, lodged within" (129), insofar as they are *perceived* as agents and thus make effective changes in the environment by their presence.

The explanation of this claim is worth close attention. Gell points out that simply to say that one attributes agency to something does not explain what a thing must be or do to count as "animate" or "anthropomorphic" (121). That is, *why* do we attribute animacy and anthropomorphism to this thing rather than that thing and *what* do we attribute when we do so? Gell seeks to answer these questions and one of the conclusions he reaches is that "ritual" animation and "possession of 'life' in a biological sense are far from being the same thing" (122). The attribution of agency to nonliving things does not rest on simple category mistakes, such as mistaking inanimate objects like boulders for biological organisms like bears (122). So not just on the hyperactive agency detection device, HADD, as per Justin Barrett (2004, 35). Gell focuses largely on Hindu *murtis*, which he calls idols, as exemplary of religious representations, but the argument holds for any visual or verbal representation. They are all representational indexes, which are apprehended as social others, and as repositories of agency (123). Although most people tend to think that that agency requires intentionality, that is, a thinking mind that "intends" actions prior to performing them (125), Gell disagrees. He points out that there are no material tests for agency or intentionality (126) so how, in practice, do we attribute either? Following Peter Winch, Gell insists that the possession of a mind itself "is something we attribute to others, provisionally, on the basis of our intuition that their behavior (e.g. their linguistic behavior) follows some 'rule' which, in principle, we may reconstruct" (126). He goes on to argue that, "the whole panoply of 'mind' is not a series of inner, private experiences at all, but is out there, in the public domain, as language, practices, routines, rules of the game, etc.; that is, 'forms of life'" and he calls this "the 'externalist' theory of agency attribution" (126).

However, he insists that this externalist theory of agency is inadequate to account for the animation of idols. There is an "internalist" theory at work as well (135). The problematic status of this internalist or mentalist theory was pointed out by, among others, Daniel Dennett in *Brainstorms* (1979) and *The Mind's I* (Hofstadter and Dennett 1982). The problem is that in order to explain the complexities of human activity internally one must posit internal representations, a sort of homunculus or inner self, which must have internal representations of its own. This can only lead either to circularity or

to infinite regress. However, as a form of "folk psychology" the internalist assumption *appears* "true, ethnographically and psychologically, because of the innateness of the 'theory-of-mind module' which attributes intentionality to persons (and things as well, under certain circumstances)" (129). A predictable consequence of such an innate propensity to attribute intentional psychology to others is attributing a homunculus-like form to the intentionality of the other (131).

Given the creativity of human symbol use, *anything* can be used to represent anything else: "an uncarved stone can be an iconic representation of God just as well as a minutely carved stone idol which looks much more 'realistic' to us" (131). One of the consequences of this is that the "homunculus-effect," ascribing inner intentionality to anything other than ourselves, "can be achieved *without anthropomorphizing the index,* so long as the crucial feature of concentricity and 'containment' is preserved" (133, emphasis added). Adding features which would make, for example, a

> sphere more "anthropomorphic" (by the addition of eyes, mouth, etc.) do not just serve the purpose of making the sphere a more realistic "depiction" of a human being, they render it more spiritual, more inward, by opening up *routes of access* to this inwardness. The "internalist" theory of agency (in its informal guise as part of everyday thinking) motivates the development of "representational", if not "realistic" religious images, because the inner versus the outer, mind versus body contrast, prompts the development of images with "marked" characteristics of inwardness verses outwardness.
>
> (132)

Gell's argument is that the indication of the mind/body contrast "is primordially *spatial and concentric*; the mind is 'internal', enclosed, surrounded, by something (the body) that is non-mind. Now we begin to see why idols are so often hollow envelopes, with enclosures" (132–133). This is why particular attention is paid to the eyes of religious representations—

> not from the need to represent the body realistically, but from the need to represent the body in such a way as to imply that the body is *only* a body, and that a much more important entity, the mind, is immured within it.
>
> (136)

Thus *murtis*

> come to stand for 'mind' and interiority … By becoming the animating 'minds' of the huge, busy, and awe-inspiring temple complex. Just as the 'mind' is conceived of as an interior person, a homunculus, within the body, so the idols are homunculi within the 'body' of the temple.
>
> (136)

A similar image of interiority is familiar in the Christian iconic tradition, the Sacred Heart of Jesus, echoed in the common and similarly interiorizing image of "letting Jesus into one's heart," this repeats the complex of the interiorization of the divine in order to "save" or "consecrate" the devotee. This inescapably religious language may be rendered more empirical by observing the actual behavior—the devotee persists in their focus upon the specific objects and activities that present that form of the divine. This is accompanied by verbal behavior that expresses a subjective sense of assurance that such persistence is beneficial and the right thing to do. Interiority is a common image in many religious symbols in other, non-anthropomorphic forms such as the mandala, where the simple device of concentric circles implies interiority. We recognize both the representations of the sacred as allowing access to their "interiors," that is, their non-physical but real agency, and we recognize the potential of cultivating such agency in ourselves.

These concepts of interiority and interiorization are significant elements in identifying the common ancestor of those behaviors we now identify as art and religion and of the associated mental faculties that produce and enable them. Interiority, particularly the depiction of an inanimate object, a statue or painting, as having an "interior," particularly when that object is located within this type of extended matrix of stylistically related artifacts, is powerfully evocative of our ability to empathize, of something like theory of mind. This specific ability to abduct the intentional state of the other—recalling that abduction is performing an inference that constructs a hypothesis from observed data in an attempt to understand how best to respond to the observation—is usually experienced, not as a rational or discursive process, but as an unmediated perception of the subjectivity of another. It is particularly active in art.

The ability to recognize that other agents are possessed of minds similar to one's own but with their own beliefs, desires, and intentions, is a particular adaptive cognitive function. It becomes active when anything is identified as an agent. It may begin by simply registering motion as indicating potential agency. However, it rapidly progresses—because of our need to *predict* the activities of agency in the environment—to identifying the *nature and character* of agency, against which to gauge the advisability of our own potential behavior and to select among the otherwise bewildering array of choices open to any human individual. Naturally, to recognize—and especially to *predict*—pattern, design, intention, or purposefulness in the environment is highly adaptive, and to do so effectively this brain function must gain some reliable insight into the inner workings of the assumed agent. Cognitive scientists of religion seem to assume that we discern such purposeful traces from the natural environment. I argue that it is, in fact, as much from skilled human artifice—art, and especially the composite arts of religion—that we discern it. Remember how the monumental art of Göbekli Tepe improved the understanding of agency. It is the reciprocal interaction of skill and the environment that ultimately validates any skill as worthy of attention. The (re)

presentation of interiority is one key means of engaging empathy. One of the main things that draws us to art is the manifestation of a *personality*. Art behavior can establish a powerful mood in the listener, the sense of an individual personality that inevitably entails a suggestion of response. Ethologists of art such as Denis Dutton believe that our intense interest in art derives from the desire to experience and thus gain knowledge of other personalities, so that "talking about art becomes an indirect way of talking about the inner lives of other people" (2009, 235). Brian Boyd agrees: "Storytelling appeals to our social intelligence. It arises out of our intense interest in monitoring one another and out of our evolved capacity to understand one another through theory of mind" (2009, 382). Generalizing from this appreciation of art as a mode of cognition of agency reveals a potential function of religion as a mode of cognition concerning the external environment, or, more accurately, our response to it.

This is, of course, potentially disastrous. Attempting to fathom the structure of external reality from things that we ourselves have made can obviously be seriously misleading. However, as we have seen, there are several safeguards in place. One is always to distinguish between the representation and the thing represented (my interpretation of the second commandment). Another is the homology, assured by evolution, between the external world and the perceiving consciousness. Another is the appetite for authenticity in the arts, which "means at the most profound level communication with another human soul, [and] is something we are destined by evolution to want from literature, music, painting, and the other arts" (Dutton 2009, 193). Finally, however, we are dependent on the subtleties of our own aesthetic sensibility and evolved emotional intelligence to continue to be drawn to the beauty of truth (and the truth of beauty) rather than to the meretricious and false.

This is why icons of Jesus and Hanumān have that common representation of interiority, and why even maṇḍala designs can also induce a sense of agency. Even verbal formulae can suggest interiority: the archetypal verbal form may be seen in the famous Hindu and Buddhist mantra: *Om mane padme hum*, "the jewel is in the lotus." Something of great value, something infinitely desirable, lies within the beautiful. Our sense of perceiving another personality to which we can respond more or less appropriately, is powerfully, but not exclusively, activated by the attribution of interiority to representations of the agent: from St. Theresa's *Interior Castle* of 1577 to the 2014 Christian rock song, "greater is the One living inside of me, than he who is living in the world" ("Greater" by Mercy Me).

Integrating cognitive science, religion, and the ethology of art in this way implies that art objects and events give us a peculiarly strong sense of insight into agency; initially, perhaps, the agency of an originating author or artist but extended to the character or personality of that which is represented and to fictive or hypothetical superhuman[2] agents and thus to the nature of nature itself, the personality of reality. Combining these perspectives, it is natural to use the abilities that allow us to "perceive the mind of the artist" to

apprehend the religious, even mystical, phenomenon of the direct perception of "the spirit world." That is, of God, the devas, the Dao, the sacred, or the transcendent, apprehended as the governing character of the environment to which we must respond. Especially given this tendency to attribute interiority and agency to inanimate objects, the function can easily be generalized to the whole of reality, as in monotheism. By means of "material religion," we apprehend both a predictable character to our own experience and a nature or personality to the environment to which we can respond with greater confidence (at least, as confidently as we can respond to other people). Specific, humanly wrought and experienced objects, acts, and events have only relatively recently come to be identified as "art." Through them, we perceive—or better we apperceive, because this involves more creative and active interpretation rather than any simple "passive perception"—an attribution that is experienced as a perception. Such apperception, because of the assurance, persistence, and consistency it lends to the individual response to the environment, but even more because of the cohesion it lends to the response of any social group that shares the same apperception, constitutes an adaptation in the evolutionary sense. This is manifested in ensuing behavior, again only relatively recently deemed "religious," as if the invisible were visible, as if our imaginative representation of the character of the real were an independent reality, because we *do* perceive it as real—as real as the emotions we "see" before our eyes. We interiorize this perceived personality of external reality by a process of mimesis, the *imitatio dei* or *imitatio Christi*, or by taking Rāma and Sītā, or Hanumanji, into our hearts. It is a natural human propensity to emulate the personality perceived as potent and skilled. The adoration of the Divine is reflected in our admiration of those who most skillfully internalize, emulate, and manifest that divine—the prophets, seers, and sages, the saints and holy men or women of the world's religions. This allows us, as individuals and as cultures, to "harmoniously adjust" to the "unseen order" of the real.

It may seem that, described in this way, this process is most marked and apparent in the Abrahamic traditions in which the singular godhead can be easily seen as the "personality of reality" or the "character of the cosmos." Other, less "personal" religious traditions may seem to militate against this interpretation. What of Confucianism, or the impersonal Dao, or non-theistic forms of philosophical Buddhism? Such a process of attributing interiority is far from being the *only* way of engaging the theory of mind function that brings our emotional intelligence to bear on existential problems—it is crucial to recognize that, as we have seen, any skillfully wrought object or event, any art as the ethologists of art identify it, engages that same function. While the Dao itself might be impersonal, Daoism is a profoundly aesthetic tradition—as, indeed, are all religious traditions—with a full panoply of visual, narrative, aural, and performing arts. Daoist sages are closely associated with art more often than not. Sinologist Tony Swain informs us that early *Ru* (the term recently preferred as more accurate than "Confucians")

were scholars devoted to a particular corpus of texts that were believed to have been written by sages and to have scriptural authority (2017, 6). For them, reading was a sacred art that could bring about a "face-to-face encounter with sages" (32), but they were also closely associated with musical as well as ritual performance (7). Kongzi [Confucius]

> regularly paired ritual (*li*) with music (*yue*) and he was as determined to return to the best in ancient music, that of the virtuous sage kings ([Lun Yu] 9:15, 15:11), as he was to reform the rites. Sublime music had an overwhelming emotional impact on him (7:14, 8:15), and the aesthetic aspect of both music and ritual should never be underestimated. *Li* and *yue* were typically found working together as the music to which he referred was primarily ceremonial performance.
>
> (60 t)

Likewise, Xunzi [Xun Kuang, c. 310–220 BCE] is remembered for having advocated ritual and music—which incorporated rhythm, melody, the words of odes and even historic themes enacted through dance—as the best instruments for shaping people (70).

Even if the Dao is not conceived of in personal terms, the emotional intelligence and theory of mind capacities engaged by the apprehension of such aesthetic acts and objects encourage an intensely subtle and complex apperception of the character of the Dao. Just as we can speak of the character of a road, or a mountain, or a stretch of sea without necessarily attributing intelligence, personhood, or intentionality to it (although, of course, that is precisely what polytheism often did), so we can relate to the Dao as the principal causal agency of reality; we can "read" it and fathom its nature, without attributing person-like status to it. The accuracy of such a reading would be considerably encouraged by the engagement of theory of mind functions occasioned by our interaction with skillfully wrought art. Of course, in these evolutionary terms, "accuracy" means nothing more than our ability to persist with consistent behavior in response to our apperception without compromising our ability to survive and reproduce. Good, just, and even "godly" behavior is that behavior in which we can persist without necessitating constant change and adjustment: it permits "psychobiological homeostasis."

Such an understanding not only gives us a new and potentially enlightening approach to understanding the function of art in religion and gives us some insight into the workings of, and our cognitive responses to, works of art that engage and employ this complex phenomenon. (It also implies some specific critiques of contemporary Western culture.) Individual performances and works of art attract the attention of the audience first by the natural salience of any skilled activity, which automatically engages empathy or theory of mind.[3] They hold that attention by their beauty, which promises a positive reward for continued attention. A complex matrix of interrelated art forms induces an apperception of the character of the real, the personality of reality,

such that it is not attributed to any *human* agency, but is apprehended as revelatory of the "superhuman" truth at best channeled by or inspired in some human medium, but by no means "created" by any one of *us*. Such an apperception could not but manifest itself in the continuing behavior of those who experience it—once experienced one becomes a different person, a person whose attention constantly focuses and refocuses upon the object of devotion.

That to which we most closely attend shapes our apperception of reality, but it is not so much how we see the world that matters as how we *behave* in response to that perception. As we saw in Chapter 8, the attention we pay can change the world we live in. This shift to behavior would be very helpful for scholars of religion, since behavior is observable while the content of perception is not. Furthermore, it provides a parameter whereby the "improvement of cognition" can be understood. One's cognition of the environment is improved when one's behavior in response to it can be sustained and repeated effectively in such a way as to contribute to individual, group, and species survival and to comfort or quality of life, since we are unlikely to achieve homeostasis in any condition that is uncomfortable. Nor can we hope continuously to provoke discomfort in others without necessitating change of some kind. These apperceptions are "true" in a pragmatic sense if they accomplish such improvements. Classifying and ordering the world of one's experience in such a way as to determine a sustainable behavioral response to its implicate order is a highly developed and valuable skill. The entire world of even one individual's personal experience is too complex, even chaotic, for a fully considered and rational response. We must engage our *emotional* intelligence here. Increasingly it has been recognized that "emotion lies at the root of intelligent action in the world" (Mithen 2005, 86). In the constant human need to choose among courses of possible action, our emotional responses guide us in situations of imperfect knowledge and multiple possible outcomes. Thus, the ability to respond with an emotional assurance to the external world as if it were an intentional agent involves the engagement of that highly adaptive ability.[4]

My claim, then, is that apprehending interiority is just one—relatively obvious—means to engage socio/psychological brain functions bringing greater (possibly our greatest) mental resources to bear on behavioral problems—it encourages advancement by mimesis of the superhuman/supernatural—what is known in the Eastern Orthodox tradition as *theosis*.[5] We cease to be anthropoid apes by "aping" the living spirit of the world—the perception of which we have abducted from the world of our experience—and taking it into our hearts. There is a tendency, basal, but not indispensable, to religious behavior, to attribute agency, *anima*, to everything.[6] Humans have evolved to detect and respond to intentional agency with great subtlety and finesse. The cognition of the external world *as if* directed by intentional agency harnesses those sophisticated resources in relation to behavioral problems. What keeps that projection more reliable than the simple free play of an uninformed imagination is *skill*. This skill is expressed in the production of

all art, but especially great art, and in the skill exemplified by what are rightly called the world's wisdom traditions—religion. Great art and great wisdom have the same roots. They create veridical ("truthy") representations of reality that invite and encourage effective, persistent, sustainable responses to the environment. Skill itself can be defined as: "capability of accomplishing something with precision and certainty; practical knowledge in combination with ability; cleverness, expertness" (Concise OED 1782). That is, the ability to do something better, easier, more quickly, perhaps with less effort and certainly with greater effect. Such skill is clearly one of the primary constitutive features of all art and realistically does embody and express principles of nature made known by problem-solving, whether the problems be architectural or those of securing audience attention. (Although the situation is more complex than might at first appear, because various areas of skill are involved: skill, not only of production, but of reception and of conception.) More than the material skill of producing maximum effect with minimum effort, wisdom, the practical skill of religion, unavoidably takes account of the "interior" component of production/behavior and therefore of subjective "quality of life" issues—not just the skills of getting what one wants, of manipulating the environment according to the ability of the agent, but the immensely more subtle skill of wanting the right things, of manipulating the agent (oneself) by accommodating one's own interiority to the apprehended character of the really real so as to adapt most effectively to the environment. This necessarily involves the integration of material and emotional abilities. With this insight as basic, we can accommodate such diverse religious phenomena as the famous prayer of St. Ignatius of Loyola:

> To give and not to count the cost,
> To fight and not to seek for rest,
> To labour and not to seek for any reward,
> Save that of knowing that I do thy will.

and the Tantric Buddhist practice of *sādhana*, in which the practitioner seeks to become a Buddha or Bodhisattva and "important individuals are regarded as emanations of great deities, bodhisattvas, and Cosmic Buddhas acting out an epic drama for the protection and prosperity of the Tibetan nation and its Buddhist religion" (Robinson, Johnson, and Thanissaro 269). In both cases, the skilled practitioner recognizes and internalizes the "will," the personality and character of the apperceived Divine, and subordinates their own will and ego to it, and they do it through exposure to the art of religion.

Given the presence, persistence, and practical function of art in religious traditions it seems unlikely that the importance of art to religion would ever be called into question. Nonetheless, this is precisely what has occurred in several different contexts, most frequently in the monotheist, bibliophile traditions of the west. The various controversies and even wars of iconoclasm appear to be obvious examples. These, however, are more often than not in opposition to

particular representations of the divine—your icons as opposed to our icons—
as in the mutual destruction of divine images and references undertaken by
the Pharaohs of the Amarna period in the 14th century BCE and their suc-
cessors. Or against visual representation of the divine as opposed to literary,
as in the destruction of Hindu temples during the Muslim conquests of India,
or the iconoclasm of the Protestant Reformation. Of more immediate interest
are religiously motivated denials that certain phenomena—performances or
artifacts—that are permitted and encouraged by the tradition are simply *not*
art when, by any other standard, they clearly are. That is, the denial of the
fundamentally artistic nature of religious phenomena and the insistence on a
categorical distinction between art and religion.

One of the best-documented and widely discussed examples of this is the
common Muslim insistence that the sonorous and beautiful recitation of the
Qur'ān is not music. Some Ṣufī brotherhoods, the Naqshbandiyya order, for
example, go so far as to ban all (other) forms of music while practicing the
mellifluous recitation (*tajwīd*) of the Qur'ān, which they insist is not "music."
In his chapter on "Islam and Music" in *The Oxford Handbook of Religion and
the Arts*, Amnon Shiloah tells us "many who insisted on the unlawfulness
of music claimed that the best emotion is that evoked by listening to the
chanting of the Qur'ān" (323), so the chanting of the Qur'ān, even with
elaborate *tajwīd* or cantillation, was not regarded as *ġinā'* or music (323). Yet
Navid Kermani tells us that *tajwīd* is literally to make good or beautiful (141)
so it must be art by the very definition of art as "making special." Still, most
Muslim theologians would, according to Kermani, insist that the Qur'ān is
not poetry and it is not music: "it cannot be, because it must not be" (132).
Kermani recognizes a tension that exists in all religions between the religious
message and musical performance that leads to conflicts between apologists
and critics of an aesthetic communication of the revelation (132). We see
a similar prohibition of secular music among the Reformed Presbyterians
who practice "exclusive psalmody" and will chant the Biblical Psalms while
insisting that this is unlike any other human art. Muslims are usually careful
not to refer to the recitation of the Qur'ān as music (*ġinā* or *mūsīqā*), or to the
reciter (*muqri'*, *qāri'*, or *tālī*) as a singer (*muġannī*). This avoids implying any
equivalence between scripture and songs created by humans. Nonetheless,
theologians encourage a strong melodic component in recitation, not to pop-
ularize recitation, but to achieve the ideal recitation (Kermani 150).

Søren Kierkegaard similarly insisted on the fundamental incomparability
of sacred and profane inspiration. Just like the Muslim who must distinguish
the Qur'ān from music and poetry, it is the ascribed *source* of the inspiration,
the fact that it was Christ who said it, that distinguishes the sacred revelation.
For Kierkegaard, St. Paul cannot be compared to Plato or Shakespeare, to
do so is to reduce his work to "mere" aestheticism. Kierkegaard's perspec-
tive misses the overall impact of Paul's work in its location in the extended
matrix of protention and retention that constitutes the Christian tradition in
which Paul is a greater influence than both Plato and Shakespeare combined.

Kierkegaard protested against the aestheticization of religion and Kermani points out that Nikolaus Ludwig von Zinzendorf (1700–1760), another proponent of Lutheran Pietism, "declared the aesthetic principle per se to be human and therefore absent from holy scripture: 'If something divine is to be in a song, what is humanly beautiful must go out'" (Kermani 186, quoting Zinzendorf). This is characteristic of the drive to isolate human activity from divine inspiration. That upon which we base our apprehension of the personality of reality, the nature of nature, must be more than human. But such a claim denies the ability of the arts ever to express anything that is more than human. If art is understood as proposed, however, this is a fundamental error.

In a fascinating consideration of "The Place of Music in Qur'anic Recitation" Abdurrahman Cetin, Professor of *Ilahiyat* [Theology] at Uludag University in Turkey, concludes that "one cannot be against music, provided that it is performed and used in a positive and *halal* way" (120). Cetin proceeds from the perspective of a Muslim theologian, considering first the Qur'ān itself, then the authoritative traditions of *hadith*, and only finally the considerations of reasoned thought, so long as they are not in opposition to the scriptures. While he recognizes that there is discussion and even conflict over the point, he insists, "it is impossible to separate music from man. What is important is that one should perform it in a *halal* way" (111). This is *halal*, permissible, entirely in keeping with the text of the Qur'ān. The drive to distinguish religious music, and all religious art, as categorically distinct from secular art may itself be misguided, *haram* (not permissible, forbidden), as opposed to *halal*. What is finally halal or haram is not the art itself but the way in which it is performed and the end to which it is used. If it "provokes man to diverge from the straight way of God and blunts his spirit, leading him to sin, fault, and guilt, then it is considered *haram* ... it becomes *halal* or *haram* depending upon how it is performed" (112). Once again, we see the distinction that I proposed earlier between the beautiful and the meretricious. As long as the fascination exerted by the art is finally to the benefit of the audience it is truly beautiful and to be encouraged.

The controversy over the place of music in Islam has the virtue of being open, debated, and (largely) settled in favor of art. There may, however, be a less open and possibly more pernicious suppression of the healthy function of art in other areas. Kierkegaard and von Zinzendorf are far from alone in expressing a categorical distinction between sacred and profane inspiration and vehemently opposing the "aestheticization" of religion. From such a perspective, it is very difficult to see the Christian Gospels as works of literary art. The dramatic post-Reformation emphasis on scripture as the sole medium of revelation, combined with the monotheistic graphomancy developed since the time of the Prophets, exacerbated by this rejection of religion as art, lead almost inexorably to literalism and fundamentalism. The text is presented and accepted as a simple chronicle of historical events and the literal truth. Such a naïve and artless attitude to the text has become the primary identifying characteristic of religious belief, and primary target, of

critics of religion such as the "four horsemen" of the new atheist debate. Richard Dawkins (2006), Christopher Hitchens (2007), Daniel Dennett (1987, 2006), and Sam Harris (2005) are by no means alone in seeing this attitude as unacceptably irrational and potentially dangerous. Both they and the religious devotees who adopt this position, however, seem to have fallen prey to a particularly modern (mis)representation of religion that entirely fails to recognize its close relation to art. This may have been a serious mistake on both sides of the divide between the religious and the secular.

Notes

1　www.youtube.com/watch?v=rRiNIwd9Yao
2　Superhuman only in the sense of being, not "supernatural," but more powerful than ourselves as were, for example, the wild bulls and leopards of Çatalhöyük.
3　Remember that the very concept of "individual works of art" is a hallmark of the modern Western (mis)conception of art as "Gallery Art." The extended matrix of the religious tradition is more fully in keeping with the pre-modern and un-differentiated operations of art behavior and religion behavior.
4　On emotional intelligence as crucial to the effective determination of behavior, see Evans (2001).
5　... or *sādhana* in tantric Buddhism, *Mokṣa* in Hinduism, achieving immortality (*xian*) in Daoism, more humbly perhaps (although not according to Confucius) becoming a Chun Tzu/junzi.
6　This sheds some light on the debate between E. B. Tyler and Andrew Lang concerning animism and religious evolution: Tyler may have been more correct than was allowed at the time—the mistake that he made was to reason as if it were *religion*, not humanity, which evolves. That is, religion has not "evolved" from animism to monotheism as Tyler suggested, rather humans have evolved to perceive agency and personality in the environment and this has resulted in traditions from animism to monotheism.

References

Bambrough, Renford. "Intuition and the Inexpressible." In *Mysticism and Philosophical Analysis*, edited by Steven T. Katz, 200–213. London: Sheldon Press, 1978.

Barrett, Justin. *Why Would Anyone Believe in God?* Walnut Creek, CA: Altamira Press, 2004.

Boyd, Brian. *On the Origin of Stories: Evolution, Cognition, and Fiction.* Cambridge, MA: Belknap Press of Harvard University Press, 2009.

Cetin, Abdurrahman. "The Place of Music in Qur'anic Recitation." *American Journal of Islamic Social Sciences* 16, no. 1 (1999): 111–122.

Dawkins, Richard. *The God Delusion.* New York: Houghton Mifflin, 2006.

Dennett, Daniel. *Brainstorms: Philosophical Essays on Mind and Psychology.* Cambridge, MA: MIT Press, 1979.

Dennett, Daniel. *The Intentional Stance.* Cambridge, MA: MIT Press, 1987.

Dennett, Daniel. *Breaking the Spell.* New York: Viking, 2006.

Dutton, Denis. *The Art Instinct: Beauty, Pleasure, and Human Evolution.* New York, Berlin, and London: Bloomsbury Press, 2009.

Evans, Dylan. *Emotions: The Science of Sentiment*. Oxford, UK: Oxford University Press, 2001.

Gell, Alfred. *Art and Agency: An Anthropological Theory*. Oxford, UK: Oxford University Press, 1998.

Harris, Sam. *The End of Faith*. New York: W. W. Norton, 2005.

Hitchens, Christopher. *God is Not Great*. New York: 12, Hachette Book Group, 2007.

Hofstadter, Douglas and Daniel Dennett. *The Mind's I: Fantasies and Reflections on Self and Soul*. New York: Basic Books, 1982.

Kermani, Navid. *God is Beautiful: The Aesthetic Experience of the Quran*. Cambridge, UK: Polity Press, 2015.

Kierkegaard, Søren. *Of the Difference between a Genius and an Apostle*. Translated by Alexander Dru. New York: Harper Torchbooks, 1940.

Mithen, Steven J. *The Singing Neanderthals: The Origins of Music, Language, Mind, and Body*. London: Weidenfeld and Nicholson, 2005.

Robinson, Richard H., Willard L. Johnson, and Thaissaro Bhikkhu. *Buddhist Religions: A Historical Introduction*. Belmont, CA: Wadsworth, 2005.

Shiloah, Amnon. "Islam and Music." In *The Oxford Handbook of Religion and the Arts*, edited by Frank Burch Brown, 321–326. Oxford, UK and New York: Oxford University Press, 2014.

Swain, Tony. *Confucianism in China: An Introduction*. London: Bloomsbury Academic, 2017.

13 Where is the religion we have lost in art?

> The gestures we make when holding pictures we admire (not only masterpieces) are those befitting precious objects; but also, let us not forget, objects claiming veneration. … the art museum is by way of becoming a sort of shrine, the only one of the modern age; the man who looks at an Annunciation in the National Gallery of Washington is moved by it no less profoundly than the man who sees it in an Italian church. True, a Braque still-life is not a sacred object; nevertheless, … it, too, belongs to another world and it is hallowed by its association with a vague deity known as Art …. In this context the religious vocabulary may jar on us; but unhappily we have no other.
>
> (André Malraux, *The Voices of Silence*, 600)

If we concentrate too intensely on that which is more than human, on unknown but potential future benefits, on the elevation of humanity above its current status, on the sense of rectitude, and on the perceived personality of reality, that is, on the religious in the arts, we are inclined to lose sight of the operation of the art in religious behavior. By the same token, if we concentrate too intensely on art there is a tendency to lose sight of what is religious in art behavior and to elevate art over religion. Evolutionary ethology of religion could reintegrate the insights of both art and religion. Focusing on the behavior that is ancestral to both art and religion, which can be seen in both art behavior and in religious behavior, brings valuable new insights to both fields.

Between 2014 and 2015, two books appeared, *A History of Religion in 5½ Objects: Bringing the Spiritual to its Senses* by S. Brent Plate and *Envisioning Howard Finster: The Religion and Art of a Stranger from Another World* by Norman Girardot. Both of these books are significant for this thesis in several ways—obviously, because they concern religion and art—but for other, more specific reasons as well. I warned at the outset of this volume that the work at hand would remain irreducibly creative and imaginative. That is, that I agree with Brian Boyd that a "biocultural" approach to human behavioral phenomena, even if that approach is based in ethology and evolutionary theory, is informed by science, but "does not limit itself to scientific reduction, since art by its nature invites a creative and original response, to some degree

subjective and open-ended, an aura of implication rather than an exact of transfer information" (Boyd 2009, 390). On the other hand, I do wish to avoid going too far in the other direction. In art, there is a common tendency to "fight fire with fire" and to respond to the ineffable power of art with more art—that is, with creative, tropological language that suggests more than it says. This is a strength and a weakness of discourse in both art and religion—the mystical, particularly, employs it to great effect. Such suggestive, poetic language can invoke a powerful sensation of the character of the sacred, but it fails to engage robustly with the task of *explanation*, which I hope at least to begin.

Plate is a leading proponent of the study of religion as material culture, and his earlier anthology, *Religion, Art and Visual Culture: A Cross-Cultural Reader* (2002) has been regarded as an essential collection of contributions to that study. However, "visual culture" alone is inadequate as a category to fully account for the "material culture" of religion. We can replace "material culture" with the more general, and more adequate, "art," as proposed by the ethologists of art. This art is obviously more than visual, and Plate recognizes as much in his later *5½ Objects*. This book is named for the five senses, plus the "half object," the incomplete human as the desiring self—a subject needing an object. Plate calls this self the soul (215–224), and sees it as a product of the encounter between the subjective and objective realms of experience, mediated by the body in its interaction with objects. In this case, its interactions with stones, incense, drums, crosses, and bread, respectively representing the senses of touch, smell, hearing, sight, and taste, and exemplifying the personal encounter with the sacred.

Such an approach goes far in correcting the common misconception that religion is primarily centered in belief—making verbal behavior primary—and in re-centering religion in the body—in all experience and behavior. Plate suggests that "we imagine religious histories as histories of *technology*" (21) and thus that the religious devotee is not so much a "believer" as a "technologist" who can experience both natural and artifactual objects as wellsprings of faith. He demonstrates that physical experience is the stuff from which religion is made, correcting explanations of religion that see material expressions as secondary to verbal expressions. "There is no thinking without first sensing, no minds without their entanglement in bodies," Plate argues. Religion "is rooted in the body and in its sensual relations with the world. It always has been and it always will be" (7).

I agree with almost all that Plate has to say and without his having said it, I would not have been so encouraged to go further, but I am concerned that we avoid inducing any attitude that avoids the remaining explanatory task as impossible or counterproductive. For Plate "the parallels between artists and shamans, poets and priests" is the underlying aspect of his work (8) and we need to make some progress in *explaining* that parallel. His argument is, in a nutshell, "that religious history is incomplete if it ignores the sensing body and the seemingly trivial things it confronts." On the contrary, "religion

must be understood as deriving from rudimentary human experiences, from lived, embodied practices" and because of this, poets and visual artists "have as much to teach us about the history of religion as the philosophers and theologians" (14, 15, 18). So far, I am in emphatic agreement. We must embrace the sensual and the bodily, and we have much to learn from artists. But when Plate continues, "… actually, more so" (18), I must demur. Going down the primrose path that elevates the artist *over* the scholar, and art over religion, one is unsurprised to encounter sentiments like: "We have to divest ourselves of the idea that we can get to know something about a tradition by reading their sacred texts" (20–21). Of course we can get to know *something* about a tradition by reading sacred texts! The ideas of which we must divest ourselves is that we can get to know *everything* that way and that the literary arts are fundamentally different from all other arts. As we have seen, Plate "suggest[s] we imagine religious histories as histories of *technology*" (21), and I applaud, but counsel caution. We must not forget that the production and interpretation of texts is a particularly potent technology in its own write.[1]

It is predictable and acceptable that art appreciation is other than art, and also that the analysis of art and religion is other than science. In fact, it is crucial that we avoid the unwarranted certainties of modernist scientism—and worse, pseudoscience—and the entirely fallacious claim that the only way to generate new knowledge is by methodical scientific procedure in the sense of the physical sciences.[2] Nonetheless, the generation of new knowledge does require more than the solely suggestive, either-you-get-it-or-you-don't— (and, of course, *I* get it!) elitism of much discourse around "the art world." Plate hints at what I believe to be the right direction with his occasional use of scientific data and references to neuroscience (for example, 63, 118, 173). In the case of incense, he collects an impressive array of evidence and adds that

> olfactory nerves head straight for the limbic system and directly trigger the amygdala, a small region in the medial temporal lobes of the brain … Here memories are processed and emotions are born. Smell touches our species' deep desires and fears.
>
> (63)

The point is that the frequent connection of smell with holiness (78) has a neurological basis. Plate's further insight that "soul … is a technology" (22) is a profoundly important one that deserves to be developed. "Soul," apparently, depends on skill.

Finally, the question that Plate asks, is "why certain objects and ideas stick and others don't" and it deserves more than the observation that "we seem to be wired this way" (173).[3] We must begin to *account* for the selective retention of artifacts, of practices, and of visions and encourage more analytic, more scientific or at least more *wissenschaftliche*, descriptions.

Norman Girardot is a professor of Chinese religion (now *emeritus*). He has also been organizer and curator of a series of symposia and exhibitions

featuring "outsider" and folk art, especially religious folk art. These have included "Mr. Imagination," Gregory Warmack (1948–2012), an American outsider artist with no formal training as an artist, who nonetheless produced and sold "street art" from his youth. Warmack was shot in a mugging and had some kind of religious experience while in a coma, after which he became even more productive and adopted the name Mr. Imagination. He has exhibited at many galleries, including the American Visionary Art Museum in Baltimore, and has pieces in the Smithsonian. Girardot also curated several exhibitions of works by Howard Finster (1916–2001), another untrained outsider artist. Finster was a Baptist minister who was inspired to transform his two-and-a-half acre yard into "Paradise Garden," filled with *"objets trouvés,"* or "readymades"—found articles transformed into art—and with "primitive" pieces, paintings, and placards often, but not always, densely packed with Biblical references and religious exhortations. "I built this park of broken pieces to try to mend a broken world of people who are travelling their last road" (see Girardot, Figure 13.1, 120, *I am Howard Finster a Stranger from Another World*). Finster also enjoyed some measure of success and appeared on the *Tonight* show with Johnny Carson in 1983.

Although Girardot certainly gives free reign to the arch and the poetic in his writing, he maintains a rational focus on "the variability of human consciousness" (*xiv*) and insists that the pertinent question regards "what exactly is normal, or everyday, consciousness" (*xiv*).[4] He points out that "visionary artists revive, reshape, and recycle the ordinary world by giving themselves and all of us access to other, more vibrant alternative realms" (*xv*). In his discussion of myth (97–107) Girardot combines the history-of-religion understanding of myth with the function of art:

> as the infrastructure of a cultural worldview, myth in modern civilizational cultures is often invisible and taken for granted. The issue is not one of scientific or literal truth but the more implicit human, cultural, symbolic, and emotional truth communicated by certain kinds of imaginative narratives and theatrical performances. Simply put, it has to do with why a novel by Jane Austen, or a play by Tom Stoppard, often says more that is truthful about the human condition than any best-selling college textbook.
>
> (97)

This is what we must *explain*, and Girardot begins to do so:

> It is this response—a negotiation of the artist, object or story, and audience—that creates or mediates meaning. Meaning is not an intrinsic property but the variably perceived or interpreted content of a sign— the very ability to experience and respond to something or anything as significant.
>
> (99–100)

He is well aware that an understanding of the narrative and artistic significance of myth "is supported by recent work in evolutionary psychology and cognitive science ... the crucial evolutionary importance of the imagination in the adaptive emergence and development of human nature and culture" (100).

These are the advances that the work of Plate and Girardot invite—the data of evolutionary psychology, cognitive science, neurology, and the ethological study of behavior, hold increasing promise of contributing to an effective analysis of art/religion phenomena. Girardot says, "Finster's approach to religion and art is remarkably suggestive of recent discoveries about the evolutionary and adaptive significance of the narrative craft of myth and the performative templates of ritual" (107). These have revealed that "the human creative ability to narratively imagine, express, and focus attention on 'as if' or fictive scenarios of possible future outcomes" (109) have been effective in the struggle for survival and "visionary art ranging from Paleolithic cave paintings to the work of ... Howard Finster, documents that visual inspiration is often connected with altered, ecstatic, trancelike, or broadly shamanistic states of symbolic or creative consciousness" (136).

Girardot's contention is that *all* "states of consciousness" are "visions." Normal everyday consciousness is just the most common, most often shared, vision (in our experience). Without such a shared vision, we cannot function. Like all visions, it is ultimately unreal, and alternate, trickster visions are constantly required to deal with that unreality, with its potential flaws, and implicit dangers. The purpose of such visions is pragmatic: the ability to persist, which requires a sense of assurance, and the ability to sustain that persistence without fatal effects. Such visions are required because no representation is the thing represented, and our consciousness of "reality" itself is always a representation.

Consciousness of anything can tell us something about everything, because everything of which we are conscious is a product of consciousness interacting with the external world. Plate's work is a convincing example of the way that "ordinary things become extraordinary in religious experience" (5) and Girardot's exhortation "to see and feel the incarnational presence of God in every aspect of the created world" (13) is a similar recognition of the ubiquity of potential hierophany. The question is, how and why does anything specific *realize* that potential? Plate explains that his sacred stones "are humanly *used* pieces of rock" (39 emphasis added). That is, that some *skill* is always involved. "The difference lies in technology, ... A stone axe and a stone monolith ... are products of technology ... The Stone does not even need to be physically altered, simply put to use in some humanly meaningful, creative way" (40). Whether it is through alteration or application, the relative skill of utilization will be manifest either way. All matter is potentially hierophanic but it requires skill to become conscious of that potential. Not a specific "skill of sacralization," but *any* skill—from baking bread to standing *en pointe*. Anything from unworked rock to highly worked bread (as Plate), but especially visionary art (as Girardot), brings out the hierophany latent in all things by

persuading our consciousness to attend intently to it and to associate it with other experiences of sacrality. The specific *intensity of consciousness* constitutes the hierophany—and thus the tracks of the "common ancestor" of art and religion are thrown into relief.

The demonstration of "the parallels between artists and shamans, poets and priests" given by Plate and Girardot (among others) corroborates, or at least is coherent with, my analysis of religion and art behavior. Using the evolutionary tools of ethology and cognition, we can begin more precisely to identify the common ancestor of these behaviors. Any fear that this might "demystify" or "disenchant" art or religion is reminiscent of critics of Newton who thought his prismatics could take the magic out of the rainbow. It can't because the magic is real.[5] Scholars like Boyd, Dissanayake, and Dutton have made great strides in applying such approaches to the analysis and understanding of art and to explaining how and why art behavior evolved as an adaptive response to our environment. The adaptation of their work to religion is very much encouraged by Plate's and Girardot's observations. The bodily ability to exercise skill of varying degrees—getting things just right, from baking bread to pounding percussion to interpreting texts—proves the vision, as bread is proofed. "It is probed, tried, tested, and tasted as it is created" (Plate 203). That is, we "taste" it and test it by paying close attention, attempting to cultivate and preserve it. How do we, most reliably, with the least effort, most predictably, produce that sharp edge, that magical loaf, that entrancing rhythm, that transcendentally true narrative? That vision is true and that behavior will be perpetuated. Now we can propose a greater elucidation of an answer to the question of the relationship of art and religion, and a solution to the puzzle of "seeing the unseen." The sensual perception of a constellation of skillfully wrought acts and artifacts induces and empowers a consciousness that is assured that it knows better—enough to act confidently and persistently—what is really going on, what it means to be really real. That involves consciousness of answers to the questions, what is the pattern, what are the rules, of the unperceived determinants of events? And what is the appropriate behavior in response?

As Girardot says,

> visionary visitations to other planets, and their artistic expression in word and image, seem primarily related to how the human engagement with—experience, perception, and understand of—the world is always mediated, conditioned, or filtered by the creative or mythic imagination. Visionary experience and art is in this way mostly a fabulation, a "seeing" of our visionary voyage among the multiple worlds of meaning It is because of these vividly imagined, and often celestial, other worlds visited by, reported on, and visually depicted by specially gifted religious and artistic travelers that we are able to live in, and go bravely forward in, the temporal flux, material conditions, cultural matrix, and gravid bodily forms given to us. ... The simple truth is that, finally, all human worlds

are made from the dreamy utopian miasma of the visionary imagination. All our worlds, even the most mundane, were once quite fantastic and unreal—at that moment of creation when the bloody umbilical cord of the imagination was still uncut.

(149, 166)

Why does one world become *the* world? Because, like Finster being "strong and happy" because of his celestial visions (again, Girardot, Figure 13.1, 120, *I am Howard Finster a Stranger from Another World*), the vision that provides such assurance persists. We cherish the skills that help us to persist with (divine) assurance in ways that are not all-too-human and self-destructive. There is

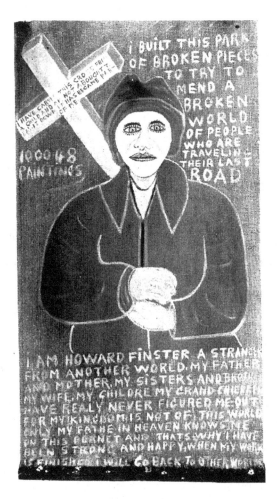

Figure 13.1 I am Howard Finster a Stranger from Another World by Howard Finster (1978). Enamel paint on burlap, 44.5 x 24.5 inches. Artwork no. 1048. John F. Turner Collection © Photograph by M. Lee Fatherree.

always a better way to see the world and, maybe, in Girardot's words, "with the prophetic inspiration of some new stranger from yet another world showing the way, we all may share in the sacred task of caring for this garden planet and for each other" (206).

Dutton gives voice to the common distinction made between religion and art on the grounds that "religion by its very nature makes grand claims about morality, ... [whereas] works of art seldom make overt assertions of fact or instruct people on how they must behave" (10). Based on that distinction he assumed that it follows necessarily that "explaining religion in terms of an evolutionary source attacks religion at its core" (10). Boyd, on the other hand, argued that "creativity ultimately benefits us in producing a wide array of behavioral options, some of which will survive better than others under unpredictable selection pressures" (Boyd 382). My point here is that "providing an array of behavioral options ... which will survive" and "instructing people on how they must behave" are ethologically indistinguishable. When Finster tells us how to be "strong and happy" by "mending a broken world," is this not art instructing us on how we must behave in order to be happy?

Perhaps one might respond that, no, that is not art but religion, precisely because it instructs us so. After all, there is a crucifix in the work from which this is drawn. So this is religion. But listen to Bob Dylan (a performing prophet if ever there was one) in "The Lonesome Death of Hattie Carroll,"[6]

> In the courtroom of honor, the judge pounded his gavel
> To show that all's equal and that the courts are on the level
> And that the strings in the books ain't pulled and persuaded
> And that even the nobles get properly handled
> Once that the cops have chased after and caught 'em
> And that the ladder of law has no top and no bottom
> Stared at the person who killed for no reason
> Who just happened to be feelin' that way without warnin'
> And he spoke through his cloak, most deep and distinguished
> And handed out strongly, for penalty and repentance
> William Zanzinger with a six-month sentence
> Oh, but you who philosophize disgrace and criticize all fears
> Bury the rag deep in your face
> For now is the time for your tears.
>
> (Dylan 1985, 103)

This may not give any specific instructions on what to do, but it certainly tells us how to feel, and it lets us know how we *ought* to behave. Even if the case were not historically accurate, the moral imperative is clear.

When the English artist, David Hockney (b. 1937) painted "We Two Boys Together Clinging" (1961) or "Peter Getting Out of Nick's Pool" (1966), was he not also making a moral statement about the status of gay rights? When the

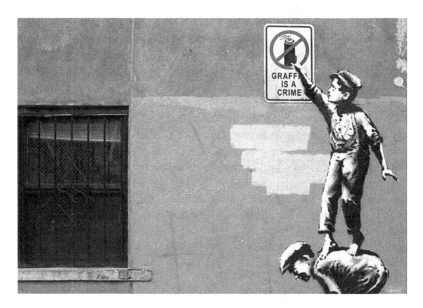

Figure 13.2 The Street Is in Play by Banksy (2013—Chinatown, New York). Used with permission of the artist.[7]

graffiti artist known only as Banksy did his 31-day "residency" in New York City in 2013, including "The Street is in Play," and "Sirens of the Lambs" was he not exhorting us to a greater concern for art in the streets and for animal rights? Even J. K. Rowling's *Harry Potter* novels have a powerful moral component.

My point here is once again not to "collapse art into religion … or religion into art" (DeConcini 1991, 323) for I continue to insist that they are, now, distinct. My point is that it is not the moral or practical function of art that distinguishes it from religion, but the nature and extent of the matrix in which it is located as a stylistically related piece. Had Dylan's song invoked the Lord, as many of them do, it might be said to be religious. But it does not. Had Hockney's paintings shown Greek gods, or Banksy's art included a Buddhist *cakra*, or Rowling's books uniquely invoked Wiccan deities, they might have been identified as religious. But they do not. They remain art. As Plate's invocation of stones, incense, drums, crosses, and bread shows, anything that is skillfully altered or applied can invoke the intensity of consciousness that in turn promotes the sense of a normative response. As Girardot's invocation of Finster shows, the work of the visionary artist can give us a vision of a better world, a way of seeing the world better.

All matter is potentially hierophanic but it requires the apperception of skilled agency to bring it out, any skill from composing verse to solving a Rubik cube. Anything from unworked rock to highly worked light, but

especially art, brings out the hierophany potential in all things when our consciousness attends to them in a certain fashion. The only characteristic that anything requires to be hierophanic is existence. Existence is the possibility that we might become conscious of it. It is the specific mode of consciousness that constitutes the hierophany. Instances of extreme visionary art like Finster demonstrate the consanguinity of art and religion by the "shamanistic" character of their behavior where art and religion come together (as with the prophets). This reveals the "common ancestor" of art and religion. Once revealed, that common ancestor can be analyzed, beginning with the evolutionary tools of ethology and cognitive science.

Of bread and bread-making, Plate can argue, "for probably there is no chiropractic treatment, no Yoga exercise, no hour of meditation in a music-throbbing chapel, that will leave you emptier of bad thoughts than this homely ceremony of making bread" (205). What more perfectly skillful task can there be then the ineffable processes of producing the perfect home-made loaf? "Breadmaking, like ritual making, is born of the body" (206). True, but it is the bodily ability to body forth skill of varying degrees—getting things just right—that provides the guide that we all seek and we all follow. Bread "becomes a powerful tool to carry us across great reaches of continents and cultures, inventions and ideologies. All of which is not unlike the objects and activities of religious tradition" (212). This is true of all human skills—artistic, technical, scientific, social. The question is why and how? And now we can propose at least the beginnings of an answer: out of sensually perceived acts and objects of skill we can construct a consciousness of skilled agency such that we feel assured that we actually know (within limits—but enough to function confidently and skillfully) what is going on and what is the appropriate basis for our behavior.

Like Howard Finster being strong and happy because of his celestial visions, we should all become more assured and persistent because of our visions of reality. Myth and ritual are forms of therapy in which it is allowed that we are all, always already, hallucinating, but these hallucinations can be worked by human creativity into those that help us to persist with divine assurance in ways there are not self-destructive. There is always a better way to see the world and, maybe, with the help of art and artists, we can see the world better.

Notes

1 Pardon the pun—which I appropriated from John Lennon ... *in His Own Write* (Lennon, 1964).
2 It is regrettable that the use of the word "science" in the English language has almost entirely lost its reference to *Geisteswissenschaft*, the humanities or interpretive science, as distinct from *Naturwissenschaft*, physical or explanatory science.
3 Harvey Whitehouse, among others, has addressed this question directly in *Modes of Religiosity: A Cognitive Theory of Religious Transmission*—but the division into imagistic and doctrinal modes based on episodic and semantic memory functions, coupled with the tendency to recall "minimally counter-intuitive ideas,"

does not appear to fully explain the transmission of specific religious tropes—it just does not, well … stick.

4 On alternative modes of consciousness, see also David Lewis-Williams (2002, 121–126).

5 The on-going demonization of Mircea Eliade is largely conducted by modernists who seem terrified that the magic *is* real. That is, that his vision might reveal that religion and the sacred really *do* have something of value to offer of which the modern mind has lost sight. Loss of sight and recovering from blindness is a recurrent visionary theme.

6 Hattie Carroll was an African American barmaid, who, in Baltimore in 1963, died as a direct result of a blow from a cane by a drunken, wealthy, white, to-bacco farmer, who was subsequently given a six-month sentence. Copyright © 1964, 1966 by Warner Bros. Inc.; renewed 1992, 1994 by Special Rider Music. All rights reserved. International copyright secured. Reprinted by permission.

7 Banksy is quoted by BBC world news as saying, "I still encourage anyone to copy, borrow, steal and amend my art for amusement, academic research or activism. I just don't want them to get sole custody of my name" (www.bbc.com/news/uk-england-london-49895129).

References

Boyd, Brian. *On the Origin of Stories: Evolution, Cognition, and Fiction.* Cambridge, MA: Belknap Press of Harvard University Press, 2009.

DeConcini, Barbara. "The Crisis of Meaning in Religion and Art." *The Christian Century* 108, no. 10 March 20–27 (1991): 223–326.

Dylan, Bob. *Lyrics, 1962 – 1985 by Bob Dylan.* New York: Alfred A. Knopf, Inc., 1985.

Girardot, Norman J. *Envisioning Howard Finster: The Religion and Art of a Stranger from Another World.* Oakland: University of California Press, 2015.

Lennon, John. *In His Own Write.* London: Jonathan Cape, 1964.

Lewis-Williams, D. *The Mind in the Cave: Consciousness and the Origins of Art.* London: Thames and Hudson, 2002.

Malraux, André. *The Voices of Silence.* Translated by Stuart Gilbert. Garden City, NY: Doubleday, 1953.

Plate, S. Brent. *Religion, Art, and Visual Culture: A Cross-Cultural Reader.* New York: Palgrave Macmillan, 2002.

Plate, S. Brent. *A History of Religion in 5½ Objects: Bringing the Spiritual to its Senses.* Boston, MA: Beacon Press, 2014.

14 Conclusion

Representation as response to the really real

> There was no sweet sleep for Zeus, though the other gods and the warriors, those lords of the chariot, slept all night long, since he was wondering how to honor Achilles and bring death to the Achaeans beside their ships. And the plan he thought seemed best was to send a false dream to Agamemnon. So he spoke, summoning one with his winged words: "Go, evil dream, to the Achaean long-ships, and when you reach Agamemnon's hut speak exactly as I wish. ... And Rumor, Zeus' messenger, drove them on like wildfire, till all were gathered."
>
> (Homer, *Iliad*, Book II)

The problem with which this work began was the lack of clarity in the relationship of art and religion: there is no doubt that they *are* related, but precisely *how*? I have proposed that the relationship can be much better understood and more clearly, completely, and accurately described if an ethological approach is adopted and both religion and art are considered accordingly as universal human behaviors—"universal" initially in the sense that they are found in all known societies and, at least potentially, in all individuals. Such an approach more or less requires that the behavior in question must have been adaptive in order to have been selected for in humanity's evolutionary development. Undoubtedly, this question remains open, with many cognitive scientists of religion arguing that religious behavior is at best a "spandrel," at worst parasitic upon genuinely adaptive behaviors. In describing the close relation of art and religion and in considering some small part of the history of religions I believe that I have given a clearer sense of the way in which religious behavior may have been adaptive in our Pleistocene past and could continue to be so if it does not succumb to its inherent weakness, idolatry. The temptation to treat the representation as if it were the thing represented can be seen to have brought us to our present, perilous religious situation. Understood this way, all religion is grounded in representation, and all representation is a *response* to the really real. It is not the really real itself. The warning of the second commandment with which I began must be reiterated. Religion is a set of behavioral responses including representations of reality in reaction to that

which is experienced as most compelling and salient. The eternal temptation to confuse our representations for reality itself must always be resisted.

The behavioral tendency ancestral to both "art" and "religion" is to make things special and to make special things. "Special" here means fascinating and salient because of the cognition of an apperceived promise to repay that fascination. Fascination can be valuable in that it induces behavioral modifications that are individually and collectively beneficial. This is a tendency upon which the environment can act and genes can transmit. It has proven adaptive because it ensures our fascination with and attention to things including acts and products of human skill that can be cultivated, perpetuated, and communicated so as to reveal the nature of skilled agency. It involves cognitive mechanisms, possibly evolved to assist in interactions with conspecifics but applicable to the wider environment, which involve the attribution of hidden or potential factors and of agency, including possibly "internal" states, to the entities with which we interact. These mechanisms are just as useful in dealing with the non-human and similar attributions are made to human and to non-human entities. The evolutionary benefit, including but not limited to the recognition, retention, acquisition, and transmission of useful skills is, at its most general, the ability to cognize what is especially skillful, that is, what will repay our attention so that we might become more skillful ourselves. The external behavior of persistent attention and sustainable activity correlates with an internal sensation of contentment with the cognition that one is "doing the right thing," that is, responding to the present dominant agency (which may be apprehended as human-like but is other than human) in the correct fashion.

The cognition of skill necessarily involves the ascription of agency and when "special" agency is ascribed to non-human entities, we have the chance, not only to gain greater understanding of what effective agency is, but also to apply emotional intelligence to the challenges of normative behavior. Specific benefits may be in the development of new manipulative skills or successful mating behavior, but more generally benefit lies in the cognition of any potentially sustainable behavior, accompanied by inner contentment. Persistence in behavior allows the achievement of more complex, long-term goals. Contentment in attitude allows altruism and resilience, recognized in religious traditions as "wisdom." This behavior is ancestral to both religion and art. The initial process of making and paying attention to special things encourages novel behavioral responses to the environment. When a significant number of special things are related in a *gestalt*, the complex pattern of behavior produced tends to be highly conservative and profoundly persistent: religion behavior as distinct from art behavior.

Religion, thus understood, is a genetically determined behavior-producing engine driven by the "persuasion devices" of art. By focusing attention upon material artifacts and empirical experiences, it produces persistent and repetitive behavior in the direction of increasing species fitness. Sometimes it works well and produces wisdom. Sometimes it produces nothing but

vacuous yet persistent ritual and ceremonial, which may even subvert its supposed benefits ("I hate, I despise your feasts ..." Amos 5:21). "Religion" promotes persistence where "art" promotes creativity, and their "common ancestor" produced them both. As an adaptation, it only had to be slightly more effective than self-destructive in order to be selected for and to become ubiquitous. The possibility of empirical research into religious behavior is encouraged by such an understanding. We need to understand what neurological and cognitive mechanisms are at work when we are fascinated by and attracted to the special objects and events of art. Persistence and confident assurance are adaptive rather than maladaptive behaviors and they can be clinically observed. We need to understand more precisely how art objects in a matrix contribute to such behavior (and to mate selection). The cladistics of art and religion implies that related behaviors such as sport and play must also be considered as consanguineous—descendants from a common ancestor. Such an understanding may open possibilities of clinical research, but it must never be forgotten that, in order to gain an improved understanding of the behemoth in the mist that is religious behavior, we need the parallax that can only be gained from multiple perspectives. That is, it is imperative that the scientific approach to the cognitive science of religion be supplemented and complemented by the creative and open-ended approach that is itself the operation of art behavior.

Even the question of the adaptive value of art behavior is far from settled. In a recent entry in an *Encyclopedia of Evolutionary Psychological Science* (Scalise Sugiyama 2019, no page numbers), Michelle Scalise Sugiyama points out that "opinion is divided over whether these activities are adaptations or by-products." She concludes that

> strong congruencies between animal signals and art behaviors suggest that the latter are most parsimoniously explained as the result of complex interactions between evolved perceptual biases and adaptations for innovation, communication, symbolic behavior, and manipulation of the physical and social environment.

However, in the process she points out that art behaviors emerged in a hunting-and-gathering context. They are not an outgrowth of "civilization" but pre-dated it and so are "species-typical." Such behaviors impose considerable time and energy costs yet appear to yield no fitness benefits. They are highly varied but do share certain characteristics, the most obvious being that they arouse attention and emotion, and are the product of agency, thus ruling out sunsets and rainbows as *objets d'art*. This, however, neglects the contention that agency is an attribution and, without the modern understanding of animacy, biology, humanity, and intentionality, there is no effective difference between the *apprehension* of agency and "real" or intentional agency. Responding to dreams and rumors as if they were agents as Homer does in Book Two of the *Iliad*, for example, or speaking of Aphrodite as the agent

responsible for amorous entanglements, may not be scientifically accurate, but if it encourages the development of skill in dealing with such phenomena, it is not *wrong*.

According to Scalise Sugiyama, the characteristics of art suggest that animal signaling and human art behavior are analogous, that is, traits designed to influence the behavior of other agents via their sense organs. They are behaviors intended to modify subsequent behaviors. Art behavior specifically leans on perceptual biases that help us make sense of the chaos of sights, sounds, textures, and scents with which we are confronted. Symmetry, self-propelled movement, and the presence of eyes are all important indices provoking the attribution of agency. Such perceptual biases did not themselves evolve in order to produce or appreciate art. This does not settle the question of whether, like animal signals, art behaviors are evolved traits, but it leaves open the possibility that they could be adaptations. Scalise Sugiyama points out that it does not shed light on what the adaptive function of art behavior might be, if it has one. It is my contention that, unless the "religious," that is, the compound and conservative, role of art behaviors is considered that function cannot be fully assessed.

Art behaviors are used for diverse purposes rather than dedicated to any single function and the use of art behaviors for so many different purposes challenges the claim that they are adaptations and makes it difficult to determine which application came first. Scalise Sugiyama rightly draws attention to the fact that, lacking the keen senses and anatomical advantages that other animals possess, humans depend for their survival on *improvisational intelligence*. That is, on a highly developed capacity for inventing new ways of doing things. My suggestion has been that, as an adaptation, art behavior has helped us to identify what new behaviors were most promising, that is, most likely to reward the investment of the effort and attention they arouse. That is, art behavior directly contributes to the effective functioning of improvisational intelligence, promoting innovation. Religious behavior, as a composite of the same functions, prevents improvisation and innovation from being overly rapid, superficial, and potentially damaging. This is, of course, a very different understanding of religion from both the common, secular idea that religion is fundamentally a matter of unwarranted false belief, and the tradition–specific understanding that any one tradition is the only accurate representation of the real.

I have already considered the apparently paradoxical nature of this dynamic in producing change in the service of stability. A few more words of clarification on that matter will be salutary. "As noted at Çatalhöyük, religion was a pervasive and important component of all social and economic life, both productive of change and at times producing constraint" (Hodder 2014, 21). The social focus on wild bulls and ancestors at Çatalhöyük produced changes that worked well for a long time. "It allowed resilience and flexibility in a society based on a diversity of resources" (3), but around 6,500 BCE, this system became restrictive and constraining, *preventing* change (18). Maurice

Bloch, who denied the operation of religion at Çatalhöyük in the earlier (2010) volume, states that human societies

> are built on representations of their continuity in time that transcend the moment. Such representation is to a certain extent counterintuitive in that the empirical appearance of human beings and their interaction is continual movement, incessant change and modification. The representation of the social as permanent therefore requires a cognitive feat of imagination.
>
> (Bloch 2010, 156)

He considers the transcendental as that which seems "to negate the empirical flux of life" (157), made manifest through an act of the creative imagination and he recognizes that "an obvious question about this transcendental imagination is how it is that it can be given phenomenological reality" (157). It is given phenomenological reality through art. It is manifest in behavior in response to art as representing the really real. The "transcendental" is that which negates the empirical flux of life in the sense of providing clues as to how to use that (profane/meaningless) flux for (sacred/meaningful) improvement. Clues as to how to listen to and decipher "the voice of the gods" or potent non-human agencies in the environment. To that extent we must recognize "Culturally Posited Supernatural Agents" as really real (but not "supernatural"). Since they have real effects, they can only be real causes. In the case of Çatalhöyük, behavior as if the houses were eternal and the flux of life transitory; as if the mundane (profane/meaningless) were distinctly subordinate to the transcendent (sacred/meaningful); as if that which cannot be seen were more significant than that which can. Persistent behavior was thus induced, justified with reference to the skillfully wrought artifices of houses and their associated artifacts, which had initially wrought the very changes that made their existence possible. As Webb Keane says in the same volume, "[t]he Neolithic in Anatolia was marked by a massive increase in the sheer quantity of things made by people, including buildings, pottery and textiles" (Keane 2010, 209). Art inspires new interpretation and a change of behavior, and religion congeals the sustainable and perpetuates behavior, constituting a valid distinction between the operation of art and the operation of religion that can be retrojected even to Çatalhöyük. In more recent terms, consider the failed counter-culture of the 1960s, driven largely by recorded music and other relatively new arts, and consider the ways in which Renaissance artists like Michelangelo and da Vinci attempted to subvert the very ecclesiastical culture that their art was commissioned to serve. The very impulse to produce persistence constantly threatens to produce paths to change that subvert the initial drive. Great art leads to great subversion and requires complex mechanisms to decelerate rates of change. Religious tradition provides those mechanisms by congealing multiple manifestations of relatable behavioral modifiers into coherent wholes that have far greater impact than any single

deviant expression. Hence the common characteristic of religious tradition beginning with a revolutionary founder but rapidly developing into a highly conservative institution.

Objects of art provide imaginative experience for both producers and audiences. Art is experienced in a make-believe world marked by the manner in which it decouples imagination from immediate practical concern, freeing it from the constraints of logic and rational understanding and producing behavior in response to stimuli that might be considered other than real since they are not empirically present. This applies to what I have identified as the specifically religious mode of art behavior, when it is compounded and enhanced by stylistic extension and prolonged cultural habituation to induce a sense of the nature, character, or personality of the real. It provides something to which to respond, consistently and resiliently, when physical, historical factors are too complex to reveal an effective response.

The more specifically religious aspect of this behavior might be seen as a category of art behavior in which *fascination, enchantment* or *adoration* is more important, more significant, than other aspects of that behavior. In his book-length examination of the subject, C. Stephen Jaeger speaks of enchantment as "the arrest and capture of the viewer," and as "a state that has much in common with faith. Both urge the reality of things beyond everyday life. ... Both promise transformation and a kind of redemption" (Jaeger 2012, 373). According to the foregoing analysis of art and religion, the specific type of enchantment of which I speak is brought about by the promise of a return on the investment of attention via the apperception of a comprehensible order-liness to the imperceptible determinative agencies of the world, the cognition of a comprehensible "personality" to which one can respond. Through objects and events experienced as special, beautiful, and promising, one feels emotionally assured in one's response. This provides the core and the adaptive value of the behavior. Employed in this way, imagination allows the abduction of explanation from indirect evidence, the apprehension and sustainable comprehension of realities merely (but perhaps strongly) *suggested* by our experience. It gives us the ability to react to stimuli that are not actually present or are present only as (re)presentations rather than first-order presences. These invisible factors are by definition beyond the scope of human control and so cannot be directly manipulated to evaluate differing responses.[1] In Chapter Six of *The Art Instinct* Dutton investigates "The Uses of Fiction" (103–134) without considering its application to understanding religion. That whole chapter is well worth reading, but for present purposes, a basic introduction to his argument may be abstracted from his words.

> Adaptiveness derives from the capacity of the human mind to build a store of experience in terms of individual, concrete cases—not just the actual lived and self-described life experiences of an individual but the narratives accumulated in memory that make up storytelling traditions.
>
> (113)

The narratives that make up the great storytelling traditions are examples of such imaginative representation that is so intensively connected to the real that it cannot be profitably distinguished from it.

The narrative component of religious behavior is of immense and undeniable importance. As we have seen, however, music, the visual arts, drama, architecture, and all the arts contribute emotionally and powerfully to our "store of experience." The ability to perceive coherent pattern to the whole store of experiences, to conceive it *as* a whole—or more accurately, *to experience a consistent emotional reaction to one's experience as a whole*—is a crucial step on the road to individual art experiences becoming what we recognize as religious behavior, and this does not happen with narrative alone. That cosmogony and cosmology are such crucial components of religious traditions highlights the importance of unifying the store of experiences into a singular whole.

> Brian Boyd religion suggested that the chief functions of art and story lie in improving human cognition, cooperation, and creativity ... [an effective story] develops social cognition, encourages cooperation, and fosters the imagination, linking imagination with understanding our world more fully, with the creativity of human life as a whole, in religion and science as well as in art.
>
> (2009, 378)

As Alfred Gell has said of secular society, "[w]e have neutralized our idols by reclassifying them as art" (1998, 97). Either we must fall into one of the two positions lamented by Barbara DeConcini (DeConcini 1991, 323), in which we can simply no longer distinguish art and religion, or we must develop a more complex and sophisticated appreciation of them both and of their intertwined and reciprocating natures. I have suggested that art behavior begins from the human tendency to attend closely to a wide spectrum of items and actions that promise greater-than-average returns on the investment of that attention. That is why we devote so much time and attention to participating in or attending to skillful performance (even video games on our smartphones) with no apparent benefit. Effectively, creative activity inevitably leads to an expression of the self and of the nature of reality as the self apprehends it. The skills of cognition and presentation required to achieve such expression—and the skills of cognition and reception required to apprehend such expressions—engage intense attention and give rise to an emotional attribution and apprehension of the *character* of the world, the "personality of reality," which shapes both our ongoing apperception of our environment and our cognitive schemas of the real, thereby modifying our behavior. If the modifications are viable, the behavior continues. No singular artistic expression (if such a phenomenon could ever be entirely singular) can be as effective as expressions that are associated in an extended matrix of stylistically related expressions, and so those expressions

that are so embedded are more readily received and retained and repeated. Such reception and repetition communicates a sense of the unseen forces at work in the universe—personal or impersonal—adequate to promote an emotional response. That emotional response amounts to a moral consciousness, a sense of what is right and what is wrong. Thus, a stylistically related body of art behaviors has a distinctly religious dimension, which no singular art object or event could accurately be said to possess alone. When a body of art behaviors becomes extensive and idiosyncratic enough to be seen as distinct from comparable bodies, "a religion" as an institution has emerged. Thus, although we see that they are never truly free of one another, religion and art can be seen as having the distinguishable existences that we attribute to them today. The modern distinction is not *wrong* (save when it is apprehended as implying that the one can exist entirely without the other). However, the distinction is fostered by, and in turn continues to foster, the inaccurate understanding of art as gallery art and religion as institutionalized belief. These are not delusional, but they do limit and misrepresent the nature of both—disguising especially their once adaptive components—and they hamper our understanding of the origin, nature, and function of each. The final product of this behavior may be characterized as the skill of living a human life well, consistently, coherently, and to good individual and social effect. This skill may be termed wisdom.

Such a perspective on religion and art should hammer the final nails into the coffin of understanding and studying religion as primarily a matter of belief. Not only is belief a mentalistic entity, which is thus unavailable to empirical inspection, but the term is overloaded with Christian connotations (Fitzgerald 2000, 3–10). As Jason Slone famously pointed out, there is a significant gulf between religious beliefs professed in contemplative, official, or public situations, and the operative beliefs that motivate action (Slone 2004). Such operative beliefs are usually underdetermined by people's behavior—a specific act could be motivated by any number of incommensurable beliefs. What Barbara Herrnstein Smith identifies as the "traditional rationalist view of cognition," involves "a conception of beliefs as discrete true/false propositions about, or correct/incorrect mental representations of, an autonomous reality," and is distinctly limiting in understanding the nature of religion (B. H. Smith 2009, 70). As Smith points out, the term "belief" covers a wide range of phenomena from "discrete, verbally framed creeds to vague mental images" (71). While those vague images cannot be subject to empirical research, the verbally framed creeds can. As linguistic behavior, they are amenable to proper study. They are themselves more or less skilled products of the religious tradition in question and can be inspected as any other phenomenal manifestation. It is behavior rather than belief that we must study to understand religion.

It can be suggested that our predisposition to mentalistic entities such as beliefs in the monotheistic West is itself a product of the bibliolatry and

graphomancy that has accompanied Western monotheism. The hegemony of verbal representation, especially the written word, lends weight and substance to those concepts of internal motivation and mental representation so necessary to any skillful narrative—but perhaps less significant in the empirical investigation of human phenomena. It is what people *do* that matters, and what we say and write is only a small part of what we do. Representations of thought are immensely useful in predicting or explaining action, but false representations can be as effective as true representations as long as they are paired with affective systems that, together with the false representation, give rise to accurate prediction or satisfying explanation.[2] It has been one of the major errors of the "new atheist debate," and can be seen to be a by-product of logocentrism and graphomancy, to identify religion almost exclusively with false belief and to dismiss it on those grounds. As we have seen, this is also one of the reasons that ethologists of art have failed to grasp the significance of their understanding in explaining religion: religion is not so much a matter of belief, and certainly not of false and ineffective belief, as it is of divination and the attempt to predetermine what will be satisfactory and sustainable behavior. Religion should be studied as an identifiable group of human behaviors that have developed through our evolutionary past under the influence of our instinctive tendency to be drawn to the promise of sustainable action.

When people behave as if in response to some agent or agency in the external environment there is more at work here than mere promiscuous anthropomorphism and an unwonted tendency to ascribe human attributes to non-human phenomena (S. Guthrie 1993). The environment is experienced as suffused with agency. As Gell most effectively pointed out (but many other observations have corroborated), agency is itself an attribution, like beauty and the sacred. Agency is not something that we experience directly and empirically, but something which we attribute along with attributions of interiority and intentionality. Human beings attribute agency to and apperceive intentionality in non-human agents, inanimate objects, and those imaginary beings that are representations of the agency of the environment. It is the behavior in response to such attribution that matters rather than its putative scientific accuracy. If such attribution can contribute to the development of skills beneficial in the negotiation of our complex lives then they may, indeed, be wise. Given this understanding of religion, it is not paradoxical to understand the events of experience as products of intentionality; the workings of the Dao, or karma, or the will of Allah, or the acts of God or the gods. That is, indeed, how some of us apprehend our experience, though some of us do not. Just as some of us apprehend the beauty of a Martha Graham dance or Italian opera, or the sacrality of the Sultan Ahmed Mosque or Stonehenge, while some of us do not. As long as that apprehension (or its absence) does not issue in behavior that is evidently unsustainable, it is simply inaccurate to identify it as "false."

Notes

1 It may be a useful distinguishing feature of religious behavior that it issues from responses to some borderline between what can be—and is best—*distinguished from* the "real world" (in the specific sense of the historical, inter-subjectively physical and available) and some realm of imaginative or theoretical representation that is so intensively *connected* to that real world that it *cannot* be entirely distinguished from the real. Perhaps religion may profitably be seen as some kind of profoundly serious "play" that requires the *denial* that it is play—that involves the *un*willing, in the sense of unconscious, suspension of disbelief.

2 I am paraphrasing Michael J. Murray's quotation, given in Chapter 8: "false beliefs can be as adaptive as true beliefs *as long as they are paired with affective systems that, together with the false beliefs, give rise to adaptive behaviors*" (Murray 2008, 370, emphasis original).

References

Boyd, Brian. *On the Origin of Stories: Evolution, Cognition, and Fiction.* Cambridge, MA and London: The Belknap Press of Harvard University Press, 2009.

Bloch, Maurice. "Is There Religion at Çatalhöyük … or Are There Just Houses?" In *Religion in the Emergence of Civilization*, edited by Ian Hodder, 146–162. Cambridge, UK: Cambridge University Press, 2010.

DeConcini, Barbara. "The Crisis of Meaning in Religion and Art." *The Christian Century*, March 20–27 (1991): 223–326.

Dutton, Denis. *The Art Instinct: Beauty, Pleasure, and Human Evolution.* New York, Berlin, and London: Bloomsbury Press, 2009.

Fitzgerald, Timothy. *The Ideology of Religious Studies.* Oxford, UK and New York: Oxford University Press, 2000.

Gell, Alfred. *Art and Agency: An Anthropological Theory.* Oxford: Oxford University Press, 1998.

Guthrie, Stewart. *Faces in the Clouds: A New Theory of Religion.* Oxford: Oxford University Press, 1993.

Hodder, Ian ed. *Religion at Work in a Neolithic Society: Vital Matters.* Cambridge, UK: Cambridge University Press, 2014.

Jaeger, C. Stephen. *Enchantment: on Charisma and the Sublime in the Arts of the West.* Philadelphia: University of Pennsylvania Press, 2012.

Keane, Webb. "Marked, Absent, Habitual: Approaches to Neolithic Religion at Çatalhöyük." In *Religion in the Emergence of Civilization*, edited by Ian Hodder, 187–219. Cambridge, UK: Cambridge University Press, 2010.

Scalise Sugiyama, M. "Art Production, Appreciation and Fitness." In *Encyclopedia of Evolutionary Psychological Science*, edited by Todd Shackelford and Viviana Weekes-Shackelford. Cham: Springer International, 2019.

Slone, D. Jason. *Theological Incorrectness: Why Religious People Believe What They Shouldn't.* Oxford, UK: Oxford University Press, 2004.

Smith, Barbara Herrnstein. *Natural Reflections: Human Cognition at the Nexus of Science and Religion.* New Haven, CT and London: Yale University Press, 2009.

Index

Note: Page numbers followed by "n" denote endnotes.

Printed in the United States
By Bookmasters